山おくで、かりうどをしてたらしい。

うちの先祖ってどんな人？

はっきりわからないんだけどね。

鳥やけものを取って、ほそぼそと暮らしてたそうだ。

ぱっとしないなあ。

うちは先祖が……。

負けてたまるか!!

うちも家老……。いや、とのさまにしてやる。

ええっ。

タイムマシンでうちの先祖に会いに行こう！

Amano Masanao
Julius Wiedemann (Ed.)

TASCHEN
Bibliotheca Universalis

下山中

そういえば私とN子って高校時代の最後超ケンカしたんですよ〜

そうそう卒業以降も一言も口きかなかったよね！

へ〜

なぜケンカしたかもどうやって仲直りしたかも覚えてないけど

夕日の中でクラスの男子がギターをなぜか奏でる中激しく口論したよね〜！

思い出すわ〜

ポロ

りょうくんも大学2年の時私のこと超嫌いで集まりに来るとあまり不機嫌になってたよね

全然覚えてない

それもひどい…

そんな話をしながら下山し打ち上げ飲み会へ

クタクタでベロベロになってしまいあまり記憶はないけど楽しかった…

ばははウケる〜

数日後マンガを描くために写真を整理していた私

カチッ カチッ

カチッ

CONTENTS

007 Introduction/
 Einleitung

010 Tomomi Abe
016 Mitsuru Adachi
022 Koji Aihara
026 Ken Akamatsu
032 Fujio Akatsuka
036 Osamu Akimoto
042 Moyoco Anno
048 Yūji Aoki
054 Gosho Aoyama
060 Hirohiko Araki
064 Inio Asano
072 Kiyohiko Azuma
078 Tetsuya Chiba
084 Tatsuya Egawa
090 Hisashi Eguchi
096 Fujiko Fujio
102 Minoru Furuya
108 Usamaru Furuya
114 Moto Hagio
120 Kengo Hanazawa
126 Tetsuo Hara
132 Yasuhisa Hara
138 Akiko Higashimura
144 Kenshi Hirokane
148 Tsukasa Hōjō
154 Yoriko Hoshi
158 Yukari Ichijō
164 Haruko Ichikawa
170 Riyoko Ikeda
174 Santa Inoue
180 Takehiko Inoue
186 Hajime Isayama
192 Shotaro Ishinomori
198 Shinichi Ishizuka

204 Keisuke Itagaki
210 Junji Itō
214 Hitoshi Iwaaki
220 Mariko Iwadate
224 Shintarō Kago
230 Atsushi Kaneko
236 Masashi Kishimoto
242 Satoshi Kon
246 Yūjirô Koyama &
 Iipyao
252 Mitsurô Kubo
258 Iou Kuroda
262 Masayuki Kusumi
268 Machiko Kyô
274 Gatarô Man
280 Shôhei Manabe
286 Suehiro Maruo
290 Leiji Matsumoto
296 Taiyô Matsumoto
300 Ryôji Minagawa
306 Nayuka Mine
310 Natsujikei Miyazaki
316 Shigeru Mizuki
324 Minetaro Mochizuki
328 Milk Morizono
334 Daijirô Morohoshi
340 Gô Nagai
346 Tsuchika Nishimura
352 Miho Obana
356 Takeshi Obata
360 Eiichiro Oda
364 Reiko Okano
370 Kyôko Okazaki
376 Hiroya Oku
382 Yumiko Ôshima
386 Shuzo Oshimi
394 Katsuhirô Ôtomo

400 Yoshiyuki Sadamoto
406 Rieko Saibara
412 Fumi Saimon
416 Takao Saitô
422 Momoko Sakura
426 Noriko Sasaki
432 Kotobuki Shiriagari
438 Ken'ichi Tachibana &
 Yū Sasuga
444 Gengoroh Tagame
450 Yuzo Takada
456 Rumiko Takahashi
462 Fumiko Takano
468 Jirô Taniguchi
474 Natsuko Taniguchi
480 Kazuto Tatsuta
486 Osamu Tezuka
492 Yoshihiro Togashi
498 Akira Toriyama
504 Yoshiharu Tsuge
508 Kazuo Umezu
514 Chika Umino
518 Naoki Urasawa
522 Hideo Yamamoto
528 Naoki Yamamoto
534 Kazumi Yamashita
540 Mari Yamazaki
546 Ai Yazawa
550 Sensha Yoshida
556 Fumi Yoshinaga

562 Glossary/Glossar/
 Glossaire

565 Credits/Crédits

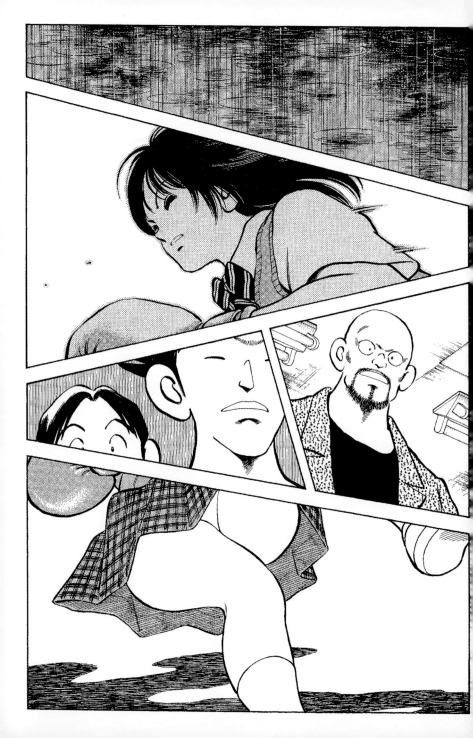

INTRODUCTION

Julius Wiedemann

Manga are Japanese comics created for Japanese readers. They are mostly published in anthologized series, usually in black and white, and with a new adventure in every issue in which new characters are introduced. Compared to the comic scene in any other country, manga have much higher print runs and are much more influential in their reach. Many manga books can have a weekly circulation in the millions. The support and reaction of the readers continues to be a major influence on the length of every series.

In Japan, manga can be found on every street corner. In Tokyo, manga stores can carry as many as 110,000 different titles. Manga have been the Japanese mainstream culture for decades, and the inspiration for many creative areas, such as Anime, advertising, film, and the visual arts. For some time now, Manga has also influenced western comic authors, designers, filmmakers, advertisers, and creative professionals in general.

The word manga came into use in the 19th century, when Hokusai, a well-known woodblock artist, used the two *kanji* (Japanese characters, derived from Chinese, that represent words and meanings) "man" (translated as lax) and "ga" (picture) to signify the characters he developed. But the art of telling stories in sequential blocks had already started in Japan a couple centuries before.

After the Meiji revolution in the 19th century, Japan opened its ports and culture to foreigners, and the West began to exercise a strong influence on culture and lifestyle. At this point, manga had an appeal comparable to that of Western comics. A "new" form of manga that had a mixture of Western and Japanese designs was beginning to emerge. A breakthrough came when Osamu Tezuka started to publish his books. Until then, the readers, mostly born before the 1950s, would stop reading manga in junior high school. Tezuka developed a more dynamic design, using angles, close-ups, perspective, and cinematic techniques from German and French movies of that time. His debut in 1947, "New Treasure Island," marked a turning point in manga history. The new narrative style fascinated new readers, who kept on reading manga into their adulthood.

This revised edition includes not only the celebrated stars of the last decade, it has been updated to incorporate the newest stars in the field, including a former porn star and mangaka, as manga artists are called, from a family of samurai. The book is also a journey in time, including artists who have passed away, but whose contributions cannot be forgotten

EINLEITUNG

Julius Wiedemann

Mangas sind japanische Comics, geschaffen für ein japanisches Lesepublikum. Sie werden in anthologisierten Serien veröffentlicht, meist in Schwarz-Weiß, mit einem neuen Abenteuer in jeder Ausgabe, in dem neue Charaktere eingeführt werden. Verglichen mit der Comicszene in anderen Ländern, haben Mangas nicht nur sehr viel höhere Auflagenzahlen, sondern sind auch sehr viel einflussreicher. Viele Manga-Magazine erreichen wöchentlich mehrere Millionen Leser. Die Popularität bei den Lesern sowie deren Reaktionen haben dabei einen großen Einfluss auf die Länge der Serie.

In Japan findet man Mangas an jeder Straßenecke. In Tôkyô gibt es darauf spezialisierte Läden, die teilweise bis zu 110 000 verschiedene Titel vorrätig haben. Mangas sind seit Jahrzehnten ein Teil des japanischen Mainstreams und dienen in vielen Kreativbereichen als Inspirationsquelle, so zum Beispiel im Anime, in der Werbung, im Film und in den visuellen Künsten. Seit einiger Zeit zeigen sich nun auch westliche Comiczeichner, Designer, Filmemacher, Werbeproduzenten und andere Angehörige kreativer Berufe von japanischen Mangas beeinflusst.

Der Begriff Manga stammt aus dem 19. Jahrhundert, als der berühmte ukiyoe-Künstler Hokusai die beiden kanji (aus dem Chinesischen übernommene Schriftzeichen mit Wort- und Sinnbedeutung) für „spontan" (man) und „Bild" (ga) zum Titel seiner Skizzenblätter machte. Die Kunst, Geschichten

in kurzen, aufeinanderfolgenden Einheiten zu erzählen, reicht in Japan aber noch einige Jahrhunderte weiter zurück.

Nach der Meiji-Restauration Ende des 19. Jahrhunderts öffnete Japan seine Häfen und seine Kultur dem Ausland, der Westen begann einen starken Einfluss auf die japanische Kultur und Lebensweise auszuüben. Zu diesem Zeitpunkt entstand eine neue Manga-Form als Mischung aus westlichen und japanischen Einflüssen. Der endgültige Durchbruch sollte aber erst mit Osamu Tezukas Werken erfolgen. Vor 1950 geborene Leser wandten sich meist in der Mittelschule von Mangas ab. Tezuka entwickelte einen sehr viel dynamischeren Zeichenstil mit Nahaufnahmen, Perspektiven- und Einstellungswechseln sowie kinematografischen Techniken aus deutschen und französischen Filmen dieser Zeit. Sein Debüt 1947 mit „New Treasure Island" markierte einen Wendepunkt. Der neue narrative Stil faszinierte neue Leser, die diesem Medium auch als Erwachsene treu blieben.

In dem vorliegenden aktualisierten Buch werden neben berühmten Künstlern des letzten Jahrzehnts nun auch die neuesten Stars in der Manga-Welt präsentiert, wie zum Beispiel ein ehemaliger Pornostar oder ein Mangaka – so werden Manga-Künstler genannt–, der von einem Samurai abstammt. Zugleich ist der Band eine Reise durch die Zeit, mit Porträts bereits verstorbener Künstler, die durch ihre Werke unvergesslich bleiben.

INTRODUCTION

Julius Wiedemann

Les mangas sont des bandes dessinées japonaises créées pour des Japonais. Elles sont généralement publiées sous forme de séries, souvent en noir et blanc, et chaque parution fait découvrir de nouveaux personnages et de nouvelles aventures. Lorsqu'on les compare aux bandes dessinées d'autres pays, les mangas n'ont pas seulement un plus grand tirage, ils ont également un énorme impact. De nombreux ouvrages de mangas sont publiés chaque semaine en millions d'exemplaires, et les lecteurs exercent une forte influence sur la durée des séries.

Au Japon, on trouve des mangas à chaque coin de rue et à Tokyo, les librairies spécialisées peuvent offrir jusqu'à 110 000 titres. Les mangas sont le courant dominant du pays depuis des décennies et l'inspiration de nombreux domaines créatifs tels que l'anime, la publicité, le cinéma et les arts visuels. Les mangas ont depuis quelque temps déjà commencé à influencer en Occident les auteurs de bandes dessinées, les illustrateurs, les cinéastes, les publicitaires et les professionnels de la création.

Le mot manga a commencé à être employé au 19ᵉ siècle, lorsque le célèbre artiste sur bois nommé Hokusai a associé les deux kanji (des caractères japonais issus de l'alphabet chinois et qui représentent des mots et des significations) « man » (divertissant, exagéré) et « ga » (image) pour décrire les personnages qu'il avait créés. L'art de raconter des histoires en blocs séquentiels était toutefois connu au Japon depuis déjà deux siècles.

Après la révolution Meiji au 19ᵉ siècle, le Japon a ouvert ses ports et sa culture aux étrangers, connaissant alors une forte influence occidentale en matière de technologie et de style de vie. À cette époque, les mangas japonais suscitaient le même intérêt que les bandes dessinées d'Occident. Un nouveau type de manga mêlant dessins japonais et occidentaux a fait son apparition, la culmination étant la publication des œuvres d'Osamu Tezuka. Jusque là, les lecteurs, dont la plupart étaient nés avant les années 1950, arrêtaient de lire des mangas après le collège. Tezuka a développé un style plus dynamique, avec différents angles, des gros plans, de la perspective et des techniques cinématographiques provenant des films allemands et français du moment. Ses débuts en 1947 avec « La nouvelle île au trésor » ont marqué un tournant dans l'histoire du manga. Le nouveau type de récit a tellement plu que les lecteurs y sont restés fidèles, même une fois adultes.

Cette nouvelle édition présente les grands noms de la dernière décennie, ainsi que les nouvelles promesses dans le domaine, dont un mangaka (artiste manga) qui est une ancienne star du porno et le descendant d'une famille de samouraïs. L'ouvrage est également un voyage dans le temps avec des références à des auteurs décédés, mais dont on ne peut oublier la contribution.

A collection of short stories, Tomomi Abe's best-selling title to date, "Sora ga haiiro Dakara," bets on the idea of overcoming great difficulties. With characters ranging from a lonely woman who has crippling social anxiety, a girl who is dumped by her closest friend, a single mother who struggles to understand how to make her daughter happy, and a girl who desperately wants to buy a dress that she thinks could change her life, the artist focuses on very contemporary issues in the country. Constantly looking from an anthropological viewpoint, Abe's "Chi-chan wa chotto tarinai" [Chi-chan isn't quite good enough] manga has been ranked among the top 20 bestselling manga for female readers . Other titles such as "Black Galaxy and Dragon Swallow" are an attempt by Tomomi Abe to escape from the realism that has made her titles so well known. Apart from weekly and monthly magazines, her works have been cleverly published on Pixiv, an online SNS that focuses on illustration, from where she has been able to captivate a large fan base.

TOMOMI ABE

Debut

with "Hakai Shokogun" in 2010
published in *Weekly Shônen Champion*

Best known works

"Sora ga haiiro dakara"
"Chi-chan wa chotto tarinai"

Prizes

- 74th New Face Manga Award of *Weekly Shônen Champion* (2010)
- 18th Japan Media Arts Festival: New Face Award in Manga Division (2014)
- Ranked 1st in "This is the Amazing Manga! Girls Section 2015 Kono manga ga sugoi! Onna hen 2015" (2015)

あの二人って
どこまで進んで
いるんだろう

すき———っ！

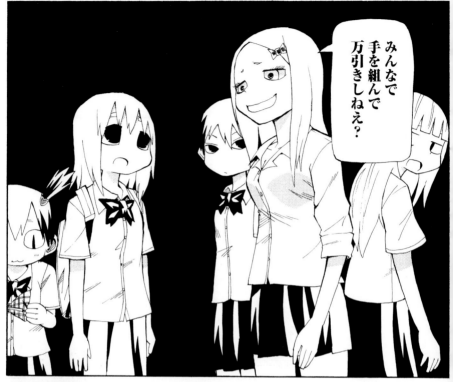

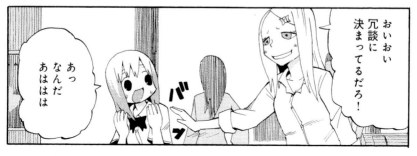

さらばじんるいよ──
あの子は旅だつっ
もーくせいにぃー

歌詞が
まざ,てるよ
ずいぶんと
古いよう
だけど

奥島くん
ちーちゃんを
いつも
かまって
くれて
優しいね
うれしいね

やさしい!
うれしい!
おぐじまく!

ぽ
か

ぽ
か

あ──!
もしかして
ちーちゃん好きなの
奥島くんのことっ!

Die Kurzgeschichtensammlung „Sora ga haiiro dakara", der bis heute absatzstärkste Titel von Tomomi Abe, handelt von der Überwindung großer Schwierigkeiten. Zu ihren Charakteren zählt eine einsame, menschenscheue Frau, ein Mädchen, das von seiner besten Freundin fallengelassen wird, eine alleinerziehende Mutter, die gerne wissen möchte, wie sie ihre Tochter glücklich machen kann, und ein Mädchen, das unbedingt ein Kleid kaufen möchte, von dem es glaubt, es könne sein Leben verändern. Durch diese widmet sich die Künstlerin aktuellen Themen aus ihrer Heimat. Das aus anthropologischer Sicht geschriebene „Chi-chan wa chotto tarinai" gehört zu den 20 meistverkauften Mangas für weibliche Leser. Mit Werken wie „Black Galaxy" und „Dragon Swallow" versucht sich Abe von jenem Realismus abzusetzen, durch den sie bekannt wurde. Außer in Wochen- und Monatszeitschriften finden sich ihre Arbeiten auch im sozialen Netz Pixiv, das auf Illustrationen spezialisiert ist und ihr eine große Fangemeinde verschafft hat.

Recueil de nouvelles, le plus grand best-seller de Tomomi Abe à ce jour s'intitule « Sora ga haiiro Dakara », et traite de l'idée de surmonter des difficultés majeures. Les personnages comptent une femme solitaire souffrante d'une angoisse sociale invalidante, une fille que sa meilleure amie laisse tomber, une mère célibataire qui tente de comprendre comment rendre sa fille heureuse, et une fille qui tient désespérément à acheter une robe, pensant qu'elle lui changera la vie. L'artiste exploite donc une série de problèmes très contemporains au Japon. Avec un point de vue toujours anthropologique, le manga « Chi-chan wa chotto tarinai » a été classé dans les 20 meilleures ventes de mangas pour femmes. Dans des titres comme « Black Galaxy » et « Dragon Swallow », Tomomi Abe tente d'échapper au réalisme qui a fait le succès de ses autres œuvres. Outre des parutions hebdomadaires et mensuelles, son travail a été publié sur Pixiv, une communauté en ligne d'illustrateurs où elle a conquis une foule de fans.

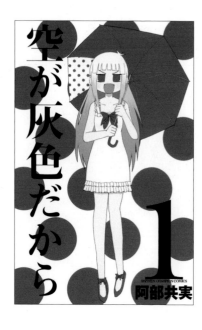

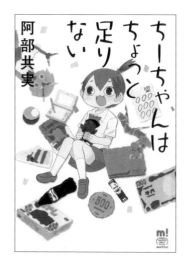

ストーカーは
あんたでしょ

ねえ
お兄ちゃん！

ずっと後をつけてきて
じろじろずっとこっちを見てて
バレてないとでも思ってた!?

こわい

なんで
そうなるの!?

追っていた私を泳がせて
逆にストーキング
してたっていうの!?

お兄ちゃん
この人こわいよ
アレもんだよ

During the 1970s Mitsuru Adachi mostly focused on comics designed for young girls. But in the 1980s he switched his activities to comics for young boys, and since then has continued to create a number of runaway comic hits. His pivotal success came from revolutionizing Boys Comics by being the first to truly incorporate the elements of love and romance, which were being monopolized by Girls Comics at the time. Before he heralded these changes, Boys Comics consisted exclusively of naive main characters. Adachi cut out the long explanatory dialogues and became skilled at more subtly portraying characters in love. He was a main player in the start of the Boys Comics love comedy boom. His best known work, "Touch," is a story revolving around the delicate relationships between a high school student named Kazuya Uesugi, whose goal it is to play in the Koushien national high school baseball championship), his older twin brother Tatsuya, and their childhood friend/girl next door Minami Asakura. During the series publication, Kazuya unexpectedly died in a traffic accident before he could fulfill his ultimate dream. This shocking turn of events met with an enormous response from fans everywhere. However, Tatsuya ends up taking over for Kazuya in his dream of taking Minami to the Koushien. The series also became a huge TV animation hit. Mitsuru Adachi's works have become synonymous with youth.

MITSURU ADACHI

Born
1951

Debut
with publication of "kieta bakuon," which appeared in *Deluxe Shônen Sunday* in 1970

Best known works
"Miyuki"
"Touch"
"H2"

TV/Anime adaptation
"Touch"
"Nine"
"Miyuki"

Prizes
• 28th Shôgakukan Manga Award (1983)

チチチ…

6時のニュースです!!

はじめに──
フィリピンのサンボアンガ沖に墜落した旅客機の救助活動は、

その後の天候悪化のためいったん中止され……

In den 1970er Jahren zeichnete Adachi hauptsächlich für *shôjo*-Magazine, aber seit den 1980er Jahren verlagerte er seine Aktivitäten zunehmend mit großem Erfolg auf den *shônen*-Bereich. Seine bahnbrechende Idee war es, die bisher ausschließlich den *shôjo*-Mangas vorbehaltene Liebe ernstlich in einem *shônen*-Manga zu thematisieren. In völliger Abkehr von bisheriger *shônen*-Praxis entwarf er zartfühlende Protagonisten, verzichtete auf Dialoge mit Erklärungsfunktion und brachte feingezeichnete Gefühle zum Ausdruck. So übernahm Mitsuru Adachi die zentrale Rolle im *love comedy*-Boom der *shônen*-Magazine. Bezeichnend für seinen Stil ist „Touch", eine Geschichte um das delikate Verhältnis zwischen den Zwillingsbrüdern Kazuya und Tatsuya Uesugi und deren Kindheitsfreundin und Nachbarstochter Minami Asakura. Kazuya spielt Baseball und trainiert für eine Teilnahme am Kôshien, dem alljährlich im Fernsehen übertragenen Turnier der besten Schulteams aus ganz Japan. Als der Autor ihn mitten in der Serie bei einem Verkehrsunfall sterben ließ, versetzte er seinem Lesepublikum einen schweren Schock. Kazuyas Bruder übernimmt dessen Traum, mit Minami zusammen zum Kôshien-Turnier zu fahren. Der auf diesem Manga basierende TV-Anime wurde ebenfalls ein großer Erfolg und Mitsuru Adachis Mangas gelten in Japan als Synonym für Jugendzeit.

Durant les années 70, Mitsuru Adachi s'est concentré sur la création de mangas shoujo [bandes dessinées pour jeunes filles]. Dans les années 1980, il est passé aux mangas shounen [bandes dessinées pour jeunes garçons] et a depuis lors continué de créer de nombreuses bandes dessinées populaires. Son succès dans ce domaine est dû à la manière dont il a révolutionné les mangas shounen en devenant le premier auteur à incorporer des éléments d'amour et de romance, qui étaient habituellement monopolisés par les mangas shoujo de l'époque. Avant ces changements, les mangas shounen n'étaient constitués que de personnages naïfs. Adachi a laissé de côté les longs dialogues et a exercé son talent à l'interprétation des personnages tombant amoureux. Il était un des principaux auteurs de bandes dessinées à l'origine du succès des mangas shounen sur le thème de la comédie amoureuse. Son œuvre la plus connue est « Touch », une histoire sur la relation délicate entre un lycéen nommé Kazuya Uesugi, dont le but est de participer au Koushien (le championnat national de baseball lycéen), de son frère jumeau Tatsuya et de leur amie d'enfance et voisine Minami Asakura. Durant l'histoire, Kazuya meurt de façon inattendue dans un accident de la route avant d'avoir pu réaliser son rêve ultime. Cet événement choquant a déclenché une réaction énorme de la part des fans. Ainsi, Tatsuya poursuit le rêve de Kazuya d'emmener Minami au Koushien. La série a été adaptée pour la télévision et a rencontré un vif succès. Les travaux de Mitsuru Adachi sont devenus synonymes de jeunesse.

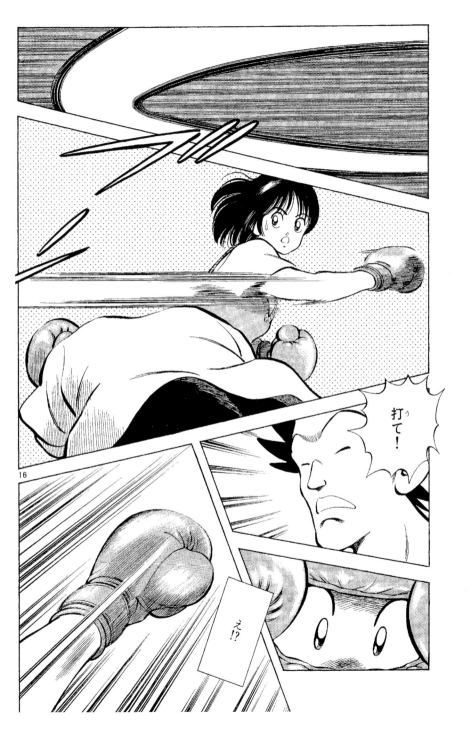

Not only does Koji Aihara continue to experiment with new themes in the realm of gag comics, his material is distinguished by its attention to meticulous detail. The finished product is always top quality. Most typical of Aihara's work is his comic strip parody of a prominent Japanese dictionary, a yon koma manga entitled "Kōjien." This mock instructional book has been based so closely on a standard dictionary that each of the four frame comic strips has been placed in alphabetical order. They are arranged each on one page, with each comic strip depicting the explanation of a particular word. There is an appendix at the back of the book explaining the different styles of gag manga. By deliberately basing the book closely on a standard dictionary, Aihara has injected the work with extraordinary humor.

He even analyzes and pokes fun at the manga world with his series entitled "Even a Monkey Can Draw Manga." In this series nicknamed "Saruman," the main character is a person who strives to create a manga that will sell. Popular drawing styles and themes, questions such as "Which words will create laughter?", and manga trends are all unraveled with thoughtful analytical explanations that invoke laughter. In "Manka," like the tanka poem, which is the most compact form of expression in Japanese literature, the comic strips prove that it is possible to convey emotions like happiness or sadness within the compact boundary of the yon koma manga. Aihara's works always have a distinct theme, together with gags that contain keen insights into present-day society.

KOJI AIHARA

Born

1963 in Hokkaidō, Japan

Debut

with "Hachigatsu no Nureta Pantsu" In 1983
published in the *Weekly Manga Action Magazine*

Best known works

"Bunka jinrui gag"
"Kōjien"
"Saru demo kakeru manga kyōshitsu" [Even a Monkey Can Draw Manga] (in collaboration with Kentaro Takekuma)
"Mujina"
"Manka"

燃える性　　　　　　視線恐怖

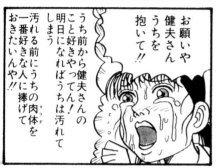

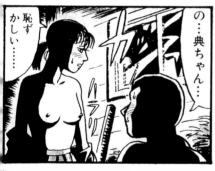

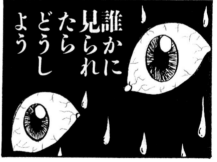

Sein Genre ist der Gag-Manga – hier versucht er sich an immer wieder Neuem, veröffentlicht auch experimentellere Arbeiten, legt dabei aber stets Wert auf ein sorgfältig durchdachtes Konzept und eine hochgradig perfekte Ausführung. In seiner Parodie auf Japans bekanntestes Konversationslexikon, im „Kôjien", beispielsweise entspricht die Aufmachung seines Manga äußerlich genau dem Original und auch die Einträge sind korrekt nach dem japanischen Silbenalphabet geordnet. Allerdings ersetzt er die Erklärungen durch Vier-Bilder-Mangas und im Anhang findet sich unter anderem eine Deklination des Gag-Manga. In Japan wurde diese konsequent durchgezogene Parodie begeistert aufgenommen. In „Saru demo kakeru manga kyôshitsu" [Manga, die sogar Affen zeichnen können – ein Lehrbuch], kurz „Saruman" [aus Affe, *saru*, und Manga] wird der Manga an sich zum Studien- und Spaßobjekt. Die Figuren sind auf der Suche nach einem Rezept für Bestseller-Mangas und bis sie am Ende die erfolgreichsten Bildformen und Storys sowie die witzigsten Wörter ausfindig gemacht haben, werden typische Spannungsbögen und Manga-Motive höchst wissenschaftlich erläutert und der Leser amüsiert sich dabei köstlich. Die Grundidee von „Manka", dessen Titel auf die kürzeste festgelegte japanische Gedichtform, das Tanka, anspielt, besteht wiederum darin, subtilste Gemütsbewegungen und Gefühlsregungen in nur vier Bildern auszudrücken. Aihara hat sich durch seinen scharfsinnigen Witz und seine bis ins letzte Detail ausgearbeiteten Mangas in Japan eine große Fangemeinde erobert.

Non seulement Koji Aihara continue d'expérimenter de nouveaux thèmes dans le domaine des mangas humoristiques, mais ses œuvres se distinguent par leurs détails méticuleux. Le produit fini est toujours de la meilleure qualité. L'œuvre la plus typique d'Aihara est sa bande dessinée parodique d'un éminent dictionnaire japonais, un manga yon koma intitulé « Kôjien ». Ce faux ouvrage pédagogique ressemble tellement à un dictionnaire classique que ses bandes dessinées en quatre vignettes sont classées par ordre alphabétique. Une bande dessinée est disposée sur chaque page, et chacune donne l'explication d'un mot spécifique. L'annexe en fin d'ouvrage explique les différents types de mangas humoristiques. En donnant à son ouvrage l'apparence d'un dictionnaire, Aihara y a injecté une bonne dose d'humour. Il se moque même de la bande dessinée en elle-même avec sa série intitulée « Saru demo kakeru manga kyôshitsu » [Même un singe peut dessiner des mangas]. Dans cette série, surnommée « Saruman », le personnage principal est un individu qui tente de créer une bande dessinée en espérant qu'elle se vendra bien. Les styles de dessin et les thèmes populaires, les questions telles que « quels mots font rire ? » et les tendances des mangas sont démêlés à l'aide d'explications analytiques profondes qui provoquent le rire des lecteurs. Dans « Manka », comme le poème tanka qui est la forme d'expression la plus compacte de la littérature japonaise, la bande dessinée prouve qu'il est possible de transmettre des émotions telles que la joie ou la tristesse, dans le cadre concis des mangas yon koma. Les mangas d'Aihara ont toujours un thème distinct et des gags qui donnent un aperçu mordant de la société contemporaine.

ここで、このカシムが丸太の義足に仕込んでいた銃について説明しておこう。

特別図解 カシムの必殺武器 足鉄砲の仕組み

普段は銃口は
絶えず地面と
接しているため、
土が入らぬよう
蓋がついている。

銃を撃つ時は
この部分を
地面にぶつけて
蓋を開ける。

パカ

ガッ

地面

弾丸

導火線

火縄

板バネ

ヒモ

火縄バサミ

一般的な火縄銃は銃口から
火薬と弾をこめるが、この
仕込み銃の場合、銃口は
いつも下を向いてるので
そんなことをすれば火薬も弾も
下に落ちてしまう。
よって弾はカートリッジ式に
なっている。

弾丸　火薬

半紙　　導火線

カートリッジ
装填の図

止め金

①ヒモを引っ張ると
②火縄が導火線に着火
③火薬が爆発し弾丸が
　発射される

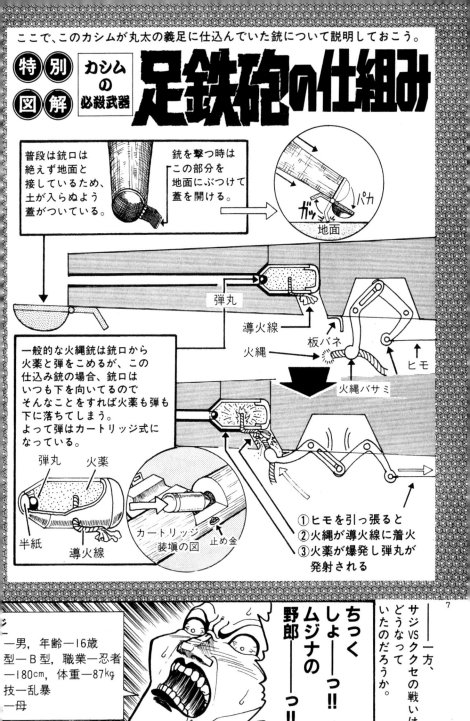

―男，年齢―16歳
型―B型，職業―忍者
―180cm，体重―87kg
技―乱暴
―母

ちっくしょーっ!!
ムジナの
野郎―っ!!

一方、
サジVSククセの戦いは、
どうなって
いたのだろうか。

7

What would happen if a young man who has no redeeming features suddenly became popular with girls? This theme for the love/comedy comic series "Love Hina" is every young man's fantasy. The main character is introduced as a young man who has failed to pass the entrance exams needed for acceptance into university. For various reasons he has to live in a woman's dormitory, surrounded by girls. When we are first introduced to the main character he seems rather unreliable, although he does manage to have romantic relations with many of the girls, including the story's main heroine. As the plot develops, the characters run up against a number of conflicts, which prove captivating for the reader. And with time, the young man grows to become a confident and reliable individual who finally gets the girl in a great happy ending. The repetitive use of situations in which the female characters kiss the male lead by accident, or likewise appear naked in front of him, may seem fairly orthodox fare for a love comedy. However, this simple technique is very popular with male comic fans, especially the hard-core fanatics [called "otaku"]. This concept is also widely used in other Japanese animations and in romantic novels.

KEN AKAMATSU

Born

1968 in Aichi Prefecture, Japan

Debut

with "One Summer KIDS Game" published in *Magazine Fresh*

Best known works

"Ai ga tomaranai" [A.I. Love You]
"Love Hina"
"Mahô sensei Negima" [Negima]

TV/Anime adaptation

"Love Hina"

Prizes

• 25th Kôdansha Manga of the Year Award (2002)

Durch einen glücklichen Zufall sieht sich ein Junge ohne besondere Qualitäten auf einmal von hübschen Mädchen umschwärmt – die Tagträume junger Männer werden in Akamatsus bekanntestem Werk „Love Hina" konsequent bedient. Der Protagonist dieser *love comedy* bereitet sich zum wiederholten Male auf die Aufnahmeprüfung zur Universität vor und landet einstweilen in einer Mädchen-Pension, wo er naturgemäß scharenweise von Mädchen umgeben ist. Anfangs ein recht unzuverlässiger Tolpatsch, verliebt er sich im Laufe der Serie in diverse junge Damen – allen voran natürlich in die weibliche Hauptfigur –, verzankt sich wieder mit ihnen, stiftet allgemeine Verwirrung auch beim Leser und reift schließlich zu einem vortrefflichen jungen Mann, der zum Happy End natürlich die Heldin bekommt. Durch allerlei Versehen wird er ständig von den Mädchen geküsst oder überrascht sie nackt. Die häufige Wiederholung solcher Szenen stellt für das Genre der *love comedy* zwar keine Innovation dar, wird aber vom überwiegend aus jungen Männern, insbesondere *Otakus*, bestehenden Lesepublikum heiß und innig geliebt. Eine ähnliche Entwicklung lässt sich auch in anderen Medien, sei es Anime oder Roman, beobachten.

Que se passerait-il si un jeune garçon qui n'a aucun charme devenait soudainement populaire auprès des filles ? Le thème de la comédie amoureuse de la série « Love Hina » est le fantasme de tous les jeunes hommes. Le personnage principal nous est présenté comme étant un jeune homme qui a raté son examen d'entrée à l'université. Pour différentes raisons, il doit vivre dans un dortoir entouré de filles. Lorsque nous rencontrons ce personnage pour la première fois, il semble plutôt douteux, bien qu'il se débrouille pour avoir des liaisons avec de nombreuses filles dont l'héroïne principale. Durant le développement de l'histoire, les personnages font face à des conflits qui captivent les lecteurs. Avec le temps, le jeune garçon évolue et devient un individu plus confiant et plus fiable qui finit par gagner en beauté le cœur de la fille au terme de l'histoire. L'utilisation systématique de situations dans lesquelles les personnages féminins embrassent par accident le personnage principal, ou apparaissent nues devant lui, semble assez peu orthodoxe dans le cadre d'une comédie amoureuse. Toutefois, cette technique simple est très populaire auprès des fans de mangas, et plus particulièrement ceux appelés « otaku ». Ce concept est également très utilisé dans d'autres romans sentimentaux et films d'animation japonais.

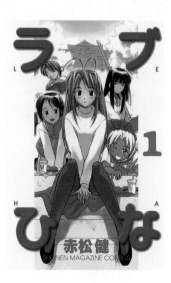

Fujio Akatsuka is one of Japan's top gag comic artists, and created some of the most well known Japanese characters. He was one of the regulars at the famed Tokiwaso, an apartment where Japan's legendary manga artists used to meet to trade ideas. He first started out drawing *shoujo manga* (Girls Comic), but hit it big when he launched "Osomatsu-kun" in a 1962 *shounen manga* (Boys Comic) magazine. The famous character "Iyami," is often heard crying the word "Chez!" while assuming an unusual pose. This unique pose and the accompanying exclamation became widely popular. This was followed by his most famous creation, "Tensai Bakabon." Here again fans were introduced to an absurd character who came to be known as "Bakabon's Dad" – a hilarious character who has a unique way with words, saying things like "I feel the opposite of agree," or the punch line which may be concluded with the word: "Well, that's fine!" The character has been practically branded on Japanese people's minds. "Mouretsu A Tarou" drew the hot-blooded and manly view of the world centering on the good boys of influence who perform a greengrocery, and also induced a noted character, such as Nyarome of a cat. Another wildly popular series published in a *shoujo manga* magazine was a story about a cute little witch called "Himitsu no Akko-chan." This was a highly original concept that came to be copied time and again by other manga artists. The way in which the main character casts a spell using a small compact and the magic words "Teku-maku-maya-kon" to alter her appearance or simply to disappear became the basis for a whole row of cute young witch characters that eventually followed. Akatsuka's popular manga became an animated series long ago, but it still continues to be loved by children of all ages. His creations have been revised many times over, evidence of their tremendous popularity.

F U J I O A K A T S U K A

Dates

Born 1935 in Manchuria
Died 2008 in Tokyo

Debut

with the publication of "Arashi wo Koete" [Overcoming the Storm]

Best known works

"Osomatsu-kun" [Young Sextuplets]
"Himitsu no Akko-chan"
[The Secret Akko-chan]
"Tensai Bakabon" [Genius Idiot]
"Mouretsu Ataro" [Violent Ataro]

Anime adaptation

"Osomatsu-kun"
"Himitsu no Akko-chan"
"Tensai Bakabon"

Prizes

• 10th Shôgakukan Children's Manga Award (1965)
• 18th Bunshun Manga Award (1972)
• 26th Education Minister Award from the Japan Cartoonists Association (1997)
• The Purple Ribbon Medal (1998)

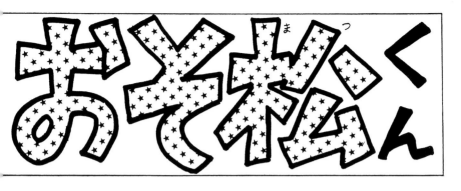

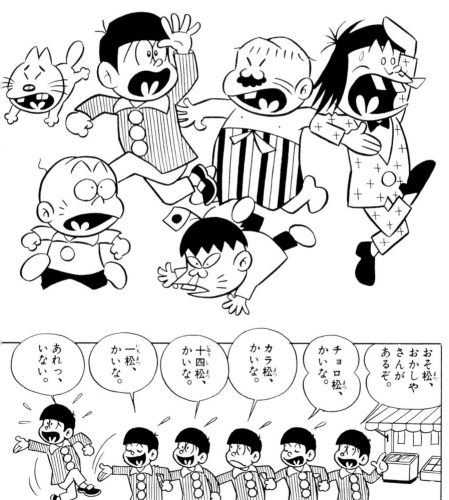

Der für Japans Gag-Manga vielleicht typischste Vertreter und geistige Vater unzähliger volkstümlicher Figuren wohnte einst in dem legendären Mietshaus Tokiwa-sô, dessen Bewohner alle zu Giganten der Manga-Welt werden sollten. Ursprünglich zeichnete Akatsuka Mangas, die eher dem *shôjo*-Genre zuzuordnen sind, begann 1962 aber in einem *shônen*-Magazin mit „Osomatsu-kun", der ihm den endgültigen Durchbruch verschaffte: In ganz Japan ahmte man die typische Arm- und Beinverdrehung mit dem dazugehörigen Ausruf „Shei!" der Iyami-Figur nach. Das im Anschluss veröffentlichte „Tensai Bakabon" gilt als sein Hauptwerk und mit Bakabons Vater schuf er erneut eine extreme Nonsensfigur: Für deren japanweite Bekanntheit sorgten widersinnige Sprüche wie „Ich verneine die Bejahung!" und die alles abschließende Bemerkung „Lassen wir's damit gut sein." – natürlich war die jeweilige Situation alles andere als gut. Auch die Urmutter aller *magical girl*-Mangas „Himitsu no Akko-chan" wurde ein Riesenerfolg. Wie die Protagonistin ihre Puderdose öffnet, den Zauberspruch „Tekumakumayakon" murmelt und sich dann verwandelt, wurde stilbildend für die vielen nachfolgenden Mädchen mit Verwandlungszauberkünsten in Japans Manga-Universum. Mit diesen Serien, die alle auch mehrfach als Anime verfilmt wurden, schuf Akatsuka ein unvergessliches Werkensemble.

Fujio Akatsuka est l'un des principaux auteurs de bandes dessinées du Japon, et il a créé les personnages japonais les plus connus. Il était un des habitués du fameux « Tokiwaso », un appartement où les auteurs légendaires de mangas japonais se rencontraient pour échanger des idées. Il a débuté sa carrière en dessinant des mangas shoujo (bandes dessinées pour jeunes filles), mais son succès le plus important fut le lancement de « Osomatsu-kun » [Les jeunes sextuplés] dans un magazine de mangas shounen (bandes dessinées pour jeunes garçons) en 1962. Suite à cela, il a créé sa fameuse série « Tensai Bakabon » [L'idiot génial]. Ici aussi les fans ont découvert « le père de Bakabon », un personnage absurde et hilarant, qui a une manière particulière de s'exprimer, disant par exemple « Je ressens l'opposé de d'accord », ou bien encore il s'exclame « Tout va parfaitement bien ! » dans des situations quelques peu délicates. Les jeunes ont adoré la série pour son humour tarte à la crème, tandis que les lecteurs plus âgés l'ont admirée pour ses jeux de mots ingénieux et sa satire mordante de la société. « Himitsu no Akko-chan » [L'Akko-chan secret] raconte l'histoire d'une ravissante petite sorcière. La manière dont le personnage principal jette un sort à l'aide d'un petit poudrier et des mots magiques « Teku-maku-maya-kon » pour altérer son apparence ou simplement disparaître, a donné naissance à une série de nouveaux personnages de jeunes sorcières. Les mangas populaires d'Akatsuka sont depuis longtemps devenus des séries animées qui continuent d'être appréciées par les enfants de tout âge. Ses créations ont été rééditées de nombreuses fois, preuve de leur incroyable popularité.

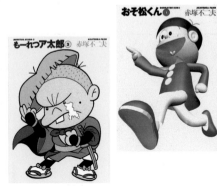

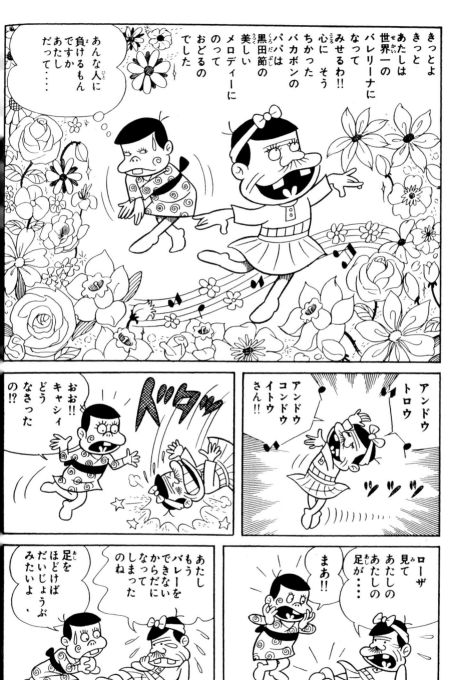

Osamu Akimoto debuted under the pen-name of Tatsuhiko Yamadome, but later returned to using his real name. His first comic series "This Is the Police Box in front of Kameari Park, Katsushika Ward" is considered his defining work. This popular series began publication in 1976 and has carried on ever since in a record-setting long run of 28 years! An astounding 136 volumes have been published to date, appearing as a serial for 28 years in a weekly comic magazine. The main character is an unconventional police officer named Ryô-san. The secret of the comic's success can be attributed to two contradictory elements: one

is the comic writer's foresight to cleverly incorporate the latest fads, such as games and computers. The other is his ability to remain true to the Japanese traditions that are symbolic of the Shitamachi area of Tokyo. The comic's storyline is based around the familiar world of "Kochi Kame" (a shortened version of the title), with new and fresh story ingredients being added to each episode. This seems to be the secret to its tireless run of 28 years. The series has also been made into a long-running TV animation series. It looks like the popularity of "Kochi Kame" will continue for years to come.

OSAMU AKIMOTO

Born

1952 in Tokyo, Japan

Debut

with "Kochira Katsushika-ku Kameari Kôen-mae hashutsujo" [This Is the Police Box in front of Kameari Park, Katsushika Ward] in 1976 published in *Weekly Shônen Jump*

Best known works

"Kochira Katsushika-ku Kameari Kôen-mae hashutsujo" [This Is the Police Box in front of Kameari Park, Katsushika Ward]
"Mr. Clice"
"Akimoto Osamu kessakushû" [Osamu Akimoto Masterpiece Collections]

Anime adaptation

"Kochira Katsushika-ku Kameari Kôen-mae hashutsujo" [This Is the Police Box in front of Kameari Park, Katsushika Ward]

Prizes

• 30th Japan Cartoonists Association Grand Prize (2001)

弾が あたらな
かったのか!?
クリスちゃん

おもいきり
あたったよ
183発くらい

おれの体はボディー
アーマーコーティング
されてるから
なんとかたすかった!

G11の
テストを
かねて
しかえしを
してやる

なん
だと!

わかって
いる

そのスコープは
1倍で
望遠スコープとは
ちがうんだぞ!

おれの目の
有効射程
距離は
1000
メートル

葬式だってアロハにすればムード一新だぞ！

えっ!?

黒い重苦しいモノトーンの世界から…

葬式

ハイビスカスやブーゲンビリアなどカラフルな原色の世界になるぞ！

お経などもスチールギターやマラカスをフュージョンする

住職のアロハ姿はかっこいいぞ

ライブ'96夏式

アロハを着れば気持ちも明るくなるのだ！

ムチャクチャですよ！

だから我がアロハシャツ普及委員会では日本一アロハシャツの似合う男所ジョージにアドバイザーになってもらう

アドバイザー 所マイタイジョージ

でも意外とアロハシャツを着こなすのはむずかしいわよね

ヤンキーやあやしいブローカーに見られる恐れがあるからな

ちなみに私アロハ普及の会長をしています

今年を日本アロハシャツ元年とします!!

だからこそ浴衣や半纏と同様に日本の夏に定着させなければならんのです!!

アロハを「合呂羽」と名を変え古来からある事にするのです!

JAI
日本アロハシャツ普及委員会 会長
両津カイマラヒラ
Eメール JSDN:1(@)R・KAIMARAHIRA

背広の堅さをアロハシャツで打ちくだくのだ!

アロハシャツで仕事するんですか!

法律でアロハ着用を義務づけるべきです!

7月8月はアロハ月間として全員着用!

アロハを着たとたん「遊び上手な業界人」に見えるほどアロハには魔力があるのだ!

アロハシャツで会議に出たらどんなに仕事ができる人も疑わしく見える!

すごく身近で親しみやすくなる!

この魔力を利用し役所や警察 銀行など堅い所でアロハを着用すると…

交番

Ganz am Anfang seiner Karriere veröffentlichte er unter dem Pseudonym Tatsuhiko Yamadome, später dann unter seinem eigenen Namen Osamu Akimoto. Sein 1976 begonnenes Hauptwerk „Kochira Katsushika-ku Kameari Kôen-mae hashutsujo" [Hier die Polizeiwache vor dem Kameari-Park im Stadtteil Katsushika], war sein erster Fortsetzungsmanga und entwickelte sich zu einer alle Rekorde brechenden Langzeitserie: 28 Jahre in wöchentlichen Episoden mit inzwischen 136 Sammelbänden – eine derartige Ausdauer erscheint fast schon unheimlich. Hauptdarsteller ist der etwas aus dem Rahmen fallende Polizist Ryô-san. Das Erfolgsgeheimnis dieses Mangas liegt in zwei Ingredienzen, die scheinbar im Widerspruch zueinander stehen. Zum einen hat der Autor ein sicheres Gespür für aktuelle Trends wie beispielsweise Videospiele und Computer und versteht es, diese geschickt in die Handlung einzuflechten; zum anderen verbreitet er eine Atmosphäre der guten alten Zeit, wie sie durch die Menschlichkeit der Bewohner im alten Shitamachi-Distrikt Tokios symbolisiert wird. Akimoto erschuf zunächst eine unveränderliche „Kochi Kame" [Hier die Kame-Wache] -Welt und diese vertraute Kost würzt er jedes Mal neu. Auf diese Weise gelang ihm das Kunststück, in 28 Jahren seinen Lesern niemals langweilig zu werden. Der gleichnamige TV-Anime wurde ebenfalls jahrelang ausgestrahlt und noch gibt es keinerlei Anzeichen für ein baldiges Ableben des Methusalem-Manga „Kochi Kame".

Osamu Akimoto a débuté sa carrière sous le nom d'artiste Tatsuhiko Yamadome, mais a utilisé son véritable nom par la suite. Sa première série de mangas « Kochira Katsushika-ku Kameari Kouen-mae Hashutsujo » [Le commissariat de police situé en face du parc Kameari, dans la circonscription de Katsushika] est considérée comme étant l'œuvre qui l'a défini. La publication de cette série populaire a débuté en 1976 et se prolonge jusqu'à aujourd'hui, un record de longévité de 28 ans ! Un nombre impressionnant de 136 tomes ont été publiés à ce jour et la série est publiée dans un magazine de mangas hebdomadaire. Le personnage principal est un officier de police peu conventionnel nommé Ryô-san. Le secret de la réussite de ce manga peut être attribué à deux éléments contradictoires. L'un est dû à la présence d'esprit d'Akimoto d'incorporer les dernières modes, telles que les jeux et les ordinateurs. L'autre est dû à sa capacité à adhérer aux traditions japonaises qui sont symboliques des quartiers Shitamachi de Tokyo. Le scénario de ce manga repose sur l'environnement familier de « Kochi Kame » (une version écourtée du titre), et des ingrédients nouveaux et rafraîchissants ajoutés à chaque épisode. Cela semble être le secret de cette série infatigable de 28 ans. Elle a également donné lieu à une fameuse série animée pour la télévision. Il semble que la popularité de « Kochi Kame » se poursuivra dans les années à venir.

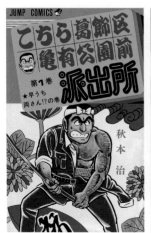

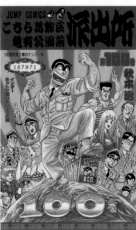

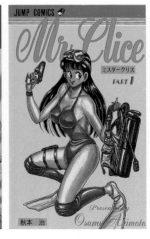

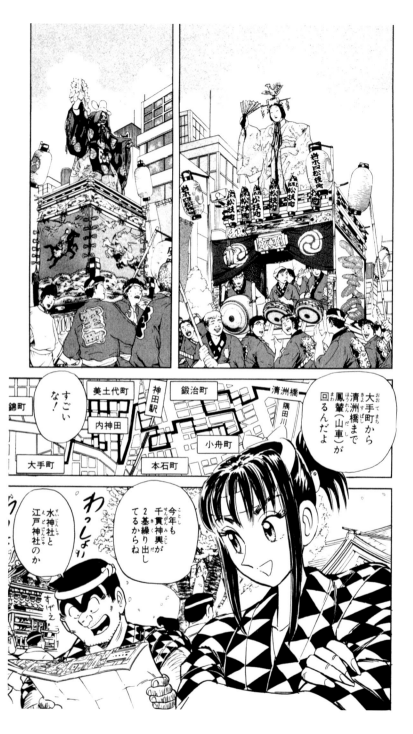

すごいな！

大手町から清洲橋まで鳳輦（山車）が回るんだよ

今年も千貫神輿が2基繰り出してるからね

水神社と江戸神社のか

わっしょい

すげえ

美土代町

神田駅

鍛治町

清洲橋

錦町

内神田

隅田川

小舟町

大手町

本石町

In "Happy Mania," Moyoco Anno's definitive work, the protagonist Kayoko Shigeta experiences the repetitive cycle of falling in love and breaking up, as she searches for the one true love of her life. The hopes and dreams of all modern women to find an ideal mate and find happiness in marriage are portrayed through the highly excitable character. The series appealed widely to young women of this generation who identified with these elements of the story. Her current series, "Flowers and Bees," is a comedy featuring an unpopular high school boy, Komatsu-kun, and his struggle to become a ladies man. The author works with themes like the definition of "coolness" and the psychology of a woman's mind when is in a relationship with a man, all in an entertaining fashion. Anno's works have a strong foundation in love and romance, but she also explores the psychology and actions of her characters in a thoughtful way to create highly entertaining stories. She is considered one of the top comic artists with her highly fashionable drawings and rough yet artistic style. She is also known for writing beauty columns, journals, collections of interviews with Japanese celebrities, and other books unrelated to manga.

MOYOCO ANNO

Born

1971 in Tokyo, Japan

Debut

with "Mattaku ikashita yatsura da ze!" published in *Magazine Friend* in 1989

Best known works

"Happy Mania"
"Jelly Beans"
"Hana to mitsubachi"
[Flowers and Bees]

Drama

"Jelly in the Merry-go-round"
"Happy Mania"

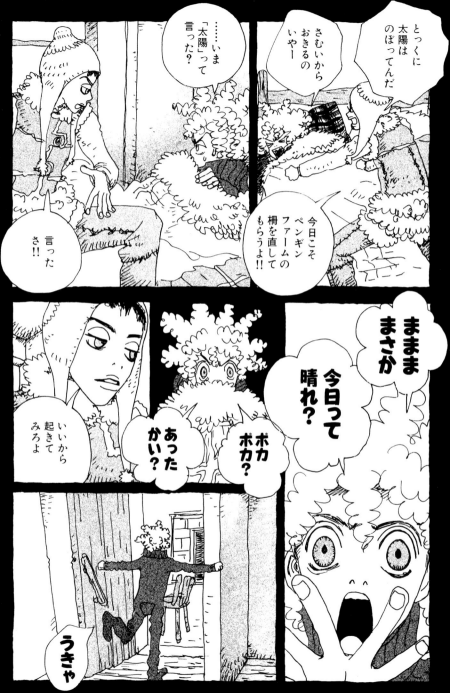

In ihrem bekanntesten Manga „Happy Mania" beschreibt Anno die Verwicklungen im Leben der Kayoko Shigeta, die auf der Suche nach dem Mann fürs Leben ein Fiasko nach dem anderen erlebt. Moderne Frauen mit ihren Sehnsüchten nach dem idealen Partner und einer glücklichen Ehe fanden sich in der aufgekratzten Protagonistin wieder und machten den Manga zu einem Bestseller. Ihr aktueller Manga „Hana to mitsubachi" zeigt den nicht allzu hellen Oberschüler Komatsu-kun bei seinen verzweifelten Bemühungen, ein Frauenheld zu werden. Sehr witzig geht es darum, was wahre Coolness ist und wie die weibliche Psyche auf Männer reagiert. Anno beschreibt anhand von Beziehungsgeschichten das menschliche Seelenleben und dabei gelingt ihr erstklassige Unterhaltung. Mit einem ausgeprägten Sinn für Mode und ausdrucksstarken Bildern, die trotz ihrer Einfachheit ihr zeichnerisches Talent bezeugen, gehört sie zu den Besten. Neben Mangas hat Moyoco Anno bisher auch eine ganze Reihe anderer Bücher veröffentlicht, so zum Beispiel Kolumnen zum Thema Schönheitspflege, Tagebuchaufzeichnungen und Gespräche mit Prominenten.

Dans « Happy Mania », l'œuvre de Moyoco Anno, la protagoniste Kayoko Shigeta ne cesse de tomber amoureuse et de rompre, durant sa quête du véritable amour de sa vie. Les espoirs et les rêves des femmes modernes de trouver le partenaire idéal et d'être heureuses dans le mariage sont dépeints au travers de ce personnage nerveux. La série a rencontré un vif succès auprès des jeunes femmes de cette génération qui s'identifiaient avec les éléments de cette histoire. Sa série actuelle, « Hana to mitsubachi » [Fleurs et abeilles], est une comédie sur un lycéen impopulaire, Komatsu-kun, et son envie de devenir un homme à femmes. L'auteur travaille avec des thèmes tels que la définition de ce qui est « cool » et la psychologie d'une femme lorsqu'elle entretient une relation avec un homme, tout cela de manière divertissante. Les œuvres d'Anno sont ancrées dans l'amour et la romance, et elle explore également profondément la psychologie et les actions de ses personnages pour créer des histoires très divertissantes. Elle est considérée comme étant l'un des principaux auteurs de mangas et ses dessins sont très en vogue. Son style est brut mais artistique. Elle est également l'auteure d'articles, de journaux et d'interviews pour des rubriques de beauté sur des célébrités japonaises, et a écrit d'autres ouvrages non liés aux mangas.

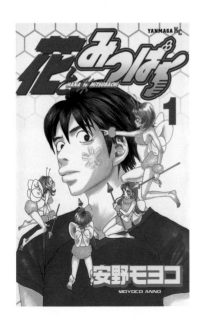

Yûji Aoki made his official debut at the age of 45 with the comic book drama "Naniwa kin'yûdô," which depicts the lives of a variety of people from the perspective of a loan shark. This series became a huge hit and even a popular TV drama. How will people react when their money runs out? How will they carry on with their lives? These are the kind of questions that Aoki has set about answering through his comic series. The dramatic personal sagas are seen through the eyes of the main character, a moneylender whose job is not only to lend money but also to collect debts, which sometimes requires hardball tactics. Not only is he constantly ducking the law, in some cases he even breaks it. Debt collection is shown in an unforgettable way that reveals the deep and profound stories of these people living on the edge. It makes one think of Dostoevsky! In fact, the comic writer openly acknowledged that he subscribed to Marxist principles and began writing comics to advocate his theories. After the tremendous hit of "Naniwa kin'yûdô," he at once retired from comic writing. However, diehard fans kept on pleading for his return, so he acted as supervising editor over a series drawn by his assistant, "Kabachitare!", and he continues to be involved with essay writing. Sadly Yûji Aoki passed away in 2003.

YÛJI AOKI

Dates

Born 1945 in Kyôto Prefecture, Japan
Died 2003 in Hyôgo

Debut

with "Naniwa kin'yûdô," which was published in the *Weekly Morning* magazine in 1990

Best known works

"Naniwa kin'yûdô"
"Kabachitare" (Supervising editor)

TV dramatization

"Naniwa kin'yûdô"

Prizes

- 16th Kôdansha Manga Award (1992)
- 2nd Tezuka Osamu Cultural Prize Manga Award for Excellence (1998)

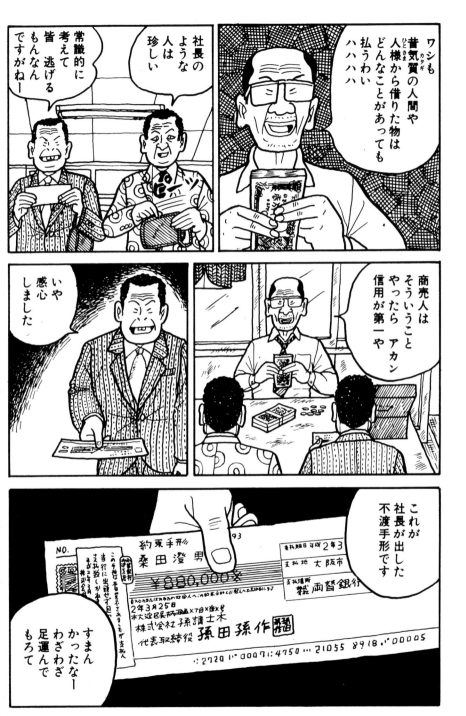

Yûji Aoki gab erst im Alter von 45 Jahren sein Debüt als professioneller Mangaka. „Naniwa kin'yûdô " handelt von den unzähligen menschlichen Dramen, die sich im Umfeld privater Kreditunternehmer des Naniwa-Finanzdistrikts abspielen. Der Manga wurde zu einem riesigen Überraschungserfolg und lieferte sogar die Vorlage für eine Fernsehserie. Aoki beschreibt Menschen, die keinen Cent mehr besitzen. Außergewöhnlich dabei ist, dass er die Geschichte aus der Perspektive derjenigen erzählt, die mit professioneller Unbarmherzigkeit und halblegalen oder sogar widerrechtlichen Methoden die Schulden eintreiben. Wie ein Dostojewski lenkt der Autor den Blick auf Existenzen am Rande unserer Gesellschaft und zeigt, dass auch diese Menschen eine komplexe Geschichte haben. Als erklärter Marxist zeichnete Aoki diesen Manga nach eigenem Bekunden als Beleg für sein Weltbild. Nachdem er „Naniwa kin'yûdô " mit großem Erfolg beendet hatte, zog er sich kurz entschlossen ganz aus dem Manga-Geschäft zurück. Aber bald wurden viele Stimmen laut, die mehr von ihm sehen wollten und er gab ihnen zumindest teilweise nach, indem er beispielsweise den Manga eines seiner Assistenten „Kabachitare" redigierte und die Story schrieb. Er starb 2003.

Yûji Aoki a fait officiellement ses débuts à l'âge de 45 ans avec son manga « Naniwa kin'yûdô » [Les finances style Naniwa], qui dépeint la vie de gens de tous horizons du point de vue d'un usurier. Cette série est devenue très populaire et a même donné lieu à une adaptation pour la télévision. Comment les gens vont-ils réagir lorsqu'ils manqueront d'argent ? Comment vont-ils continuer à vivre ? Ce sont les questions auxquelles Aoki tente de répondre au travers de sa série. Les sagas personnelles sont vues au travers des yeux du personnage principal, un usurier dont le travail n'est pas seulement de prêter de l'argent mais également de recouvrer des dettes, ce qui nécessite parfois des méthodes brutales. Non seulement il se dérobe constamment à la loi mais la viole même dans certains cas. Le recouvrement des dettes est dépeint d'une manière inoubliable qui révèle les histoires profondes de ces personnes qui vivent dangereusement. Cela fait beaucoup penser à Dostoïevski. En fait, Aoki reconnaît ouvertement qu'il a souscrit aux principes marxistes et a commencé à écrire des bandes dessinées pour recommander ces théories. Après le succès phénoménal de « Naniwa kin'yûdô », il s'est retiré de la scène. Toutefois, les fans n'ont cessé de plaider pour son retour, ce qu'il a fait en supervisant la série « Kabachitare! » dessinée par son assistant, et il a continué d'écrire des essais littéraires. Yûji Aoki est malheureusement décédé en 2003.

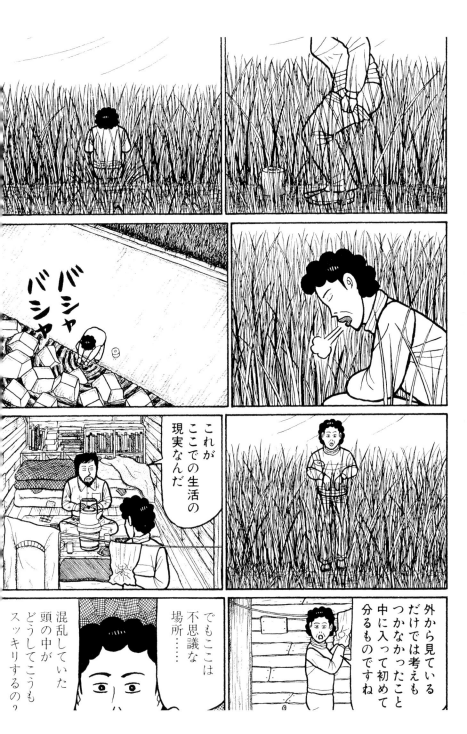

ガガガガガ

オイ菊池
この家屋
いつ頃の建物や

サー
明治時代の
ものじゃー
ないですか

そうか
今まさに明治の
建物が消滅
しよったのー

自然も社会も
たえず運動
しているんです
元のままの
状態ということは
ありえないんです

ガガガガガ

そして
またここに
新しい歴史が
出来るんですよ

なるほど…
お前ええこと
言うやないか

Gosho Aoyama's acclaimed comic series "Detective Conan" is still in publication. This series depicts a young 17-year old high school student, Shinichi Kudô, who is obsessed with solving crimes by reason and logic. Kudô's body has been reduced to the size of an elementary school student as the result of a drug administered by a mysterious criminal organization. So he adopts the name Conan Edogawa and pits himself against a row of mysteries and crimes as he searches for a way to regain his former body. Each time, he finds himself in a battle of logic with the police, Inspector Kogorô Môri, and a rival detective Heiji Hattori. Each case is solved over the course of several chapters, and the tricks involved in the various murder plots are ingenious. Yet happily the mysteries are always explained in a way that even school aged children can grasp. The series has also been turned into a popular animated series. Another popular comic that Aoyama created is a samurai series called "Yaiba" which is an action adventure that follows the life of Yaiba Tetsu, a young man brought up as a samurai. The attraction of this series is its action and fast pace, which is highly typical of a Boys Comic. The broad-minded hero and likeable sidekick characters are popular, and this comic has also been turned into an animated series. Both of these series are so wonderfully entertaining that they appeal to kids and adults alike.

GOSHO AOYAMA

Born

1963 in Tottori Prefecture, Japan

Debut

with "Chotto mattete" [Wait a Minute], which first appeared in *Weekly Shônen Sunday*

Best known works

"Yaiba"
"Magic Kaito"
"Meitantei Conan" [Detective Conan]

Anime adaptation

"Meitantei Conan" [Detective Conan]

Prizes

• 38th & 46th Shôgakukan Manga Award 1993 and 2001

わっ

怪盗キッド!?

なにをしている!?

顔を照らせ!!

はっ!!

し、しまった!!

おっ、おまえは!?

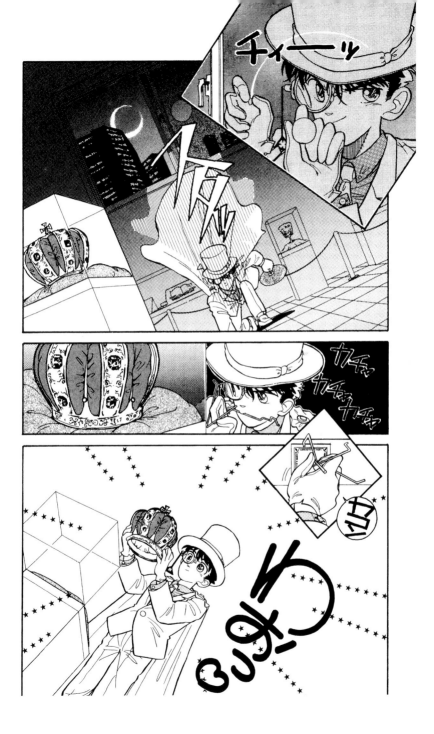

Hauptfigur in Aoyamas Krimi-Manga „Privat-detektiv Conan", von dem immer noch Fortsetzungen veröffentlicht werden, ist der krimisüchtige Oberschüler Shinichi Kudô, der sich durch das Serum einer verbrecherischen Organisation im Körper eines Grundschülers wiederfindet. Um sein ursprüngliches Äußeres zurückzubekommen, muss er in der Gestalt des kleinen Jungen Conan Edogawa unzählige Kriminalfälle lösen. Die jedes Mal in sich abgeschlossenen Geschichten zeigen Conan im Wettstreit mit dem Privat-detektiv Kogorô Môri und seinem Rivalen Heiji Hattori beim Aufdecken verzwickter Mordfälle aller Art. Das Ganze ist auch für Grundschüler leicht verständlich geschrieben und wurde zu einem Riesenerfolg mit mehreren Anime-Verfilmungen. Mit „Yaiba" gelang Aoyama ein weiterer Bestseller: Hier steht der junge, zum Samurai erzogene Yaiba Tetsu im Mittelpunkt. Die für *shônen*-Mangas typische Action zusammen mit einem edelmütigen Hauptdarsteller und liebenswerten Nebenfiguren sorgten für rasche Popularität sowie die Umsetzung als Anime. Beide Serien bieten beste *shônen*-Manga-Unterhaltung für alle Altersstufen.

La série populaire « Meitantei Conan » [Le détective Conan] d'Aoyama est toujours publiée. Cette série dépeint un jeune lycéen de 17 ans, Shinichi Kudô, qui est obsédé par la résolution de crimes grâce à la raison et la logique. Le corps de Kudô a été réduit à la taille d'un élève de l'école élémentaire, par une drogue administrée par une mystérieuse organisation criminelle. Il prend alors le nom de Conan Edogawa et se mesure à une série de mystères et de crimes durant sa quête pour retrouver son apparence normale. Il se retrouve systématiquement mêlé à des combats de logique avec l'inspecteur de police Kogorô Môri et un détective rival Heiji Hattori. Chaque affaire est résolue au bout de plusieurs chapitres, et les astuces impliquées dans les différents crimes sont ingénieuses. Heureusement, les mystères sont toujours expliqués d'une manière que même des enfants peuvent comprendre. La série a également donné lieu à une fameuse série animée. Une autre bande dessinée populaire créée par Aoyama constitue une série sur le thème du samouraï intitulée « YAIBA », une aventure sur la vie de Yaiba Tetsu, un jeune homme éduqué pour devenir samouraï. Le rythme rapide de cette série est typique des mangas shounen, ce qui explique pourquoi son héros large d'esprit et ses acolytes ont rencontré un grand succès. Ce manga a également donné lieu à une série animée pour la télévision. Ces deux séries sont si divertissantes qu'elles sont appréciées des enfants et des adultes.

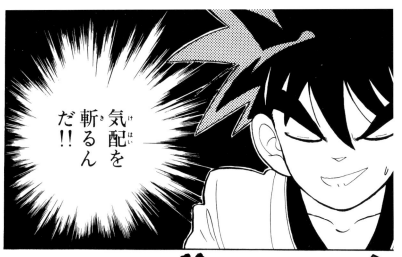

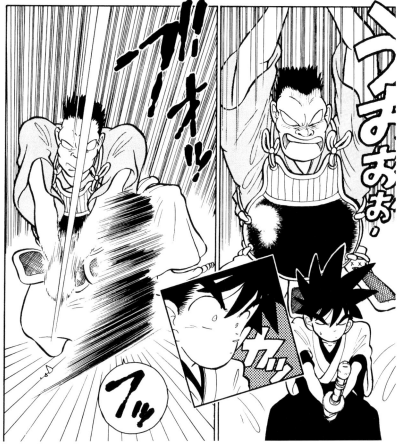

This comic artist's most popular work, "Jojo's Bizarre Adventure," tells the story of the conflicts between the black-hearted Dio and the Joestar clan. The hero of the story is a member of the English aristocracy. The series begins in England, before moving to America, Japan, and then Italy as the hero faces and overcomes a variety of evil adversaries. Much of the appeal of this series comes from the way the writer does not depict a dual nature in "evil," but instead modifies it as the situation changes. The Joestar clan is always portrayed as a family that seeks out hope during its struggles, all the while acting with courage. There is plenty of blood and any number of grotesque scenes in the series, but these scenes seem to celebrate the fact that "humans can overcome all difficulties." In addition, the story introduced a new concept by teaming up the hero with unusual animals and people that were transformed by a life force called the "stand." This pairing of the main character with unusual sidekicks changed the course of Boys Comics. The drawings are known for lots of eye-catching poses that seem to defy the physics of the human body. Paired with frame layouts that are cut diagonally, the overall result is a unique world that seems to draw the reader in. The author is recognized for his drawings that show highly stylish and appealing fashions, as well as the high quality of his overall design work.

HIROHIKO ARAKI

Born

1960 in Miyagi Prefecture, Japan

Debut

with "Busou Poker," which was first published in *Weekly Shōnen Jump* in 1980

Best known works

"Mashōnen BT" [Magical BT]
"Baoh raihōsha" [Baoh]
"Jojo no kimyō na bōken"
[Jojo's Bizarre Adventure]

Anime adaptation

"Baoh raihōsha" [Baoh]
"Jojo no kimyô na bôken"
[Jojo's Bizarre Adventure]

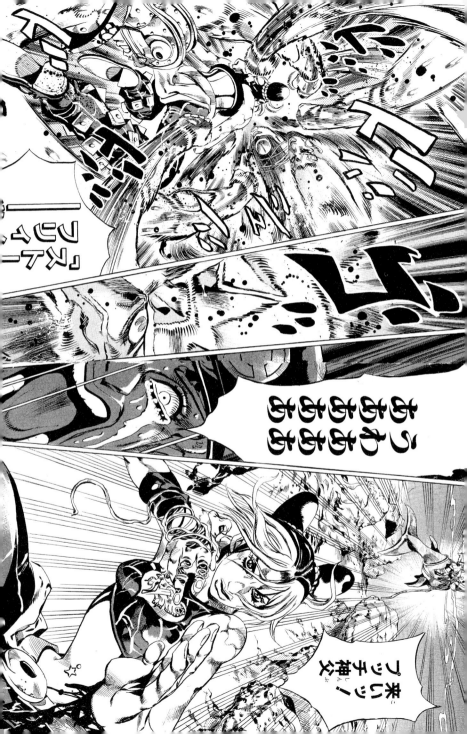

„Jojo no kimyô na bôken" [Jojo's Bizzare Adventure] ist eine Saga um den ewigen Kampf zwischen dem niederträchtigen Dio und dem Haus der Joestar. In jedem Geschichtenzyklus wechselt die Generation und der Schauplatz und so besiegen die Joestars, Nachkommen eines englischen Aristokraten, ihre Erzfeinde in Amerika, Japan und Italien. Eine Besonderheit dieses Mangas liegt darin, dass Araki das Böse nicht als Teil eines dualistischen Weltbilds darstellt, sondern als etwas, das sich ständig verändert. Joestar selbst ist ein beherzter Tatmensch, der auch mitten im Kampf noch Grund zum Optimismus findet. Blutvergießen und grausige Szenen gibt es zwar zuhauf, aber sie dienen letztlich der Erhöhung des siegreichen Überwinders von Schrecknis und Ungemach. Araki etabliert hier auch das Bild der in verschiedenen Charakteren und Tieren personifizierten Lebensenergie (in „Jojo" *sutando* oder *stand* genannt), die gemeinsam mit dem Protagonisten kämpft – eine Idee, die stilbildend für eine ganze Untergruppe im *shônen*-Manga wurde. Auch zeichnerisch entwickelt er eine unverwechselbare eigene Welt mit schräg angeschnittenen Panels und aufsehenerregenden Figurendarstellungen, die gleichwohl nicht immer mit der menschlichen Anatomie zu vereinbaren sind. Dieses von seinen Fans so geschätzte Gespür für Design stellt Araki auch mit der eleganten aber individuellen Garderobe seiner Charaktere unter Beweis.

L'œuvre la plus populaire de ce mangaka est « Jojo no kimyô na bôken » [L'aventure bizarre de Jojo], qui raconte l'histoire d'un conflit entre le mauvais Dio et le clan Joestar. Le héros de cette histoire est un membre de l'aristocratie anglaise. La série débute en Angleterre et se poursuit en Amérique, au Japon puis en Italie, tandis que le héros réussit à vaincre des adversaires redoutables. Le succès de cette série est dû en grande partie à la manière dont l'auteur ne dépeint pas la nature double du mal, mais le modifie plutôt en fonction des changements de situation. Le clan Joestar est toujours dépeint comme une famille s'accrochant à l'espoir durant ses luttes, tout en se comportant avec courage. La série est remplie de scènes grotesques et de sang, mais les scènes semblent se réjouir du fait que « les humains parviennent à surmonter toutes les difficultés ». De plus, l'histoire introduit de nouveaux concepts en associant le héros à des animaux et des personnages peu courants transformés par une force vitale appelée « stand ». Cette association a modifié le cours des mangas shounen. Les dessins d'Araki sont fameux pour les poses de leurs personnages qui semblent défier les lois de la physique du corps humain. Les vignettes sont également coupées en diagonale, ce qui à pour résultat de créer un monde unique qui semble aspirer le lecteur. L'auteur est reconnu pour l'utilisation de vêtements attrayants et très chics, ainsi que pour la qualité générale de ses dessins.

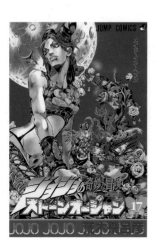

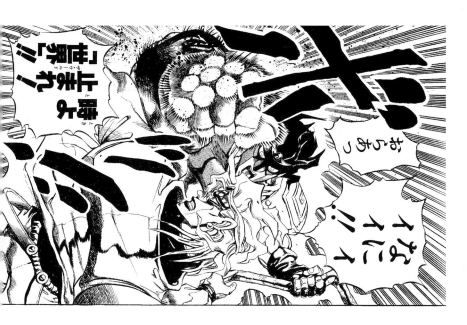
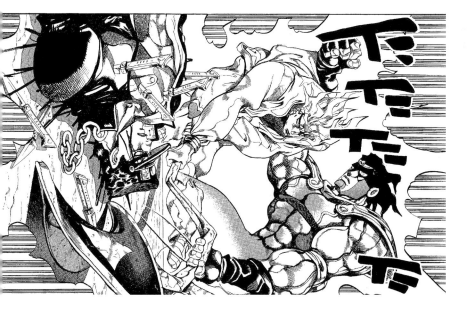

Born in 1980 in Ishioka, Inio Asano is known for his first big bestseller "Solanin," which was made into a feature film in 2010. After his debut at the age of 17, he went on to make his first release as a professional mangaka in the year 2000, with the titles "Futsū no Hi" at *Big Comic Spirits*. After working with bestseller Shin Taka-hashi, Asano received the prize for adult man-gas from *Sunday Gene-X* magazine with the title "Uchū kara Konnichi wa." His publications have attracted a younger generation, especially because of his character-driven storytelling.

He has consistently drawn with deep attention to every detail, mixing both manual and computer illustration, breaking new ground in the field of manga. Asano has also ventured into erotic stories, working on "Umibe no onna no ko" be-tween 2009 and 2013 for Ōta Shuppan's *Manga Erotics F-Magazin*. Some of his latest work in-cludes "Toshi no Se" (2012), "Kinoko Takenoko" (2013), "Dead Dead Demon's De De De De De-struction" (2014) and "Bakemono no Re' Chan" (2015). His work has been translated into Ger-man, English, French, and Italian.

I
N
I
O

A
S
A
N
O

Born
　1980 in Ibaraki Prefecture, Japan

Debut
　with "Kikuchi sore wa chotto yarisugi
　da!!!" in 1998 published in *Big Comic
　Spirits Zoukan Manpuku!*

Best known works
　"Soranin"
　"Goodnight Punpun"
　"Dead Dead Demon's De De De De
　Destruction"

Feature film
　"Soranin"

Prizes
　• 1st GX Newcomer Award (2001)
　• 13th Japan Media Arts Festival:
　　Jury Selections in Manga Division
　　(2009)

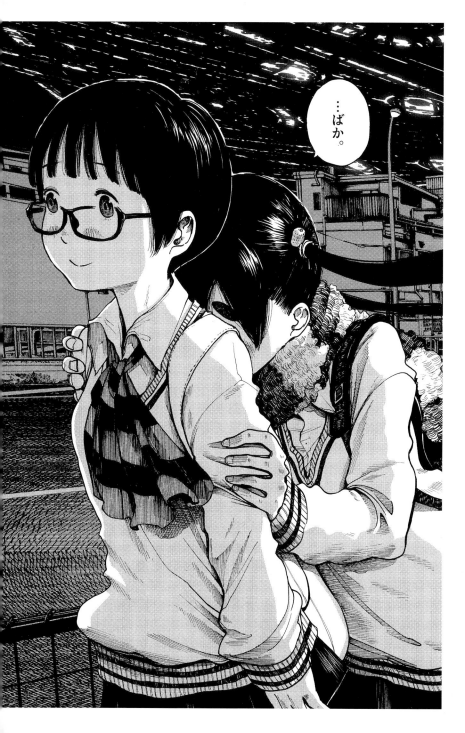

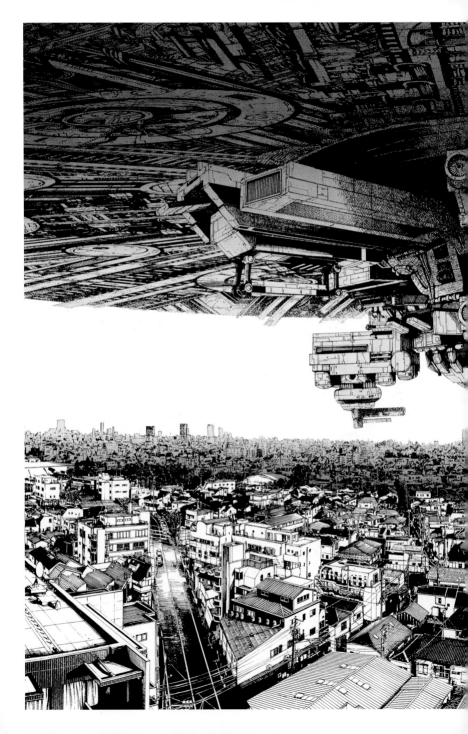

おんたんは…
空を自由に飛べたら
どうする？

…寒そう。

そうだね
今日は少し
冷えるね…

帰りましょう
帰りましょう。

26

…でもね、
僕ァ
何があっても
めげませんよ。

欺瞞と虚飾に
溢れたこの世界を
滅ぼすまでは。

Inio Asano, geboren 1980 in Ishioka, wurde durch seinen ersten großen Bestseller „Solanin" bekannt, der 2010 auch verfilmt wurde. Nach seinem Debüt mit 17 veröffentlichte er im Jahr 2000 sein erstes Werk als Berufs-Mangaka, das den Titel „Futsū no Hi" trug, in *Big Comic Spirits*. Nachdem er mit seinem erfolgreichen Kollegen Shin Takahashi zusammengearbeitet hatte, gewann Asano den Nachwuchswettbewerb für Erwachsenen-Mangas der Zeitschrift *Sunday Gene-X* mit „Uchū kara Konnichi wa". Vor allem durch seine von den Charakteren bestimmte Erzählweise haben seine Veröffentlichungen großen Anklang bei der jüngeren Generation gefunden. Er zeichnet stets mit großer Liebe zum Detail und kombiniert computergenerierte Illustrationen mit handgezeichneten, wodurch er im Bereich der Mangas Neuland betrat. Asano hat auch erotische Geschichten gezeichnet, als er zwischen 2009 und 2013 für die Zeitschrift *Manga Erotics F* von Ōta Shuppan an „Umibe no onna no ko" [Das Mädchen am Strand] arbeitete. Zu seinen jüngsten Arbeiten gehören „Toshi no Se" (2012), „Kinoko Takenoko" (2013), „Dead Dead Demon's De De De De Destruction" (2014) und „Bakemono no Re' Chan" (2015). Seine Werke wurden ins Deutsche, Englische, Französische und Italienische übersetzt.

Né en 1980 à Ishioka, Inio Asano est connu pour son premier grand best-seller « Solanin », adapté en long métrage en 2010. Il a commencé à l'âge de 17 ans et il s'est imposé comme mangaka professionnel en 2000, avec les titres « Futsū no Hi » [Jour ordinaire] dans *Big Comic Spirits*. Après sa collaboration avec Shin Takahashi, Asano a remporté le prix pour mangas pour adultes du magazine *Sunday Gene-X* avec le titre « Uchū kara Konnichi wa » [Bonjour de l'espace]. Ses publications ont conquis une génération plus jeune, notamment car ses histoires reposent sur les personnages. Il a toujours accordé une attention particulière au moindre détail, et ses ouvrages combinent l'illustration manuelle et par ordinateur, une approche inédite dans le domaine des mangas. Asano s'est aussi essayé à des histoires érotiques, avec « Umibe no onna no ko » [La fille de la plage] entre 2009 et 2013 pour le magazine *Manga Erotics F* d'Ōta Shuppan. Ses derniers travaux comptent « Toshi no Se » (2012), « Kinoko Takenoko » (2013), « Dead Dead Demon's De De De De Destruction » (2014) et « Bakemono no Re' Chan » [Le garçon et la bête] (2015). Ses ouvrages ont été traduits en allemand, en anglais, en français et en italien.

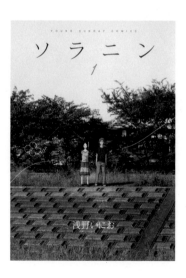

先輩も頑張れ。

なにそれ————っ!!

ちょっとヤダもぉ———っ!!

あんな女に心かき乱されちゃってるし俺———っ!!

きゃああぁ

ピピピピ

Kiyohiko Azuma's best-known work is "Azumanga daiō." This standard 4-frame comic strip brings humor and sharp insights into the everyday life of Japanese high school girls. A popular series, it always manages to top the annual sales lists whenever a new volume of his 4-frame comic strips comes out in book form. It has even been made into an animated television series, which is highly unusual for a 4-frame gag manga. The main character, Chiyo Mihama, is a young elementary school student who happens to be a genius. This has allowed her to skip several grades and enter high school. Other characters include the lovely Sakaki-san who has an ultra-cool outward appearance, but is actually crazy for cats and stuffed animals. Then there is Tomo-chan, who is full of energy but hates studying. In other words, your typical high school student. There is also Ōsaka, who is a bit slow and speaks with a rough Kansai-area accent. The bespectacled Koyomi-chan is the level-headed girl of the group. Obviously the comic does not depict actual Japanese high school girls, but through the clever use of subtle expressions, it does manage to capture the atmosphere of high school life. Some characters are remarkably popular. Not only is the overall style of the work very energetic, it also gives the reader a warm, comforting feeling. This was the primary reason for its popularity.

K A
I Z
Y U
O M
H A
I
K
O

Born
 1968 in Takasago, Japan

Debut
 Media Works' "Azumanga daiō"
 Media Works' "Yotsubato!"

Best known works
 "Azuma Comics 2"
 [Pioneer Laser Disc]

TV/Anime adaptation
 TV animation version of "The Great
 Azuma Comic King"

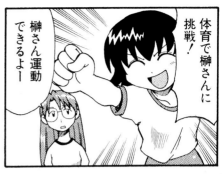

体育で榊さんに
挑戦！

榊さん運動
できるよー

ちよちゃんに
勉強で挑戦よ！

無理だと思うな

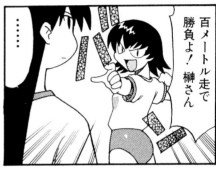

百メートル走で
勝負よ！榊さん

．．．．．

ではここ ちよちゃん
わかるかな

えーと…
わかりません

あらそう？
それじゃあ

はーいっ

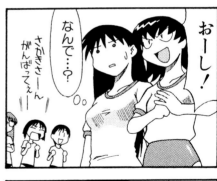

おーし！

なんで…？

さかきさーん
がんばってぇー

はい滝野さん

私も
わかりません

あ 榊さん私より8cm
胸でかいから8cm下がって
よね

なんだそれー
汚いぞ ともー！！

8センチか…

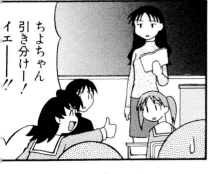

ちよちゃん
引き分けー！
イェーー！！

Sein Hauptwerk „Azumanga daiô" ist ein Sammelband seiner Vier-Bilder-Mangas, in denen das alltägliche Leben einer Gruppe von Oberschülerinnen für Komik sorgt. In Manga-Läden wurde dieses Buch zum bestverkauften Manga des Jahres und ein TV-Anime folgte – für Vier-Bilder-Mangas also ein nahezu beispielloser Erfolg. Zu den Protagonistinnen gehören die kleine Chiyo Mihama, die dank ihres Superhirns mehrere Klassen überspringen durfte und gemeinsam mit den anderen in die Oberschule geht, die mädchenhafte Sakaki-san, die unnahbar cool wirkt, eigentlich aber Kätzchen und Stofftiere über alles liebt, die ungestüme lebenslustige Tomo-chan, die fürs Lernen nicht viel übrig hat, Ôsaka, die Kansai-Dialekt spricht und etwas schwer von Begriff ist, sowie die bebrillte und ernsthafte Koyomi-chan. Obwohl es Azuma nicht um das reale Leben ging, gelang es ihm doch, die typische Stimmung der Oberschulzeit zu treffen. Die Charaktere wurden alle begeistert aufgenommen und ein Grund für die hohe Popularität dürfte darin liegen, dass Azuma den Zeitgeschmack genau getroffen hat. Mehr noch aber ist es die angenehme Atmosphäre, die seine Leser einhüllt und ihnen eine Verschnaufpause vom Alltag verschafft.

L'œuvre la plus connue de Kiyohiko Azuma est « Azumanga daiô » [Le roi de la bande dessinée]. Ce manga yon koma classique couvre avec humour et avec une vision acérée la vie de tous les jours des lycéennes japonaises. Cette série populaire a régulièrement fait des records de vente dès qu'un nouvel album était édité. Elle a même donné lieu à une série animée pour la télévision, ce qui est très rare pour une bande dessinée sur quatre vignettes. L'un des personnages principaux est Chiyo Mihama, une jeune écolière extrêmement douée. Cela lui a permis de sauter plusieurs classes pour entrer directement au lycée. Parmi les autres personnages, Sakaki-san a une apparence super cool et adore les chats et les peluches. Tomo-chan est pleine d'énergie mais a horreur d'étudier. En d'autres termes, il s'agit d'une lycéenne typique. Ôsaka est un peu lente et parle avec un fort accent de la région de Kansai. Koyomi-chan porte des lunettes et est la plus sensée du groupe. Bien sûr cette bande dessinée ne dépeint pas de véritables lycéennes japonaises, mais elle parvient à capturer l'atmosphère de la vie au lycée grâce à l'utilisation astucieuse d'expressions pertinentes. Certains personnages sont remarquablement populaires. Non seulement le style général est très énergique, mais il donne au lecteur un sentiment rassurant. C'est peut-être le secret de sa popularité.

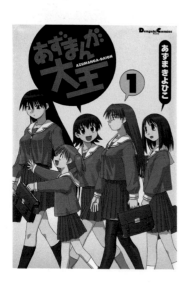

…あんまり
わかってないような…

あれ?

だからね?
あれは用もないのに
押しちゃだめなのよ?

わかった?

ふーん…

……

…うん!

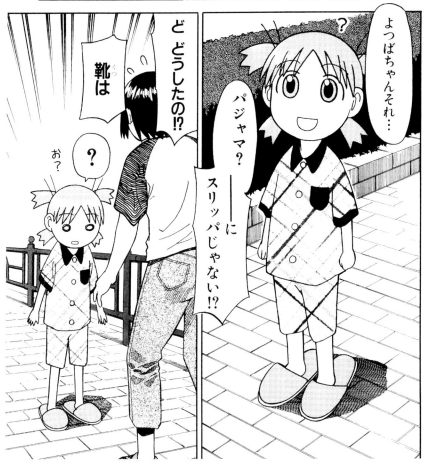

よつばちゃんそれ…

?

パジャマ?
——に
スリッパじゃない!?

ど どうしたの!?

靴は

?

お?

Tetsuya Chiba has been in the forefront of the manga industry for more than 40 years, and he is considered to be a most valuable asset. He first started out publishing his works in *shoujo* manga magazines, and then went on to become active for a long time in *shounen* manga magazines and *seinen* manga magazines. He consistently churned out hit after hit. His best known work is "Ashita no Joe" [Tomorrow's Joe], a legendary story about a prize fighter named Joe Yabuki, who commits his life to the boxing ring. The last scene in which his body is left a burned out shell, after fighting with every last ounce of his energy to go down in glory is one that will be remembered for some time to come. The storywriter Ikki Kajiwara,

who is known for many hits such as "Kyojin no Hoshi" [Star of the Giants], lends his exaggerated and strongly distinctive style, to combine with Chiba's sincere and down-to-earth drawing style. This odd combination fused brilliantly to create a miraculous piece of fiction. There is even an anecdote that although Kajiwara usually enforces compliance from the manga artists he works with, Chiba was the only exception. His works tend to revolve around sports with themes that have included golf, Kendo, and even Sumo. His works blend the dynamic aspects of sports with the lifestyle of the Shitamachi area of Tokyo, and he is a skilled master at portraying this style.

TETSUYA CHIBA

Born

1939 in Tokyo, Japan

Debut

with tankôbon "Fukushû no semushi otoko" [Revenge of the Hunchback] in 1956

Best known works

"Ashita no Joe" [Tomorrow's Joe]
"Ore wa Teppei" [I Am an Teppei]
"Notari Matsutaro"

Anime adaptation

"Ashita no Joe" [Tomorrow's Joe]
"Ashita tenki ni naare"
[A Great Super Shot Boy]
"Kunimatsu-sama no otôri da" [Make Way for Mr. Kunimatsu]

Prizes

- Kôdansha Children's Manga Award (1962)
- Kôdansha Culture Award (1976)
- Japan Cartoonists Association Special Prize (1977)
- Shôgakukan Manga Award (1978)
- Education Minister Award from the Japan Cartoonists Association (2001)

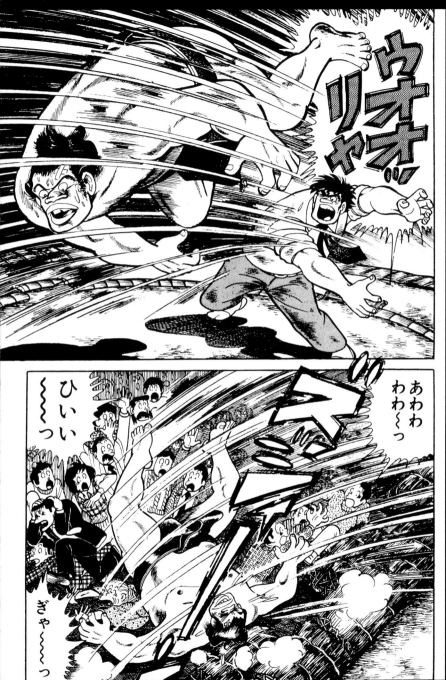

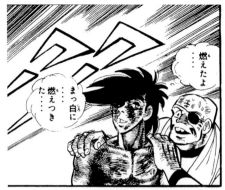

まっ白に……燃えつきた……

燃えたよ

まっ白な灰に……

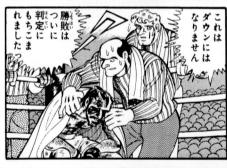

勝敗はついに判定にもちこまれましたっ

これはダウンにはなりません

終了ゴングと同時に精も根もつきはてたかチャンピオンがっくりとたおれかけましたが

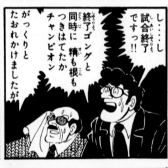

し……し試合終了ですっ!!

それにしても15ラウンドの長丁場終始すさまじい試合展開を見せたこの世界タイトルマッチ!

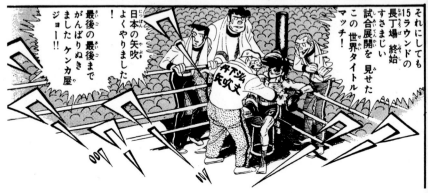

日本の矢吹よくやりました!

最後の最後までがんばりぬきましたケンカ屋ジョー!!

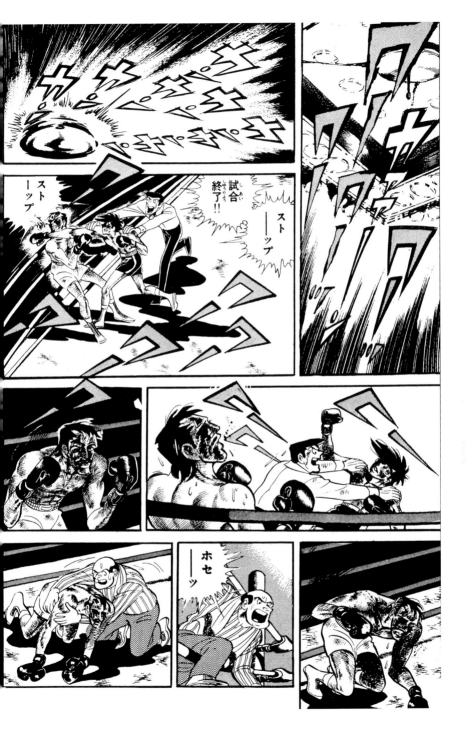

Tetsuya Chiba ist seit über 40 Jahren einer der bekanntesten Manga-Autoren und somit der Stolz der gesamten japanischen Manga-Welt. Sein Debüt gab er in einem *shôjo*-Magazin, zeichnete danach aber lange Zeit für *shônen*- und *seinen*-Zeitschriften, wo er einen Bestseller nach dem anderen veröffentlichte. Am berühmtesten ist der legendäre Manga „Ashita no Joe" um das heldenhafte Leben des Boxers Joe Yabuki, der seine Existenz dem Boxring opfert. „Let me fight until I'm white ashes!" ruft Joe Yabuki in einer Schlussszene, die in ganz Japan diskutiert wird. Der dramatische, übertriebene Stil des Szenario-Schreibers Ikki Kajiwara, der mit Bestsellern wie „Star of the Giants" berühmt wurde, und Chibas eher bodenständiger Stil vereinigten sich in diesem Manga aufs Wunderbarste. Kajiwara, der andere Mangaka zu unbedingtem Gehorsam nötigte, soll allein gegen Tetsuya Chiba nie ein Widerwort gewagt haben. Chiba zeichnete noch viele weitere Mangas über Sportarten wie Golf, Kendô oder Sumô. Er gilt als absoluter Meister darin, sportliche Dynamik mit dem volkstümlichen Lebensgefühl der einfachen Leute des alten Shitamachi-Distrikts in Tokio zu vereinen.

Chiba est à l'avant-garde des mangas depuis plus de 40 ans, et il est considéré comme l'un des maîtres en la matière. Il a publié initialement ses œuvres dans des magazines de mangas shoujo, puis s'est tourné vers le domaine des magazines de mangas shounen et seinen. Il a rencontré succès après succès. Son œuvre la plus connue est « Ashita no Joe » [Joe de demain], une histoire légendaire sur un boxeur nommé Joe Yabuki qui consacre sa vie au ring. La dernière scène dans laquelle son corps n'est plus qu'une enveloppe vide après avoir combattu avec toute son énergie, est restée dans la mémoire des lecteurs. Le scénariste de l'histoire, Ikki Kajiwara, qui est connu pour ses œuvres telles que « Kyojin no Hoshi » [L'étoile des géants], a combiné son style exagéré au dessin réaliste de Chiba. Cette combinaison étrange a donné naissance à des chefs-d'œuvre de fiction. On dit même que Kajiwara, qui fait habituellement plier les dessinateurs à son style, a fait une exception pour Chiba. Ses œuvres sont généralement sur le thème de sports tels que le golf, le kendo ou le sumo. Elles mêlent les aspects dynamiques du sport au mode de vie dans les quartiers Shitamachi de Tokyo. Chiba est très doué pour dépeindre ce style.

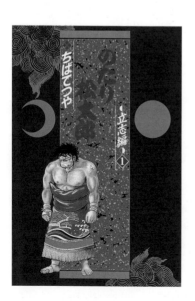

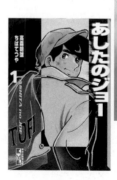

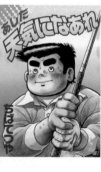

だいじょうぶだ・・・・・いけえ〜〜〜っ

おおっ・・・打球が低すぎるっ

こら池にはいるでーっ

Tatsuya Egawa debuted with a school drama entitled "Be Free!" This popular series centers on the life of a teacher who struggles to cope with a highly regimented school. The teacher is depicted as extremely unorthodox, for not only does he ride around the school grounds on a motorcycle, he is very forward with his sexual advances. The wild lifestyle of this liberal main character and the unusually rapid story development in this manga forged new grounds. It is also interesting to note that Egawa is himself a former school teacher. After the success of this series, he went on to make "Magical Tarurû-to-kun," a story of a young boy and a child magician that appeared in the most widely read Boys Comic magazine. He also went on to make "Tôkyô Daigaku monogatari," which describes academic and romantic lives set upon the backdrop of Tokyo University, the highest educational institute in Japan. He then announced the release of his rendering – the "Egawa version" as he calls it – of the literary classic "Genji monogatari" [Tale of Genji]. In his depiction of this famous tale he boldly added eroticism, further displaying his unconventional style. Nor has he shied away from exposing the violence and sexual nature of humanity, which seems to seep through into our present-day lives. This manga artist reveals the raw force of manga through his powerful scenes.

TATSUYA EGAWA

Born

1961 in Aichi Prefecture, Japan

Debut

with "Be Free!" which was first published in *Morning* magazine in 1984

Best known works

"Be Free!"
"Magical Tarurûto-kun"
"Tôkyô Daigaku monogatari"
[Tokyo University Story]
"Nichiro sensô monogatari"

Anime adaption

"Be Free!"
"Magical Tarurûto-kun"
"Tôkyô Daigaku monogatari"
[Tokyo University Story]
"Golden Boy"

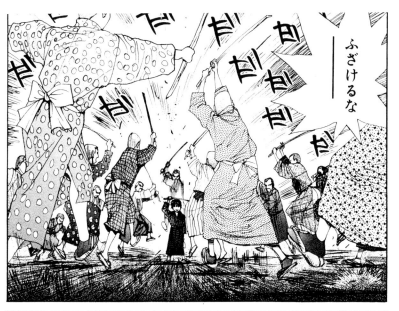

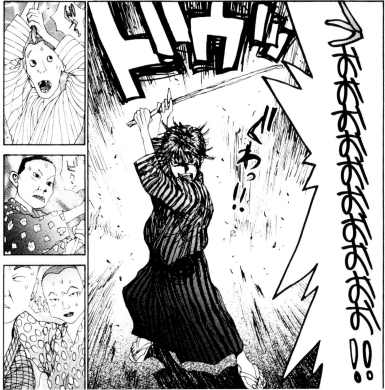

Sein Erstling „Be Free!", in dem ein kämpferischer Lehrer an einer autoritären Oberschule eine Rebellion anzettelt, ist bezeichnend für Egawas Stil. Der Protagonist brettert mit dem Motorrad über das Schulgelände, lebt seine Liebe zu Frauen offen aus und gibt sich auch sonst wild und leidenschaftlich. Mit diesem unkonventionellen Plot und der temporeichen Entwicklung eröffnete Egawa dem Manga neue Möglichkeiten. Nebenbei bemerkt war der Autor selbst einmal Lehrer. Sein nächstes Werk veröffentlichte er im auflagenstärksten *shônen*-Magazin: „Magical Tarurûto-kun " ist die Geschichte eines kleinen Jungen und seiner Begegnung mit einem kleinen Zauberer. „Tokyo University Story" zeigt eine Liebesgeschichte vor dem Hintergrund der Aufnahmeprüfungen zur prestigeträchtigsten Universität Japans und ist gleichzeitig Egawas Adaption des berühmtesten Werks klassischer japanischer Literatur, des „Genji monogatari". Vor dieser Respekt einflößenden Kulisse entwirft er Bilder von kühnem Eros und sprengte so erneut alte Formen. Der Autor zeichnet Sexualität und Gewalt als existentielle Urtriebe und stellt den Menschen völlig entblößt dar. Mit Bildern, aus denen die überwältigende Macht der Instinkte spricht, zeigt Tatsuya Egawa, was in der Kunstform Manga alles möglich ist.

Tatsuya Egawa a fait ses débuts avec une fiction intitulée « Be Free! ». Cette série populaire est centrée sur la vie d'un professeur qui tente de faire face à une école très disciplinée. Le professeur est dépeint comme étant extrêmement peu orthodoxe. Non seulement il utilise sa moto dans l'école, mais il fait également des avances aux étudiantes ! Le style de vie mouvementée de ce personnage libéral et le développement plutôt rapide de l'histoire de ce manga établissent de nouveaux territoires. Il est intéressant de noter qu'Egawa est un ancien professeur. Après le succès de cette série, il a réalisé « Magical Tarurûto-kun » [Talulu le magicien], l'histoire d'un jeune garçon et d'un enfant magicien qui a été publiée dans le magazine de manga shounen le plus populaire. Il a également réalisé « Tôkyô Daigaku monogatari », qui dépeint une histoire de romance et d'enseignement se déroulant à l'université de Tokyo, la plus élitiste institution du Japon. Il a ensuite annoncé la sortie de son interprétation – la « version Egawa » comme il l'appelle – du classique littéraire « Genji monogatari » [Dit du Genji]. Il a ajouté de l'érotisme dans la représentation de ce fameux récit, soulignant ainsi encore plus son style peu conventionnel. Il n'a pas non plus répugné à montrer la nature violente et sexuelle de l'humanité, qui semble transpirer dans nos vies courantes. Egawa nous montre la force brute des mangas au travers de ses scènes saisissantes.

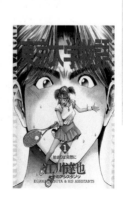

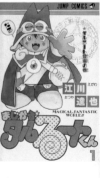

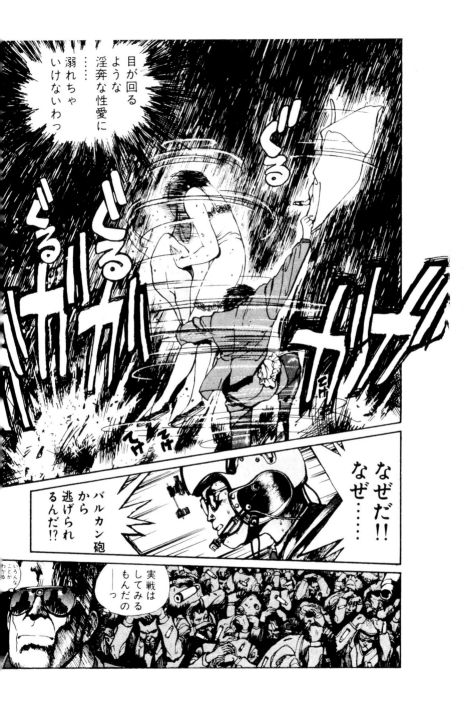

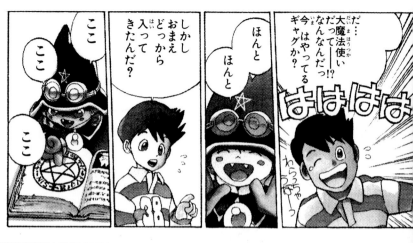

だ…大魔法使いだってなんだっ!?今はやってるギャグか?

ほんとほんと

しかしおまえどっから入ってきたんだ?

ここここここここ

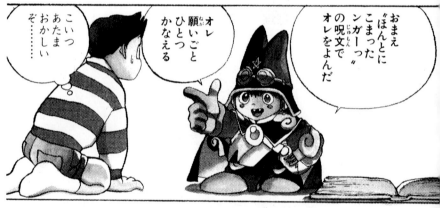

おまえ"ほんとにこまったンガーっ"の呪文でオレをよんだ

オレ願いごとひとつかなえる

こいつあたまおかしいぞ……

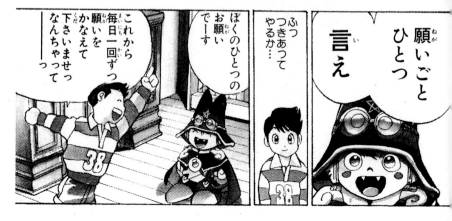

願いごとひとつ

言え

ふつきあってやるか…

ぼくのひとつのお願いでーす

これから毎日一回ずつ願いをかなえて下さいませっなんちゃってっ——

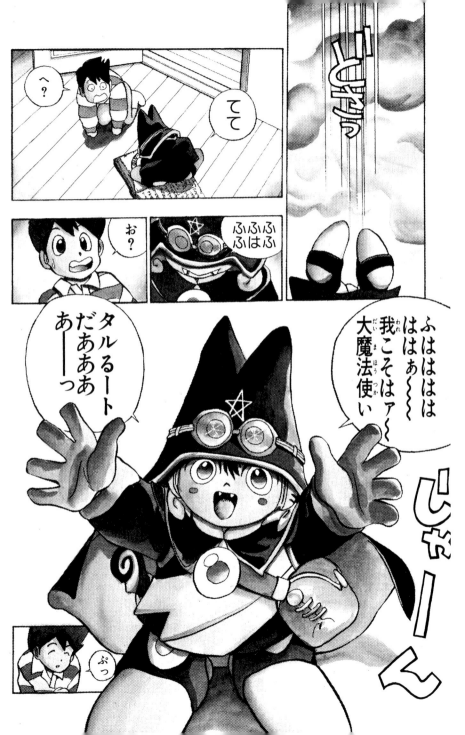

Hisashi Eguchi is best known for "Stop!! Hibari-kun!", the humorous story of a young, beautiful, feminine boy who plays with the mind of the young male main character. The comic eventually became an animation series and attracted considerable attention. Eguchi has continued to utilize excellent comic tempo and sharp gags in his stories, creating some unforgettable masterpieces in the process. He is also called Japan's best illustrator of beautiful girls, creating characters that are not only cute but also erotic and fashionably stylish. Male readers have even been known to fall madly in love with the beautiful women he has created. It is said that Eguchi played a major role in helping to create the foundation for Pop Art during the 1980's. Many illustrators and comic artists turned to his creations to get inspiration for their work. He has not only limited himself to being a comic artist, he has also branched out into animated character designs such as the animated feature film *Rōjin-Z* by director Katsuhiro Ōtomo), CD cover designs for popular Japanese musicians, and even illustration designs for family restaurants. Eguchi displays his dazzling artistic talents in a broad range of arenas.

HISASHI EGUCHI

Born
1956 in Kumamoto Prefecture, Japan

Debut
with "Osorubeki kodomotachi" published in *Shōnen Jump* in 1977

Best known works
"Susume!! Pirates"
"Stop!! Hibari-kun!"
"Ken to Erika" [Ken and Erika]
"Chara-mono"

Anime adaption
"Stop!! Hibari-kun!"

Prizes
• 38th Bungeishunjū Manga Award (1992)

君といる時
屁したくなると

グッと肛門に
力を入れて
邪悪な気泡を
腹の中に
押し戻す
んだ

だって俺の屁
臭いんだもん

じょぼぼぼぼ

ぷっ
ぷーう

いよいよガマン
できなくなったら
トイレにいって
してたよ
ぷう

でも　君の部屋の
トイレでする時は
気をつかったな

すーーう

尻の肉を
左右に広げて
音がしないよう
細心の注意を
はらったものさ

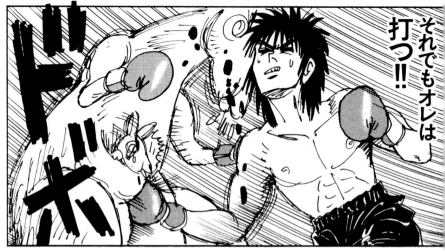

それでもオレは打つ!!

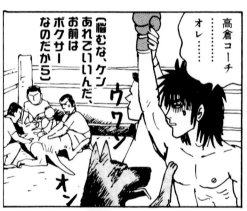

高倉コーチ
オレ……

（悩むな、ケン
あれでいいんだ、
お前は
ボクサー
なのだから）

ウワン

オン

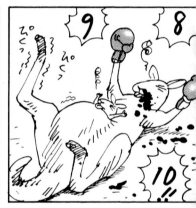

9

8

10!!

ボク
カンガルーの
赤ちゃんの
今日とっても
痛かったの

なんだよう
この
ねーちゃん

血も涙もない
鬼よ！
あんたはっ!!

ツカツカ

鬼!!

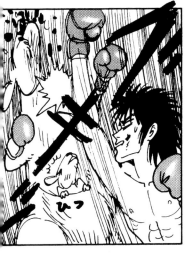

……これだから
お母さんカンガルーと
戦うのは
やだ……

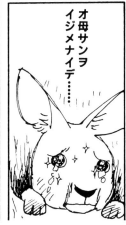

オ母サンヲ
イジメナイデ……

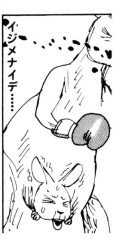

イジメナイデ……

In seinem bekanntesten Werk „Stop!! Hibarikun!" zeichnet Eguchi mit viel Komik, wie der jugendliche Protagonist von dem mädchenhaft hübschen *bishônen* Hibari zum Narren gehalten wird; der äußerst populäre Manga wurde später auch als Anime umgesetzt. Seitdem schuf Eguchi eine ganze Reihe weiterer Meisterwerke des Gag-Manga mit temporeicher Handlung und gut getimten Witzen. Viele halten ihn zudem für den begabtesten *bishôjo*-Zeichner Japans. In der Tat soll es Männer geben, die vor Sehnsucht nach von Eguchi gezeichneten Mädchen vergehen, denn die sind nicht nur niedlich, sondern auch höchst modebewusst und sexy. In den 1980er Jahren legte er das Fundament für eine neue Pop Art in Japan, und sein Stil fand viele Nachahmer unter Illustratoren und Manga-Künstlern. Neben seiner Arbeit als Mangaka findet er auch noch Zeit für Anime-Charakterdesign (berühmt geworden ist der für das Kino geschaffene *Rôjin-Z* des Regisseurs Katsuhiro Ôtomo), gestaltet CD-Cover für japanische Popstars und auch schon mal die Speisekarten für eine Restaurantkette. Kurz, er ist für alles zu haben, was mit Illustrationen zu tun hat und stellt dabei stets seinen überragenden Gestaltungssinn unter Beweis.

Eguchi est connu pour « Stop!! Hibarikun! », l'histoire comique d'un beau jeune homme efféminé qui joue avec l'esprit du jeune personnage principal masculin. Ce manga est devenue une série animée et a reçu une attention considérable. Eguchi continue d'utiliser un rythme humoristique excellent et des gags tranchants dans ses histoires, créant quelques chefs-d'œuvre inoubliables au passage. Il est également considéré comme le meilleur illustrateur de superbes jeunes filles au Japon, et il crée des personnages qui ne sont pas seulement beaux, mais également érotiques et élégants. On dit même que des lecteurs masculins sont même tombés follement amoureux des superbes femmes qu'il a créées. On dit également qu'Hisashi Eguchi a joué un rôle important dans l'avènement du Pop art dans les années 1980. De nombreux illustrateurs et dessinateurs de mangas se sont tournés vers ses créations pour trouver de l'inspiration. Il ne s'est pas contenté d'être un auteur de mangas, il a également touché aux domaines de l'animation pour le film d'animation « Rôjin-Z » (du réalisateur Katsuhiro Ôtomo), de la conception de jaquettes de CD pour des musiciens japonais populaires, et il a même réalisé des illustrations pour des restaurants familiaux japonais. Eguchi démontre ses talents artistiques éblouissants dans une foule de domaines.

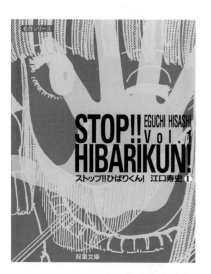

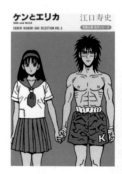

これっこれっ

ぴた

ちょいまちひばりっ
またあたしの
ブラを……

このブラは
れっきとした
ぼくのもの
です

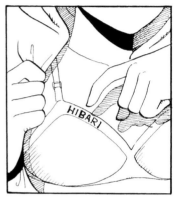
HIBARI

……ま
それなら
いいけど

ぬわに——っ
大空ひばりが
男だぁ

ウンバ
ウンバ
ウンバ

よくないでしょっ

よく
ないっ
この
変態っ

そ…
そーね

Hiroshi Fujimoto and Motoo Abiko started collaborating on manga in the 5th grade, and they made their debut in 1976 under the pseudonym of Fujiko Fujio. Some of their hits include "Obake no Q-Tarô" [Q-Tarô the Ghost] and "Ninja Hattori-kun." Both of these manga eventually became hit animated series. But their long running mega-hit is "Doraemon." The story revolves around a young elementary schoolboy named "Nobita," who is a complete failure both in school and at home. He always flunks his exams and hasn't even the slightest aptitude for sports. Then a cat-like robot called "Doraemon" arrives from the 22nd century in a time machine. Doraemon can pull out all sorts of devices from "a fourth dimensional pocket" in his chest, and uses them to help Nobita in every conceivable way. Devices like the "Dokodemo Door" [The Anywhere Door], which allows the user to go just about anywhere, and the "Takecopter" [Bamboocopter], which allows you to fly, have permeated Japanese society to become common household words. They are everyone's "dream tools," and this manga has become synonymous with children's manga. The series has been an international hit. Hiroshi Fujimoto and Motoo Abiko ended their creative collaboration under the name of Fujiko Fujio in 1987, when each of them went off to pursue their own careers. After that they adopted the names "Fujiko F. Fujio" and "Fujiko Fujio A." respectively. Fujiko Fujio A. showed enormous skill in psychological descriptions, and later published manga aimed at adult audiences that had a touch of black humor. He depicts greed and treachery, subjects he never pursued during the collaboration, and he surrealistically describes the darkness that lies within our hearts. On the other hand, Fujiko F. Fujio created a story which depicted "a town like any other and a young boy like any other," but where something mysterious and wonderful takes place. His ultimate goal was, however, to create an extended movie version of the series "Doraemon." Although Fujimoto died in 1996, neither he, nor the many works "Fujiko Fujio" created, will ever be forgotten.

FUJIKO FUJIO

1976 – 1987

Born

Fujiko F. Fujio:
1933 in Toyama
Prefecture, Japan
(1987 – 1996)
Fujiko Fujio A.:
1934 in Toyama
Prefecture, Japan
(1987–)

Debut

with "Tenshi
no Tama-chan"
published in
the *Mainichi
Shôgakusei
Shinbun* in 1952

Best known works

"Obake no Q-Tarô"
[Q-Tarô the Ghost]
"Doraemon"
"Paaman"
"Kiteretsu
daihyakka"

Anime & Drama

"Obake no Q-Tarô"
[Q-Tarô the Ghost]
"Doraemon"
"Kaibutsu-kun"
"Ninja Hattori-kun"
"Esper Mami"

Prizes

Fujio Fujiko
• 8th Shôgakukan
Manga Award
(1963)
• Japan Cartoonists
Association
Excellence Award
(1973), (1982)
Fujiko F. Fujio
• Tezuka Osamu
Cultural Prize
Manga Grand Prix
Award (1997)

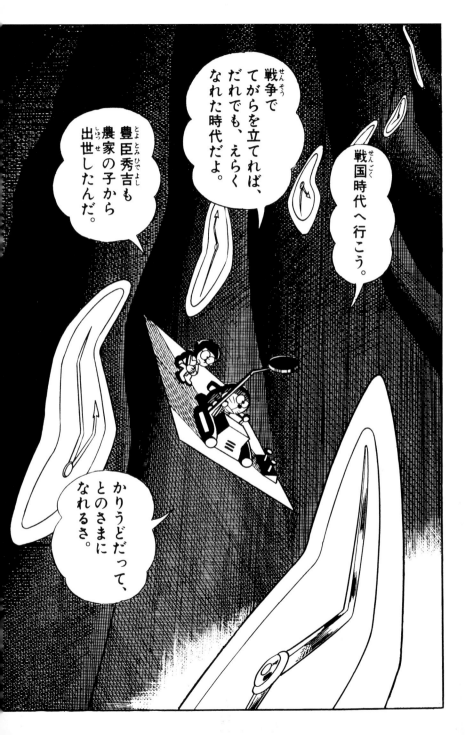

Seit ihrem elften Lebensjahr zeichneten Hiroshi Fujimoto und Motoo Abiko gemeinsam Mangas und gaben 1952 unter dem Namen Fujiko Fujio ihr professionelles Debüt. Werke wie „Q-Tarô the Ghost" oder „Ninja Hattori-kun" wurden zu Bestsellern und als Anime verfilmt. Fujiko Fujios erfolgreichste Schöpfung ist „Doraemon". Hauptfiguren sind Nobita – ein 10-jähriger Junge, der in der Schule nur Sechser schreibt und im Sport ein Totalversager ist –, und Doraemon, ein Roboter in Katzenform, der ihm aus dem 22. Jahrhundert per Zeitmaschine zu Hilfe eilt. Dies tut er meistens mit diversen Geräten, die er aus seiner „Brusttasche der vierten Dimension" hervorzuzaubern: Die *dokodemo door* [Überall-hin-Tür], durch die man an jeden Ort kommt, und der *take-copter* [Bambus-Propeller], mit dem man fliegen kann, haben sich fest im kollektiven Bewusstsein aller Japaner verankert. Auch in vielen anderen Ländern eroberte sich „Doraemon" eine riesige Fangemeinde. 1987 lösten die beiden Mangaka ihre Zusammenarbeit auf und arbeiteten getrennt unter den Namen Fujiko F. Fujio sowie Fujiko Fujio A. Letzterer gilt als ein Meister psychologischer Skizzen, die er mit viel schwarzem Humor in Erwachsenen-Mangas auslebte. Fujiko F. Fujio dagegen gelang es, in Geschichten, die überall spielen und jedem Kind widerfahren könnten, auf wunderbare Weise das Besondere zu finden, widmete sich aber hauptsächlich den langen Vorlagen für die *Doraemon*-Filme. 1996 starb Hiroshi Fujimoto.

La collaboration d'Hiroshi Fujimoto et de Motoo Abiko remonte à l'école primaire, sous le pseudonyme de Fujiko Fujio. « Obake no Q-Tarô » [Le fantôme Q-Tarô] est l'un de leurs succès. « Ninja Hattori-kun » est l'histoire d'un jeune ninja qui participe à toutes sortes d'aventures avec des enfants japonais. Ces deux mangas sont devenus des séries animées. Leur plus grand succès est « Doraemon », l'histoire d'un jeune écolier nommé Nobita qui est un raté complet autant à l'école qu'à la maison. Jusqu'au jour où un robot-chat appelé « Doraemon » arrive du 22e siècle dans une machine à remonter le temps. Doraemon utilise toute sorte d'objets qu'il sort « d'une poche dans la quatrième dimension » pour aider Nobita dans toutes les situations imaginables. Des objets tels que la « Dokodemo Door » [la porte vers n'importe où] et le « Takecopter » [l'hélicoptère bambou] ont été assimilés par la société japonaise et sont devenus des mots courants. La popularité de cette série s'est répandue dans le monde entier. Hiroshi Fujimoto et Motoo Abiko ont arrêté leur collaboration en 1987 et chacun a poursuivi sa propre carrière sous les noms « Fujiko F. Fujio » et « Fujiko Fujio A. » respectivement. Fujiko Fujio A. a démontré d'énormes talents dans les descriptions psychologiques, et a publié des mangas avec une touche l'humour noir destinés aux adultes. Fujiko F. Fujio souhaitait créer une version cinématographique de la série « Doraemon » mais il est décédé en 1996.

そう！
アバンチュール
……冒険ですよ

あなたが
いま一番
必要としてる
ものです！

きみは
なにをいって
いるんだ？
私はそんな
ものほしく
ないよ！

ドン！

私にウソ
をついては
いけませんよ
！
磯部さん

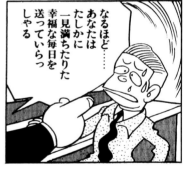

なるほど……
あなたは
たしかに
一見満ちたりた
幸福な毎日を
送っていらっ
しゃる

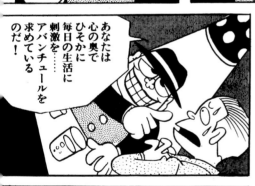

あなたは
心の奥で
ひそかに
毎日の生活に
刺激を……
アバンチュールを
求めている
のだ！

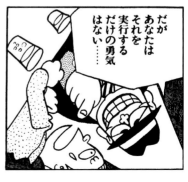

だが
あなたは
それを
実行する
だけの勇気
はない……

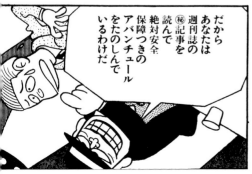

だから
あなたは
週刊誌の
㊙記事を
読んで
絶対安全
保障つきの
アバンチュール
をたのしんで
いるわけだ

猿!!
きみは
あの旗を狙った
のかっ!?

ああ！
狙ったのさ!!
旗に
ボールを包ませ
真下
へ落とすためにな!!

剣崎はん
あんた
それを一発で
入れないと
わいに一打
負けることに
なりまっせ!!

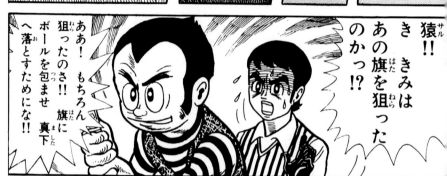

わいは
これで
このホール
二打で
あがったで!!

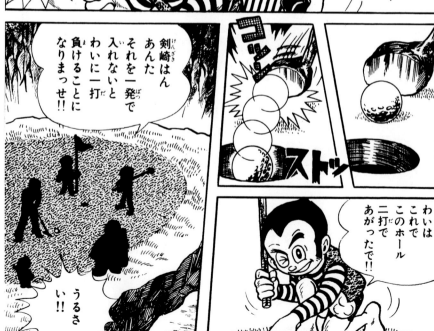

うるさ
い!!

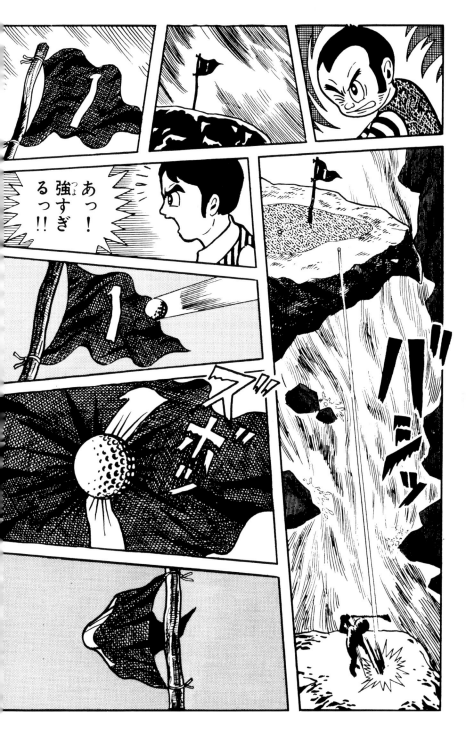

Minoru Furuya's best known work is "Ike! Ina-chū takkyū-bu" [Ping Pong Club], which was serialized in a *seinen* manga magazine. This was a hilarious gag manga telling the story of a group of junior high school students and their activities at the school's table tennis club. Furuya mostly relies on dirty jokes, but he sharply reveals the essence of the kind of silly humor that is typical in the lives of junior high school students. This hit manga has also been made into an animated television show. By describing the closed-off world of young teen-agers, and their desires to conquer it, he got quite a response from young boys. At the root of his gag humor, he seems to express the insignificance of the dreary and trifling existence of humans. The author's modern talent is in his ability to incorporate this into gags, as opposed to heavy literature. This style of expressing feelings of worry, isolation, and not fitting into modern society through gag manga is something that has become more increasingly understood and supported. In recent works, he has expanded on and refined this style of expression.

M I N O R U F U R U Y A

Born

1972 in Saitama Prefecture, Japan

Debut

with "Ike! Ina-chū takkyū-bu," which was published in the rookie issue of *Young Magazine* in 1993

Best known works

"Ike! Ina-chū takkyū-bu" [Ping-Pong Club]
"Boku to issho" [With Me]
"Green Hill"
"Himizu"

Anime adaptation

"Ike! Ina-chū takkyū-bu" [Ping-Pong Club]

Prizes

• 20th Kōdansha Manga Award (1996)

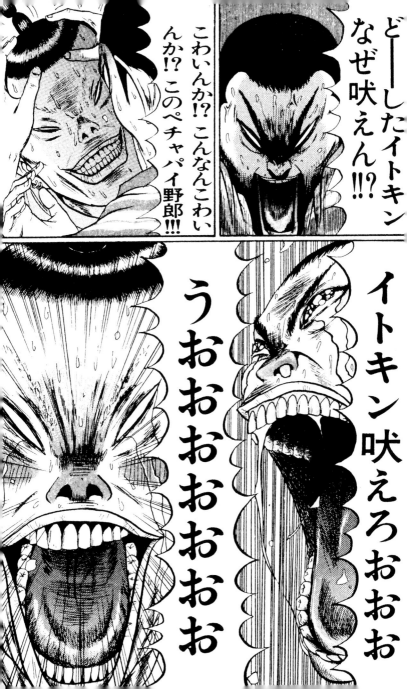

Typisch für seinen Stil ist die Serie „Ike! Ina-chû takkyû-bu" [Ping Pong Club]. Hauptakteure dieses in einem *seinen*-Magazin veröffentlichten Gag-Mangas sind Mitglieder des Tischtennis-clubs an einer Mittelschule. Minoru Furuya zeichnet Gags, hauptsächlich der anzüglichen Art, wie sie typisch für die Altersgruppe der Mittelschüler sind und so auf den ersten Blick wenig spektakulär wirken. Bei genauerem Hinsehen entpuppen sich die deformiert gezeichneten Slapstickszenen jedoch als ausgesprochen scharfsinnig und der Titel wurde ein großer Erfolg mit einer Verfilmung als TV-Anime. Gleichzeitig zeigt diese Serie das unbestimmte Gefühl dreizehn- bis fünfzehnjähriger Jungen, vom Rest der Welt abgeschnitten zu sein, und ihren Wunsch, diesen Zustand schnell hinter sich zu lassen. Damit konnte sich die Leserschaft der pubertierenden Jungen bestens identifizieren. Aus den rasch aufeinander folgenden Gags lässt sich zudem ein resignierter Grundton angesichts der Bedenkungslosigkeit menschlicher Existenz heraushören. Das wird nicht auf schwierige, literarische Weise ausgedrückt, sondern mit belanglosen Witzen, und eben darin liegt das Talent und die Modernität von Minoru Furuya. Sich im Leben deplaziert oder isoliert zu fühlen, von Sorgen geplagt zu sein – die Idee, solche Gefühle mit einem Gag-Manga auszudrücken, findet immer mehr Bewunderer. Diesen besonderen Stil erweiterte Furuya in seinen jüngsten Werken.

L'œuvre la plus connue de Minoru Furuya est « Ike! Ina-chû takkyû-bu » [Le club de ping-pong], qui est devenue une série dans un magazine de mangas seinen. Il s'agit de l'histoire hilarante d'un groupe de collégiens et de leurs activités au club de ping-pong de leur école. Furuya utilise des blagues cochonnes, mais révèle l'essence de l'humour bête qui est typique des collégiens. Ce manga populaire est devenue une série animée pour la télévision. En décrivant le monde fermé des jeunes adolescents, et leur désir de le conquérir, l'histoire a été très bien reçue par les jeunes. À la base de son humour, il semble exprimer l'insignifiance de la vie monotone et sans importance des humains. Les talents modernes de l'auteur résident dans sa capacité à incorporer ce concept dans ses gags, plutôt que de faire appel à de la littérature lourde. Ce style permettant d'exprimer des sentiments d'inquiétude, d'isolation, et de non-adéquation avec la société moderne est quelque chose qui est maintenant compris et supporté. Dans ses œuvres récentes, Furuya a peaufiné ce style d'expression.

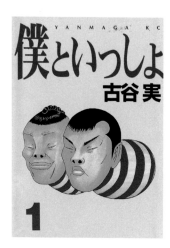

自分の乗る飛行機が落ちると思うか?

歩道を歩いていたら居眠りトラックがつっこんで来ると思うか?

肺にキノコが生えると思うか?

通り魔にあうと思うか?

家が放火されると思うか?

森で3億円拾うと思うか?

宝クジが当たると思うか?

自分にとてつもない才能があると思うか?

不幸ばかりじゃない幸福もそうだ

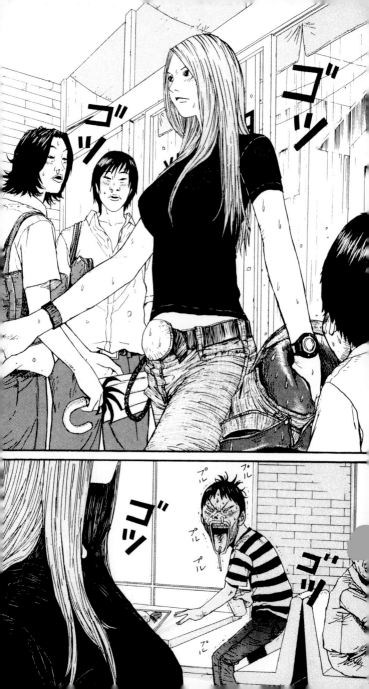

・・・・・
グリーン
ヒル？

フンッ
バイクオタクが
・・・

チュー
チュー

雨ん中
よーやるぜ

GREEN HILL

チ～

おぉ!?

With his debut work, "Palepoli," Usamaru Furuya brought artistic techniques that seem to be taken directly from the world of art. He was noticed for taking ordinary everyday situations, and adding instantaneous humor or transforming them into a mysterious world that showcases his surrealistic sense. He has done many experimental works, from photo-realistic drawings to cute little mascot-like characters and quirky gag manga. Furuya mastered the drawings of all of these different genres, while structuring them around a solid story. His second series was "Shortcuts," which was published in a major manga magazine. The theme revolved around modern ko-gal, who were a generation of high school aged girls that caused quite a sensation in Japan. This was also an experimental manga in which he created an unprecedented strange world. In addition, Furuya has published many manga that are like art pieces, which he creates using materials other than paper. These are published in a culture magazine called *Studio Voice*. He also experimented with the technique of sealing certain pages in a particularly graphic tankoubon book about an assault on a young girl. In the recent "π" he wrote a comical story of a high school student and his quest for the most beautiful bosom. The work was published in a major manga magazine. With wide-ranging styles from humor to darker themes, Furuya is a one of a kind artist who shows versatility in many genres of magazines, from major magazines to underground magazines and culture magazines.

USAMARU FURUYA

Born

1968 in Tokyo, Japan

Debut

with "Palepoli" in *Monthly Garo* in 1994

Best known works

"π"
"Shortcuts"
"Marie no kanaderu ogaku"
[The Music that Marie Plays]
"Palepoli"

Prizes

• 43rd Bungeishunjū Manga Award (1997)

日ペンの巫女さん

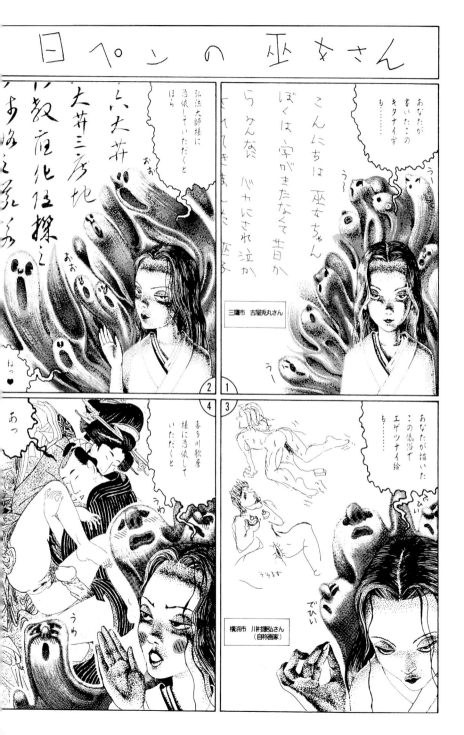

Sein für *Garo* gezeichneter Erstling „Palepoli" erregte großes Aufsehen, denn Usamaru Furuya verwendet Maltechniken, die direkt aus der Welt der hohen Kunst zu kommen scheinen. Er zaubert mit feinem Sinn fürs Surreale aus unauffälligen Alltagsszenen eine wundersame, amüsante Welt. Virtuos kombinierte er in dieser experimentellen Arbeit realistische Zeichnungen mit einem Stil, der an die Gebrauchsgrafik niedlicher Werbemaskottchen erinnert. Dazu kamen Bilder, wie sie für Gag-Mangas typisch sind. Furuyas nächstes Werk „Shortcuts", behandelt das damalige Lieblingsthema der japanischen Medien, das Phänomen der sogenannten *ko-gal*, also der neuen Generation von Oberschülerinnen. Auch hier gelingt ihm mit seinem experimentellen Stil ein beispielloses Kuriositätenkabinett. In der Kulturzeitschrift *Studio Voice* zeigt der Künstler, dass ein Manga auch eine Art Kunstobjekt sein kann und nicht immer auf Papier gezeichnet sein muss. Er experimentiert weiter mit den technischen Möglichkeiten, veröffentlicht beispielsweise ein *tankôbon*, in dem er die Vergewaltigung eines jungen Mädchens beschreibt, mit ungeschnittenen Seiten. Sein neuestes Werk „π", eine Komödie über Oberschüler auf der Suche nach dem ultimativ schönsten Busen, ist dagegen wieder in einem auflagestarken Wochenmagazin plaziert. Als Mangaka mit einer ungeheuer reichhaltigen Ausdruckspalette, die von Humor bis Weltuntergangsstimmung alles abdeckt, veröffentlicht Furuya in den unterschiedlichsten Foren, in Untergrundmagazinen genauso wie in etablierten Mainstream-Magazinen. Damit ist er wohl einzigartig in Japan.

Avec sa première œuvre « Palepoli », Usamaru Furuya a fait preuve d'une technique artistique qui semble venir directement du monde de l'art. Il sait parfaitement décrire des situations de la vie ordinaire et leur ajouter de l'humour ou les transformer en des mondes mystérieux qui démontrent son sens surréaliste. Il a produit de nombreuses œuvres expérimentales, comme des dessins photoréalistes ou de petits personnages et des gags excentriques. Furuya est passé maître dans presque tous ces genres, tout en les structurant autour d'une histoire solide. Sa seconde série, « Shortcuts » a été publiée dans un important magazine de mangas. Il s'agit d'une histoire sur le thème des « kogaru » modernes, une génération de lycéennes qui ont fait sensation au Japon. C'était également un manga expérimental dans lequel il a créé un monde étrange sans pareil. Furuya a publié de nombreux mangas qui ressemblent à des œuvres d'art et qui utilisent d'autres matériaux que le papier. Ils ont été publiés dans le magazine culturel Studio Voice. Il s'est également essayé à la technique du cachetage des pages dans un tankoubon particulièrement cru sur l'agression d'une jeune fille. Dans le récent « π », il a écrit une histoire comique sur un lycéen et sa quête de la poitrine la plus opulente. Ce manga a été publié dans un important magazine de mangas. Furuya est doué pour passer du thème de l'humour à des thèmes plus sombres. Il est un auteur unique qui fait preuve d'une grande polyvalence, et il est capable de travailler pour différents types de publications, que ce soit des magazines underground, des magazines à forte diffusion ou des magazines culturels.

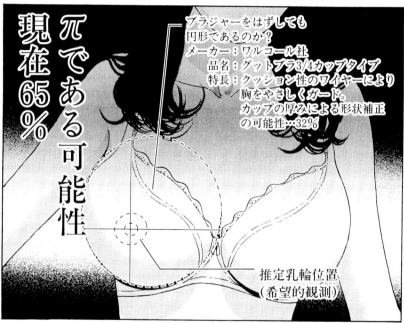

π である可能性
現在65％

ブラジャーをはずしても
円形であるのか？
メーカー：ワルコール社
品名：グットブラ3/4カップタイプ
特長：クッション性のワイヤーにより
胸をやさしくガード。
カップの厚みによる形状補正
の可能性…32％

推定乳輪位置
（希望的観測）

そう。

いや…

主よ！

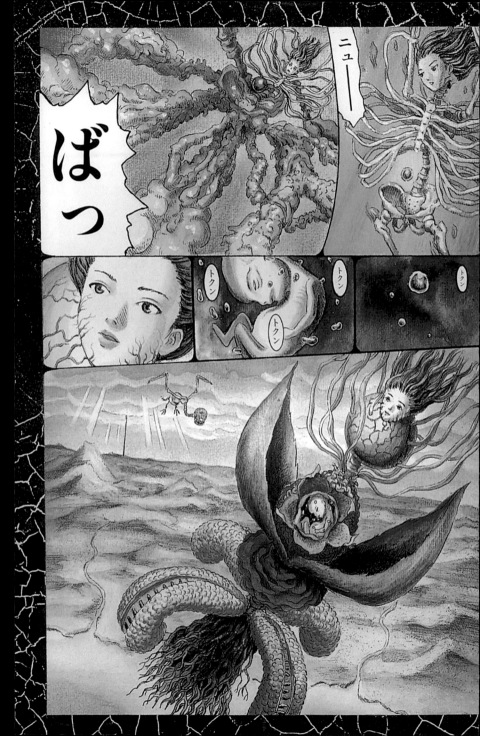

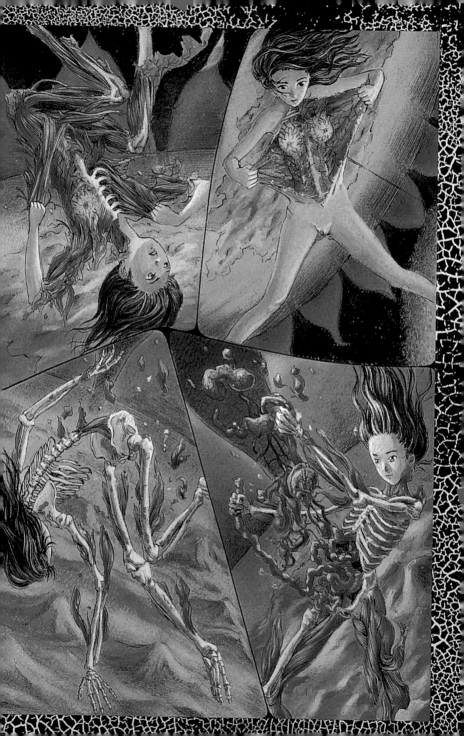

Moto Hagio is a member of the famous "24 Group," a band of manga artists that changed the course of Japan's *shoujo* manga. The nickname "24 Group" was given to a certain group of mangaka who were born in the year Showa 24 (1949). At a time when love stories were at an all time high within the *shoujo* manga genre, these artists created stories with a philosophical theme and about life in general. Hagio is a rare author who often writes about children and loneliness. At the age of 23, she started writing a series called "Poe no ichizoku" [The Poe Clan], a story about vampires who cannot live ordinary lives. Her masterpiece "Hanshin" is portrayed in 16 short pages, the minimum needed to establish a story manga, and focuses on a pair of Siamese twin girls attached at birth, and how one is left to live alone. The series "Zankoku na kami ga shihai suru" [A Cruel God Rules], which was still in publication until recently, told the story of the loneliness and subsequent recovery of a young boy who was sexually abused by a step-father. Hagio's stories tend to depict children, who are the most vulnerable members of society, and her main characters tend to be young boys. In the mid-1970s and 1980s she was highly praised for her compositional style and highly imaginative ideas in the science fiction works "11 Nin Iru!" [They Were Eleven], "Star Red," and "Marginal." She still maintains her position at the forefront of the Japanese manga industry as one of the top *shoujo* manga artists.

MOTO
HAGIO

Born

1949 in Fukuoka Prefecture, Japan

Debut

with "Ruru to Mimi" [Lulu and Mimi] in *Nakayoshi* magazine in 1969

Best known works

"Poe no ichizoku" [The Poe Clan]
"Toma no shinzō" [Thomas' Heart]
"11 nin iru!" [They Were Eleven]
"Zankoku na kami ga shihai suru" [A Cruel God Rules]

Anime adaption

"11 nin iru!" [They Were Eleven]
"Iguana no musume" [Iguana's Daughter]

Prizes

- 21st Shôgakukan Manga Award (1976)
- 11th Seiun Award (1980)
- 14th Seiun Award (1983)
- 16th Seiun Award (1985)
- 1st Tezuka Osamu Cultural Prize Manga Award for Excellence (1997)

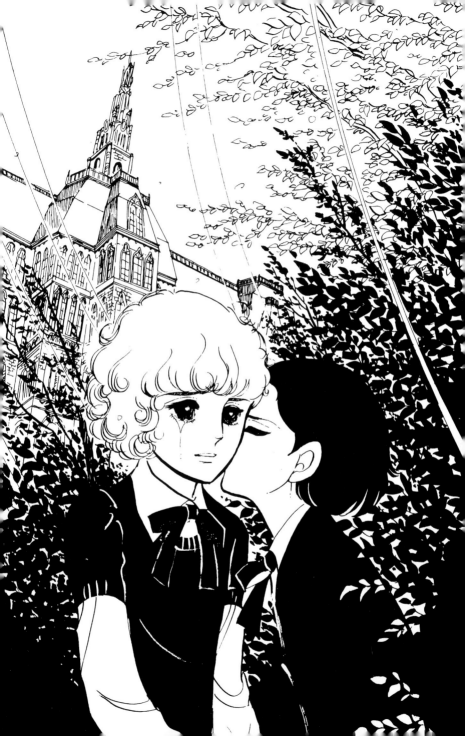

Moto Hagio ist eine führende Vertreterin der für den *shôjo*-Manga epochalen Gruppe der 24er. Darunter versteht man die im Jahr Shôwa 24 (1949) geborenen Manga-Autorinnen, die erstmals philosophische Themen und existentielle Fragen in den bis dahin von Liebesgeschichten bestimmten *shôjo*-Manga brachten. Mit ihren immer gleichen Themen Kindheit und Einsamkeit nimmt Hagio in dieser Gruppe eine Sonderstellung ein. Mit 23 Jahren begann sie die Serie „Poe no ichizoku " [The Clan of Poe] über am Leben verzweifelnde Vampire. „Hanshin" ist ein Meisterwerk auf nur 16 Seiten – die geringstmögliche Seitenzahl für einen Story-Manga – über die Trennung siamesischer Zwillingsmädchen. Die vor Kurzem abgeschlossene Serie „Zankoku na kami ga shihai suru" [A Savage God Dominates oder A Cruel God Rules in Heaven] handelt von der Einsamkeit und dem Wiederaufleben eines Jungen, der von seinem Stiefvater sexuell missbraucht wurde. Kinder, in ihrer schwachen Stellung in der Gesellschaft, sind die Hauptpersonen in Hagios Geschichten – dass es sich dabei hauptsächlich um Jungen handelt, ist das Besondere an ihren Werken. Zwischen 1975 und 1980 zeichnete sie mit „They Were Eleven", „Star Red" und „Marginal" Sciencefiction-Mangas, die durch ihre Nachdenklichkeit und überzeugende Komposition ein großes Publikum fanden. Auch heute ist Moto Hagio eine der führenden *shôjo*-Mangaka in Japan.

Moto Hagio est membre du fameux « 24 Group », un groupe d'auteurs de mangas qui ont transformé les mangas shoujo japonais. Ce surnom de « 24 Group » a été attribué à un groupe de mangakas nés dans l'année Showa 24 (1949). À une période où les histoires d'amour étaient très populaires dans les mangas shoujo, ces auteurs ont créé des histoires sur des thèmes philosophiques et sur la vie en général. Hagio est un auteur unique qui écrit souvent sur les enfants et la solitude. À l'âge de 23 ans, elle a commencé à écrire une série intitulée « Poe no ichizoku » [Le clan Poe]. Il s'agit d'une histoire de vampires qui ne peuvent vivre des vies ordinaires. Son œuvre « Hanshin » tient sur 16 pages, le minimum requis pour un manga. Elle se concentre sur des jumelles siamoises attachées à la naissance, et sur celle qui est amenée à vivre seule. La série « Zankoku na kami ga shihai suru » [La domination d'un dieu cruel], qui était encore publiée récemment, raconte l'histoire d'un jeune garçon abusé par un beau-père cruel, sa solitude et sa guérison. Les histoires d'Hagio tendent à représenter des enfants qui sont les membres de la société les plus vulnérables, et ses personnages principaux sont souvent de jeunes garçons. Dans les années 1970 et 1980, elle a écrit « 11 Nin Iru! » [Ils étaient onze !], « Star Red » et « Marginal », des histoires fascinantes de science-fiction qui lui ont valu de nombreux éloges. Elle reste l'un des principaux auteurs de mangas shoujo.

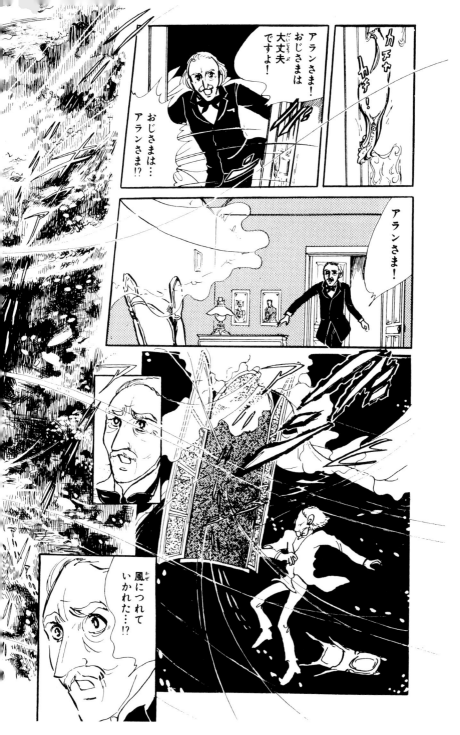

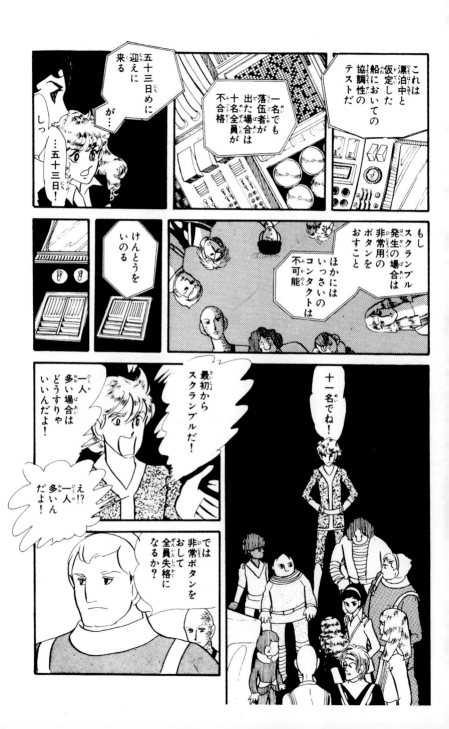

この黒い二か所が爆発したとこ

上層中部の住宅区らしい

…もう非常用シャッターがしまってる

船のエア・ロックがとじられて七分たつと

自動的に爆発するようにセットされてる

二分半で一発ずつ全部で百二十発

——じゃこれがテストか!?

試験官が行けばわかると言っていたのはこれか!?

じゃエア・ロックでさわがずにさっさと来りゃきみもさわいだろ

ありゃききさまが

おまえらホネばった顔してんな

?

きみたち十名はこれから五十三日間この宇宙船・白号の乗員として船内にとどまること

メッセージを送る

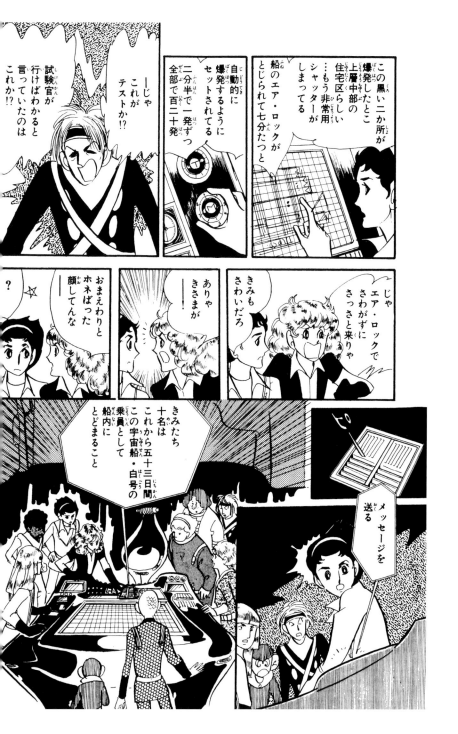

After graduating from high school and failing to pass the exams to all the universities he tried, Kengo Hanazawa worked on a variety of jobs for a while before making his debut with the work "Ressentiment" in 2004, for which he won the Topic Award of the 2005 Sense of Gender Awards. This self-made mangaka who specializes in *seinen* titles (usually marketed to young men between 18 and 30) has also been nominated for the acclaimed Manga Taishō for "I Am a Hero," first released in 2009 by Big Comic Spirits.

Following his success in print, "Boys on the Run," and later "I Am a Hero," have been adapted into live action films. In a rare case of perseverance, Kengo Hanazawa worked with veteran mangaka Osamu Uoto before going solo. Born in Aomori, Hanazawa admits that many episodes in his manga are based on his real experiences. In all his titles, including "Akizakura" and "Tokkaten," he has authored drama, comedy, romance, action, horror, and adult among other genres.

KENGO HANAZAWA

Born

1974 in Aomori Prefecture, Japan

Debut

in 2004 with "Ressentiment"
in *Big Comic Spirits*

Best known works

"Boys on the Run"
"I Am a Hero"

Feature film

"Boys on the Run"
"I Am a Hero"

Prizes

• 5th Sense of Gender Award:
Popularity Prize (2005)
• 58th Shōgakukan Manga Award
for general manga (2012)

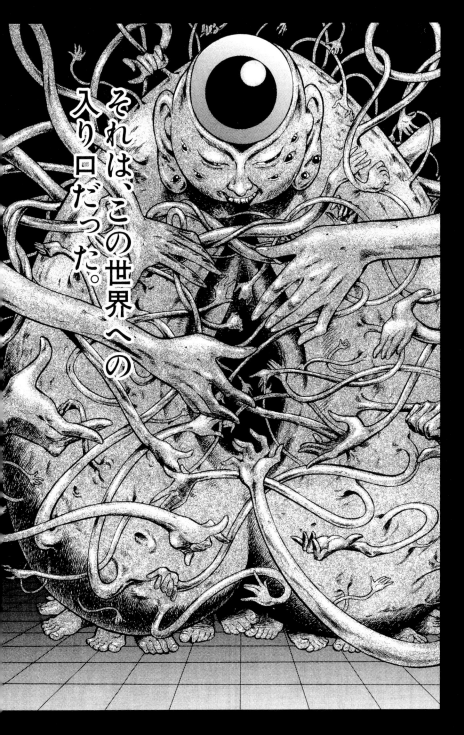

それは、この世界への入り口だった。

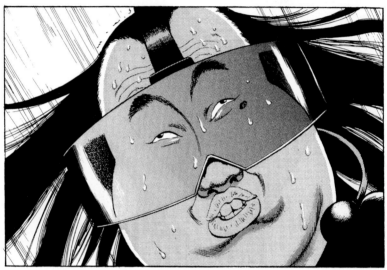

ここにいれば、

おれ達ですら勝者になれるのだ。

8

Als Kengo Hanazawa nach seinem Schulabschluss an sämtlichen Universitäten, an denen er es versuchte, durch die Aufnahmeprüfung fiel, hielt er sich mit diversen Jobs über Wasser, bis ihm 2004 mit „Ressentiment" sein Manga-Einstand gelang, für den er mit dem Topic Award bei den Sense of Gender Awards 2005 ausgezeichnet wurde. Der Manga-Autodidakt, der sich auf *seinen*-Titel (Manga für junge Männer zwischen 18 und 30) spezialisiert hat, wurde für sein Werk „I Am a Hero", das 2009 in *Big Comic Spirits* erschien, zudem mit dem angesehenen Manga Taishô gewürdigt. Nach den Erfolgen in Buchform wurden zuerst „Boys on the Run" und später auch „I Am a Hero" als Spielfilme adaptiert. Hanazawa arbeitete zunächst mit dem erfahrenen Mangaka Osamu Uoto zusammen, bevor er seine Solokarriere begann. Viele Manga-Episoden des in Aomori geborenen Künstlers basieren, wie er selbst zugibt, auf eigenen Erfahrungen. In all seinen Titeln – darunter auch „Akizakura" und „Tokkaten" – vermischt er zahlreiche Formen und Gattungen miteinander, wie etwa Drama, Komödie, Romantik, Action, Horror und Erotik.

À la sortie du lycée, après avoir échoué à tous les examens d'entrée des universités qui l'intéressaient, Kengo Hanazawa a travaillé dans divers endroits jusqu'à son premier ouvrage en 2004, « Ressentiment », qui lui a valu en 2005 le Topic Award lors des Sense of Gender Awards. Ce mangaka autodidacte spécialisé dans les titres seinen (visant généralement un public masculin entre 18 et 30 ans) a également été nominé pour le célèbre grand prix du Manga Taish pour « I am a Hero », d'abord sorti en 2009 par *Big Comic Spirits*. Après le succès de ses publications, « Boys on the Run » puis « I am a Hero » ont été adaptés en longs métrages. À titre exceptionnel, Kengo Hanazawa a collaboré avec le mangaka vétéran Osamu Uoto avant d'exercer en solo. Né à Aomori, Hanazawa reconnaît que de nombreux passages de ses mangas sont basés sur des expériences réelles. Dans toutes ses œuvres, dont « Akizakura » et « Tokkaten », il a touché à tous les genres : drame, comédie, romance, action, horreur et contenu pour adultes, entre autres.

"Hokuto no ken" [Fist of the North Star] was first published in a *shounen* magazine in 1983, and along with the animation, it became an unprecedented big hit. It succeeded in exciting kids all over Japan and still continues to do so today. Even the adults who read the manga as kids have continued to remain firm fans. The story is set in the not-so-distant future, when the world is in ruins and violence reigns the planet. The story's hero is Kenshirō, who is a master of the "Hokuto Shinken" martial arts style. He fights old enemies and fierce monsters, and eventually has a showdown with his brother Raou, who is the strongest man alive. In this martial arts style, the opponent's body is destroyed from the inside out, so many times the opponent's body becomes manipulated, or he may not realize that he is already dead, or he simply explodes. These strange deaths fascinated readers, and Kenjiro's catchphrase, "Omae wa mou shindeiru" [You're already dead] really caught on among the fans. After completing "Hokuto no ken," Hara wrote the historical piece, "Hana no keiji/Kumo no kanata ni," which was an adaptation of a novel. It was about the real-life *kabuki-mono*, a stylish group of flashy radicals that lived during the last days of the Tokugawa shogunate. Hara portrays the dynamic men who fought during these turbulent times. In 1999, he participated in the creation of a new manga publishing company called Coamix. In *Comic Bunch*, which was one of the company's magazines, he published a sequel to "Hokuto no ken" entitled "Sōten no ken" [Fist of the Blue Sky]. The series continues to attract more and more fans.

T E T S U O

H A R A

Born

1961 in Tokyo, Japan

Debut

with "Tetsu no Don Kihōte" [Iron Don Quixote] published in a special issue of *Weekly Shōnen Jump* in 1982

Best known works

"Hokuto no ken" [Fist of the North Star] (original concept by Buronson)
"Hana no Keiji/Kumo no kanata ni" (original concept by Keiichiro Ryu, script by Mio Aso)
"Sōten no ken" [Fist of the Blue Sky] (supervised by Buronson)

Anime adaption

"Hokuto no ken" [Fist of the North Star]

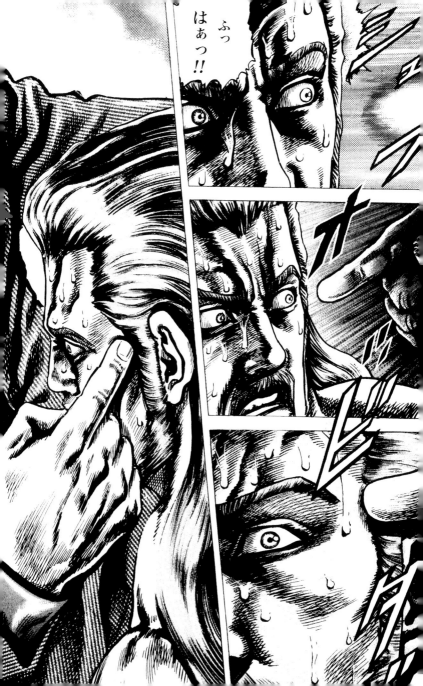

Seine 1983 in einem *shônen*-Magazin erstmals veröffentlichte Serie „Hokuto no ken" [Fist of the North Star] wurde zu einem beispiellosen Erfolg, wozu sicherlich auch die Anime-Verfilmung beitrug. Kinder in ganz Japan begeisterten sich für diesen Manga und blieben ihm auch als Erwachsene treu – „Fist of the North Star" erfreut sich nach wie vor ungeheurer Popularität. In einer post-apokalyptischen, gewaltbeherrschten Welt muss der Held Kenshirô, Meister der „Hokuto Shinken"-Kampfkunst, seine überwältigende Stärke im Kampf gegen diverse Feinde sowie andere Kerle im Monster-Format unter Beweis stellen. Schließlich trifft er mit dem Stärksten von allen – niemand Geringerer als sein eigener Bruder Raou – zusammen. Seine Kampftechnik besteht darin, über Energiepunkte am gegnerischen Körper diesen von innen heraus zu manipulieren oder zu zerstören, so dass die Gegner teilweise, ehe sie sichs versehen, implodieren. Zusammen mit seinem cool hingeworfenen „Du bist bereits gestorben!" begeisterte die zahlreichen Fans, die den Spruch zum Modeausdruck in ganz Japan machten. Sein nächstes Werk „Hana no keiji" zeichnete Tetsuo Hara nach einer Romanvorlage über sogenannte *kabukimono* – exzentrische, elegante Männer, die gegen Ende der Edo-Zeit lebten. Auch hier und in seinen anderen historischen Mangas stellte er kämpfende Männer und Kriegswirren voller Dynamik dar. 1999 beteiligte er sich dann an der Gründung eines neuen Manga-Verlags, Coamix, und veröffentlichte in *Comic Bunc*h, einem Magazin dieses Verlages, „Sôten no ken", eine Art Fortsetzung von „Fist of the North Star", die ebenfalls sehr beliebt ist.

« Hokuto no ken » [Le poing de l'étoile du nord] a été publié pour la première fois dans un magazine shounen en 1983, et il est devenu avec sa version animée un succès sans précédent. Ce manga a conquis les enfants dans tous le Japon et continue de le faire aujourd'hui. Même les adultes qui lisaient la série en étant jeunes restent des fans inconditionnels. L'histoire se déroule dans un futur relativement proche, lorsque le monde est en ruine et la violence règne sur la planète. Le héros de l'histoire est « Kenshirô », un maître dans la technique d'arts martiaux « Hokuto Shinken ». Il se bat contre d'anciens ennemis et des monstres féroces, et combat même son propre frère Raou, qui est l'homme le plus fort au monde. Dans ce style d'arts martiaux, le corps des adversaires est détruit de l'intérieur. De nombreuses fois, le corps des ennemis est manipulé, la victime ne sait pas encore qu'elle est morte, ou son corps explose littéralement. Ces morts étranges ont fasciné les lecteurs, ainsi que la phrase clé de Kenshirô « Omae wa mou shindeiru » [Tu es déjà mort]. Après avoir terminé « Hokuto no ken », Hara a écrit un histoire intitulée « Hana no keiji/Kumo no kanata ni » [La floraison de Keiji : De l'autre côté des nuages], adaptée d'un roman. Elle décrit le « kabukimono », un groupe de radicaux qui vivaient durant les derniers jours de la dynastie shogun Tokugawa. Hara dépeint un homme dynamique qui s'est battu durant cette période de troubles. En 1999, il a participé à la création d'une maison d'édition de bandes dessinées appelé « Coamix », avec laquelle il a publié la suite de sa série « Hokuto no ken », intitulée « Sôten no ken » [Le poing du ciel bleu]. La série continue d'attirer de plus en plus de fans.

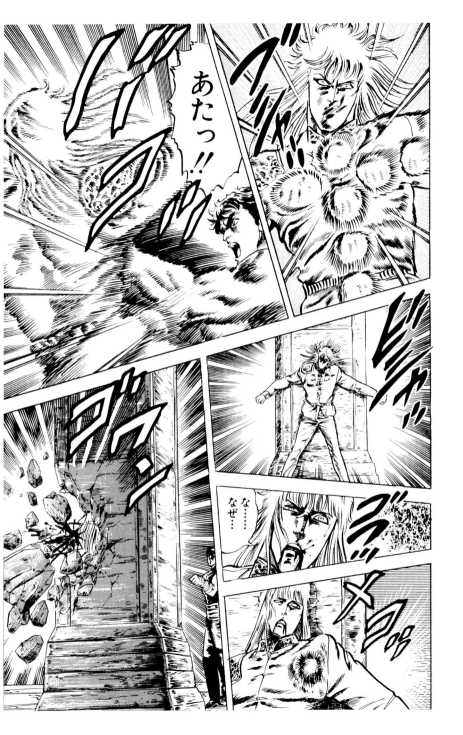

With "Kingdom," a manga whose sales have surpassed six million copies, Yasuhisa Hara not only received the 17th Manga Taishō Osamu Tezuka Award in 2013, with one of the judges claiming to have read over 30 volumes, he has also entered the Guinness Book with greatest collaborative work to redraw one of its volumes. The work of 1087 illustrators was later posted on the official website of the *Shūkan Young Jump* weekly comics magazine. The tale is a historical fiction that tells the story of Xin, a war orphan, who fights alongside his comrades to become the general responsible for unifying China for the first time in history. As an assistant to Takehiko Inoue, the legendary mangaka of the megaseller series "Slam Dunk," Yasuhisa Hara cultivated a fruitful relationship and years of mentoring before going solo. Other successful titles from the artist include "Li Mu" and "Meng Wu" and "Chu Zi," both historical dramas, and part of his early work was released in 2004 and 2005 respectively. "Kingdom" has been made into a TV series since 2012, with a video game released in 2010 for the Play Station platform.

YASUHISA HARA

Born
1975 in Saga Prefecture, Japan

Debut
with "Otomatsu" in 1999 published in *Bessatsu Young Magazine*

Best known works
"Kingdom"

Feature animation
"Kingdom"

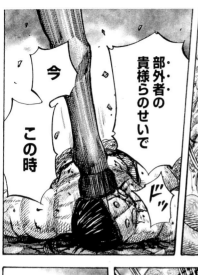

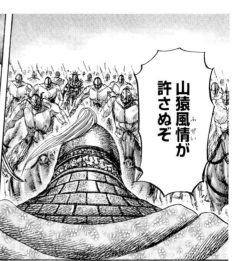

山猿風情が
許さぬぞ

部外者の
貴様らのせいで

今 この時

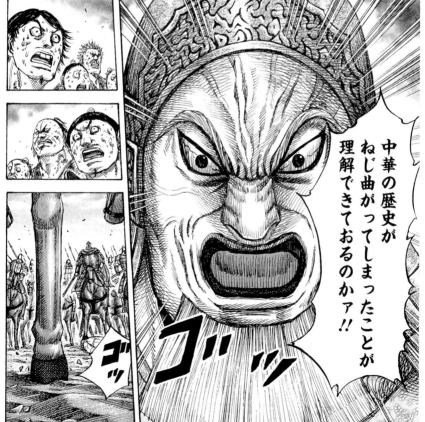

中華の歴史が
ねじ曲がってしまったことが
理解できておるのかァ!!

ゴッ コッ ゴッ

ドッ

Für „Kingdom", ein Manga, von dem über sechs Millionen Exemplare verkauft wurden, erhielt Yasuhisa Hara 2013 den 17. Osamu-Tezuka-Kulturpreis, wobei einer der Juroren behauptete, er habe über 30 Bände gelesen. Aufgrund des großen Teams, das an einem der Bände beteiligt war, wurde der Manga auch ins Guinness-Buch der Rekorde aufgenommen. Die Arbeit der insgesamt 1087 Zeichner erschien anschließend auf der offiziellen Website der Manga-Zeitschrift *Shūkan Young Jump*. Es handelt sich bei der Saga um eine historische Fiktion, in deren Mittelpunkt der Kriegswaise Shin [chinesisch Xin] steht, der zum Feldherr aufsteigt und erstmals in der Geschichte ganz China in einem Reich vereint. Bevor Hara seine Solokarriere begann, war er einige Zeit als Assistent von Takehiko Inoue tätig, dem legendären Autor der erfolgreichen Manga-Serie „Slam Dunk", und profitierte von dessen Erfahrung. Zu Haras weiteren Erfolgen gehören die Titel „Li Mu" und „Meng Wu and Chu Zi", beides ebenfalls historische Dramen. Darüber hinaus wurden 2004 und 2005 Teile seines Frühwerks veröffentlicht. „Kingdom" wurde ab 2012 auch als Anime-Serie im Fernsehen ausgestrahlt und 2010 erschien – ausschließlich in Japan – eine Videospielfassung für die PlayStation Portable.

Grâce à « Kingdom », un manga dont les ventes ont dépassé les six millions d'exemplaires, Yasuhisa Hara a reçu le 17e prix culturel du manga Osamu Tezuka en 2013, dont l'un des juges a affirmé avoir lu plus de 30 volumes. Il figure aussi dans le livre Guinness des records pour l'immense travail d'équipe pour la mise à jour de l'un des volumes. Le travail de 1 087 illustrateurs a ensuite été publié sur le site Web officiel du magazine hebdomadaire *Shūkan Young Jump*. Il s'agit d'une fiction historique avec Xin, un orphelin de guerre qui lutte avec ses camarades pour parvenir à l'unification de la Chine. En tant qu'assistant de Takehiko Inoue, mangaka légendaire de la si populaire série « SLAM DUNK », Yasuhisa Hara a entretenu une relation fructueuse avec lui et profité d'années d'apprentissage à ses côtés avant de se lancer en solo. Il est aussi l'auteur de succès comme « Li Mu » et « Meng Wu and Chu Zi », deux drames historiques, et une partie de ses récents travaux est parue en 2004 et 2005. « Kingdom » a été adapté en téléfilm en 2012, et un jeu vidéo est sorti en 2010 pour la PlayStation.

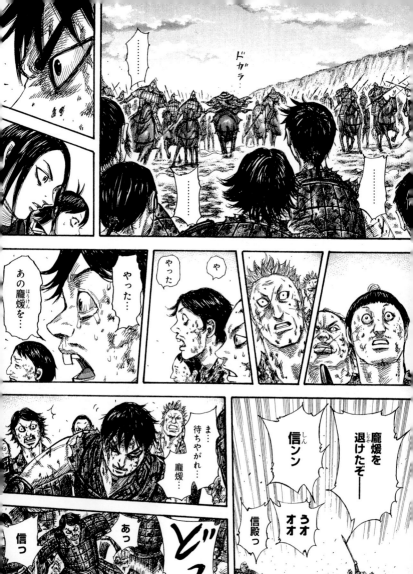

ドガラ……

あの龐煖を…… やった…… や った

ま…待ちやがれ…　龐煖…

龐煖を退けたぞ——
信ン
信殿っ
うォォ

あっ
信っ

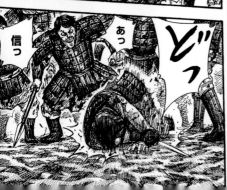

どっ

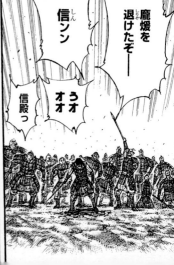

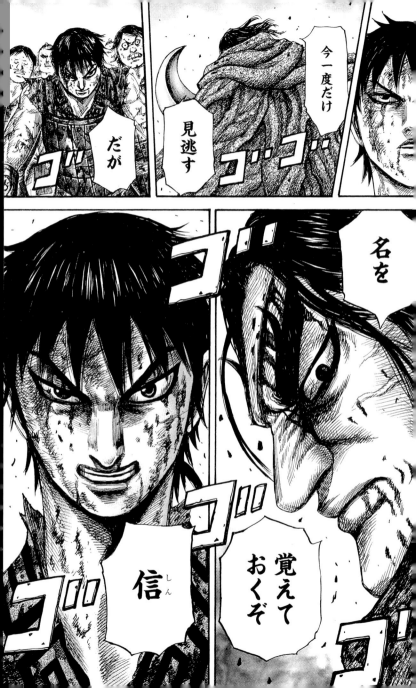

With over 20 titles Akiko Higashimura is part of the growing group of female mangaka stars, having debuted straight with the Kôdansha's *Shûkan Morning* magazine. The artist went on to finally win the Manga Taishô in 2015 for her title "Kakukaku Shikajika." Also a visiting professor, she has created stories beyond her preferred genre of gag manga and has become probably the most popular female artist in the field with titles such as "Omo ni naitemasu," "Meropon dashi!," "Tôkyô tarareba musume," and "Bishoku tentei." In 2015 she resumed the serialization of "Princess Jellyfish" with Kôdansha's *Kiss.* "Princess Jellyfish," which inspired a 2010 television anime series, tells the story of Amamizukan, from a fan-girl-only dorm, who has loved jellyfish from a young age, and who needs to be rescued by a woman who turns out to be a man.

AKIKO HIGASHIMURA

Born

1975 in Miyazaki Prefecture, Japan

Debut

with "Fruits kômori" in 1999 published in *Bu-ke DX New Year zôkan*

Best known works

"Omo ni naitemasu"
"Kurage hime"
[The Jellyfish Princess]
"Kakukaku shikajika"

Anime adaption

"Omo ni naitemasu"
"Kurage hime"
[The Jellyfish Princess]
"Kakukaku shikajika"

Prizes

- 17th Japan Media Arts Festival: Jury Selections in Manga Division (2013)
- 34th Kôdansha Manga Award: Girl's Comic Division (2010)
- 8th Cartoon Grand Prize (2015)
- 19th Japan Media Arts Festival: Grand Prize in Manga Division (2015)

今の私には
分かります

今さらもう
遅いよね

怒らないでね
先生

Mit über 20 Titeln und zwei Nominierungen für den angesehenen Manga Taishô gehört Akiko Higashimura zu der wachsenden Gruppe weiblicher Star-Mangaka. Ihren Einstand gab die in Miyazaki geborene Künstlerin gleich in der bekannten Wochenzeitschrift *Shūkan Morning* des Verlagshauses Kôdansha. Im Jahr 2015 gewann sie schließlich den begehrten Manga Taishô für ihren Titel „Kakukaku Shikajika". Higashimura, die nebenbei als Gastprofessorin tätig ist, schrieb auch Geschichten jenseits des von ihr bevorzugten Genres des Gag-Manga, mit Titeln wie „Omo ni naitemasu ", „Meropon dashi!", „Tôkyô tarareba musume " und „Bishoku tentei " wurde sie aber zur wohl bekanntesten Künstlerin auf diesem Gebiet. 2015 setzte sie die Serie „Princess Jellyfish" in der Zeitschrift *Kiss* des Verlags Kôdansha fort, nachdem sie in den Jahren zuvor eine Reihe von Beiträgen für *Shūkan Shônen* geliefert hatte. „Princess Jellyfish", das 2010 auch als Vorlage für eine Anime-Serie gedient hatte, ist die Geschichte von Amamizukan, einem Mietshaus in Tokio, in dem ausschließlich weibliche *Otakus* [fanatische Manga-Anhängerinnen] wohnen – mit Ausnahme des Transvestiten Koibuchi Kuranosuke. Dessen wahre Identität kennt aber nur eines der Mädchen, nämlich die 18-jährige Kurashita Tsukimi, die seit ihrer Kindheit Quallen liebt und eine als Haustier hält.

Avec plus de 20 titres et deux nominations au grand prix du Manga Taishô, Akiko Higashimura fait partie de la communauté chaque fois plus grande de femmes mangakas de renom. Elle a débuté directement avec le magazine *Shūkan Morning* de Kôdansha. Née à Mayazaki, l'artiste a remporté le grand prix du Manga Taishô en 2015 pour son titre « Kakukaku Shikajika ». Exerçant aussi comme professeure invitée, elle a construit des histoires au-delà de son genre préféré qu'est le manga comique et s'est probablement inscrite comme l'artiste femme la plus célèbre dans ce domaine, avec des titres comme « Omo ni naitemasu », « Meropon dashi! », « Tôkyô tarareba musume » et « Bishoku tentei ». En 2015, elle a repris la série « Princess Jellyfish » avec le magazine *Kiss* de Kôdansha, après diverses contributions pendant deux ans pour le magazine *Shūkan Shônen*. « Princess Jellyfish », adapté en 2010 en série télévisée d'animation, raconte l'histoire d'Amamizukan, qui vit dans une résidence pour filles et qui est depuis toute jeune passionnée de méduses ; elle apprendra beaucoup d'une personne qu'elle croit femme mais qui s'avérera être un homme.

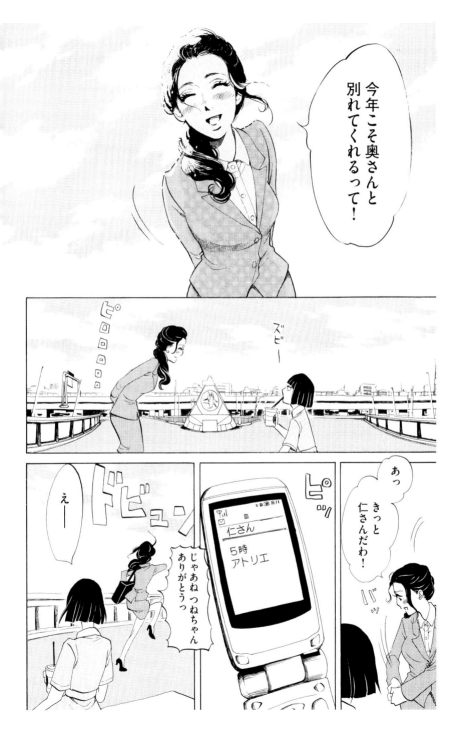

Kenshi Hirokane's creative works maintain a close connection with the political and economic aspects of modern society. He belongs to a faction called "society" manga artists. He is best known for "Kachô Shima Kôsaku" [Section Manager Kôsaku Shima], a story set in an electronic products company that Hirokane once worked in. The reason for its high popularity is that the salary man (businessman) portrayed in the story remains uncorrupted by different corporate sects, and he embodies the "ideals of a salary man." He gets promoted to department manager and to director, and the title of the series changes with each new promotion. The series is still being published today. Another story takes place in the world of politics. In "Kaji Ryûsuke no gi" [Kaji Ryûsuke] Hirokane depicts a young ideological politician. The writer himself has close contacts with a number of politicians, and he was praised for the way he shows an inner working of current politics, while actively developing a story line. In addition, Hirokane expertly creates human drama. This artist's value is not only in being a "society" manga artist, but also in his art of drama creation. Besides manga, he has also written essays on life, he has been active in the lecture circuit, and appeared on guest appearances on TV.

K E N S H I

H I R O K A N E

Born
1947 in Yamaguchi Prefecture, Japan

Debut
with "Kaze kaoru" which appeared in *Big Comic* in 1974

Best known works
"Asa no yôkô no naka de"
[In the Morning Sun]
"Kachô Shima Kôsaku"
[Section Manager Kôsaku Shima]
"Ningen Kôsaten" [Human Scramble]
(original story by Masao Yajima)

Anime adaption
"Tasigare ryûseigun"
[Like Shooting Stars in the Twilight]
"Kachô Shima Kôsaku"
[Section Manager Kôsaku Shima]

Prizes
• 30th Shôgakukan Manga
 Award (1985)
• 15th Kôdansha Manga Award
 (1991)
• 32nd Japan Cartoonists
 Association Grand Prize (2003)

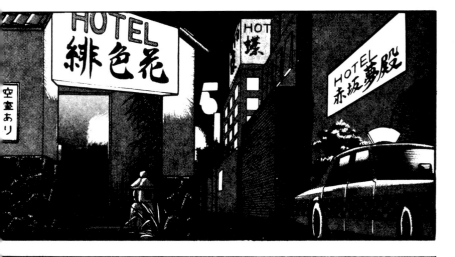

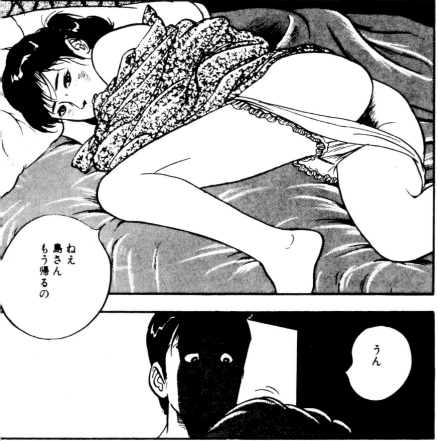

Kenshi Hirokane ist ein Mangaka soziologischer Ausprägung, der in seiner kreativen Tätigkeit Berührungspunkte zur realen Welt der Politik und Wirtschaft nicht vernachlässigt. Bezeichnend für seinen Stil ist die Serie „Abteilungsleiter Shima Kôsaku", deren Handlung sich in einer Elektrofirma abspielt, wie der Autor früher selbst bei einer angestellt war. Hirokane entwirft in diesem populären Manga das Idealbild eines Angestellten, der seinen eigenen Überzeugungen folgt, ohne sich auf firmeninterne Klüngeleien einzulassen. Der Serientitel wurde einige Male geändert, um den jeweiligen Beförderungen der Titelfigur – vom Hauptabteilungsleiter bis zum Direktor – Rechnung zu tragen und es werden noch immer neue Folgen veröffentlicht. In „Kaji Ryûsuke no gi" befasst Hirokane sich mit der Welt der Politik: Im Mittelpunkt der Handlung steht ein idealistischer junger Abgeordneter. Der Autor, der selbst viele Beziehungen zu japanischen Politikern hat, ließ reale Vorkommnisse des politischen Tagesgeschehens in die dynamische Story einfließen und sorgte so für reichlich Gesprächsstoff. Außer für diese gesellschaftliche Relevanz verdient der Autor auch Beachtung für die virtuose Darstellung zwischenmenschlicher Dramen. Darüberhinaus ist Hirokane als Verfasser lebensanschaulicher Essays bekannt und tritt im Fernsehen sowie als Redner in Erscheinung.

Les œuvres créatives d'Hirokane sont étroitement liées aux aspects politiques et économiques de la société moderne. Il appartient à un mouvement d'auteurs de mangas de « société ». Son œuvre la plus connue est « Kachô Shima Kôsaku » [Le chef de service Kôsaku Shima], une histoire qui se déroule dans une entreprise de produits électroniques dans laquelle Hirokane a travaillé. Son succès est dû à l'employé dépeint dans l'histoire, qui reste inflexible face aux différentes pressions et qui représente le type de salarié idéal. Il est promu au poste de chef de service puis de directeur, et le titre de la série change avec les nouvelles promotions. La série est encore publiée à ce jour. Une autre de ses histoires se déroule dans le monde de la politique. Dans « Kaji Ryûsuke no gi », Hirokane dépeint un jeune politicien idéologique. L'auteur lui-même a de proches contacts avec des politiciens, et le fonctionnement qu'il décrit de la politique actuelle, ainsi que le développement de son scénario, lui ont valu les éloges de nombreux fans. Hirokane représente avec talent les interactions humaines dans ses histoires. Il a également écrit des essais sur la vie en général, a participé activement à des cercles de lecture et a été invité à plusieurs émissions de télévision.

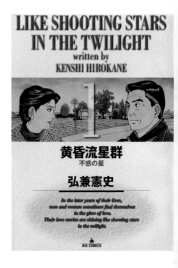

バカ！

プ、

いいさ、キミの体で払ってもらう。

採用する。

23

Tsukasa Hôjô's best-known work is "Cat's Eye," which is about three beautiful sisters who are mysterious thieves that steal works of art created by their artist father. The series incorporates all manner of elements, ranging from love, comedy, and action, to serious drama. The premise that the police inspector who is out to catch the thieves is actually the boyfriend of one of the girls may be stereotypical. However, although it starts out as a humorous element, it is eventually developed into an important role as the key that leads into a complicated dramatic situation. The realism of the drawings is similar in style to that of gekiga. In particular, the female characters are drawn very beautifully (both their faces as well as their bodies), which has done much to boost Hôjô's reputation. In 1996 his series "F. Compo" was published in a *seinen* manga magazine. A comedy drama, it told the story of a college student who comes to live in the home of a husband and wife whose bodies are reversed. Amid gales of laughter we are treated to a number of serious problems that the characters have to overcome. With its splendid story composition, this work is considered to be Hôjô's underrated gem. Hôjô is one of the rare manga artists who continues to produce the kind of works that has adults yearning for more.

TSUKASA HÔJÔ

Born

1959 in Fukuoka Prefecture, Japan

Debut

with "Ore wa otoko da!" [I Am a Man!] published in a special issue of *Weekly Shônen Jump* in 1980

Best known works

"Cat's Eye"
"City Hunter"
"Angel Heart"

Anime adaption

"Cat's Eye"
"City Hunter"

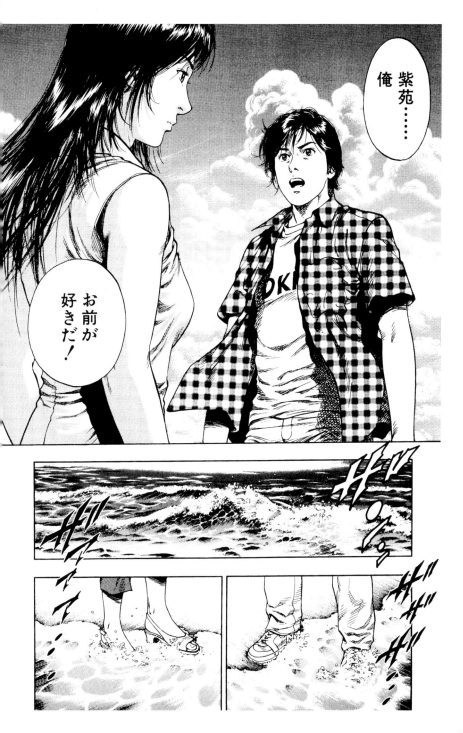

In seinem bekanntesten Werk „Cat's Eye" begeben sich drei schöne Schwestern auf Diebestour durch Museen und Galerien. Objekt ihrer Begierde sind die Gemälde des Vaters; der Manga ist eine Mischung aus Beziehungskomödie, Action und ernstem Drama. Die Idee, dass die Freundin des ermittelnden Polizisten in Wahrheit eine der geheimnisvollen Diebinnen ist, erscheint auf den ersten Blick banal, bietet jedoch viel komödiantisches Potential und übernimmt schließlich eine Schlüsselrolle in dem immer komplizierteren Drama. Die überzeugenden Zeichnungen erinnern mit ihrem realistischen Stil fast an *gekiga*. Einen besonderen Ruf für schöne Gesichter und Körper genießen hier die weiblichen Charaktere. In einem *seinen*-Magazin veröffentlichte Hôjô ab 1996 das witzige Drama „F. Compo" über einen jungen Studenten, der bei einem Ehepaar einzieht, wo der Mann aussieht wie eine Frau und die Frau wie ein Mann. Diese Serie gilt als Geheimtipp unter den Werken des Mangaka, hinter der Komik verbergen sich ernste Themen und die Handlung ist so spannend, dass man den Manga nur ungern aus der Hand legt. Tsukasa Hôjô bereitet dem erwachsenen Publikum immer wieder schöne Leseerlebnisse.

L'œuvre la plus connue de Tsukasa Hôjô est « Cat's Eye » [Œil de chat]. Il s'agit de l'histoire de trois sœurs qui sont de mystérieuses voleuses qui dérobent les œuvres d'art de leur père. La série intègre toute sorte d'éléments ; amour, comédie, action et mélodrame. Le fait qu'un inspecteur de police à la recherche des voleurs soit le petit ami d'une des filles peut paraître stéréotypé. Toutefois, bien que cet élément soit au départ de l'humour, il prend un rôle clé important qui mène à une situation compliquée. Le réalisme des dessins est similaire à celui des gekiga. En particulier, les personnages féminins sont extrêmement jolies (autant de visage que de corps), ce qui a propulsé la réputation de Hôjô. En 1996, la série « F. Compo » a été publiée dans un magazine de mangas seinen. Cette comédie raconte l'histoire d'un étudiant à l'université qui vit dans la maison d'un couple, dont les corps du mari et de sa femme sont inversés. Parmi les éclats de rire, nous assistons à des problèmes sérieux que les personnages doivent surmonter. La composition de cette histoire est sublime, et de nombreux fans la considèrent comme étant une perle sous-estimée. Hôjô est l'un des rares auteurs de bandes dessinées plébiscités par les adultes.

ぐ……ふ……
まさか そんな
手が……

ききさま
おれよりも…

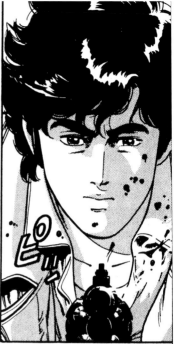

ズ
ズ

ピ
ク

ま…窓が…
われてない…

弾の威力が
強すぎれば
適当な物を貫通して
弱めればいい

カタッ
カタッ

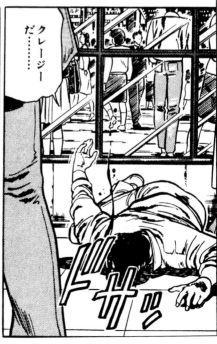

クレージー
だ……

ドサッ

Illustrator and writer Yoriko Hoshi started her career as a web-comic artist, with her masterpiece "Kyô no Nekomura-san," a story of a cat, which instantly became a bestseller, and was soon made into print. Nekomura, the main character, became the most famous housekeeper in the country. Hoshi was born in the Kansai region, where she still lives and works. Since attending art college, she has kept working on a variety of titles, and was awarded the 19th Tezuka Osamu Cultural Prize's Grand Prix in 2015 for her latest work "Aizawa Riku." The story, which broke new ground in her narrative, tells the story of Riku, a middle-school student girl who can turn on fake tears. The two-volume book employs uncommon sensitivity with very simple drawing, following in the steps of her early success with the "Nekomura" series, "Boku to Pork," (launched in 2007, retains Hoshi's trademark of simple lines and pastel colors to depict the life of a boy and his pork pet. After great demand, "Nekomura" has also made it into a TV series.

YORIKO HOSHI

Born
 1974 in Japan

Debut
 in 2003 with "Kyô no Nekomura-san" published in *@NetHome* (web)

Best known works
 "Kyô no Nekomura-san"
 "Aizawa Riku"

Prizes
 19th Tezuka Osamu Cultural Prize's Grand Prix (2015)

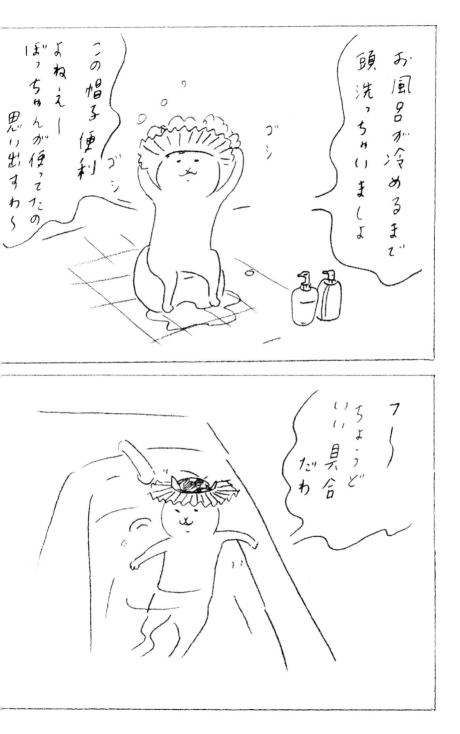

Die Zeichnerin und Texterin Yoriko Hoshi begann ihre Karriere mit dem Zeichnen von Web-Comics. Ihr Meisterwerk *Kyô no Nekomura-san*, die Geschichte einer Katze, erreichte auf der Stelle Bestsellerstatus und erschien bald darauf auch in gedruckter Form. Die Hauptfigur des Mangas, die Katze Nekomura, wurde zur berühmtesten Haushälterin des Landes. Hoshi stammt aus der Region Kansai, wo sie noch immer lebt und arbeitet. Seit dem Besuch der Kunsthochschule hat sie an unterschiedlichen Titeln gearbeitet, für ihr jüngstes Werk *Aizawa Riku* erhielt sie schließlich 2015 den 19. Osamu-Tezuka-Kulturpreis. Die Geschichte, bei der sie einen neuen Erzählstil anwandte, handelt von der Schülerin Riku, die spontan in Tränen ausbrechen kann. Das zweibändige Werk zeigt in sehr einfachen Zeichnungen großes Einfühlungsvermögen, ähnlich wie schon bei der erfolgreichen „Nekomura"-Reihe. Auch bei dem 2007 erschienenen Werk „Boku to Pork" behält Hoshi die für sie so charakteristischen einfachen Striche und Pastellfarben bei, um das Leben eines Jungen und seines Schweins, das er als Haustier hält, zu schildern. Aufgrund der großen Nachfrage wurde „Nekomura" inzwischen auch als Fernsehserie adaptiert.

Illustratrice et écrivain, Yoriko Hoshi a débuté sa carrière de dessinatrice de pages Web et de bandes dessinées avec son chef-d'œuvre « Kyô no Nekomura-san » devenu instantanément un best-seller. Le personnage principal de cette histoire est un chat, Nekomura, qui devient l'aide ménagère la plus célèbre du pays. Hoshi est née dans la région de Kansai où elle vit et travaille. Depuis ses études artistiques, elle a travaillé pour une variété de titres et a été récompensée en 2015 du 19e grand prix culturel Tezuka Osamu pour son ouvrage *Aizawa Riku*. Cette histoire, qui a marqué un tournant dans son œuvre, est celle de la collégienne Riku dotée de la capacité de pleurer de fausses larmes. Ce livre en deux volumes dégage une sensibilité inhabituelle et se compose de dessins très simples. Sur les traces de son premier succès avec la série « Nekomura », « Boku to Pork », sorti en 2007, conserve la marque de fabrique de Hoshi : des lignes épurées et des couleurs pastel pour illustrer la vie d'un garçon et de son cochon. Pour répondre à l'énorme demande, « Nekomura » a été adapté en téléfilm.

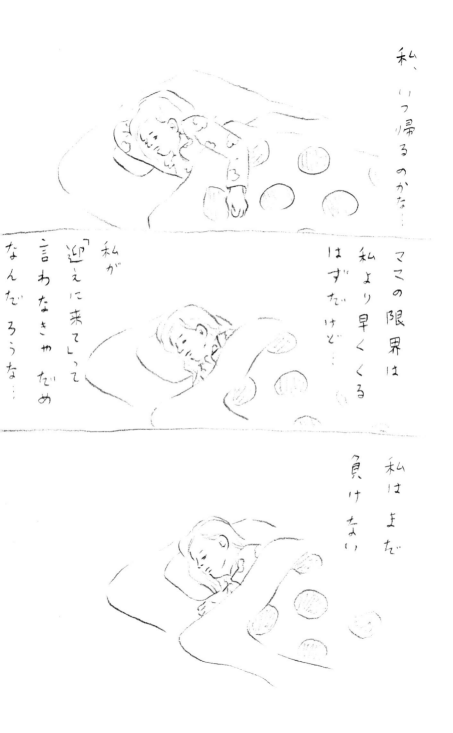

私、いつ帰るのかな…

ママの限界は
私より早くくる
はずだけど…

私が
「迎えに来て」って
言わなきゃだめ
なんだろうな…

私はまだ
負けない

The comic series "Yûkan kurabu" [The Leisure Club] tells the story of a bunch of students who attend a prestigious private high school, where they form a student organization. It is considered one of the most famous Japanese comics for young girls. The story portrays six rich high school students who have a lot of time and money on their hands. Amid this seemingly normal, family-oriented environment, the six students discover a number of government conspiracies and criminal mysteries, which ultimately they must solve. The comic characters utilize beauty, intelligence, skill, and action to tackle all of the cases that come their way. With its over-the-top action and plot development reminiscent of a spy movie, there is enough entertainment value to appeal to both male and female fans. In addition, Yukari Ichijô has also produced numerous popular comics focusing on love and romance. Beginning with "Suna no shiro" [The Sand Castle] and "Designer," and extending to her newest story "Pride," she has dealt with such themes as love, break up, getting back together, the love-hate relationship between parents and children, incestuous relationships, and the conflicts between women. With dramatic turns of events, she gives the audience no time to catch their breath. She is a skilled comic artist who never fails to captivate the reader. In terms of sales and ability, she is one of the leading *shoujo* manga [Girls Comic] writers working in Japan today.

YUKARI ICHIJÔ

Born
 1949 in Okayama, Japan

Debut
 with the book "Ame no ko Non-chan"
 by Wakagi Publications in 1966

Best known works
 "Designer"
 "Suna no shiro" [The Sand Castle]
 "Yûkan kurabu" [The Leisure Club]

Prizes
 • 10th Kôdansha Manga Award
 (1986)

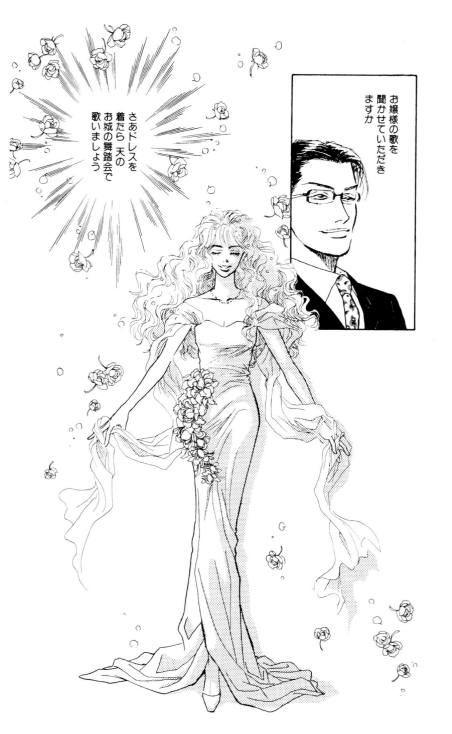

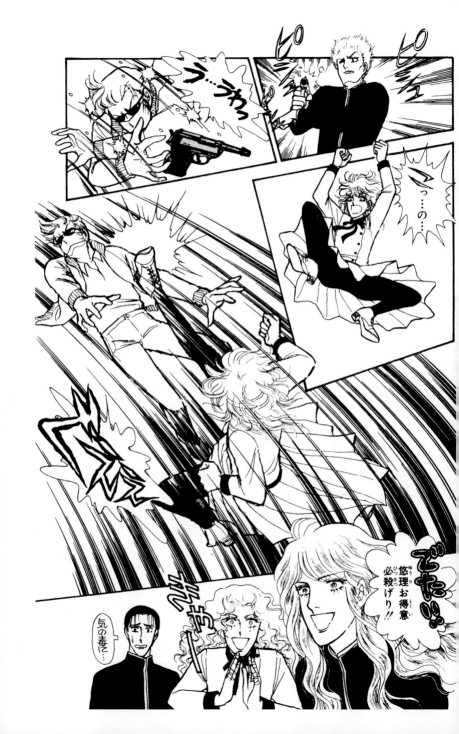

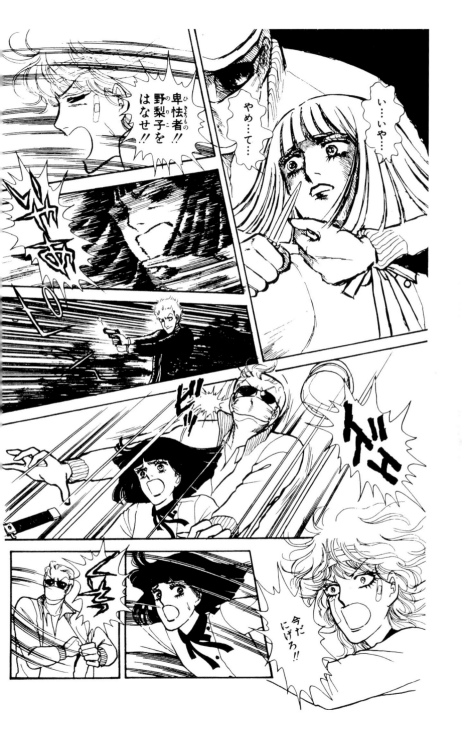

„Yûkan kurabu", mit einer Schülergruppe an einer elitären Privatschule im Mittelpunkt, ist einer der bekanntesten *shôjo*-Mangas in Japan. Die sechs Hauptfiguren, die nicht wissen wohin mit Geld und Freizeit, werden durch ihr familiäres Umfeld in politische Intrigen und Kriminalfälle verwickelt, die sie dank Schönheit, Talent, Technik und Power mit Bravour lösen. Mit dieser an Agentenfilme erinnernden Machart und rasanter Action bietet der Manga dem weiblichen und dem männlichen Lesepublikum gleichermaßen Unterhaltung pur. Daneben hat Ichijô auch eine Reihe berühmt gewordener Romanzen über Liebesbeziehungen zwischen Frauen und Männern gezeichnet. Mangas wie „Suna no shiro" und „Designer" aus der Anfangszeit der Mangaka sowie ihr neuestes Werk „Pride" sind an Dramatik kaum zu überbieten: weit ausgreifende Geschichten über Abschied und Wiedersehen zwischen Liebenden, Zuneigung und Hass innerhalb von Familien, Rivalität unter Frauen und sogar Inzest strapazieren zwar manchmal die Vorstellungskraft ihrer Leserinnen, üben aber eine unglaubliche Faszination aus. Yukari Ichijô gelingt es auf unnachahmliche Art ihr Lesepublikum völlig in Bann zu schlagen, es förmlich in den Sog ihrer Geschichte hineinzuziehen und so gilt sie – sowohl was ihr Talent als auch was ihre Verkaufszahlen angeht – als eine Ikone des japanischen *shôjo*-Manga.

La série « Yûkan kurabu » [Le club de loisirs] raconte l'histoire d'un groupe d'étudiantes dans un lycée privé prestigieux, où elles forment une association étudiante. Elle est considéré comme étant l'un des plus fameux mangas shoujo japonais. L'histoire dépeint six lycéennes riches qui ont beaucoup de temps et d'argent entre leurs mains. Dans ce qui semble être un environnement familial normal, les six jeunes filles découvrent un certain nombre de conspirations et de crimes gouvernementaux qu'elles doivent résoudre. Les personnages utilisent leur attrait physique, leur habileté et une dose d'action pour déchiffrer les énigmes qu'elles rencontrent. L'action, le développement du scénario qui rappelle les films d'espionnage et le divertissement procuré sont si prenants que la série a attiré une audience masculine et féminine. Ichijô a également produit de nombreux mangas sur le thème de l'amour et de la romance. Débutant par « Suna no shiro » [Le château de sable] et « Designer », et se poursuivant avec l'actuel « Pride », elle s'attaque à des thèmes aussi variés que l'amour en général, les rencontres et les séparations, l'amour et la haine entre les parents et les enfants, les relations incestueuses et les conflits entre femmes. Avec ses retournements dramatiques de situation, elle ne laisse pas le temps à son audience de reprendre son souffle. C'est une auteure habile qui ne cesse de captiver ses lecteurs. En termes de ventes et de talent, elle est actuellement l'un des auteurs de mangas shoujo japonais les plus couronnés de succès.

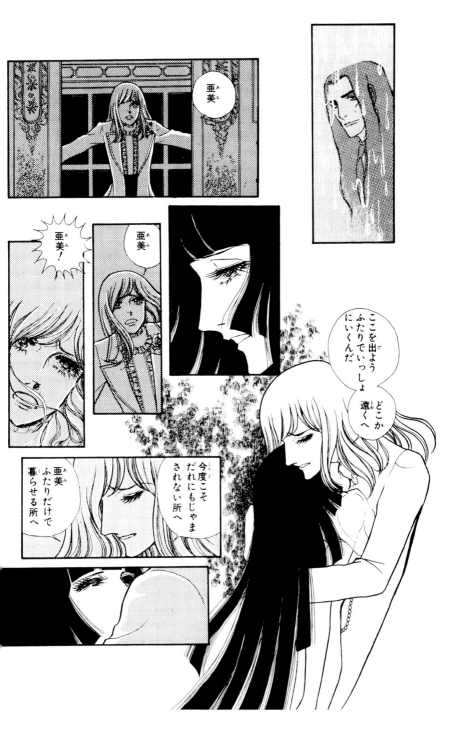

Haruko Ichikawa has found her own unique scope in manga, with surreal dramas that incorporate surprising precepts and unpredictable endings. "The Hinoshita Siblings" is a moving story about a high-school baseball player and his injured shoulder. Using a classic drama of many Japanese players that are never spared and need to perform regardless of the pain they feel, Ichikawa built a story around the suffering. The variety of approaches to surprising narratives has rewarded Haruko Ichikawa with the Shikitaishou Prize as well as the Osamu Tezuka Artist Prize.

The majority of her stories involve metamorphoses in one way or another. In "Hoshi no koibito," a young girl, Tsutsuji, developed into a human being from her brother Satsuki's fingertip, who had it cut off by accident when he was only four. And of course the mystery continues as the older brother turns to be a bioengineer who specializes in designing insects that can camouflage themselves as humans beings. Despite the weirdness of Ichikawa's narratives, she has been able to build characters that readers empathize with, having created a solid following over the years.

HARUKO ICHIKAWA

Born

1980 in Chiba Prefecture, Japan

Debut

in 2006 with "Mushi to uta"

Best known works

"Mushi to uta"
"Hōseki no kuni"

Prizes

- Afternoon Four Seasons (Shiki) Award Summer (2006)
- 14th Tezuka Osamu Cultural Prize: New Artist Prize (2010)

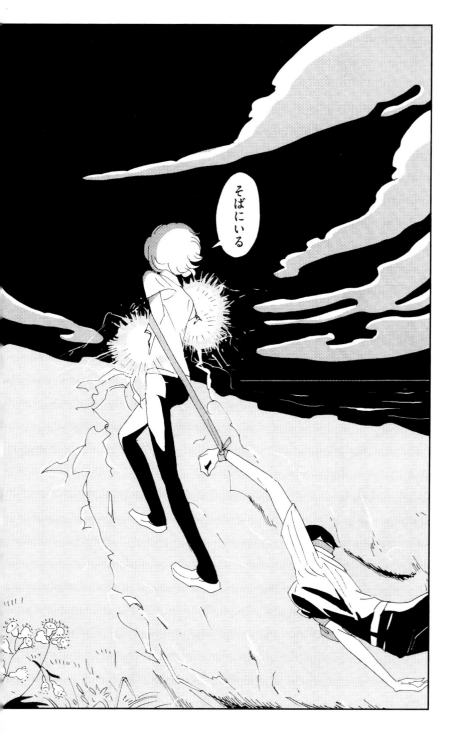

Haruko Ichikawa hat mit surrealen Dramen, die voller überraschender Ideen stecken und stets unvorhersehbar enden, ihre eigene Nische im Manga-Bereich gefunden. „The Hinoshita Siblings" ist die bewegende Geschichte eines Baseball-spielers, der Mitglied einer Schulmannschaft ist und sich eine Schulterverletzung zuzieht. Inspiriert von dem klassischen Drama vieler japanischer Sportler, die trotz Schmerzen die geforderte Leistung bringen müssen, entwickelt Ichikawa ihre Erzählung rund um das Leid des Baseballspielers. Für die Vielseitigkeit ihrer ungewöhnlichen Geschichten wurde sie sowohl mit dem Shikitaishou-Preis als auch mit dem Osamu-Tezuka-Kulturpreis belohnt. In den meisten ihrer Mangas geht es auf die eine oder andere Weise um Metamorphosen. In „Hoshi no koibito" etwa entwickelt sich das Mädchen Tsutsuji aus der Fingerspitze ihres älteren Bruders Satsuki, die dieser als Vierjähriger bei einem Unfall verlor, zu einem Menschen. Die Erzählung bleibt auch später mysteriös, als Satsuki Bioingenieur wird und hauptsächlich Insekten erschafft, die sich als Menschen tarnen können. Trotz dieser selt-samen Handlungen gelingt es Ichikawa, Figuren zu erfinden, in die sich die Leser hineinversetzen können, was ihr im Laufe der Jahre eine solide Gefolgschaft gesichert hat.

Haruko Ichikawa s'est forgé une approche parti-culière du manga, avec des drames surréalistes remplis de préceptes surprenants et de dénoue-ments imprévisibles. « The Hinoshita Siblings » est l'histoire touchante d'un joueur de baseball blessé à l'épaule. S'inspirant du drame habi-tuel de nombreux sportifs japonais poussés à la limite et devant jouer en dépit de leur douleur, Ichikawa a construit une histoire autour de la souffrance. Ses récits étonnants aux approches variées ont valu à Haruko Ichikawa le prix Shiki-taishou et le prix artistique Osamu Tezuka. Ses histoires impliquent le plus souvent des méta-morphoses. Dans « Hoshi no koibito », la jeune Tsutsuji pousse au bout du doigt coupé par acci-dent de son frère Satsuki quand il avait quatre ans. Le mystère se poursuit quand le frère devient un bioingénieur spécialisé dans la conception d'insectes capables de se camoufler sous forme d'êtres humains. Même si ses intrigues sont très étranges, Haruko a su construire des person-nages avec qui les lecteurs sympathisent et auxquels ils restent fidèles au fil des années.

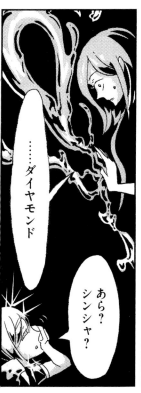

……ダイヤモンド

あら？
シンシャ？

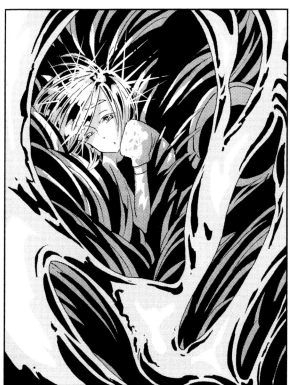

フォスがいない！

まぎらわしい！

眩しいんだ
おまえは〜

ごめんなさい
あなたの
仕事
邪魔する
つもりは……

さっさと
戻れ！

あっ

うん

なぜ
いる！

あっ

暗くて
寝ちゃったんだわ…

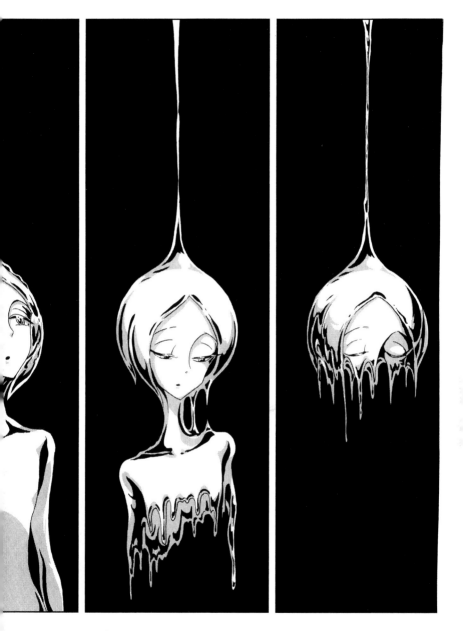

The epic story "The Rose of Versailles" follows the life of Oscar who is a beautiful woman dressed as a man, and her servant Andre. This masterpiece is both a love story and a historical manga that is set against the backdrop of the French Revolution. The series began in 1972 and soon became the phenomenon known as "Berubara [the Japanese nickname for the series] Boom." In 1974, the famous all-women theatrical troupe Takarazuka produced a musical based on the series. This musical became an extraordinary hit and continues to pull in the crowds to this day. Besides this sensational series, Riyoko Ikeda created such hits as "The Window of Orpheus,"

"Empress Katerina" and "The Glory of Napoleon – Eroika," among others. Her dramatic stories usually take place during revolutionary upheavals and are often based on historical fact. A surprising change in her career came in 1995 when she was accepted into the Tokyo College of Music with a specialization in vocal music, and from then on Ikeda devoted herself to music. She is currently involved in producing vocal lessons, concerts, and seminars, and has no plans for future comic editions. But she continues to entertain a new generation of fans by re-releasing her past stories and writing essays related to her previous work.

RIYOKO IKEDA

Born

1947 in Ôsaka, Japan

Debut

with "Barayashiki no shôjo" [The Girl from Rose Mansion] published in a special issue of *Weekly Shôjo Friend* in 1967

Best known works

"Oniisama e..." [Dear Brother]
"Orefuesu no mado" [The Window of Orpheus]
"Berusaiyu no bara" [The Rose of Versailles]

TV/Anime adaptation

"Berusaiyu no bara" [The Rose of Versailles]

Prizes

- The Dark Blue Ribbon Medal (1976)
- The Japan Cartoonists Association Excellence Award (1980)

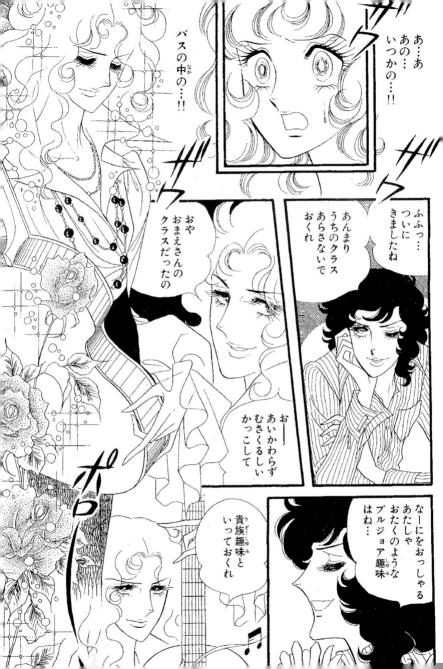

„Die Rosen von Versailles", ein Meilenstein als Historien-Manga und als Liebesgeschichte, erzählt die Vorgeschichte der französischen Revolution, insbesondere das Leben von Oscar, einer wunderschönen Frau in Männerkleidern, und ihres Kammerdieners André. Die ab 1972 veröffentlichte Serie löste einen phänomenalen *berubara*-Boom aus – *berubara* ist die eingängige Abkürzung des japanischen Titels, wobei *beru* für *berusaiyu* [Versailles] steht und *bara* Rose bedeutet. 1974 nahm sich die rein weibliche Revuetruppe Takarazuka des Mangas an und ihre Musical-Umsetzung wurde ebenfalls zu einer einzigartigen Erfolgsstory: *Berubara* ist bis heute fester Bestandteil ihres Repertoires und wurde in verschiedenen Versionen unzählige Male aufgeführt. Auch in ihren anderen Werken, wie „The Window of Orpheus", „Empress Katharina" und „Heroica", beschäftigte sich die Mangaka häufig mit den historischen Themen Umbruch und Revolution. 1995 schlug Ikeda nach bestandener Aufnahmeprüfung für die Gesangsabteilung der musikalischen Hochschule Tokio eine musikalische Karriere ein. Statt Mangas zu zeichnen, widmet sie sich heute einer Gesangsschule, gibt Konzerte und hält Vorträge. Von ihren alten Arbeiten aber gibt es immer wieder neue Veröffentlichungen in anderer Ausstattung sowie neue Sekundärliteratur, weshalb ihre Fangemeinde nun schon mehrere Generationen umfasst.

L'histoire épique « Berusaiyu no Bara » [La rose de Versailles] dépeint la vie d'Oscar, une très belle femme habillée en homme, et de son serviteur André. Cette œuvre est autant une histoire d'amour qu'un manga historique qui se déroule durant la période de la Révolution française. La série a débuté en 1972 et est rapidement devenue un phénomène appelé « Berubara Boom » (d'après son surnom japonais). En 1974, la fameuse troupe de théâtre féminine Takarazuka a produit une comédie musicale basée sur la série. Elle est devenue un succès phénoménal et continue aujourd'hui d'attirer les foules. En dehors de cette série, Ikeda a créé des séries telles que « La fenêtre d'Orphée », « L'Impératrice Catherine » et « La gloire de Napoléon – Eroica ». Ses histoires se déroulent habituellement durant des périodes d'instabilité révolutionnaire et sont souvent basées sur des faits historiques. Un changement inattendu dans sa carrière a eu lieu en 1995. Ikeda a été accepté à l'université musicale de Tokyo avec une spécialisation en chant, et depuis lors elle se dévoue à la musique. Elle produit actuellement des cours de chant, des concerts et des séminaires, et ne prévoit pas d'éditer de nouvelles bandes dessinées. Elle continue toutefois de divertir une nouvelle génération de fans en rééditant ses mangas et en écrivant des essais liés à ses travaux précédents.

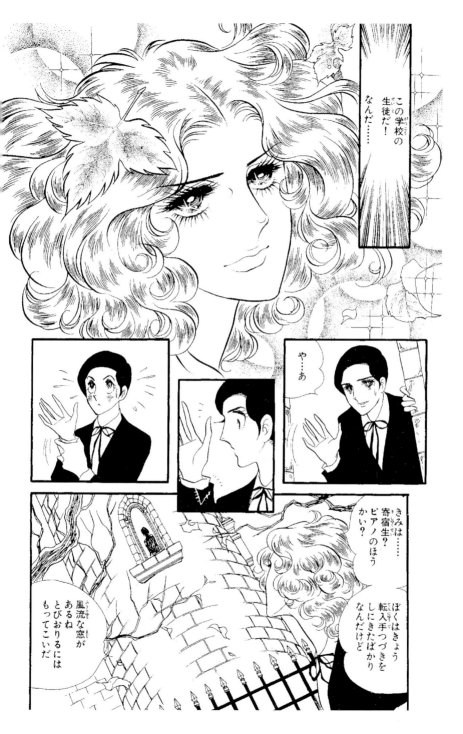

Santa Inoue's stories are set in a part of the city where young people get together, and in this setting he explores a wide range of dramatic situations. As a manga artist, he explores these themes and the street culture involved in a most thought-provoking manner, and his fan base includes a variety of people from all walks of life. His most popular work is "Tokyo Tribe 2," which depicts young men who form groups that are called tribes. Some tribes operate similarly to gangs, where others are simply a group of men who are bonded together in friendship. Inoue interweaves the descriptions of their everyday life and socialization with gang rivalry, extreme violence, and strong friendships. The comic also takes the reader into the characters' fashions and music, the so-called "street style." Because the series is being published in a fashion magazine, he gained the strong support of its young readers. Specialty shops have recently sprung up selling the featured clothes, along with character figurines, and the future possibilities for his manga seem to be limitless. Yet his popularity does not come from the fact that he was the first to explore the latest youth culture, but from the sheer power and energy of his works. His manga are not part of a small, specialized genre geared toward a particular target audience. Instead, there is a sense that they are part of the general publication. Another manga that is set in this same fictional world is published in a *seinen* magazine with the largest distribution in Japan. This is evidence that he is one of the major manga artists representing the theme of modern day Tokyo.

SANTA INOUE

Born

1968 in Paris, France

Debut

with "Mada" which was published in *Young Sunday* magazine in 1989

Best known works

"Bunpuku Chagama daimaõ"
"Rinjin 13 Gou"
"Tokyo Tribe 2"
"Born to Die"
"Tokyo Graffiti"

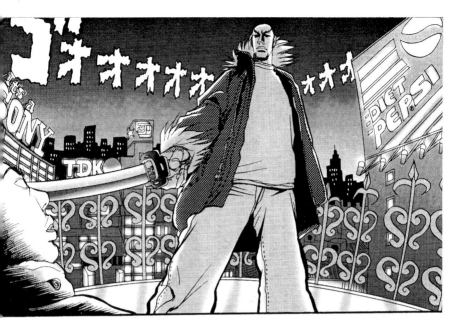

……この街にいた時
オレも純だった

世の中には100％真っ白なモノがあると信じていた…

つかえない やつらだ。

どこかに 同志が いるはずだ。

Santa Inoues Thema sind Jugendcliquen und ihr Territorium, die Straße. Nicht nur Manga-Fans schätzen seine Bildergeschichten als die aufregendsten, unmittelbarsten Dokumentationen der Straßenkultur. In seinem Hauptwerk „Tokyo Tribe 2" zeichnet er das Leben von Jugendlichen in *tribes* – die Bandbreite reicht hier von Freundschaftscliquen bis zu kriminellen Banden –, das geprägt ist von Auseinandersetzungen und einer Mischung aus extremer Gewalt und bedingungsloser Freundschaft. Die Elemente Musik, Klamotten und Streetstyle sowie die Tatsache, dass der Manga in einem hippen Fashion-Magazin veröffentlicht wurde, sorgten für Begeisterung bei allen Jugendlichen. Unlängst wurde sogar ein Laden eröffnet, der Kleidung und Figuren aus seinen Mangas vertreibt; eine Entwicklung, die dem Genre völlig neue Merchandising-Perspektiven eröffnet. Inoues Popularität ist jedoch nicht nur auf sein Gespür für japanische Jugendkultur zurückzuführen, sondern vor allem auf die Power und Vitalität seiner Bilder. Nicht nur im Rahmen einer bestimmten Zielgruppe, sondern im Manga allgemein zählt er zu den ganz Großen. Seine Mangas werden in den auflagestärksten *seinen*-Magazinen abgedruckt und er gilt als der spannendste Chronist des heutigen Tokio.

Les histoires d'Inoue se déroulent dans un quartier de la ville où de jeunes gens se rassemblent. Il explore une grande variété de situations dramatiques dans ce cadre. En tant que mangaka, il explore ces thèmes et la culture urbaine associée d'une manière qui pousse à la réflexion, et on trouve des gens de tous les milieux parmi ses fans. Son œuvre la plus populaire s'intitule « Tokyo Tribe 2 », qui dépeint de jeunes hommes qui forment des groupes appelés « tribus ». Certaines tribus fonctionnent comme des gangs, tandis que d'autres sont simplement des groupes d'hommes liés par une certaine amitié. Inoue mêle les descriptions de leur vie sociale quotidienne avec des rivalités entre gangs, de la violence extrême et une forte amitié. Le manga emporte également les lecteurs dans le monde de la mode et de la musique des personnages, un style appelé « street style ». La publication de la série dans un magazine de mode a valu à l'auteur de connaître un grand succès auprès des jeunes lecteurs. Des magasins se sont même mis à vendre les vêtements présentés dans ses mangas, avec des figurines des personnages. Les possibilités futures de ses mangas semblent être infinies. Toutefois, sa popularité ne provient pas du fait qu'il a été le premier à explorer les dernières tendances à la mode mais plutôt de l'énergie et de la puissance de ses œuvres. Ses mangas ne font pas partie d'un petit genre spécialisé destiné à une audience particulière, mais on sent qu'ils font plutôt partie d'un vaste ensemble. Un autre manga qui se déroule dans le même monde imaginaire est publié dans un magazine de mangas seinen qui est le plus distribué au Japon. C'est bien la preuve qu'il est l'un des auteurs de mangas majeurs qui utilisent les thèmes du Tokyo d'aujourd'hui.

Takehiko Inoue's most famous work is "Slam Dunk," an influential comic series that started the basketball boom in Japan during the mid-1990s. The main character of the story, Hanamichi Sakuragi, is a player in the Shohoku High School basketball team. The series broke all previous comic book first edition sales records, and was even made into a hit TV series. The comic artist himself was a basketball player in his student days and is considered a "basketball freak." He has a deep understanding and love of the game, which is highly apparent in his manga. They are unparalleled in terms of presence and strength. Not only does he develop the story in an interesting manner and introduce likeable characters,

he is also able to effectively portray the fundamental fascination with the sport of basketball. After the conclusion of the "Slam Dunk" series, which was published in a *shounen* manga [Boys Comic] magazine, Inoue took a few years off. He later started on a series called "Vagabond" that was published in a *seinen* manga [Young Mens Comic] magazine. It depicts the life of the famed samurai swordsman Musashi Miyamoto. Fans were surprised. This is the tale of a master swordsman who is on a quest to become "strong." The images in this story are filled with a kind of strength and stoic quality. This comic series played a major role in the recent "Mushashi Miyamoto" boom.

TAKEHIKO INOUE

Born
1967 in Kagoshima Prefecture, Japan

Debut
with the publication of "Kaede Purple" in *Weekly Shônen Jump* magazine in 1988

Best known works
"Slam Dunk"
"Vagabond" (story by Eiji Yoshikawa)
"Real"

TV/Anime adaptation
"Slam Dunk"

Prizes
- 40th Shôgakukan Manga Award (1995)
- 4th Agency for Cultural Affairs Media Arts Festival Grand Prize in the Manga Division (2000)
- 6th Osamu Tezuka Cultural Prize Manga Grand Prix Award (2002)

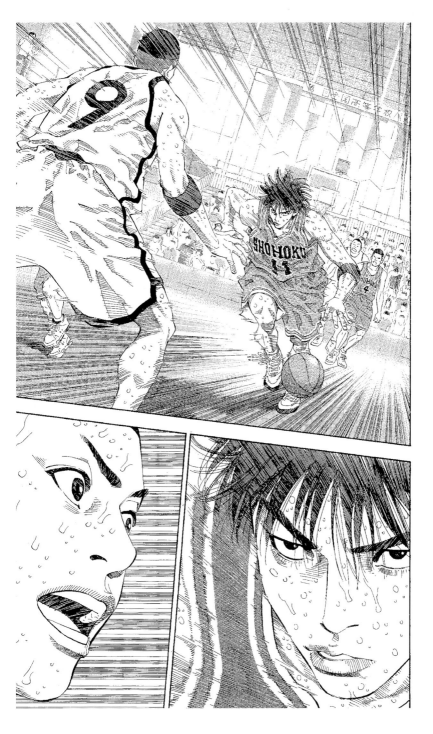

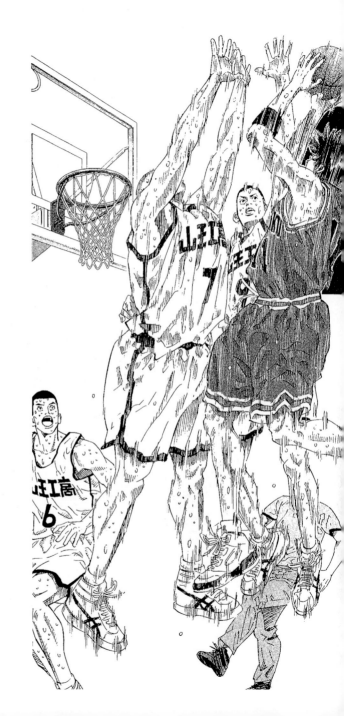

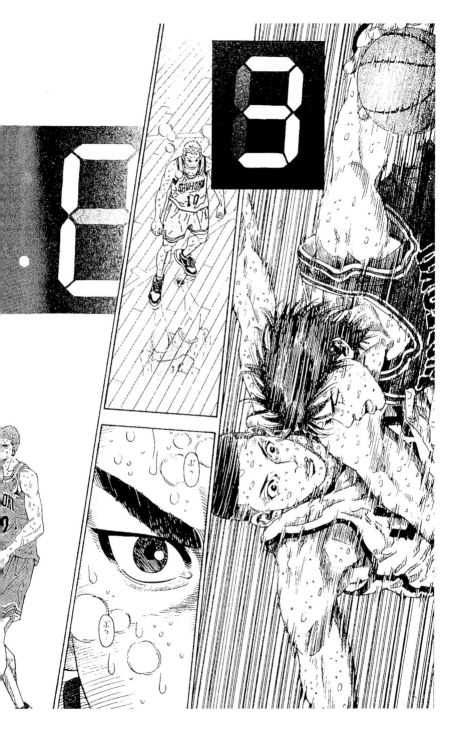

Berühmt wurde Inoue mit „Slam Dunk", einem bahnbrechenden Werk, das in Japan einen ungeheuren Basketball-Boom auslöste. Es geht um die ziemlich individuellen Mitglieder des Basketball-Clubs der Shôhoku-Oberschule, allen voran um die Hauptfigur Hanamichi Sakuragi. Der Manga wurde zu einem sensationellen Erfolg, als TV-Anime adaptiert und der Sammelband stellte einen neuen Rekord für die höchste Erstauflage auf. Der Autor spielte während seiner Oberschulzeit selbst Basketball und ist begeisterter Anhänger dieser Sportart. Seine Zeichnungen demonstrieren die Liebe und die Sachkenntnis, die er dem Wettkampf entgegenbringt, die so entstandenen Werke sind in ihrer Unmittelbarkeit einzigartig. Spannende Handlung und reizvolle Charaktere sind ein Teil der Attraktion, das Einzigartige an „Slam Dunk" besteht aber darin, dass der Autor die Faszination am Wettkampfsport Basketball zeichnerisch beschreiben kann. Nachdem er die letzte Folge dieser Serie in einem *shônen*-Magazin veröffentlicht hatte, zog er sich einige Jahre zurück, um danach – diesmal in einem *seinen*-Magazin – mit „Vagabond" eine epische Geschichte über den historischen Schwertkämpfer Musashi Miyamoto zu veröffentlichen. Seine Fangemeinde war sprachlos. Er zeichnete den großen Schwertkämpfer in kraftvollen, ruhigen Bildern auf seinem Weg „stark zu werden" und lieferte so den Auftakt für einen Musashi-Boom.

L'œuvre la plus célèbre de Takehiko Inoue est « SLAM DUNK », une série influente qui a débuté avec le boom du basket-ball au Japon vers le milieu des années 1990. Le personnage principal de l'histoire, Hanamichi Sakuragi, est un joueur de l'équipe de basket du lycée Shohoku. La série a dépassé tous les records précédents de vente d'une première édition, et a même donné lieu à une série pour la télévision. L'auteur du manga était lui-même joueur de basket pendant ses années étudiantes et il est considéré comme étant un mordu du basket. Il comprend parfaitement ce sport et l'apprécie énormément, ce qui se ressent au travers de son manga. Ses images débordent de présence et de force. Il développe non seulement ses histoires de manière intéressante et présente des personnages appréciés, il est également capable de nous montrer sa fascination fondamentale pour le basket-ball. Après avoir terminé « Slam Dunk », publié dans un magazine de mangas shounen (pour jeunes garçons), Inoue s'est arrêté pendant quelques années. Il a ensuite débuté une série intitulée « Vagabond », publiée dans un magazine de mangas seinen (pour jeunes hommes). Il dépeint la vie du fameux samouraï Musashi Miyamoto. Les fans ont été surpris. Il s'agit de l'histoire du maître et de sa quête pour devenir « fort ». Les images de cette histoire ont une certaine qualité de force et de stoïcisme. La série a joué un rôle majeur dans le phénomène récent « Mushashi Miyamoto ».

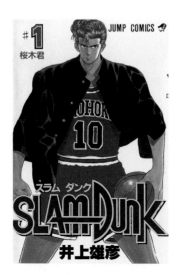

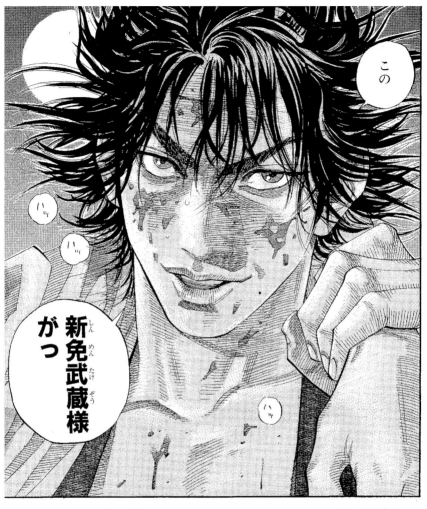

Hajime Isayama showed his natural talent to create serialized publications with his debut "Attack on Titan," for which he received the 35th Kôdansha Manga Award in 2011 and the nomination for both the 4th annual Manga Taishô Awards and the 16th Osamu Tezuka Cultural Prize. The series also generated four spin-off titles, two novel series, a television anime adaptation, several graphic novels, a video game, and a two-part live-action film. Born in Ôyama, Isayama started submitting work to manga competitions when still attending the Hita Rinko Senior High School. He went on to graduate from Kyūshū Designer College where he attended classes in the manga design program at their arts department. After moving to Tokyo at the age of 20 and making incursions into a number of publishers, he signed a deal with Kôdansha to have his work published in the famous weekly *Shûkan Shônen* magazine. "Attack on Titan" continues to be published in the monthly *Bessatsu Shônen* magazine and still enjoys great popularity. After an exhibition in 2013 and a series of lectures in 2014, the artist has been named the Tourism Ambassador of his hometown region of Hita by the city's mayor Keisuke Harada.

HAJIME ISAYAMA

Born
> 1986 in Ôita Prefecture, Japan

Debut
> in 2006 with "Attack on Titan"
> honorable mention in *Kôdansha*
> Magazine Grand Prix

Best known works
> "Attack on Titan"

Feature animation
> "Attack on Titan"

Prizes
> • 14th Japan Media Arts Festival:
> Jury Selections in Manga Division
> (2010)
> • 35th Kôdansha Manga Award:
> Boy's Comic Division (2011)

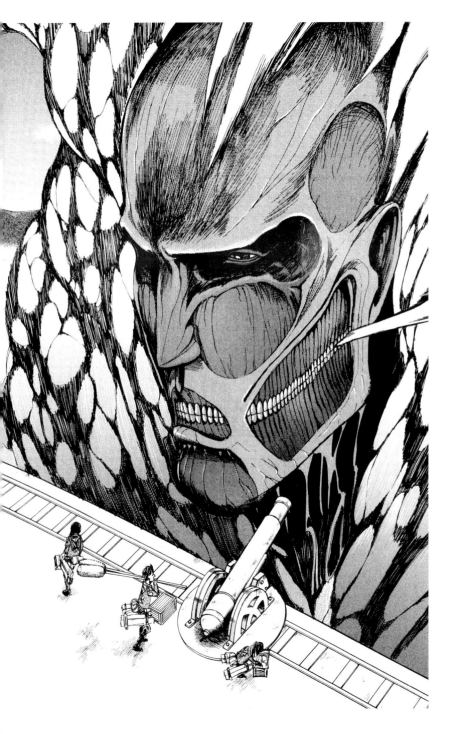

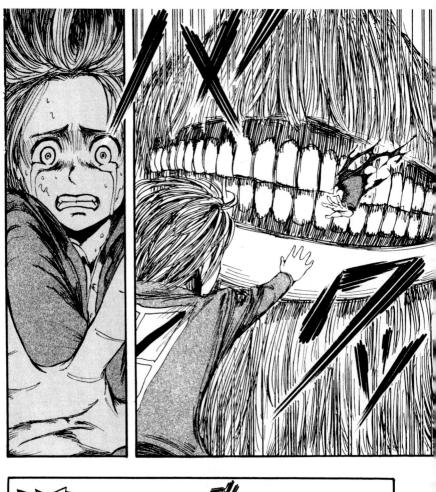

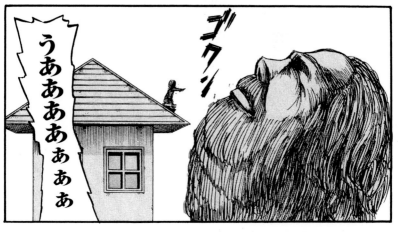

ゴクン

うあああああああ

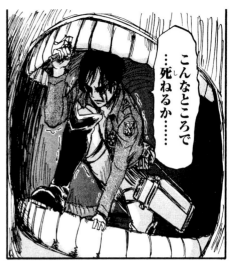

こんなところで…死ねるか……

なぁ…アルミン…

お前が……

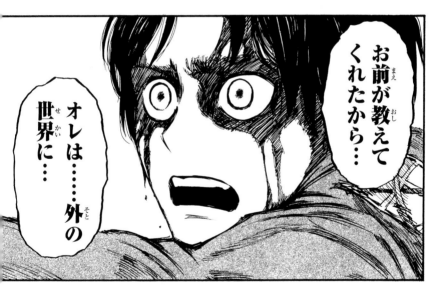

お前が教えてくれたから…

オレは……外の世界に…

エレン!!

早く!!

Hajime Isayama stellte sein Talent für Fortsetzungsgeschichten gleich mit seinem Debüt „Shingeki no Kyojin" [Attack on Titan] unter Beweis, für das er 2011 den 35. Kôdansha-Manga-Preis erhielt und zudem für den 4. jährlichen Manga Taishô sowie für den 16. Osamu-Tezuka-Kulturpreis nominiert wurde. Die Reihe hat inzwischen vier Ablegerserien, zwei Romanreihen, eine Anime-Serie für das Fernsehen, mehrere Comicromane, ein Videospiel und einen zweiteiligen Realfilm hervorgebracht. Der in Ōyama geborene Isayama begann bereits gegen Ende seiner Schulzeit an der Hita Rinko Senior High School Mangas bei Wettbewerben einzureichen. Anschließend studierte er Manga-Design im Fachbereich Kunst der Design-Hochschule von Kyūshū, die er erfolgreich abschloss. Nachdem Isayama im Alter von 20 Jahren nach Tokio gezogen war und seine Arbeit mehreren Verlagen angeboten hatte, nahm ihn Kôdansha unter Vertrag, um seine Werke in der bekannten Wochenzeitschrift *Shûkan Shônen* zu veröffentlichen. „Shingeki no kyôjin" wird bis heute in der Monatszeitschrift *Bessatsu Shônen* publiziert und erfreut sich ungebrochener Beliebtheit. Nach einer Ausstellung 2013 und einer Vortragsreihe 2014 wurde der Künstler vom Bürgermeister der Stadt Hita zum Fremdenverkehrsbotschafter ernannt.

Hajime Isayama a démontré son talent naturel pour des publications en série avec son premier titre « Shingeki no Kyojin » [L'attaque des titans], qui lui a valu le 35e prix du manga Kôdansha en 2011, ainsi qu'une nomination pour le 4e grand prix annuel Manga Taishô et le 16e prix culturel Osamu Tezuka. La série a été suivie de quatre titres dérivés, de deux recueils de nouvelles, d'une série télévisée d'animation, de plusieurs romans graphiques, d'un jeu vidéo et d'un film d'action en deux parties. Né à Ōyama, Isayama a commencé à envoyer son travail aux concours de mangas quand il était encore étudiant au lycée Hita Rinko Senior High School. Il s'est ensuite diplômé au Kyūshū Designer College où il a pris des cours de design de mangas. À 20 ans, il s'est installé à Tokyo et a été retenu par plusieurs éditeurs ; il a signé un contrat avec Kôdansha pour la publication de son travail dans le célèbre *Shûkan Shônen* magazine. « Shingeki no kyôjin » paraît toujours dans le mensuel *Bessatsu Shônen* magazine et reste très apprécié. Après une exposition en 2013 et une série de conférences en 2014, l'artiste a été nommé ambassadeur touristique de sa région natale de Hita par le maire Keisuke Harada.

Shotaro Ishinomori established himself as the leading producer of the hero archetype manga, and was one of the leading members of the Tokiwa-sō. He was the creator of such legends as "Cyborg 009," which eventually became animated. He also brought audiences such hits as "Kamen Rider" [Masked Rider], "Jinzō ningen Kikaider". [Android Kikaider], "Himitsu sentai Gorenger" [Secret Task Force Gorenger] and "Ganbare Robocon," which were made into children's television shows. Ishinomori was the founder of these hero-type special effects television programs. Most of his heroic characters have the ability to transform from ordinary human beings to superheroes. The design of the costumes worn by the trans-formed characters has fascinated children and led to the overwhelming popularity of his comics. As a cartoonist, he generally uses each frame to the fullest in order to achieve the most dramatic effect, and his frames proceed like the frames of a movie to portray action and movement. He also created such sociological works as "Nihon Keizai Nyuumon" [Japan Inc.: An Introduction to Japanese Economics] and "Manga Nihon no Rekishi" [A Manga History of Japan], which also attracted considerable attention. He sadly passed away in 1998, but his hometown in the Miyagi Prefecture has established the Shōtarō Ishinomori Memorial Museum in his honor, where all of his works are currently on display.

SHOTARO ISHINOMORI

Dates

Born 1938 in Miyagi Prefecture, Japan
Died 1998 in Tokyo Prefecture

Debut

with "Nikyū tenshi" in 1954

Best known works

"Cyborg 009"
"Sabu to Ichi torimono hikae" [Sabu and Ichi's Detective Story]
"Kamen Rider" [Masked Rider]
Animated works
"Cyborg 009"
"Kamen Rider" [Masked Rider]
"Jinzō ningen Kikaider" [Android Kikaider]

Animation adaption

"Cyborg 009"
"Kamen Rider" [Masked Rider]
"Jinzō ningen Kikaider" [Android Kikaider]

Prizes

- 7th Kôdansha Manga Award (1967)
- 13th & 33rd Shôgakukan Manga Award (1968, 1988)
- 17th Japan Cartoonists Association Grand Prize (1988)
- 2nd Osamu Tezuka Cultural Prize Special Prize (1998)

殺した
の？

いいや
殺しても
よかったん
だが……
ギルモア博士
との約束を
まもったよ

ありがとう

？

Ishinomori ist eine japanische Ikone des Super-helden-Genres und wohnte seinerzeit im legen-dären Mietshaus Tokiwa-sô Tür and Tür mit vielen anderen Mangaka. Aus seiner Feder stammt die auch als Anime umgesetzte Serie „Cyborg 009" sowie mit „Kamen Rider", „Android Kikaider", „Himitsu sentai Gorenger" und „Ganbare Robo-con" zahlreiche Mangas, die für das Kinderpro-gramm mit kostümierten Schauspielern und Spezialeffekten verfilmt wurden. Ishinomori gilt als der geistige Vater solcher Fernsehsendungen in Japan. Der Protagonist verwandelt sich dabei üblicherweise von einem gewöhnlichen Sterb-lichen in den Superhelden, als der er dann eine besondere, übernatürliche Fähigkeit zum Einsatz bringen kann. Ishinomoris jugendliches Publikum begeisterte sich vor allem für das durchweg gelungene Charakterdesign dieser Superhelden. Auch im grafischen Bereich zeigte er mit film-ähnlichen Techniken neue Wege auf. So füllte er ganze Seiten mit einem einzigen, an innerer Spannung kaum zu überbietenden Panel oder verteilte Bewegung wie im Daumenkino über mehrere Bilder. Mit „Japan GmbH" und „Japani-sche Geschichte in Mangas" zeichnete er zudem sogenannte Sach- oder Informations-Mangas, die ebenfalls viel besprochen wurden. 1998 starb Shôtarô Ishinomori, in seiner Heimatpräfektur Miyagi kann man sein Leben und Werk in einem ihm gewidmeten Museum Revue passieren lassen.

Ishinomori est le principal producteur de mangas sur l'archétype du héros et il était un des princi-paux membres du « Tokiwa-sô » (une demeure fameuse où de nombreux auteurs de mangas se réunissaient pour échanger des idées). Il fut le créateur du légendaire « Cyborg 009 » qui est de-venu une série animée. Il a également créé « Ka-men Rider » [Le cavalier masqué], « Jinzô ningen Kikaider » [L'androïde Kikaider], « Himitsu sentai Gorenger » [Le détachement spécial Gorenger] et « Ganbare Robocon » [Tu les auras, Robocon !] qui est devenu une série pour la télévision desti-née aux enfants et filmée à grand renfort d'effets spéciaux et de costumes. Ishinomori fut le fonda-teur de ces programmes de télévision basés sur des héros et des effets spéciaux.

La plupart de ses personnages héroïques sont des humains ordinaires qui ont la capacité de se transformer en super-héros. Les tenues por-tées par les personnages transformés ont fasciné les enfants et ont contribué à la popularité de ses mangas. En tant que mangaka, il utilise géné-ralement chaque vignette en entier pour obte-nir l'effet le plus saisissant et les vignettes res-semblent à celles d'un film pour illustrer l'action et le mouvement. Il a étendu les possibilités du genre en utilisant ces éléments du milieu ciné-matographique dans ses dessins. Il a également créé des travaux sociologiques tels que « Nihon Keizai Nyuumon » (un guide de l'économie japo-naise) et « Manga Nihon no Rekishi » (un ouvrage sur l'histoire de la bande dessinée japonaise), qui lui ont apporté une couverture médiatique considérable. Il est malheureusement décédé en 1998, mais sa ville natale de Miyagi lui a dédié le musée Shôtarô Shinomori Memorial Museum, qui abrite bon nombre de ses œuvres les plus fameuses.

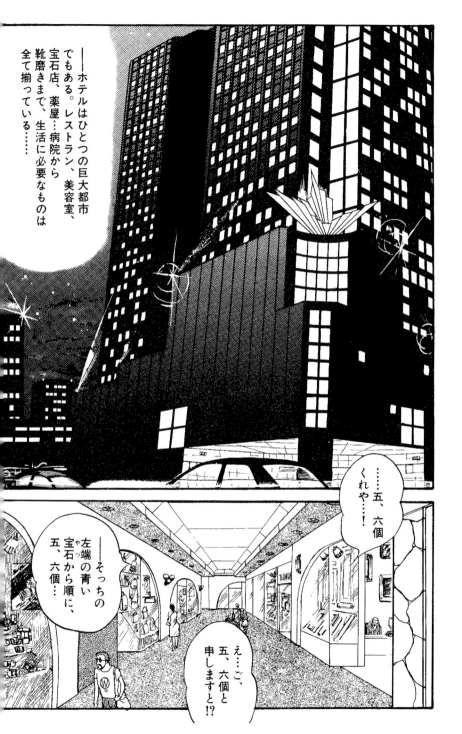

――ホテルはひとつの巨大都市でもある。レストラン、美容室、宝石店、薬屋…病院から靴磨きまで、生活に必要なものは全て揃っている……

……五、六個くれや……!

――そっちの左端の青い宝石から順に、五、六個……

え…ご、五、六個と申しますと!?

Born in the province of Ibaraki, Shinichi Ishizuka attended Southern Illinois University in the United States, where he studied meteorology and devoted a great deal of time to climbing, having now summited Grand Teton, Mount Reiner, the Fitz Roy, and a number of mountains in his homeland Japan. At the age of 28, Ishizuka finally decided to become a full time manga writer and illustrator, debuting soon after with his story "Gaku," which recounts the adventures of Sanpo, largely inspired by his experience and passion for the mountains. Living also in isolation in the countryside, close to the mountains, the artist has also released titles such as "Sonde yoshi!, Straight no Chaser," and "Tokyo Check-in." He was the winner of the 2008 Grand Prize Manga Taishō Award and the following year, the Shōgakukan Manga Award, finally crowning Ishizuka as one of the leading mangakas in Japan. After working in a quasi-autobiographical manner, the artist released "Blue Giant," the story of a jazz player, and his latest work "Kariud" revolves around hunting. His energetic characters commonly display an immense appetite for life and adventure.

SHINICHI ISHIZUKA

Born

1971 in Ibaraki Prefecture, Japan

Debut

in 2002 with "This First Step" published in *Big Comic Spirits* Zoukangou, initial issue

Best known works

"Gaku, minna no yama" [Peak: Everyone's Mountain] "Blue Giant"

Feature film

"Gaku, minna no yama" [Peak: Everyone's Mountain]

Prizes

- 49th Shōgakukan Manga Award in the general division (2001)
- 1st Cartoon Grand Prize (2008)
- 16th Japan Media Arts Festival: Excellence Award in Manga Division (2012)

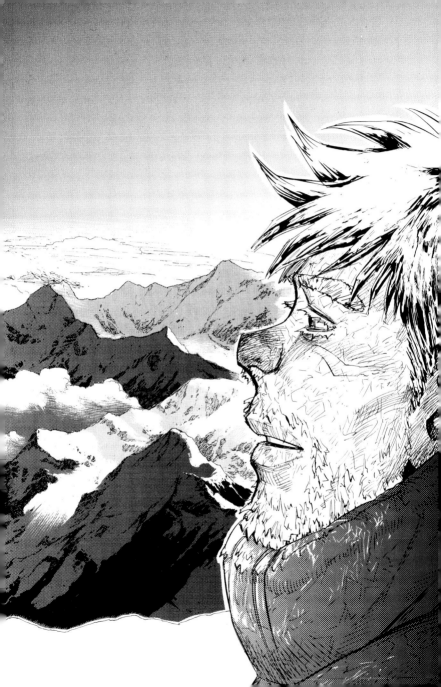

Der in der Präfektur Ibaraki geborene Shinichi Ishizuka besuchte die Southern Illinois University in den USA, wo er Meteorologie studierte und den Großteil seiner Freizeit mit Klettern verbrachte. Dabei erklomm er den Grand Teton, den Mount Rainier, den Monte Fitz Roy und eine Reihe von Bergen in seiner japanischen Heimat. Im Alter von 28 Jahren entschloss sich Ishizuka schließlich, sich ganz dem Schreiben und Zeichnen von Mangas zu widmen. Schon bald darauf gab er seinen Einstand mit der Geschichte „Gaku", die die Abenteuer von Sanpo erzählt und zu einem großen Teil von Ishizukas eigenen Erfahrungen sowie seiner Begeisterung für die Berge inspiriert wurde. Der Künstler, der abgeschieden auf dem Land in der Nähe der Berge lebt, hat außerdem Titel wie „Sonde yoshi!", „Straight no Chaser" und „Tokyo Check-in" veröffentlicht. Er gewann 2008 den Manga Taishô und im Jahr darauf den Shôgakukan Mangashô, so dass er sich nun mit Recht zu den führenden Mangaka Japans zählen darf. Nach zahlreichen autobiografisch geprägten Werken schrieb der Künstler „Blue Giant", die Geschichte eines Jazz-Musikers, und sein jüngstes Werk, „Kariud", das von der Jagd handelt. Seine lebhaften Figuren zeigen dabei häufig ungeheuren Lebenshunger und enorme Abenteuerlust.

Né dans la province d'Ibaraki, Shinichi Ishizuka a étudié la météorologie à l'université américaine du Sud de l'Illinois et consacré une bonne partie de son temps libre à escalader le Grand Teton, le mont Rainier, le Fitz Roy et plusieurs montagnes du Japon. À l'âge de 28 ans, Ishizuka s'est finalement décidé à devenir un écrivain et un illustrateur de mangas à part entière. Il a débuté avec l'histoire « Gaku » [Vertical], qui narre les aventures de Sanpo, grandement inspiré de son expérience et de sa passion pour la montagne. Menant une vie isolée à la campagne, près des sommets, l'artiste est également l'auteur de titres comme « Sonde yoshi! », « Straight no Chaser » et « Tokyo Check-in ». Il s'est vu décerner en 2008 le grand prix du Manga Taishô et l'année suivante le prix du manga Shôgakukan, couronnant ainsi Ishizuka comme l'un des mangakas phares du Japon. Après un travail quasi autobiographique, l'artiste a signé « Blue Giant », l'histoire d'un joueur de jazz, alors que son dernier titre « Kariud » traite du monde de la chasse. Ses personnages pleins de dynamisme font généralement preuve d'un énorme appétit pour la vie et l'aventure.

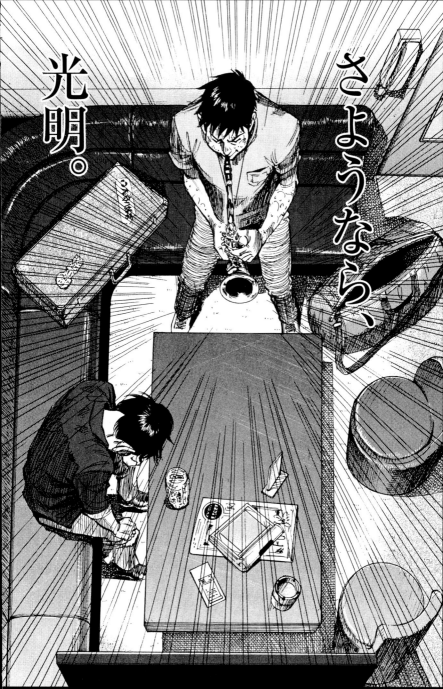

さようなら、光明。

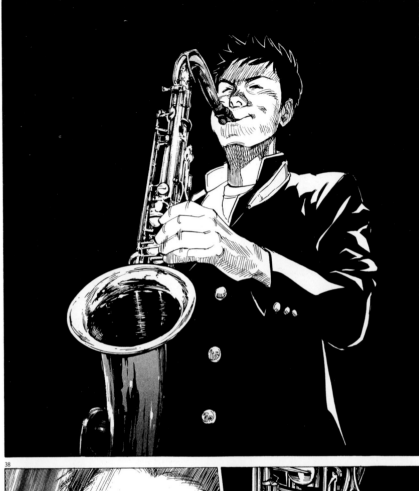

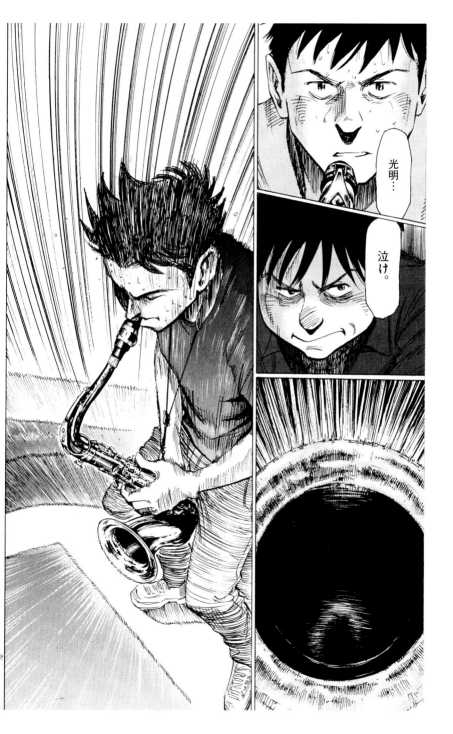

Keisuke Itagaki has revolutionized and continues to be one of the major forces in the genre that has come to be known as "Kakutou Manga" or "Martial Arts" comics. His influence has even surpassed the manga world, as he also gets tremendous support from real-life martial arts fighters, who are ardent fans of his series. His most famous work is "Baki the Grappler," which was serialized in a weekly Boys Comic magazine. This is the story of a fighter named Baki who is determined to become the best martial artist in the world. His quest brings him into numerous fights to the death with various strong and skilled opponents.

Itagaki has a tremendous knowledge of the world of martial arts, and his love and passion for them shines through in his unparalleled work. This is one of the reasons for his enormous fan base. For martial artists everywhere, their ultimate dream of having a championship where the strongest man in the world is determined became a reality in Itagaki's stories. He does not simply focus on the main characters, but introduces detailed description of the fighting styles, mentality, and drama surrounding each fighter. The second part to the "Baki the Grappler" series is entitled "Baki" and continues to attract a strong following.

KEISUKE ITAGAKI

Born

1957 in Tokyo, Japan

Debut

with "Make-Upper" which appeared in the first issue of *Young Shoot* magazine

Best known works

"Baki the Grappler"
"Garôden"
"Baki"

Feature animation

"Baki the Grappler"

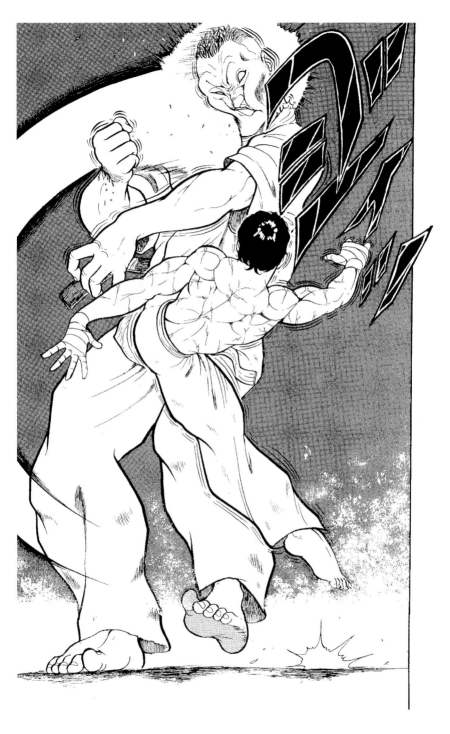

Itagaki revolutionierte den Kampfsport-Manga und gilt als der Repräsentant dieses Genres schlechthin. Sein Einfluss reicht über die Manga-Welt hinaus bis in die reale Kampfsportszene, die ihn enthusiastisch feierte. Sein Hauptwerk „Baki the Grappler" wurde zunächst in Serie in einem *shônen*-Magazin veröffentlicht. Baki will zur Nummer Eins der Kampfsportwelt werden und absolviert etliche schonungslose Fights gegen zahlreiche schlagkräftige Konkurrenten. Der Autor bringt diesem Wettkampf eine Leidenschaft und Liebe entgegen, die gepaart mit seinem profunden Sachverständnis allen Kampfsportbegeisterten großen Respekt abnötigte. Kampfsportler aller Disziplinen versammeln sich an einem Ort, um den stärksten Mann der Welt zu bestimmen – diesem Traum aller Kampfsportfans in seinem Werk ein so glänzendes Forum zu geben, ist Itagakis besonderes Verdienst. Er ist auch durchaus nicht für seine Hauptfigur eingenommen, sondern zeichnet detailverliebt und großzügig Kampftechnik, Psyche und private Dramen jedes einzelnen Kontrahenten. „Baki the Grappler" wird derzeit unter dem Titel „Baki" [wobei der Name nicht mehr in *kanji* sondern in *katakana* geschrieben wird] in der zweiten Staffel fortgesetzt – mit unvermindertem Erfolg.

Itagaki a révolutionné et continue d'être une influence majeure du genre que l'on appelle « kakutou » [manga d'arts martiaux]. Son influence a même surpassé le monde des mangas et bénéficie du soutien de véritables adeptes des arts martiaux qui sont des fans invétérés de ses séries. Son œuvre la plus fameuse est « Baki the Grappler », qui est devenue une série dans un magazine de manga shounen hebdomadaire. Il s'agit de l'histoire d'un guerrier nommé Baki déterminé à devenir le meilleur combattant en arts martiaux du monde. Sa quête le conduit à participer à de nombreux combats jusqu'à la mort avec de nombreux adversaires forts et très doués. Itagaki possède une connaissance incroyable du monde des arts martiaux et sa passion brille au travers de ses mondes sans pareils, ce qui est une des raisons de son succès. Le rêve ultime des pratiquants en arts martiaux, qui est de participer à un championnat qui déterminera l'homme le plus fort du monde, est devenu réalité dans les histoires d'Itagaki. Il ne se concentre pas simplement sur les personnages principaux, mais introduit des descriptions détaillées des styles de combat, de la mentalité et des drames de chaque combattant. La seconde partie de « Baki the Grappler » est une série qui s'intitule « Baki » et qui continue d'attirer de nombreux lecteurs.

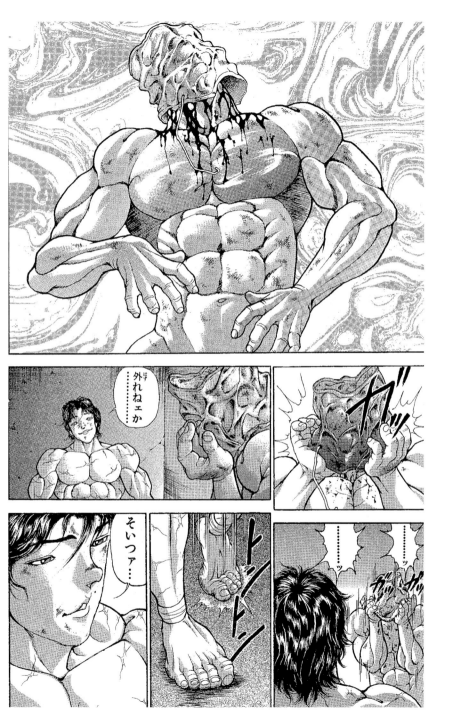

外れねェか……

そいつァ…

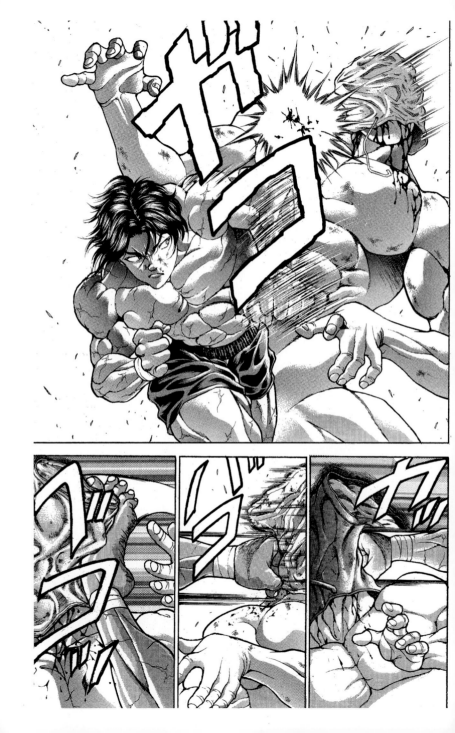

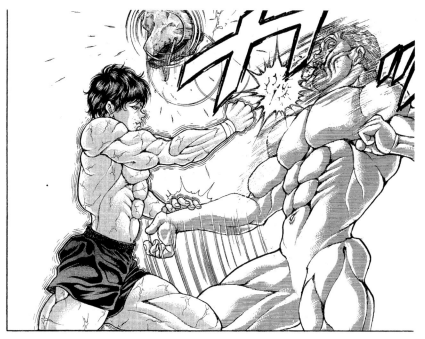

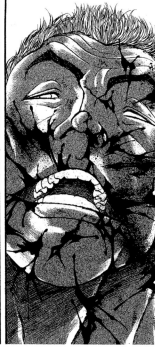

Junji Itô is a comic artist who has created horror manga using beautiful imagery. He revealed a special talent for spotting terror in seemingly ordinary life, and for portraying the horrors of a life that has become terribly out of the ordinary. He has a unique style of adding a touch of humor even in the most frightening situations. Most of his works consist of short stories, but one of the few series he has published is called "Tomie." The story portrays a beautiful young woman in the title role and her various encounters with men who become obsessed with her. Each time a man falls in love with her, she ends up being killed or her body is chopped up into pieces. Each time, she comes back to life as she is magically resurrected from a piece of her old body. The series has a large number of devotees, and it has even been made into a feature film.

The comic series "Uzumaki" [Uzumaki: Spiral into Horror] was Itô's first series to be published in a *seinen shi* [young mens magazine], and is about a variety of mysterious cases that all involve a spiral motif. The essence of Itô's works is contained here, in that although they are horrific, they still manage to retain a trace of humor. He draws with very precise lines and there is a sense of tranquility in his scenes, so that at first glance, the imagery may not seem like that of a horror comic. There is something about these drawings that seems to drip with terror.

J U N J I
I T Ô

Born

1963 in Gifu Prefecture, Japan

Debut

with "Tomie" in *Halloween Comics* in 1987

Best known works

"Tomie"
"Rojiura"
"Kubitsuri kikyû"
"Sôichi no tanoshii nikki"
"Kubi gensô"
"Uzumaki"
[Uzumaki: Spiral into Horror]
"Gyo"

Feature film

"Tomie"
"Uzumaki"
[Uzumaki: Spiral into Horror]

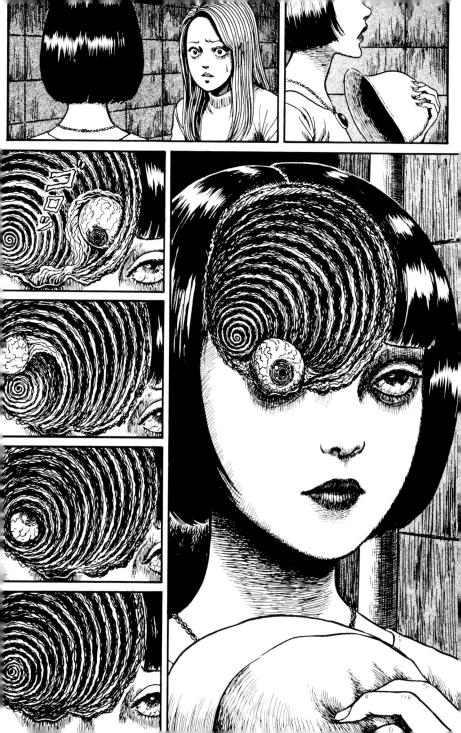

In seinen zahlreichen Horror-Mangas lauert das Grauen im Alltag oder die Atmosphäre ist alptraumartig unalltäglich – aber immer wunderschön gezeichnet. Junji Itô hat einen ganz eigenen Stil, bei dem inmitten des Horrors irgendwo auch Komik erkennbar ist. Kürzere Arbeiten sind in seinem Œuvre vorherrschend, als Hauptwerk kann dennoch eine seiner wenigen Serien gelten: In „Tomie" verzaubert die wunderschöne, über unheimliche Kräfte verfügende junge Titelheldin alle Männer in ihrer Umgebung, was dazu führt, dass sie am Ende jeder Liebesgeschichte grausam ermordet und zerstückelt wird – jedoch regeneriert sie sich aus ihren einzelnen Körperteilen immer wieder neu. Die Serie fand enthusiastische Fans und diente als Vorlage für den gleichnamigen Horror-film. Mit „Uzumaki" veröffentlichte Itô erstmals eine Arbeit in einem *shônen*-Magazin. Die Handlung dreht sich um eine Reihe unheimlicher Vorfälle, denen allen das Motiv der Spirale [japanisch *uzumaki*] gemeinsam ist. Schaurig, aber auch komisch – die Quintessenz seiner Werke zeigt sich hier leicht verständlich und so gewann Itô mit dieser Serie viele neue Fans. Seine Bilder wirken auf den ersten Blick nicht wie aus einem Horror-Manga, so sorgfältig ist die Strichführung, so friedlich wirkt das Szenario. Mit Grausen wartet man auf das unbekannte Etwas, das hinter dieser Fassade schlummert.

Itô est un mangaka qui a créé des histoires d'épouvante basées sur de superbes images. Il a un talent particulier pour repérer de la terreur dans des situations apparemment courantes, et pour dépeindre les horreurs d'une vie qui sort terriblement de l'ordinaire. Il a un style unique pour ajouter une touche d'humour aux situations les plus effrayantes. La plupart de ses œuvres consistent en des histoires courtes, mais il a pu-blié une série intitulée « Tomie ». Elle dépeint une superbe jeune femme et ses rencontres avec dif-férents hommes qui deviennent obsédés par elle. Chaque fois qu'un homme tombe amoureux d'elle, elle finit par être tuée et son corps découpé en morceaux. Elle revient chaque fois à la vie et est miraculeusement ressuscitée par une partie de son corps. La série bénéficie d'un grand nombre de lecteurs et a été adaptée en long métrage. La série « Uzumaki » [Uzumaki : Spirale dans l'horreur], qui a été la première série a être intégrée à un magazine seinen (pour jeunes hommes), dépeint un nombre d'affaires mys-térieuses qui ont en commun un thème en spi-rale. Ces histoires contiennent l'essence des œuvres de Junji Itô, et bien qu'elles soient sou-vent atroces, elles contiennent toujours une trace d'humour. Il dessine des lignes très précises et ses scènes reflètent un sentiment de tranquillité. Au premier abord, l'imagerie peut donc ne pas ressembler à celle d'un manga d'épouvante. Ses dessins ont pourtant quelque chose qui semble dégouliner de terreur.

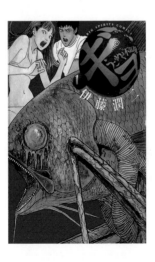

Hitoshi Iwaaki's most famous comic depicts a world in which the population has surpassed its limits and humans have wastefully depleted the earth's natural resources, forcing Mother Nature to respond with a predator to combat mankind. This mysterious "parasitic beast" is able to implant itself in the brains of unsuspecting people, gaining complete control over the central nervous system. These parasite-infected humans can then infiltrate society, where they feed on other humans. The main character, Shin'ichi Izumi, is a high school student who has narrowly missed becoming a victim, but instead of his brain, his right hand ends up being infected by the parasite (later called Migi). As a result, he is somehow able to communicate with the strange species. Learning that the entire world is in peril, Shin'ichi teams up with Migi to fight the parasite creatures. This is the basic concept behind the story of "Kiseijuu." When it was first published in 1990, it influenced and shocked Japanese readers with the chilling questions it raised about the existence of humanity. The surreal manner in which the parasites could transform parts of their body while in humanoid form was also of considerable interest for comic fans. Iwaaki is an expert comic artist who uses creative concepts to form a highly original story line, and this is best exemplified in his series "Kiseijuu."

HITOSHI IWAAKI

Born

1960 in Tokyo, Japan

Debut

with "Gomi no Umi" published in a special edition of *Morning Open* magazine

Best known works

"Fûko no iru mise"
"Kiseijû" [Parasyte]
"Heureka"

Prizes

• 17th Kôdansha Manga Award (1993)

Da die Menschen allmählich überhand nehmen und die Erde zu zerstören drohen, hält die gewaltige Natur einen „natürlichen Feind" für sie bereit. Das rätselhafte Lebewesen, um das es in Iwaakis Meisterwerk „Parasyte" geht, nistet sich im menschlichen Gehirn ein, übernimmt zunächst die Kontrolle des Nervensystems und schließlich vollständig die Rolle seines Wirts. Daraufhin mischt es sich unter die Gesellschaft und benutzt andere Menschen als Futter. Der Oberschüler Shin'ichi Izumi fällt diesem Parasit ebenfalls zum Opfer, aber dieses Mal wird durch einen Zufall nicht das Gehirn, sondern seine rechte Hand befallen und es gelingt ihm, mit seinem Parasit in freundschaftlichen Kontakt zu treten. Durch Migi, wie Shin'ichi seinen Parasit bald nennt, erfährt er von der Bedrohung der Menschheit und beginnt gemeinsam mit Migi Widerstand zu leisten. Die ersten Folgen dieses Mangas wurden 1990 veröffentlicht und die der Story zugrunde liegende Relativierung menschlicher Existenz löste große Betroffenheit aus. Auch die surrealistische Zeichnung der Szenen, in denen der Parasit den menschlichen Wirt übernimmt, erregte Aufsehen. Mit seiner unvergleichlichen Vorstellungskraft gilt Iwaaki als Meister origineller Storys und „Parasyte" ist sein Meisterstück.

Le manga le plus fameux d'Iwaaki dépeint un monde dans lequel la population a atteint ses limites et les humains ont épuisé toutes les ressources naturelles de la Terre, forçant Mère Nature à lancer un prédateur contre le genre humain. Ce mystérieux « animal parasite » est capable de s'implanter dans le cerveau d'individus qui ne se doutent de rien, et de gagner progressivement le contrôle total de leur système nerveux. Ces humains parasités peuvent alors infiltrer la société, où ils se nourrissent d'autres individus. Le personnage principal, Shin'ichi Izumi, est un lycéen qui a manqué de peu de devenir une victime, mais à la place de son cerveau, c'est sa main droite qui est infectée par le parasite (appelé plus tard « Migi »). Ainsi, il semble être capable de communiquer avec cette race étrange. Apprenant que le monde entier est en péril, Shin'ichi s'associe avec Migi pour combattre les parasites. C'est le concept de l'histoire « Kiseijuu » [Parasite]. Lorsqu'elle a été publiée en 1990 pour la première fois, elle a influencé et choqué les lecteurs japonais par sa remise en question effrayante du genre humain. La manière surréaliste dont les parasites peuvent transformer des parties de leurs corps tandis qu'ils ont pris forme humanoïde a fortement intéressé les fans. Iwaaki est un mangaka expert qui utilise des concepts créatifs pour former des scénarii très originaux, ce qui est parfaitement illustré dans sa série « Kiseijuu ».

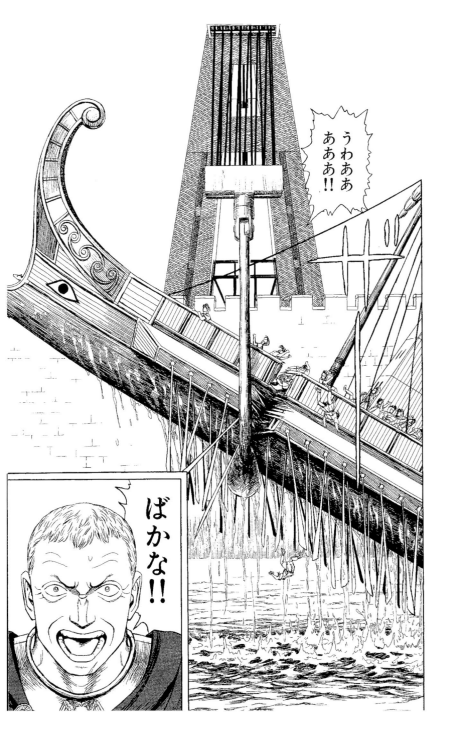

向こうから迎えにこないならこちらから出向く。

ルルルル

やめろ！頼之！！

まだ向こうへの「入口」と決まったわけではない！死ぬぞ！！

頼之さん……！わたし……わたしも連れてってください……！

な、何ィ！？幸子ちゃん！！

そう……暗いと
よく見えないん
だよね……

「心のモヤモヤ」
にもうんざりだ。

もう……この世界に
未練はない。

あん……
ななな
……

During the 1970s, when Mariko Iwadate was still at the beginning of her career, she created stereotypical *shoujo* manga stories that were of very good quality. However, she continued to explore deeper themes, so that by the 1980s her comics were able to break out of the mold of *shoujo* manga, and gain a wider support. It's a well-known fact that novelist Banana Yoshimoto has been greatly influenced by her work as a creator. Not only does she incorporate love and romance in her stories, she also explores the concept of the "family" to great effect in many of her stories. Although her comics manage to convey a soft, romantic atmosphere, she is not shy of tackling serious themes, such as the intricate relations between ordinary people. She manages to create an original "Mariko Iwadate" world that feels like the combination of literature with *shoujo* manga. The manga that was her turning point is considered to be "Angel," published in 1982. It tells the story of a girl named Sû who goes through an *omiai* [arranged marriage], and eventually falls in love with her husband after they are married. This is a work that strives to set foot in new *shoujo* manga territory, as the standard goal of a main character would typically be to find a loving boyfriend or to get married. Iwadate explored new grounds with this charming story.

MARIKO IWADATE

Born

1957 in Hokkaidô, Japan

Debut

with "Rakudai shimasu" published in the *Weekly Margaret* magazine in 1973

Best known works

"Reizôko ni Pineapple Pie"
"Uchi no Mama ga iu koto ni wa"
"Alice ni onegai"

Prizes

• 16th Kôdansha Manga Award (1992)

本当は

本当は…

あたしは…

川崎くんのことが
好きだから

なーんて…

そういう恋ばかり
何度もしてきて

それがあたりまえで

だから　いつも元気…

だけど…

Zu Beginn ihrer Karriere in den 1970er Jahren waren Iwadates *shôjo*-Mangas zwar recht ordentlich, aber doch unspektakulär. Erst allmählich entwickelte sie ihren Stoff und ihre Themen und fand so in den 1980er Jahren auch über den *shôjo*-Bereich hinaus weitreichende Anerkennung. Oft wird erzählt, dass die Schriftstellerin Banana Yoshimoto sie als diejenige Künstlerin nannte, die den größten Einfluss auf sie ausgeübt habe. Natürlich geht es bei Iwadate um Liebe, aber sie widmet sich dabei auch gerne der Familie im Hintergrund. Ernste Sujets um zwischenmenschliche Beziehungen werden in Iwadates ureigene poetische, romantische und softe Atmosphäre verpackt, diese Mariko-Iwadate-Welt ist sowohl *shôjo*-Manga-typisch als auch literarisch. Ihr 1982 veröffentlichtes Werk „Angel" markierte den Wendepunkt in ihrer Karriere: Mit der Geschichte um die Protagonistin Sû, die sich nach einer arrangierten Heirat ganz langsam in ihren Mann verliebt, sprengte Iwadate den üblichen *shôjo*-Rahmen, in dem gegenseitige Liebe und Heirat bereits das Endziel darstellen. Mit dieser bahnbrechenden Arbeit brach die Künstlerin zu neuen Horizonten auf und schuf ein einzigartiges Werk, dass man einfach lieben muss.

Durant les années 1970, lorsqu'elle était au début de sa carrière, Iwadate a créé des mangas shoujo classiques d'excellente qualité. Elle a toutefois continué d'explorer des thèmes plus profonds, et pendant les années 1980, ses mangas ont pu sortir du moule des mangas shoujo traditionnels et conquérir une audience importante. Il est bien connu que la romancière Banana Yoshimoto a été nettement influencée par ses travaux. Elle incorpore non seulement de l'amour et de la romance dans ses histoires, mais elle utilise également avec succès le concept de la famille. Bien que ses mangas véhiculent une atmosphère douce et romantique, elle ne répugne pas à s'attaquer à des thèmes sérieux, tels que les relations complexes entre gens ordinaires. Elle a créé un monde « Mariko Iwadate » original qui semble être la combinaison de la littérature avec les mangas shoujo. Le manga « Angel » publié en 1982 est considéré comme étant le tournant de sa carrière. Il s'agit de l'histoire d'une jeune femme nommée Sû et de son mariage arrangé (« omiai »), qui fini par tomber amoureuse de son mari. C'est une œuvre qui tente de s'inscrire dans le domaine des mangas shoujo, puisque le but du personnage central est soit de trouver un petit ami dévoué, soit de se marier. Iwadate a exploré de nouveaux territoires avec cette charmante histoire.

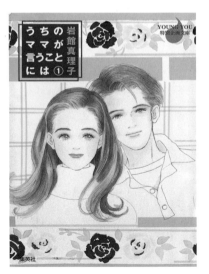

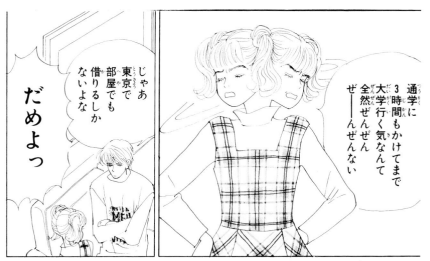

通学に3時間もかけてまで大学行く気なんて全然ぜんぜんぜーーんぜんない

じゃあ東京で部屋でも借りるしかないよな

だめよっ

だめなのっあたしに一人暮らししろっていうの？東京で一人で？考えただけでぞっとするう

じゃあ専門学校は？

だめっ

やってみたいことが考えつかないのどれもかったるいっ

じゃあ就職だ？

だめえっ

だめだめえ

だんだんなぐりたくなってきたな

とうとうなぐられるかもと思っている

↓

じゃあ……

どうしたいの？

After debuting with *Comic Box* in 1988, Shintarō Kago has been widely recognized for his "fashionable paranoia" style, as well as for being an artist dedicated to Guro, a literary and artistic movement that originated in the 1930s in Japan, which devoted itself to the explorations of the deviant, the bizarre, and the ridiculous. In over 30 years of his career with more than 30 titles released, Kago has made use of great irony not only in his best-selling titles, but also in exhibitions named *Unsanitary Condition Exhibition, Unsanitary Festival in the Cool of the Night*, and at his personal movie convention called Shit Film Festival. His works, using sexual, chaotic, and horror images, have been featured in both mainstream publications and at Dojinshi, where artists can print their work privately, escaping censorship. Even with the recent stricter regulations to avoid selling explicit and violent content to minors, Shintarō Kago continues to enjoy great popularity. His most admired title has been "Super Conductive Brains Parataxis," featured in *Shūkan Young Jump*.

SHINTARÔ
KAGO

Born
 1969 in Tokyo, Japan.

Debut
 in 1988 with "Uchû daisakusen" published in *Comic Box*

Best known works
 "Bride in front of the Station"
 "Chôdennô Parataxis" [Super Conductive Brains Parataxis]

Prizes
 • 19th Salon del Manga de Barcelona (2013)

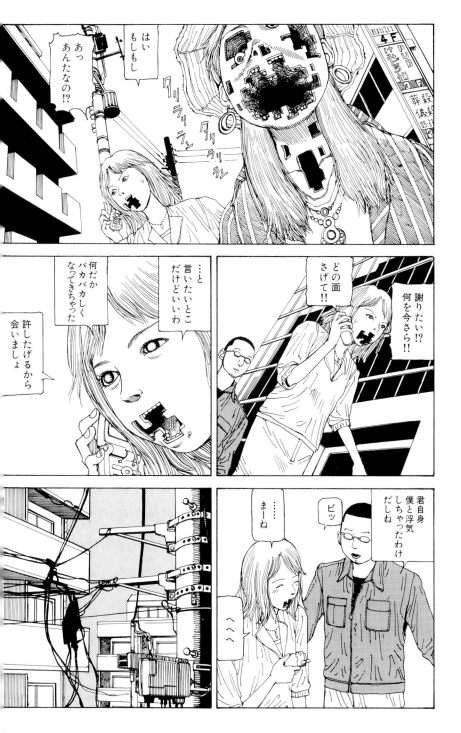

死んでいればよいが
もし生き永らえ
しかもメスで
卵が孵化など
したら一大事だ

目玉の裏側に
突入した虫の
墓場が形成
されているのだ
ろうか

目の内部は
夢の島状態だ
結晶化して鉱石が
できたりしても
不思議じゃない

虫以外でも
砂ボコリなどは
よく入る

微小な石が入って
ゴロゴロした経験
などあるだろう

虫が飛び込む
習性を利用し
たとえば

害虫に悩む
田畑に仕掛ける

それにしても
虫に入られっぱなし
ではどうにも
くやしい

何とか
逆利用
できないものか

飛んで目に入る夏の虫

目の中に虫が
飛び込んでくることが
よくある

静止している
状態や歩いている
時でも虫が自ら
目に飛び込んでくる
こともよくある

自転車に乗って
飛行中の虫と
衝突しそれが目に
突入することは
しばしばだが

虫が目に入り
外に出ずに
そのままという
ことはないだろうか

虫は一体
どこへ
行ったのだ

目には
何かしらのパワーが
備わっているのだ
ろうか

そういえば
カラスよけの
仕掛けも目玉を
模している

Nach seiner ersten Veröffentlichung im Jahr 1988 in der Zeitschrift *Comic Box* wurde Shintarô Kago weithin bekannt durch seinen Stil der „modischen Paranoia" und als Vertreter des Guro, einer künstlerisch-literarischen Bewegung, die in den 1930er Jahren in Japan entstand und sich mit Abartigem, Bizarrem und Lächerlichem beschäftigt. In seiner nun mehr als 30 Jahre währenden Karriere, in der er über 30 Titel veröffentlichte, bediente sich Kago stets einer beißenden Ironie, und das nicht nur in seinen Manga-Bestsellern, sondern auch in Ausstellungen, die Titel wie „Unhygienische Ausstellung" oder „Unhygienisches Sommerabendfestival" tragen, sowie bei seinem eigenen Filmfestival, das er „Scheißfilmfestival" nennt. Seine Werke, die sexuelle, chaotische und schreckenerregende Bilder enthalten, wurden sowohl in Mainstream-Publikationen veröffentlicht als auch in *dojinshi*. Letztere werden von den Künstlern selbst herausgegeben und unterliegen so keiner Zensur. Trotz der Gesetze, die den Verkauf sexueller und gewaltverherrlichender Inhalte an Minderjährige einschränken sollen, erfreut sich Shintarô Kago weiterhin großer Popularität. Sein am meisten bewunderter Titel war „Chôdennô Parataxis", der in *Shûkan Young Jump* erschien.

Après ses débuts dans *Comic Box* en 1988, Shintarô Kago a été principalement reconnu pour sa « paranoïa chic », ainsi que pour son appartenance à Guro. Ce mouvement littéraire et artistique a vu le jour au Japon dans les années 30 et s'est attaché à explorer les comportements déviants, bizarres et ridicules. Pendant plus de trois décennies, Kago a signé plus de 30 titres et a fait preuve d'une grande ironie, tant dans ses ouvrages que dans ses expositions Unsanitary Condition Exhibition et Unsanitary Festival in the Cool of the Night, et dans l'événement cinématographique intitulé Shit Film Festival. Empreint d'images sexuelles, chaotiques et d'horreur, son travail est paru dans des publications traditionnelles et dans des doujinshi, des productions faites par les propres artistes pour éviter la censure. En dépit de réglementations plus strictes interdisant la vente de contenu explicite et violent aux mineurs, la popularité de Shintarô Kago ne diminue pas. Son titre le plus apprécié, « Chôdennô Parataxis », est paru dans *Shûkan Young Jump*.

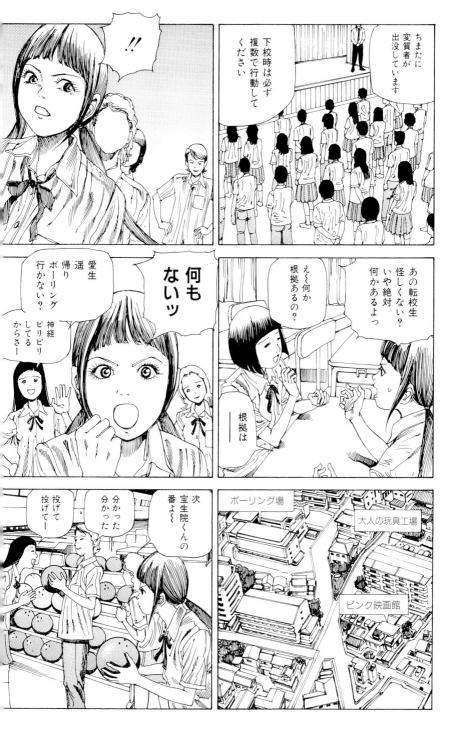

！！

ちまたに変質者が出没しています

下校時は必ず複数で行動してください

愛生遥帰りボーリング行かない？神経ピリピリしてるからさー

何もないッ

あの転校生怪しくない？いや絶対何かあるよっ

え〜何か根拠あるの？

根拠は

宝生院くんの番よく

次投げて投げてー

分かった分かった

ボーリング場

大人の玩具工場

ピンク映画館

Atsushi Kaneko draws with powerful and stylish lines, while his effective use of black and white creates sharp 3-dimensional images. He is highly popular for his violent yet cool stories. His best known work is "Bambi," a violent action tale depicting a female assassin called Bambi, who is a virgin and eats only natural foods. Although there is plenty of bloodshed, murder, and violence, the story is not told from a humanistic viewpoint, but the actions of the main character are firmly based upon her policies. Kaneko skillfully manages in this tale to portray Bambi's evil will in a cool way. This work is currently being produced as a live action film. Kaneko also uses his artistic style to collaborate with the music and fashion industries. He has offered his manga images to famous musicians to use on concert pamphlets, and his illustrations have adorned CD jackets and movie posters. He has produced T-shirts, rings, and other original items to promote his work. Atsushi Kaneko has consistently worked as a "cross-genre" artist. He currently has a series in *Comic Beam* magazine and another in a men's fashion magazine.

ATSUSHI KANEKO

Born

1966 in Yamagata, Japan

Debut

with several works in *Manga Burikko* around 1983
in "Rock'n'roll igai wa zenbu uso," which was published in *Comic Jungle* magazine in 1990

Best known works

"Bambi"
"B.Q"
"R"

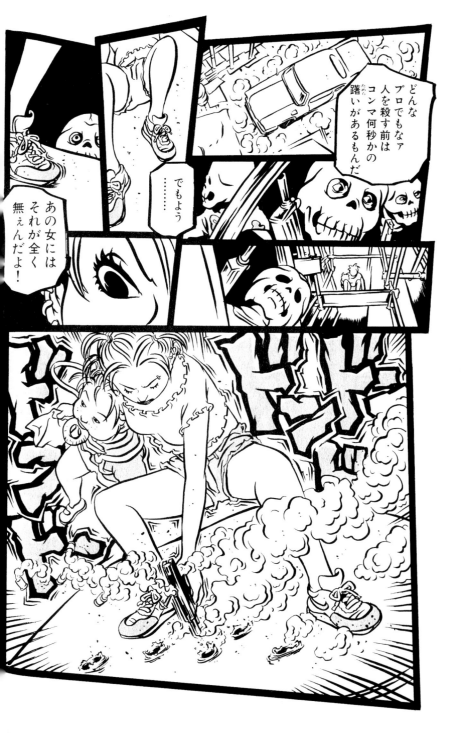

Atsushi Kanekos Zeichnungen bestechen durch differenzierte Linienführung und flächige Schwarz-Weiß-Kontraste, das Publikum liebt seine Storys voller Coolness und Gewalt. Bei der Titelfigur Bambi in seinem Hauptwerk handelt es sich um ein junges Mädchen mit einem Faible für Reformhauskost, dessen Metier – Profikillerin – einiges an brutaler Action mit sich bringt. Blutvergießen, Mord und Gewalt werden nicht von der Warte der Menschlichkeit aus gezeichnet, sondern als durch bestimmte Grundsätze der Protagonistin ausgelöste Handlungen und bei Kaneko erscheint dieser Wille hinter dem Bösen ziemlich cool. Pläne, „Bambi" als Realfilm zu drehen, sollen in naher Zukunft in die Wirklichkeit umgesetzt werden. Kanekos Zeichenstil findet in der Mode- und Musikszene ebenfalls großen Anklang und so adaptiert er bisweilen seine Comicfiguren für die Tourneeposter berühmter Musiker oder zeichnet Illustrationen für CDs und Filmplakate. Darüber hinaus produziert er selbst entworfene Shirts und Ringe – ein echtes Multitalent. Derzeit zeichnet Kaneko hauptsächlich für das Magazin *Comic Beam*, veröffentlicht aber auch in einer Männerzeitschrift für Streetfashion.

Atsushi Kaneko dessine à l'aide de lignes fortes et élégantes, mais son utilisation efficace du noir et blanc crée des images 3D très profilées. Il est célèbre pour ses histoires violentes mais cool. Son œuvre la plus connue est « BAMBi », une histoire d'action violente qui décrit une femme assassin appelée Bambi, qui est vierge et ne mange que des aliments naturels. Bien que l'histoire est remplie de meurtres, d'effusions de sang et de violence, elles est racontée d'un point de vue humaniste, et les actions du personnage principal reposent fermement sur ses principes. Atsushi Kaneko dépeint avec talent sa volonté diabolique de manière presque agréable. Un film d'action sur ce manga est actuellement en cours de production. Kaneko utilise également son style artistique en collaboration avec l'industrie de la mode et de la musique. Il a permis à des musiciens connus d'utiliser les images de ses mangas sur des brochures et ses illustrations recouvrent des jaquettes de CD et des affiches de films. Il a produit des T-shirts, des anneaux et autres éléments originaux pour la promotion de ses œuvres. Atsushi Kaneko est un artiste multigenre. Une de ses séries est actuellement publiée dans le magazine *Comic Beam* et une autre dans un magazine de mode masculin.

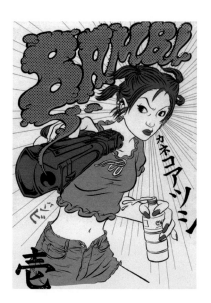

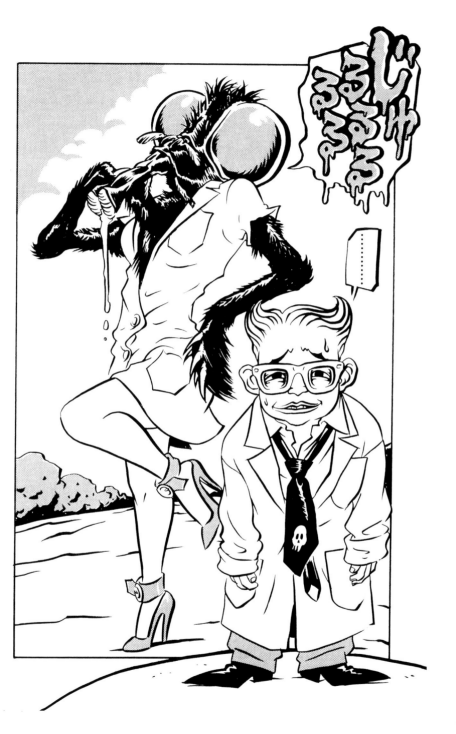

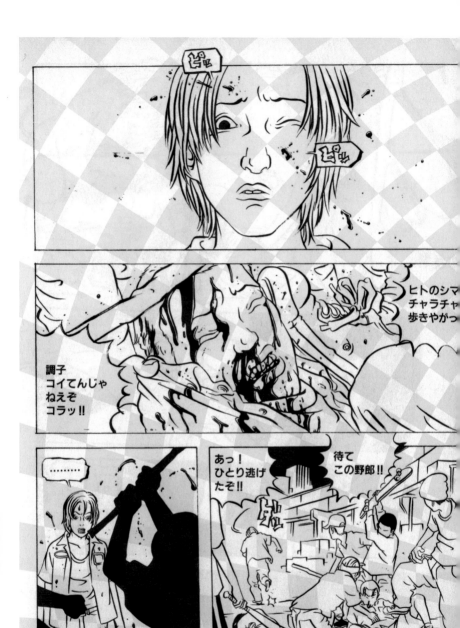

くそっ
ふざけやがって！
こっちだって
人数さえ
居りゃ‥‥

来てみろ
畜生‥‥‥
殺ってやる
‥‥‥!!

Born in Okayama Prefecture, Masashi Kishimoto has been inspired by his early childhood reading of "Dr. Slump Arale-chan" and "Doraemon" following up on Akira Torayama's "Dragon Ball" at a later stage. After a period of no interest in manga, Masashi returned to the subject after seeing Katsuhiro Ôtomo's "Akira" poster. His bestselling work "Naruto" has become a phenomenon that spanned film, toys, and TV programs. The series, first published in 1999 in the *Weekly Shônen Jump* magazine, probably the most famous boys' manga magazine in Japan, came to an end in 2014 after 15 long successful years. With his debut "Karakuri" in 1995, which received an honorable mention in Shueisha's monthly Hop Step Award, he was assigned an editor to work on a new series, and had many of his trials refused before writing a one-shot version of "Naruto" with *Akamaru Jump Summer*, which was initially well received, but proved difficult to be made into a series at that time. Kishimoto has been one of the most awarded mangakas in Japan and his stories have been made into dozens of films and TV series. He dedicated the 668th episode of "Naruto" to his father, who passed away in 2014.

M A S A S H I
K I S H I M O T O

Born
1974 in Okayama Prefecture, Japan

Debut
with "Karakuri" in 1996

Best known works
"Naruto"

Feature animation
"Naruto"

Prizes
- 132th Hop Step Award in Feburary: Fine Work (1996)
- Quill Award (2006)
- 65th New Face Award of Minister of Education Award for Fine Arts (2014)

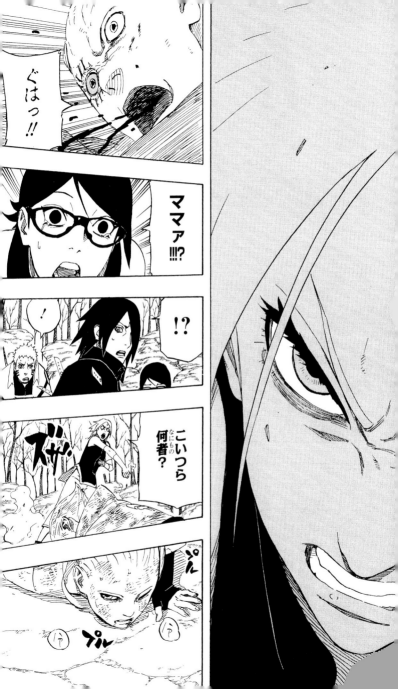

ぐはっ!!

ママァ!!!?

!?

こいつら
何者（なにもの）?

ズザ

パン

プル

……
何なんだよ
お前…

……

……

……

……
分かったよ

ホラ

必ず
届けるから

ナルトは
鎧峠の
方向だ

ボルト

渡してやれ

……

あいつ
あちしに
気があるみたい

マジ
かんべん

あ

タッ

行こ
チョウチョウ
！

……

うん

タッ
タッ
タッ

Der aus der Präfektur Okayama stammende Masashi Kishimoto wurde stark durch die Lektüre von „Dr. Slump Arale-chan" und „Doraemon" in seiner Kindheit und später von Akira Torayamas „Dragon Ball" geprägt. Nachdem er sich eine Zeit lang nicht mehr mit Mangas beschäftigt hatte, kehrte Kishimoto zu ihnen zurück, als er Katsuhiro Ôtomos Plakat für „Akira" sah. Kishimotos Bestseller „Naruto" entwickelte sich zu einem Phänomen, das auch auf Film, Fernsehen und Spielwaren übergriff. Die Reihe, die ab 1999 in der Wochenzeitschrift *Shônen Jump* erschien, dem wohl berühmtesten Manga-Magazin für Jungen in Japan, wurde nach 15 erfolgreichen Jahren 2014 eingestellt. Nach seinem Erstling „Karakuri" von 1995, der beim jährlich von Shueisha vergebenen Hop Step Award lobend erwähnt wurde, bekam Kishimoto einen Redakteur an die Seite gestellt, um mit ihm an einer neuen Serie zu arbeiten. Zahlreiche seiner Entwürfe wurden abgelehnt, bevor er „Naruto" als abgeschlossene Geschichte für *Akamaru Jump Summer* schrieb, die zwar gut ankam, sich damals aber nicht für Fortsetzungen zu eignen schien. Kishimoto gehört zu den am meisten ausgezeichneten Mangaka Japans und seine Werke wurden zu Dutzenden von Filmen und Fernsehserien verarbeitet. Die 668. Folge von „Naruto" widmete er seinem Vater, der 2014 verstarb.

Né dans la province d'Okayama, Masashi Kishimoto s'est inspiré des lectures de son enfance comme « Dr. Slump Arale-chan » et « Doraemon », puis de « Dragon Ball » d'Akira Torayama. Après un temps loin du monde manga, Kishimoto y est revenu en découvrant l'affiche « Akira » de Katsuhiro Ôtomo. Sa meilleure vente, « Naruto », est devenu un véritable phénomène converti en film, jouets et programmes télévisés. D'abord publiée en 1999 dans le magazine *Weekly Shônen Jump* (sans doute le plus célèbre magazine japonais de mangas pour jeunes hommes), la série a pris fin en 2014 après 15 longues années de succès. Grâce à son premier ouvrage « Karakuri » en 1995, qui a reçu une mention honorable au prix mensuel Hop Step Award de la maison d'édition Shueisha, il a été sollicité par un éditeur pour travailler sur une nouvelle série. Nombre de ses essais ont été refusés avant d'écrire une version de « Naruto » dans *Akamaru Jump Summer* : d'abord bien accueilli, ce titre a rencontré des difficultés pour son adaptation en série. Kishimoto est l'un des mangakas les plus primés au Japon et ses histoires ont pris vie dans des dizaines de films et téléfilms. Il a dédié le 668e épisode de « Naruto » à son père, décédé en 2014.

Currently Satoshi Kon is one of the leading animation directors in Japan. However, he made his debut as a manga artist in 1985 with a work in *Young Magajin*, a popular *seinen* manga magazine geared towards young adults. Since his manga debut, he has consistently created realistic high quality images – something that has not changed since he became an animation director. His most famous story, "Kaikisen" [Tropic of the Sea], is set in a town where residents still believe in a folk legend about "sea people." The plot revolves around a mysterious mermaid-like creature that is discovered in the town, which is being developed into a resort area. Kon captures the emotions and summons up quiet scenes with sure-handed confidence. Subsequently, Kon teamed up with storywriter Mamoru Oshii to create "Seraphim: 266613336 Wings." He also made a manga version of Katsuhiro Ōtomo's film *World Apartment Horror* (screenplay by Keiko Nobumoto, original idea by Satoshi Kon), and came up with "Opus," a tale that blends the 2-dimensional and 3-dimensional worlds, where a manga artist lands inside in his own manga universe. Unfortunately, all of these works are currently either unfinished or out-of-print.

SATOSHI KON

Dates
Born 1963 in Hokkaidō, Japan
Died 2010 in Tokyo Prefecture

Debut
with "Kaikisen," which appeared in *Young Magazine* in 1985

Best known works
"Opus"
"Kaikisen"

Anime adaption
"Perfect Blue"
"Sennen joyū" [Millennium Actress]
"Tokyo Godfathers"

サトコ！
その鉄砲を
下ろしなさい！

来るな!!

サトコ！

親にそんな物を
向けるなんて
頭がどうかしちゃっ
たんじゃないの!?

サトコ!!

キーン...

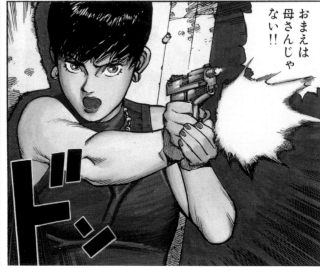

おまえは
母さんじゃ
ない!!

ドッ

Satoshi Kon ist heute als einer der bekanntesten Anime-Regisseure Japans bekannt, debütierte jedoch 1985 als Mangaka in *Young Magajin*, einem wöchentlich erscheinenden Manga-Magazin für junge Erwachsene. Von Anfang an brillierte er mit Bildern von überragender Stärke und außergewöhnlichem Realismus und daran hat sich auch bei seiner heutigen Tätigkeit als Zeichentrickfilmer nichts geändert. Typisch für seinen Stil ist der Manga „Kaikisen" [Tropic of the Sea], der in einer Gegend spielt, wo der Volksglaube der Fischer noch lebendig ist. In dieser tourismusgeschädigten Gemeinde wird ein rätselhaftes Lebewesen entdeckt, das an eine Meerjungfrau erinnert. Die sich daraus entwickelnden Komplikationen zeichnet Satoshi Kon mit sicherem Strich und reichen Gefühlsdarstellungen, die sich bis in die ruhigen Hintergründe erstrecken. Weitere Werke sind „Seraphim: 266613336 Wings" nach der Idee von Mamoru Oshii, „World Apartment Horror" nach dem gleichnamigen Film von Katsuhiro Ôtomo (Text: Keiko Nobumoto, Idee: Satoshi Kon) und „Opus": Hier gerät ein Mangaka in die von ihm geschaffene Welt und die dreidimensionale Welt vermischt sich mehr und mehr mit der zweidimensionalen. Leider wurden alle diese Serien unvollendet abgebrochen.

Satoshi Kon est un des principaux réalisateurs de films d'animation au Japon. Il a fait ses débuts en tant qu'auteur de mangas en 1985, avec une série publiée dans *Young Magajin*, un magazine de mangas seinen populaire (pour les jeunes hommes). Depuis ses débuts, il a toujours créé des images réalistes de haute qualité, ce qui n'a pas changé depuis qu'il est devenu réalisateur. Son histoire la plus célèbre, « Kaikisen » [Tropic of the Sea], se déroule dans une ville où ses habitants croient toujours à des légendes « d'êtres venus de la mer ». Le scénario évoque une créature ressemblant à une sirène qu'on a découvert dans la ville. Cette dernière est en passe de devenir une station balnéaire. Kon capture les émotions et rassemble des scènes tranquilles avec grande confiance. Il s'est ensuite associé au scénariste Mamoru Oshii pour créer « Seraphim: 266613336 Wings ». Il a également développé une version manga du film « World Apartment Horror » de Katsuhiro Ôtomo (d'après un scénario de Keiko Nobumoto, et d'une idée originale de Satoshi Kon), puis « OPUS », une histoire qui mêle des mondes en deux et trois dimensions, dans laquelle un auteur de mangas atterri dans son propre univers de mangas. Malheureusement, toutes ses œuvres sont inachevées ou ne sont plus publiées.

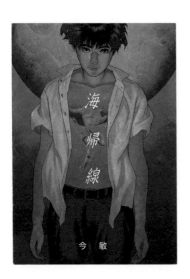

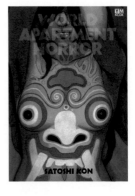

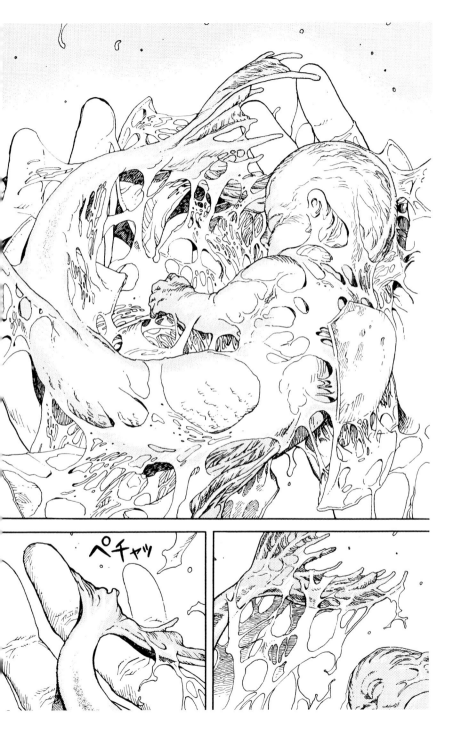

Soon to be adapted to animation, "Tonkatsu DJ Agetarô" has been published with great success by *Weekly Shônen Jump*, one of Shueisha's premium magazines. The duo Iipyao and Yûjirô Koyama have made the numbers with a simple story of Agetarô Katsumata, a music aficionado, a not intelligent but honorable man, whose family has owned a restaurant specializing in pork cutlets for three generations, and only thinks of DJ-ing. The surprising plot in their story comes from the fact that the main character Agetarô Katsumata doesn't possess any special power, keeping the story on the human level, generating great empathy with the readers. Known as newcomers in the category of gag manga, Iipyao (original writer of the title) and Yûjirô Koyama (in charge of the artwork) have demonstrated a unique sense of humor that ought to stay. After its weekly serialization at the end of 2014, shortly after its debut a panel from the comic went viral on the Internet, making the titles almost instantly popular.

YÛJIRÔ KOYAMA

DESIGN

LIPYAO

STORY

Born

Koyama Yujiro: 1990 in Tokyo, Japan

Debut

Koyama Yujiro: with
"Gentle kun" in 2014 published in
Weekly Shônen Jump

Best known works

"Tonkatsu DJ Agetarô"

Feature animation

"Tonkatsu DJ Agetarô"

Der Manga „Tonkatsu DJ Agetarô", der 2016 auch als Anime adaptiert wurde, erschien sehr erfolgreich in der Zeitschrift *Weekly Shônen Jump*, einem der Aushängeschilder des Verlagshauses Shueisha. Das Duo Iipyao und Yûjirô Koyama erzählt darin die einfache Geschichte des Musikliebhabers Agetarô Katsumata, eines schlichten, aber aufrichtigen Mannes, dessen Familie seit drei Generationen ein auf Schweineschnitzel spezialisiertes Restaurant besitzt und der nur von einer Karriere als Discjockey träumt. Das Überraschende an der Handlung ist, dass die Hauptfigur über keine besonderen Fähigkeiten oder Kräfte verfügt, so dass die Geschichte menschlich bleibt und das Mitgefühl der Leser weckt. Als Neulinge in der Gattung der Gag-Mangas bewiesen Iipyao (der Texter der Geschichte) und Yûjirô Koyama (verantwortlich für die Zeichnungen) einen einzigartigen Sinn für Humor. Kurz nach dem Debüt der Serie Ende 2014 wurde ein Bild daraus viral im Internet verbreitet, wodurch der Manga schlagartig Berühmtheit erlangte.

Bientôt adapté en animation, « Tonkatsu DJ Agetarô » a été publié avec succès par *Weekly Shônen Jump*, l'un des magazines phares de Shueisha. Le duo formé par Iipyao et Yûjirô Koyama a décroché le gros lot grâce à l'histoire d'Agetarô Katsumata, un passionné de musique qui ne pense qu'à être DJ : un homme guère intelligent mais honorable, dont la famille a tenu un restaurant spécialisé en côtelettes de porc pendant trois générations. La surprise dans l'intrigue tient au fait que le protagoniste ne possède aucun pouvoir particulier, ce qui confère à l'histoire un caractère humain et provoque l'empathie des lecteurs. Considérés comme novices en matière de manga comique, Iipyao (auteur original du titre) et Yûjirô Koyama (chargé des illustrations) ont démontré un sens de l'humour sans pareil. Peu de temps après la parution hebdomadaire de la série fin 2014, une vignette est devenue virale sur Internet et a assuré la popularité quasi immédiate des titres.

Working under a male pseudonym, Mitsurô Kubo is one of the greatest female mangakas in Japan, recognized mostly on account of "Moteki," a hit about a 29-year-old virgin man who suddenly receives romantic attention from many attractive girls. It was adapted into a Japanese television drama in 2010 and a subsequent live-action feature film in 2011, directed by Hitoshi One. In a story that showcases the relationship difficulties of temporary worker Yukiyo Fujimoto, Kubo works her best into the complexities of Japanese society, with compelling graphics and narrative. Known also for "Byôshi!!," "Again!!," "Shiawase 5 han," and "Tokkyû!!," the artist has explored a variety of approaches to her stories, sometimes within the same title, from comedy to drama, from action to supernatural. Born in 1975 in Nagasaki Prefecture in southern Japan, Mitsurô Kubo has published her series "Again!!" in the prestigious Kôdansha's *Shûkan Shônen Magajin*, which in 2014 was premiered as a live-action television feature.

M I T S U R Ô K U B O

Born
1975 in Nagasaki Prefecture, Japan

Debut
with "Shiawase 5 han" in 1996 published in *mimi*

Best known works
"Moteki"
"Again!!"

TV adaption
"Moteki"
"Again!!"

Feature film
"Moteki"

Prizes
• *Nakayoshi* magazine's manga school: Encouragement award (2003)
• *Nakayoshi* magazine's manga school: Silver award in gag catego (2004)

Unter dem männlichen Pseudonym Mitsurô Kubo wurde die 1975 in der südjapanischen Präfektur Nagasaki geborene Künstlerin zu einem der führenden weiblichen Mangaka Japans. Bekanntheit erlangte sie hauptsächlich durch ihre Reihe „Moteki", in der eine 29-jährige männliche Jungfrau plötzlich ins romantische Visier zahlreicher attraktiver Mädchen gerät. Die Geschichte wurde 2010 als Realserie fürs Fernsehen und 2012 unter der Regie von Hitoshi One als Spielfilm adaptiert. Kubo setzt sich in dieser Erzählung, die die Beziehungsprobleme des Zeitarbeiters Yukiyo Fujimoto aufzeigt, anhand fesselnder Bilder und Texte mit den Komplexitäten der japanischen Gesellschaft auseinander. In anderen Mangas hat sich die Künstlerin, von der auch „Byôshi!!", „Again!!", „Shiawase 5 han" und „Tokkyû!!" sehr bekannt sind, an verschiedenen Genres versucht und wechselt mitunter sogar innerhalb des gleichen Titels zwischen Komödie und Drama, Action und Übersinnlichem. Ihre Reihe „Again!!" wurde im angesehenen *Shûkan Shônen Magajin* des Verlagshauses Kôdansha veröffentlicht und 2014 als Realfilm für das Fernsehen adaptiert.

Exerçant sous un pseudonyme masculin, Mitsurô Kubo est l'une des plus célèbres mangakas du Japon. Elle s'est surtout fait un nom avec « Moteki », son grand succès sur un homme encore puceau à 29 ans et qui fait soudain l'objet d'intentions romantiques d'un grand nombre de femmes attirantes. L'histoire a été adaptée en 2010 en téléfilm puis en 2011 en long métrage par Hitoshi One. Dans une intrigue présentant les problèmes relationnels d'un travailleur temporaire, Yukiyo Fujimoto, Kubo dépeint avec brio les complexités de la société japonaise par le biais d'un récit et de graphismes convaincants. Également l'auteure de « Byôshi!! », Again!! », Shiawase 5 han » et « Tokkyû!! », l'artiste a exploré une variété d'approches pour ses histoires, parfois dans un même ouvrage, de la comédie au drame en passant par l'action et le surnaturel. Née en 1975 dans la province de Nagasaki, au sud du Japon, Mitsurô Kubo a publié la série « Again!! » dans le prestigieux *Shûkan Shônen Magajin* de Kôdansha avec en 2014 une adaptation en téléfilm.

Iou Kuroda is a manga artist whose style of presentation is one of the most talked about in the Japanese manga industry. He is known for the masterful way he develops his plots in a very manga-like manner. For instance, while the story may at first start out with the everyday life of an ordinary person, during the course of the manga, things heat up with the emergence of robots, elephants, bears, or some big event. The development of a character's changing facial expressions, the fast-paced dialogue, and the energy flow in Kuroda's lines and frames never fails to build up the excitement. The heated intensity never spans throughout the entire story, as there are always elements in his work that are slight- ly off kilter or humorous. Besides using a pen, he makes ample use of brushes for his manga drawings. In this way he is able to emphasize the contrast between black and white in his images. These images leave a strong impression, and the reader is drawn into a story that is simultaneous- ly full of tension and an energetic flow. He takes on new challenges by working with a variety of themes, such as present-day stories, historical fiction, and futuristic science fiction. He recently created a highly praised manga about a bicycle race, which was also made into an animated film. Even when using unorthodox story settings, Kuroda is an expert at vividly portraying the lives of ordinary people.

I K
O U
U R
O
D
A

Born

> 1971 in Sapporo, Hokkaidō Prefecture, Japan

Debut

> with "Ka, nanten, kuma, tôasa," which was published in *Monthly Afternoon* in 1993

Best known works

> "Dainippon tengutô ekotoba"
> "Nasu" [Eggplant]
> "Daiô"
> "Kurofune" [Black Ship]
> "Sexy Voice and Robo"

Prizes

> • 6th Agency for Cultural Affairs Media Arts Festival Grand Prize in the Manga Division (2002)

見ろ

魔法だ

Als einer der in Japan meistbeachteten Manga-Künstler, beweist Kuroda ein sicheres Gespür für die Manga-gerechte Umsetzung einer Story. Glaubt man sich beispielsweise in einer nüchternen Geschichte über das alltägliche Leben, wird man plötzlich überrumpelt von Robotern, Bären, Elefanten und diversen spektakulären Zwischenfällen. In flotten Dialogen und lebhafter Mimik entfaltet sich die Handlung; dynamische Strichführung und Bildaufteilung tragen das ihre zu einem aufregenden Leseerlebnis bei. Es geht hier aber nicht um vor Aufregung schweißnasse Hände, sondern eher um ein amüsiertes Konstatieren einer unbestimmt verschobenen Welt. Kuroda verwendet neben den bei Mangaka üblichen Stiften auch gerne Pinsel und betont so die Schwarz-Weiß-Akzentverteilung auf der Bildfläche. Ohne diese Wirkung zu schmälern, zeichnet er dazu dynamische Effektlinien, die den Leser in die Geschichte ziehen. Kuroda versucht sich an allen möglichen Themen, von historischen Dramen über Zeitgenössisches bis zu Sciencefiction. Sein vielbewunderter Manga über einen Radrennsportler wurde gar zur Vorlage für einen Kino-Anime. Iou Kuroda versteht es, auch in einem ungewöhnlichen Setting Alltagssituationen zu thematisieren und gilt als eines der ganz großen Manga-Talente.

Kuroda est un auteur dont le style est un des plus en vogue dans l'industrie des mangas japonais. Il est connu pour maîtriser le développement de ses scénarii dans un cadre propre aux mangas. Par exemple, tandis que l'histoire peut sembler débuter par la vie ordinaire d'une personne ordinaire, le lecteur est soudain confronté à des robots, des éléphants, des ours ou des événements importants. Les changements qui se produisent sur les visages des personnages, les dialogues rapides et l'énergie qui circule dans les lignes et les vignettes de Kuroda ne manquent jamais d'exciter les lecteurs. Cette intensité ne dure jamais tout au long de l'histoire : Kuroda intègre toujours des éléments humoristiques ou en décalage. En plus d'utiliser des feutres, il utilise très largement des pinceaux. De cette manière, il peut mettre l'accent sur le contraste du noir et du blanc dans ses images. Ses images laissent d'ailleurs une forte impression et les lecteurs sont attirés dans des histoires qui sont simultanément remplies de tension et de flux énergétique. Il travaille sur une variété de thèmes, telles que des histoires contemporaines, des fictions historiques, et de la science-fiction futuriste. Il a récemment créé un manga très apprécié à propos d'une course cycliste, qui a donné lieu à un film d'animation. Même lorsqu'il utilise des scénarii peu orthodoxes, Kuroda est un expert pour décrire la vie de gens ordinaires.

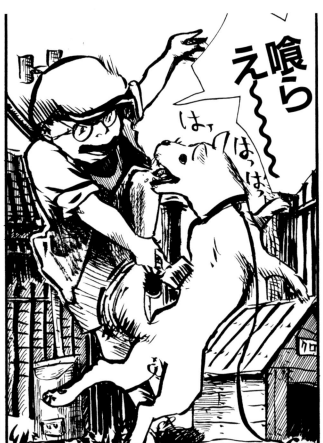

Masayuki Kusumi is best known for his original food stories in manga form. His bestselling title "Kodoku no gurume" [Loneliness of a Gourmet] is a story about the foodie business man Goro Inogashira, who enjoys his meal breaks always alone, a typical setting of modern-day Japan, where the "salary-man" work for long hours, are lonely, and find great pleasure looking for the best, yet simple, places to eat. Made into a longstanding hit TV drama which has run since 2012, it has captivated its fan base and has been now translated into nine foreign languages. Despite his success as a mangaka, Kusumi has been also an active musician, designer, and essayist. His debut, "Night," was released in 1981 in collaboration with Izumi Hare Osamu. Other titles which focus on food include "Gourmet Wilderness," "Hana Slob Rice," "Flat Asayu Wine," "Shrewdly Onsen," and "One Callings Yuriko." Among many other spin-offs of his titles, Kusumi's "Hana Slob Rice" has been made into a cookbook. Born in Tokyo in 1958, he has been awarded the Bungeishunjū Manga Award for his work in collaboration with his brother Takuya Kusumi (QBB) for their work in "Junior High School Student Diary."

M K
A U
S S
A U
Y M
U I
K
I

Born

1958 in Tokyo, Japan

Debut

with "Yagyō" in 1981 published in
Goro (drawing by Izumi Haruki)

Best known works

"Chūgakusei nikki" (by unit QBB)
"Kodoku no gurume" (drawing by
Taniguchi Jiro)
"Hana no zuborameshi" (drawing
by Mizusawa Etsuko)

TV adaption

"Kodoku no gurume"
"Hana no zuborameshi"

Feature film

"Chūgakusei nikki"

Prizes

• 45th Bungeishunjū Manga Award
• Ranked 1st in "This Is the Amazing
 Manga! Girl's Section 2012 (Kono
 manga ga sugoi! Onna hen 2012)"
 (2012)

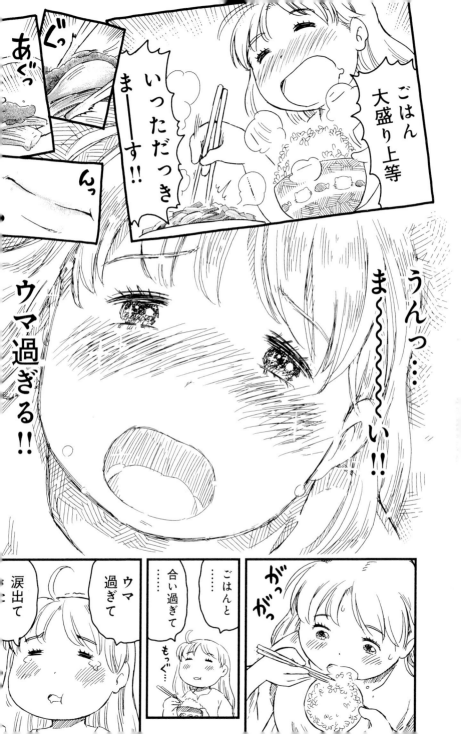

Masayuki Kusumi ist vor allem für seine originellen kulinarischen Geschichten in Manga-Form bekannt. Sein Bestseller „Kodoku no gurume" [Der Gourmet: Von der Kunst, allein zu genießen] ist die Geschichte des Geschäftsmanns und Feinschmeckers Goro Inogashira, der seine Essenspausen bevorzugt allein genießt – eine typische Situation im modernen Japan, wo Angestellte lange arbeiten, einsam sind und großes Vergnügen daran haben, hervorragende und zugleich einfache Restaurants ausfindig zu machen. Als Serie, die bereits seit 2012 im japanischen Fernsehen läuft, hat sich die Reihe eine breite Fangemeinde aufgebaut und wurde inzwischen in neun Sprachen übersetzt. Neben seinem Erfolg als Mangaka ist Kusumi auch Musiker, Grafiker und Essayist. Sein Debüt „Night" erschien 1981 in Zusammenarbeit mit Izumi Hare Osamu. Zu seinen weiteren Titeln, die kulinarische Themen behandeln, gehören „Kôya no gurume", „Hana no zuborameshi", „Flat Asayu Wine", „Chakkari onsen" und „One Callings Yuriko". Aus seinen Büchern entstanden zahlreiche Nebenprodukte, unter anderem auch ein Kochbuch nach der Vorlage von „Hana no zuborameshi". Der 1958 in Tokio geborene Künstler wurde für den Titel „Chûgakusei nikki", den er zusammen mit seinem Bruder Takuya Kusumi unter dem Pseudonym QBB. veröffentlichte, 1999 mit dem Bungeishunjû-Manga-Preis ausgezeichnet.

Masayuki Kusumi est surtout connu pour ses petites histoires gastronomiques sous forme de mangas. Son titre « Kodoku no gurume » [Le gourmet solitaire] raconte l'histoire de Goro Inogashira, un homme d'affaires foodie qui préfère manger seul, à l'image du Japon moderne où le travailleur fait de longues heures, mène une vie solitaire et adore découvrir les meilleurs restaurants. Adapté en série télévisée diffusée depuis 2012, il a su fidéliser son public et a été traduit dans neuf langues. Outre son succès comme mangaka, Kusumi est aussi musicien, designer et essayiste. Sorti en 1981, son premier titre « Night » s'est fait en collaboration avec Izumi Hare Osamu. D'autres de ses ouvrages portent sur la gastronomie, dont « Gourmet Wilderness », « Hana Slob Rice », « Flat Asayu Wine », « Shrewdly Onsen » et « One Callings Yuriko ». Parmi les nombreux dérivés de ses ouvrages, « Hana Slob Rice » a été adapté en livre de recettes. Né à Tokyo en 1958, il a obtenu le Prix du manga de la revue *Bungeishunjû* pour son travail en collaboration avec son frère Takuya Kusumi (QBB) pour « Junior High School Student Diary ».

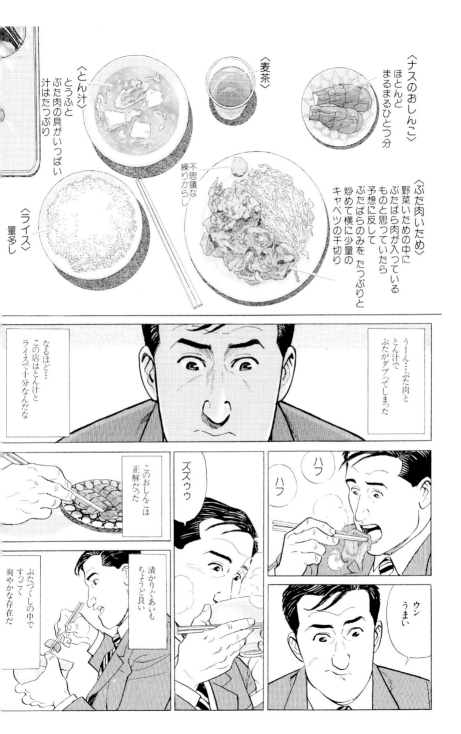

〈ナスのおしんこ〉
ほとんど
まるまるひとつ分

〈麦茶〉

〈とん汁〉
とうふと
ぶた肉の具がいっぱい
汁はたっぷり

〈ライス〉
量多し

不思議な
練りからし

〈ぶた肉いため〉
野菜いための中に
ぶたばら肉が入っている
ものと思っていたら
予想に反して
ぶたばらのみを たっぷりと
炒めて横に少量の
キャベツの干切り

うーん…ぶた肉と
とん汁で
ぶたがダブってしまった

なるほど…
この店はとん汁と
ライスで十分なんだな

ハフ
ハフ

ズズゥウ

ウン
うまい

このおしんこは
正解だった

漬かりぐあいも
ちょうど良い

ぶたづくしの中で
すっごく
爽やかな存在だ

Originally published online, due to its meteoric word-of-mouth popularity, "Sennen Gaho" catapulted Machiko Kyô's career before she signed up with Ôta Shuppan Publishing Company in 2008. A couple of years later, inspired by a visit to a pet shop in Jiyûgaoka where she bought a cat named Mum, Machiko Kyô set out to create another story. The simple lines and light colors have been strong characteristics of hers since her early beginning, after leaving art school. "Cocoon," her bestselling titles to date tells of Himeyuri, a girl who endured the tragic events in Okinawa during World War II. It didn't take long before the story with profound historical depth became appreciated, having now being exhibited in a number of galleries in Japan, Philippines, Vietnam, and Korea. The subject, enough to raise emotions and deep reflection, is approached in a compelling and candid way, imbued with subtleties that still today surround the contradictory feelings for that period. More recent titles from the artist include "Mitsuami no kami-sama," "Neko musume Mûmu," "Nymph," "Oni to hagoromo," and "Yoshino kita kôkô tosho iinkai."

M K
A Y
C Ô
H
I
K
O

Born

1980 in Tokyo, Japan

Debut

with "Hakai Shokogun" in 2010 published in *Weekly Shônen Champion*

Best known works

"Sora ga Haiiro dakara"
"Chi-chan wa Chotto Tarinai"

Prizes

- 74th New Face Manga Award of *Weekly Shônen Champion* (2010)
- 18th Japan Media Arts Festival: New Face Award in Manga Division (2014)
- Ranked 1st in "This Is the Amazing Manga! Girl's Section 2015 (Kono manga ga Sugoi! Onna hen 2012)" (2015)

Der Manga „Sennen Gaho", der ursprünglich online publiziert wurde und durch Mundpropaganda über Nacht zum Hit wurde, brachte Machiko Kyôs Karriere bereits ins Rollen, bevor sie 2008 beim Verlag Ôta Shuppan unter Vertrag genommen wurde. Einige Jahre später schrieb sie eine weitere Geschichte, angeregt durch einen Besuch in einer Tierhandlung in Jiyûgaoka, wo sie ihre Katze Mum kaufte. Einfache Striche und helle Farben waren von Anfang an, seit sie die Kunsthochschule verließ, eines ihrer Markenzeichen. „Cocoon", ihr bis heute meistverkaufter Manga-Titel, erzählt von dem Mädchen Himeyuri, das auf Okinawa während des Zweiten Weltkriegs schreckliche Ereignisse erlebt. Diese tiefgründige Geschichte mit historischem Hintergrund fand rasch großen Anklang und wird inzwischen von mehreren Galerien in Japan, Vietnam und Korea sowie auf den Philippinen ausgestellt. Das Thema, das Gefühle weckt und zum Nachdenken anregt, geht Kyô auf eine freimütige und mitreißende Art an, wobei sie auch nicht vor den Kontroversen zurückschreckt, die die damalige Zeit bis heute auslöst. Zu den jüngeren Veröffentlichungen der Künstlerin gehören „Mitsuami no kami-sama ", „Neko musume Mûmu", „Nymph", „Oni to hagoromo" und „Yoshino kita kôkô tosho iinkai ".

D'abord publié en ligne et avec une popularité fulgurante, « Sennen Gaho » a catapulté la carrière de Machiko Kyô ; elle a en 2008 signé un contrat avec Ôta Shuppan Publishing Company. Deux ans après, inspirée par la visite d'une animalerie à Jiyûgaoka où elle a acheté son chat Mum, Machiko Kyô a élaboré une autre histoire. Les traits simples et les couleurs claires caractérisent son travail depuis ses débuts à la sortie de l'école d'art. Son grand succès « Cocoon » a pour protagoniste Himeyuri, une fille victime des événements tragiques d'Okinawa lors de la Seconde Guerre mondiale. Ce récit d'une profondeur historique a rapidement conquis les lecteurs, et il a fait l'objet d'expositions dans plusieurs galeries au Japon, aux Philippines, au Vietnam et en Corée. Le sujet en appelle aux émotions et à une réflexion poussée, et il est abordé d'une façon sincère et irrésistible, imprégné de subtilités qui aujourd'hui encore se retrouvent dans les sentiments contradictoires sur cette période. Plus récemment, l'artiste a signé les titres « Mitsuami no kami-sama », « Neko musume Mûmu », « Nymph », « Oni to hagoromo » et « Yoshino kita kôkô tosho iinkai ».

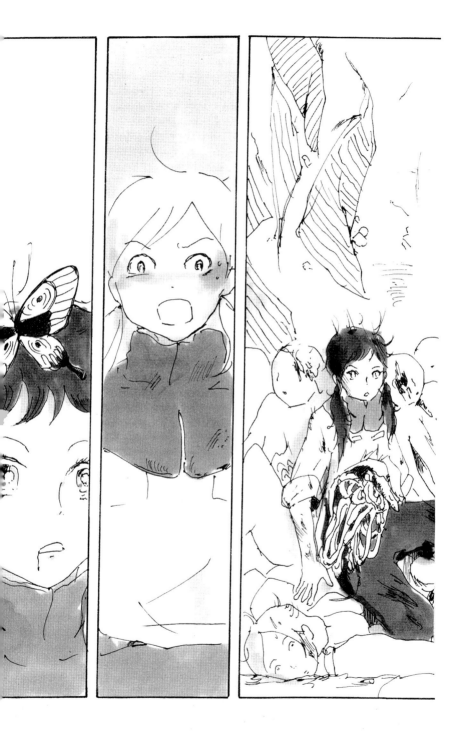

Gatarō Man first published his work in the *Weekly Shōnen Jump*, an orthodox *shounen* manga magazine with the highest distribution in Japan. He has a cult-like following as a brazen and unique gag artist, with his ugly characters and vulgar and violent stories. He has even poked fun at manga drawing techniques by copying the same frame many times over to use in a scene. His latest series "Chin'yūki" is based on the Chinese classic "Saiyūki" [Journey to the West], and the story develops similarly to a long distance journey movie. During this time he developed his eccentric style which established his huge popularity. The expressions on the faces of his characters have tremendous impact, and he breaks many conventional molds in the development of the story, creating his own unique and absurd world. In addition, he even makes himself the target of absurdity, by impudently revealing in his profiles that he is over two meters tall, or that he is a cyborg. Although his work does not have detailed story lines or precise frame layout, the essence of his gags have power and explosiveness.

GATARÔ MAN

Debut

with "Ningen nante RARARA" published in *Weekly Shōnen Jump* in 1990

Best known works

"Chin'yūki"
"Hade Hendrix monogatari" [Hade Hendrix Story]
"Jigoku Kōshien" [Battlefield Baseball]

Anime adaption

"Jigoku Kōshien" [Battlefield Baseball]

274—279

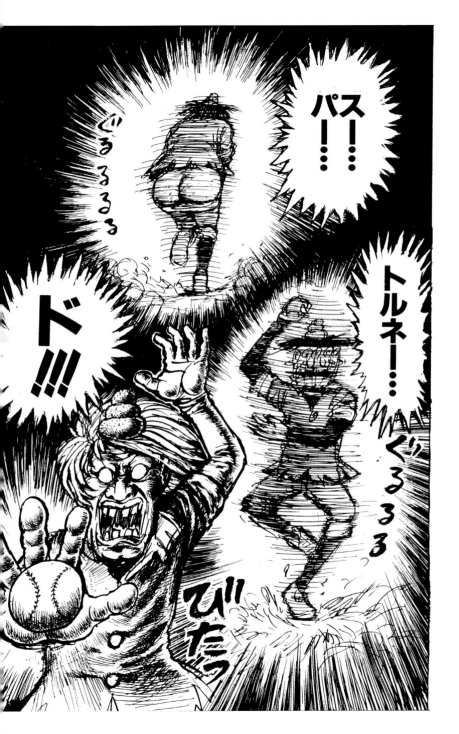

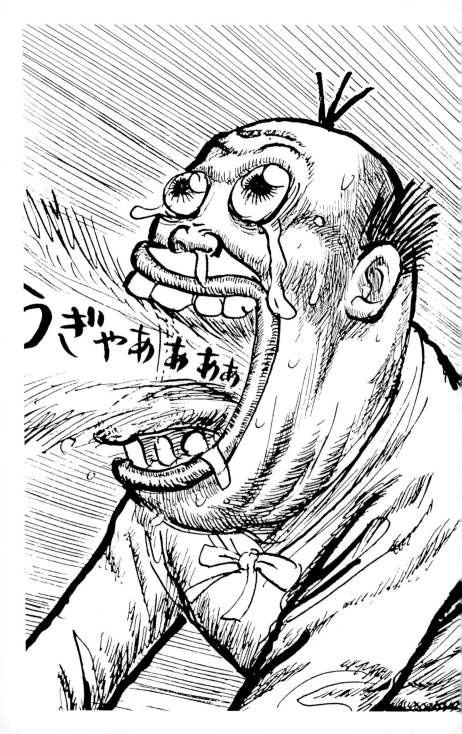

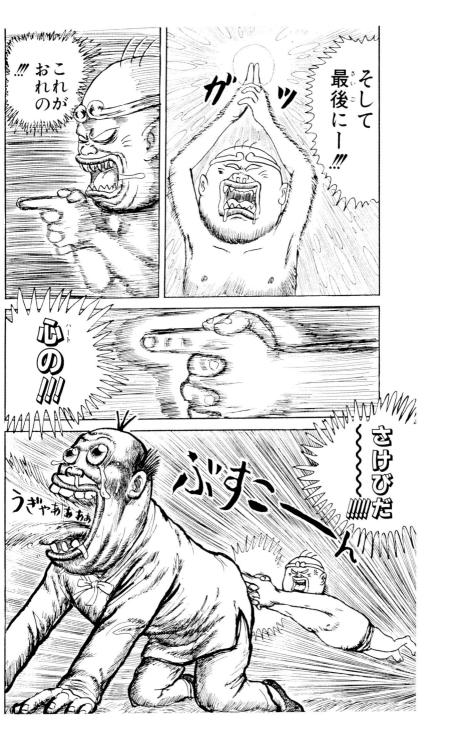

Gatarô Man debütierte zwar in „Shônen Jump", also im auflagestärksten Manga-Magazin klassischer *shônen*-Kost. Seine Fangemeinde, die ihn als Kultautor feiert, eroberte er sich jedoch mit hässlichen Zeichnungen, ordinären Geschichten voller Gewalt, bizarren, hohntriefenden Gags und sogar satirischen Attacken auf das Zeichnen von Mangas, wie in der endlosen Wiederholung des immer gleichen Bildes. Seine erste Serie „Chin'yûki", eine Art Roadmovie, basiert auf dem klassischen chinesischen Roman „Die Pilgerfahrt nach dem Westen", auf Japanisch „Saiyûki". Gatarô Mans exzentrischer Stil kam hier erstmals voll zur Geltung und der Manga wurde sehr populär. Insbesondere mit seiner Darstellung von Gesichtsausdrücken erzielte er große Wirkung. Storyentwicklung interessiert ihn wenig, vielmehr bricht er alle Spielregeln und entwirft eine Nonsens-Welt. Auch in seinen biografischen Angaben behauptet er gerne, über zwei Meter groß zu sein oder sich in einen Cyborg verwandelt zu haben – seine eigene Existenz dient ihm ebenfalls als Anlass für Witzeleien und Blödsinn. Eine raffiniert durchkonstruierte Handlung und ausgefeilte Bildaufteilung wird man in seinen Werken nicht finden. Das Vergnügen liegt vielmehr in den explosiven Gags, deren Schwung die Leser förmlich mitreißt.

Il a publié ses premières œuvres dans le magazine *Weekly Shônen Jump*, un magazine de mangas shounen classiques qui est le plus vendu au Japon. Il est adulé par ses fans et est un auteur humoriste unique, avec ses vilains personnages et ses séries vulgaires et violentes. Il s'est même moqué des techniques de dessin de mangas en répétant la même vignette de nombreuses fois pour composer une scène. Sa série la plus récente « Chin'yûki » est inspirée du classique chinois « Saiyûki » [Voyage vers l'ouest], et l'histoire évolue à la manière d'un long voyage. Il a développé son style excentrique qui lui a valu sa popularité. Les expressions sur les visages de ses personnages ont un impact énorme et son scénario innovant crée son propre monde unique et absurde. De plus, il se rend lui-même absurde en révélant imprudemment dans son profil qu'il fait plus de 2 mètres ou qu'il est un cyborg. Bien que ses œuvres n'aient pas de scénario détaillé ou de mise en page précise, l'essence de ses gags est explosive. Ce qui importe est la manière dont cette énergie est transmise aux lecteurs, et l'auteur utilise tout son potentiel pour accomplir cela.

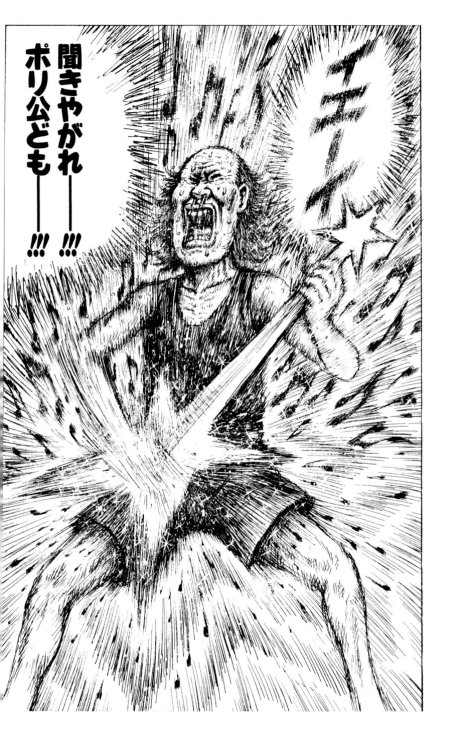

One of Shōhei Manabe's greatest successes was adapted into a film in 2010 after the best-selling manga "Yamikin Ushijima-kun" [Ushijima the Loan Shark]. The story, set in an underground society, telling of a girl who decides to pay off her mother's debt, is a typical plot of Manabe's world, which builds on the daily dilemmas of the contemporary Japanese society and its struggle with honor, family values, and indulgence, and ultimately desperation, to achieve happiness. The title has been featured in the *Monthly* *Big Comic Spirits*, a prestigious publication. In another case, "Dead End" [originally titled "The End"], tells the story of Shirou, a construction worker, sick of the typical boring routine, who has his wishes to end his monotony fulfilled by young Lucy, who falls naked from the sky to enter his life. The story evolves into a surreal plot to reconcile Lucy's appearance with the reality of his life. Other titles by Manabe include "Smuggler," "Kingen 100," and "Aozora no hate no hate."

SHÔHEI MANABE

Debut
with "Hato-kun" in 1993 in Gomes Manga Grand prix

Best known works
"Smuggler"
"Yamikin Ushijima-kun"

TV adaption
"Yamikin Ushijima-kun"

Feature film
"Smuggler"
"Yamikin Ushijima-kun"

Prizes
• 56th Shōgakukan Manga Award for General Manga (2010)

そうか。

村田久美子、来ましたよ。

丑嶋さん……

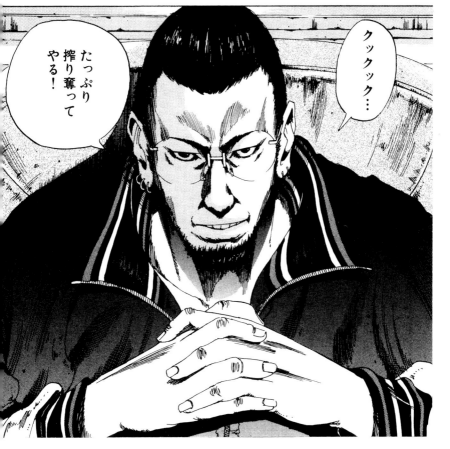

たっぷり搾り奪ってやる!

クックック…

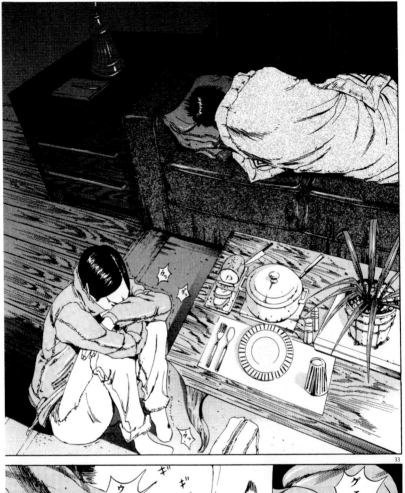

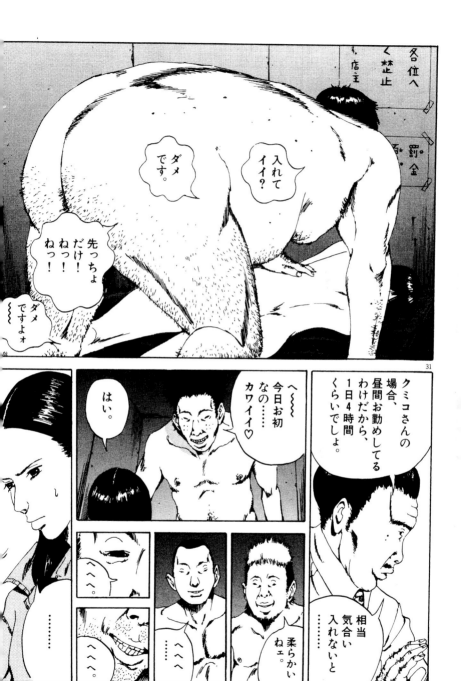

Einer von Shôhei Manabes größten Erfolgen, der Manga-Bestseller „Yamikin Ushijima-kun", wurde 2010 verfilmt. Die in einer Untergrund-zivilisation angesiedelte Geschichte handelt von einem Mädchen, das sich entschließt, die Schulden ihrer Mutter zu begleichen. Die Erzählung ist typisch für Manabes Welt, in der sich alles um die Zwickmühlen des Alltags in der modernen japanischen Gesellschaft dreht und um deren Auseinandersetzung mit Ehre, Familienwerten, Schwäche sowie dem verzweifelten Streben nach Glück. Der Titel erschien in der angesehenen Monatszeitschrift *Big Comic Spirits*. In seinem Manga „Ji Endo" [The End, in den USA Dead End] erzählt Manabe die Geschichte des Bauarbeiters Shirou, der seines Alltags überdrüssig ist und seinen Wunsch nach einem Ende der Monotonie erfüllt sieht, als das Mädchen Lucy nackt vom Himmel in sein Leben stürzt. In der surrealen Handlung versucht er, Lucys Erscheinen mit der Wirklichkeit seines Lebens in Einklang zu bringen. Darüber hinaus schrieb Manabe unter anderem „Smuggler", „Kingen 100" und „Aozora no hate no hate".

En 2010, l'un des plus grands succès de Shôhei Manabe, « Yamikin Ushijima-kun » [Ushijima, l'usurier de l'ombre], a été adapté en film. Se déroulant dans une société clandestine, l'histoire raconte comment une fille décide de régler les dettes de sa mère. Il s'agit d'une intrigue courante dans le monde de Manabe, inspiré des dilemmes quotidiens de la société japonaise d'aujourd'hui et de sa lutte avec l'honneur, les valeurs familiales, l'indulgence et le désespoir pour atteindre le bonheur. L'œuvre est parue dans la prestigieuse publication *Monthly Big Comic Spirits*. Dans l'ouvrage « Dead End » (d'abord intitulé « The End »), Manabe raconte l'histoire de Shirou un ouvrier de la construction las de sa routine : l'apparition de Lucy, tombée nue du ciel, vient mettre fin à cette monotonie mais quand l'histoire se transforme en intrigue surréaliste, il se trouve face à un mystère à résoudre. Manabe est aussi l'auteur de « Smuggler », « Kingen 100 » et « Aozora no hate no hate ».

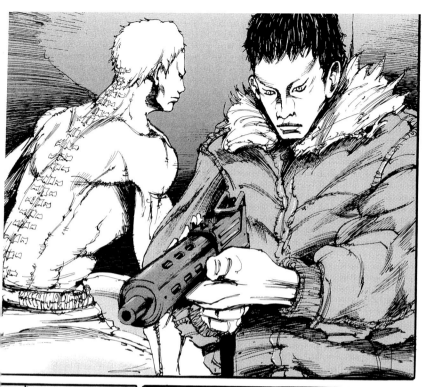

Suehiro Maruo is a manga artist with a cult-like following in Japan as well as overseas. He skillfully uses artistic techniques such as lines and solidly colored images, and combines it with realism. This gives his drawings a finely detailed illustrative style. In particular, the images he brings to life with this beautiful style are outstanding. He skillfully depicts girls and boys with smooth doll-like qualities, and the various grotesque characters they encounter – the ugly hairy guy, a pregnant woman, a freak, a deformed man, a maniac, a murderer, etc. These characters wind up getting cut up with blood splattering everywhere, as their inner organs are displayed. In addition, many boys and girls are cruelly killed at the mad and sadistic whims of others. However, there is no serious hidden message in his stories, which are drawn in an indifferent manner. In fact they contain more of a sense of humor. Rather than relying on the coherence and logical aspects of the story, he prefers to get his point across with destructive power and explosive images. There is a sense of thrill in seeing his cruel stories portrayed in the gekiga-like style. He does not concern himself with the story or the meaning of "death," and this is what gives his worlds a genuine and unmatched originality. He publishes mostly short stories, but in "Shôjo tsubaki" [Mr. Arashi's Amazing Freak Show] he tells the tale of a young girl called Midori who goes from a miserable home life to life in a freak show.

SUEHIRO MARUO

Born

1956 in Nagasaki Prefecture, Japan

Debut

with "Ribbon no kishi" published in *Garo* magazine in 1980

Best known works

"Barairo no kaibutsu" [The Rose-Colored Monster]
"National Kid"
"Shôjo tsubaki" [Mr. Arashi's Amazing Freak Show]
"Maruo jigoku" [Maruo Hell]

Anime adaption

"Shôjo tsubaki" [Mr. Arashi's Amazing Freak Show]

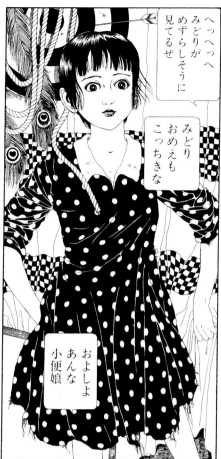

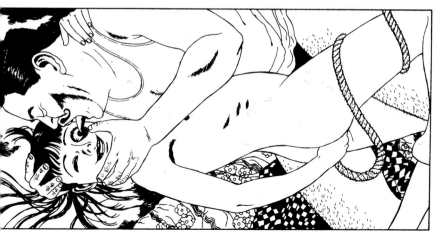

Suehiro Maruo genießt sowohl in Japan als auch im Ausland einen Ruf als Kultautor. Seine kunstvolle Linienführung und der flächige Einsatz von Schwarz zusammen mit wirklichkeitsgetreuer Darstellung erinnern an Buchdruckillustrationen. Die Inhalte, die in diesem wunderschönen Zeichenstil transportiert werden, verdienen genauere Beachtung: Kleine Jungen und Mädchen, die so hübsch hergerichtet sind wie Puppen, kontrastieren mit monströsen Gestalten – hässliche, haarige Erwachsene, schwangere Frauen, Missgestaltete, Krüppel, Verrückte, Mörder. Diverse Protagonisten werden aufgeschlitzt, überall spritzt Blut, innere Organe werden herausgeschnitten. Zahlreiche Kinder sterben einen elenden Tod, verursacht durch wahnsinnige, sadistische Begierden. Diese Szenen dienen jedoch nicht einem ernsten Thema, sondern wirken eher teilnahmslos gezeichnet, ja man spürt sogar so etwas wie Humor. Die Handlung ist nicht unbedingt schlüssig, der Schwerpunkt liegt vielmehr auf zerstörerischer Kraft in einer Explosion von Bildern. Sie vermittelt den erregenden Schauder einer in Bilder umgesetzten grausigen Geschichte. Da Maruo sich nicht mit Erzählstruktur oder der realen Bedeutung von Tod aufhält, wirkt seine Welt rein und absolut unvergleichlich. Er zeichnet hauptsächlich Kurzgeschichten, aber als Einstiegswerk, das seinen Stil gut vermittelt, kann der Einzelband „Shôjo tsubaki" [Mr. Arashi's Amazing Freak Show] gelten. Die Handlung dreht sich hier um das Mädchen Midori, das aus elenden Verhältnissen stammt und in einem bizarren Wanderzirkus landet.

Maruo est un auteur de mangas adulé au Japon et à l'étranger. Il utilise avec talent des techniques artistiques telles que des lignes et des images colorées, et les combine avec un certain réalisme. Ses dessins ont un style illustratif finement détaillé. En particulier, les images qu'il dessine dans ce style sont exceptionnelles. Il dépeint parfaitement des filles et des garçons, qui ressemblent à des poupées, ainsi que les différents personnages grotesques qu'ils rencontrent, tels qu'un horrible type poilu, une femme enceinte, un monstre, un homme déformé, un maniaque, un meurtrier, etc. Ces personnages finissent par être découpés, le sang gicle partout et leurs organes sont exposés. De plus, de nombreux garçons et filles sont tués cruellement selon les caprices sadiques des uns ou des autres. Ses histoires ne contiennent toutefois pas de message caché et sont dessinées de manière indifférente. En fait, elles dénotent plutôt un certain sens de l'humour. Plutôt que de s'appuyer sur des aspects de cohérence et de logique pour l'histoire, il préfère transmettre son message à l'aide d'images explosives et d'un pouvoir destructeur. Il se dégage un certain frisson de ses histoires cruelles dépeintes dans un style gekiga. Il ne se préoccupe pas de la signification de la mort. C'est ce qui donne à son monde une originalité unique et sans précédent. Il publie principalement des histoires courtes, mais dans « Shôjo tsubaki » [Le cirque des monstres de Mr Arashi] il raconte l'histoire d'une jeune fille nommée Midori qui passe d'une vie de famille misérable à une vie dans un cirque de monstres.

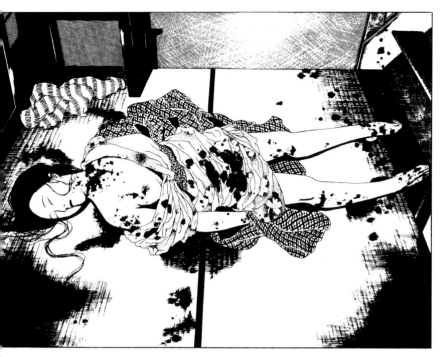

みんな
あんたが
悪い

あんたが
悪いんだ
ぞ!!

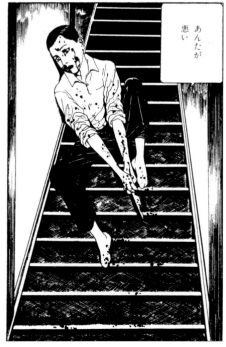

あんたが
悪い

Ever since he first published his work in a manga magazine to debut at the young age of 15, he has continued to be active in Japan's manga world for some 50 years. When he first debuted, he wrote mostly for *shoujo* manga magazines but in the 1960's he switched to *shounen* manga magazines. He won the Kôdansha Culture Award with the publication of "Otoko oidon" [I Am a Man], in which he wrote about his experiences with poverty while living in a tiny apartment during his bachelor years. He then wrote "Uchûsenkan Yamato" [Space Cruiser Yamato], in which the crew of the Yamato goes on a heroic journey to a distant planet to try to save the earth. In 1974 it was made into an animated series, and the subsequent release of the animated movie version caused a social sensation. Another phenomenal hit was "Ginga Tetsudô 999" [Galaxy Express 999] about a boy who sets off on a journey through space. Through the years Matsumoto was able to depict various worlds, from the dilapidated apartment room to the huge expanse of space. However, the constant theme to his works seems to be the growth and development of boys and young men who, through their bravery and ambition, overcome loneliness. In addition, the popularity of a space pirate character named Captain Harlock that appeared in "Ginga Tetsudô 999" [Galaxy Express 999] led to the creation of a successful spin-off series. Matsumoto's space-themed manga make him one Japan's leading science fiction writers.

LEIJI MATSUMOTO

Born
1938 in Fukuoka Prefecture, Japan

Debut
with "Mitsubachi no bôken" [Adventures of a Honeybee] published in *Manga Shônen* in 1954

Best known works
"Otoko oidon" [I Am a Man]
"Uchûsenkan Yamato" [Space Cruiser Yamato]
"Ginga Tetsudô 999" [Galaxy Express 999]

Anime & Drama
"Ginga Tetsudô 999" [Galaxy Express 999]
"Uchû kaizoku Captain Harlock" [Space Pirate Captain Harlock]

Prizes
• 3rd Kôdansha Culture Award Children's Manga Award (1972)
• 7th Japan Cartoonists Association -Special Prize (1978)
• Purple Ribbon Medal (2001)

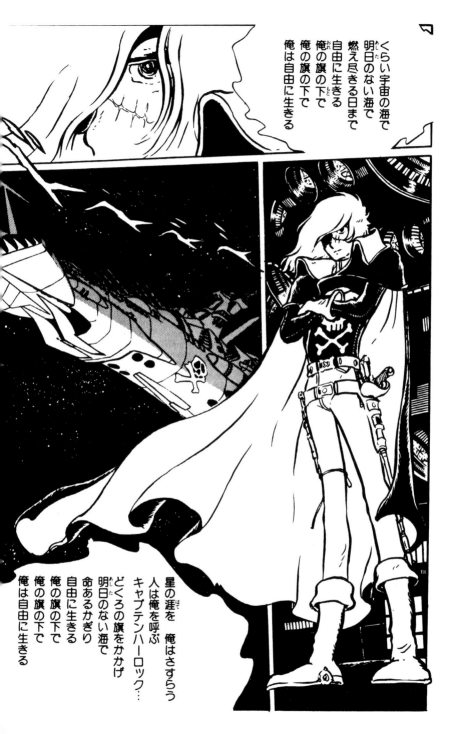

くらい宇宙の海で
明日のない海で
燃え尽きる日まで
自由に生きる
俺の旗の下で
俺は自由に生きる

星の涯を　俺はさすらう
人は俺を呼ぶ
キャプテンハーロック…
どくろの旗をかかげ
命あるかぎり
明日のない海で
自由に生きる
俺の旗の下で
俺の旗の下で
俺は自由に生きる

Mit 15 reichte er einen Beitrag bei einem Manga-Magazin ein, der prompt veröffentlicht wurde und den Beginn seiner bisher über 50-jährigen Karriere als Mangaka darstellte. Zunächst zeichnete Matsumoto für *shôjo*-Magazine, konzentrierte sich seit den 1960er Jahren aber mehr und mehr auf *shônen*-Mangas. Mit „Otoko oidon" [I Am a man], in dem er eigene Erlebnisse als armer Jungeselle in einem winzigen Zimmerchen verarbeitete, gewann er schließlich den Kulturpreis des Kôdansha-Verlags. In „Uchûsenkan Yamato" zeichnete er die tragische Weltraumreise einer Gruppe von Astronauten, die zu einem weit entfernten Planeten aufbrechen, um die Erde zu retten. 1974 lief die Anime-Serie im Fernsehen und der spätere Kino-Anime löste eine derartige Welle der Begeisterung aus, dass man bereits von einem gesellschaftlichen Phänomen sprach. Die Zugreise eines kleinen Jungen, der einen Maschinenkörper und damit ewiges Leben erlangen möchte, steht im Mittelpunkt von „Ginga Tetsudô 999". Aus dem winzigen Zimmer wurde der weite Weltraum, die eigentlichen Themen des Autors blieben jedoch die gleichen: die Entwicklung seiner jungen Protagonisten, ihre Einsamkeit und wie sie mit Mut und Ehrgeiz dagegen angehen. Mit Serien wie „Captain Harlock" um den Piraten, der bereits in „Ginga Tetsudô 999" einen Gastauftritt hatte, erzeichnete sich Matsumoto schließlich eine unangefochtene Spitzenstellung im Weltraum-Sciencefiction-Manga.

À ses débuts à 15 ans il a principalement écrit pour les magazines de mangas shoujo, mais durant les années 1960, il est passé aux magazines de mangas shounen. Il a reçu le Prix culturel Kôdansha pour son œuvre « Otoko oidon » [Je suis un homme], dans laquelle il a écrit sur sa propre expérience de la pauvreté. Il a ensuite écrit l'histoire « Uchûsenkan Yamato » [Navette spatiale Yamato], dans laquelle l'équipage du Yamato part pour une aventure héroïque sur une lointaine planète dans le but de sauver la Terre polluée par des déchets nucléaires. En 1974, cette histoire est devenue une série animée, et le film d'animation qui a suivi a fait sensation parmi les jeunes de l'époque. Une autre de ses séries populaires est « Ginga Tetsudô 999 » [Galaxy Express 999], qui décrit un garçon partant dans l'espace à la recherche de la vie éternelle. La solitude du personnage principal et les nouveaux personnages qu'il rencontre et quitte à chaque arrêt du train, sont dépeints avec lyrisme. Matsumoto a dépeint des mondes différents au travers de sa carrière, que ce soit des appartements délabrés ou de vastes régions spatiales. Toutefois le thème récurrent de ses œuvres semble être le développement des jeunes garçons et des jeunes hommes qui, grâce à leur bravoure et leur imagination, réussissent à vaincre leur solitude. La popularité d'un pirate de l'espace nommé Capitaine Albator, qui est apparu dans « Ginga Tetsudô 999 » a conduit à la création d'une série animée populaire. Les mangas de Matsumoto sur des thèmes spatiaux ont fait de lui l'un des principaux auteurs de mangas de science-fiction du Japon.

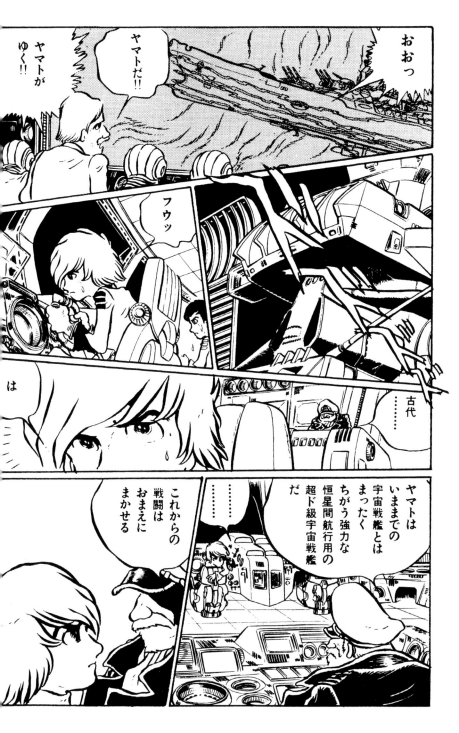

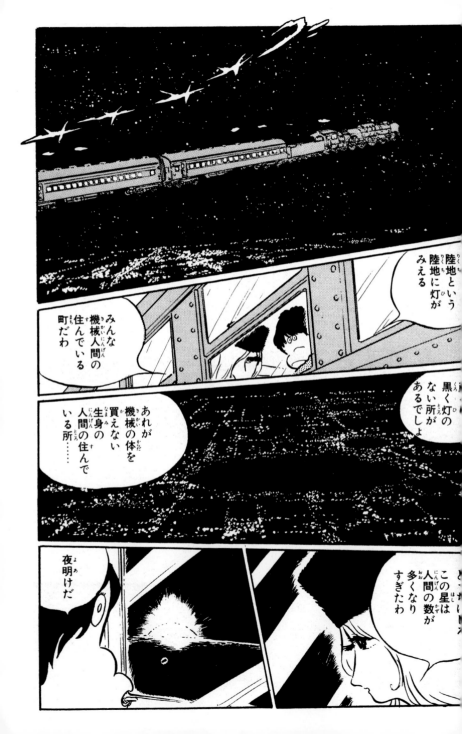

He prefers to draw all his images using freehand, creating nostalgic backgrounds and expressions. The world Taiyō Matsumoto portrays is drawn with sketchy wavering lines. In rainy scenes, the reader almost feels the humidity rising from the pages. Readers can also feel the silence in the darkness and the heat on a sunny summer day. He has fascinated readers with his skilled expressions. The images and illustrations he creates are highly original, unlike any others in the industry. He seems to have brought a welcome new change to the manga industry. His stories include "Ping-Pong" about the friendship between Peco who aims to be the world's best ping-pong player, and Smile, a cool character who never smiles and has no ambition. With the use of clever composition, he gives his images the feeling of speed. He manages to build tension and a rhythm to the story with smart dialogue and a poetic lyricism. He creates a sport manga unlike any seen before, where we can feel the essence of the sport. He liberally uses extreme close-ups with fisheye lens camera work to help create a climactic effect to his manga. He has also published long version tankoubon manga that are directly published in book form, which are not seen much in Japan. He has been very active with works such as his recent "No. 5," which features highly original and international background and characters. He has many fans among the youth, and he is considered one of the top manga artists working today at the forefront of the industry.

TAIYÔ MATSUMOTO

Born
1967 in Tokyo, Japan

Debut
with "Straight" published in a special issue of *Monthly Afternoon* magazine in 1986

Best known works
"Tekkon kinkuriito" [Black & White]
"Ping-Pong"
"No. 5"
"Gogo Monster"

Anime adaption
"Tekkon kinkuriito" [Black & White]
"Ping-Pong"
"Aoi haru" [A Blue Spring]

Prizes
• 30th Japan Cartoonists Association Special Prize

Alle Bilder sind mit weichem Strich ausschließlich von Hand angefertigt, Hintergrund und Typografie wirken unbestimmt nostalgisch. Diese mit sanft krakeligen Linien gezeichnete Welt des Taiyô Matsumoto fasziniert mit einer unvergleichlichen Ausdruckskraft. Die Luftfeuchtigkeit bei Regenszenen ist fast körperlich erfahrbar, genauso wie die Mittagshitze an einem Sommertag oder die Stille in der Dunkelheit. Solche in Mangas und Illustrationen bisher nie dagewesenen Bilder brachen mit explosiver Wirkung in die Manga-Szene ein. In „Ping-Pong" dreht sich die Handlung um zwei sehr unterschiedliche Freunde: Der offene, direkte Peco möchte unbedingt zum weltbesten Tischtennisspieler werden, während der zurückhaltende Smile, der sich nie auch nur zu einem Lächeln versteigt, völlig ohne Ehrgeiz ist. Matsumotos kunstfertige Zeichnungen vermitteln Geschwindigkeit, poetische Gefühlsbeschreibungen zusammen mit den Dialogen schaffen Spannung und Rhythmus. Auf eine andere Art und Weise als dies in bisherigen Sport-Mangas der Fall war, fühlt sich der Leser unmittelbar am Geschehen beteiligt. Filmähnliche Techniken, wie extreme Nahaufnahmen oder durch ein Fischaugenobjektiv verzerrte Optik tragen zum Reiz dieser ungewöhnlichen Arbeit bei. In langen Geschichten, die er – für Japan eher ungewöhnlich – direkt als *tankôbon* veröffentlichte, und in seinem neuesten Werk „No.5" erschafft er mit Charakteren und Schauplatz eine ganz eigene Atmosphäre, die keinem Land eindeutig zuzuordnen ist. Seine Werke gelten als Autoren-Mangas, werden aber vom jungen Publikum begeistert aufgenommen. Taiyô Matsumoto wird seinen Weg als Ausnahmetalent an vorderster Stelle fortsetzen.

Taiyô Matsumoto préfère dessiner toutes ses images à la main, et il crée des décors et des expressions nostalgiques. Le monde qu'il dépeint est fait de lignes ondulantes et vagues. Dans les scènes pluvieuses, les lecteurs pourraient presque sentir l'humidité remonter des pages. Les lecteurs peuvent également ressentir le silence de la nuit et la chaleur d'un jour ensoleillé. Il a fasciné les lecteurs avec ses expressions réalistes. Les images et les illustrations qu'il crée sont véritablement originales, au contraire des autres dessinateurs. Il semble avoir introduit un changement dans le monde des mangas. Son histoire « Ping-Pong » décrit l'amitié entre Peco, qui cherche à devenir le meilleur joueur de ping-pong du monde, et Smile, un personnage cool qui ne sourit jamais et n'a aucune ambition. Grâce à une composition astucieuse, il donne une impression de vitesse à ses images. Il parvient à donner une tension et un rythme à l'histoire grâce à des dialogues intelligents et un lyrisme poétique. Il a créé un manga sur le sport différent de tout autre, dans lequel nous pouvons ressentir l'essence sportive. Il utilise délibérément des plans très rapprochés avec des objectifs grand angle pour créer des effets frappants. Il a également publié des mangas tankoubon en version longue directement sous forme d'ouvrage relié, ce qui est peu courant au Japon. Il est très actif et a publié des œuvres telles que « N° 5 », qui décrit des situations et des personnages originaux et internationaux. Il a de nombreux fans parmi les jeunes et est considéré aujourd'hui comme l'un des meilleurs auteurs de mangas.

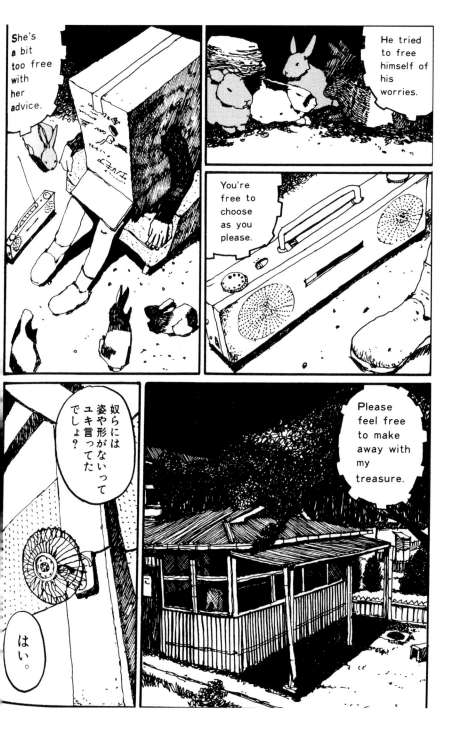

Ryôji Minagawa consistently continues to produce action manga. He creates fast-moving images using effective lines, and he specializes in fighting scenes that emphasize the characters. His best known manga is "Spriggan," which tells the story of the fight over an ancient and dangerous relic called O-Parts, something that modern science cannot explain. Various nations and sinister research organizations battle for its possession. Actual weapons such as guns, tanks, and aircrafts are drawn with precise accuracy. In addition, werewolves, aliens, and even spirits fight with an array of strange and unusual weaponry. Even when depicting fanciful creatures, his character designs are extraordinarily realistic, and in battle scenes along with highly detailed humans, it is easy to forget that the work is fiction. With Minagawa's excellent design sense and his powerful images, a simple combat theme evolves into a manga involving exploration and adventure as well. In 1999 he published "Arms," a story about a group of characters that gain mysterious transformational powers, for which he won the 44th Shôgakukan Manga Award.

RYÔJI MINAGAWA

Born
1964 in Tokyo, Japan

Debut
with "Heaven" published in *Weekly Shônen Sunday* in 1988

Best known works
"Spriggan"
"Arms"
"Kyô"

Anime adaption
"Spriggan"
"Arms"

Prizes
• 44th Shôgakukan Manga Award (1999)

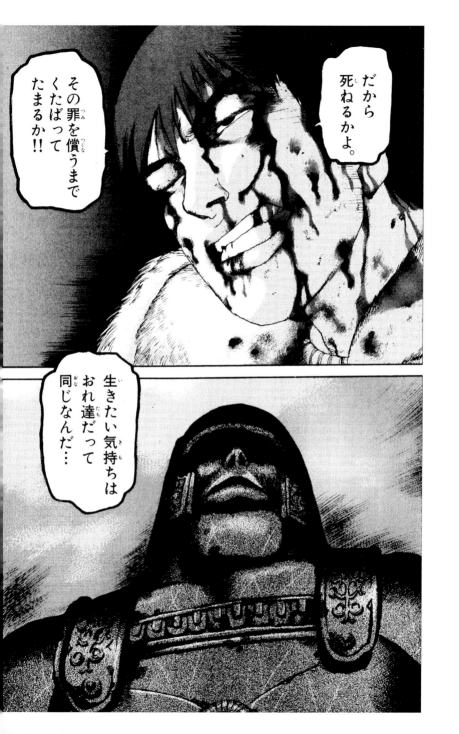

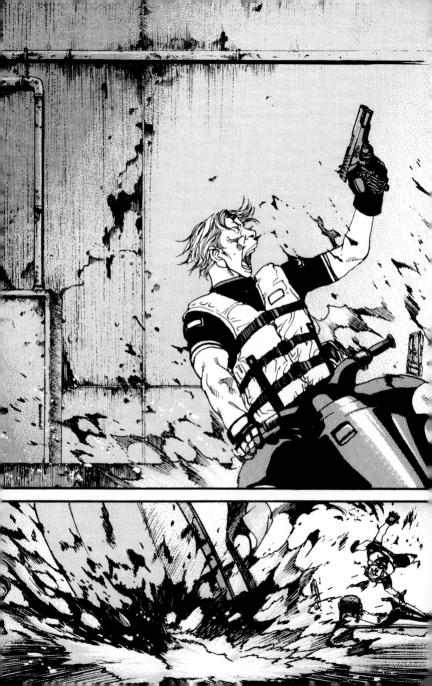

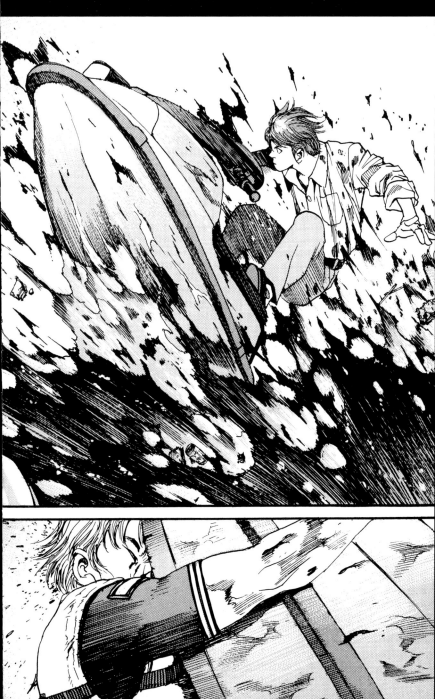

Unter verschwenderischem Einsatz von Effekt-linien zeichnet Minagawa Bilder voller Tempo. Seine Stärke liegt in der Darstellung von Kampf- und Schlachtenszenen, bei denen Menschen im Mittelpunkt stehen und so hat er sich folgerichtig dem Action-Genre verschrieben. Typisch für diesen Stil ist „Spriggan" [auch unter dem Titel „Striker" übersetzt]: Regierungen, Forschungs-einrichtungen und andere Gruppen bekämpfen sich auf das Heftigste, um an gefährliche Relikte einer untergegangenen Zivilisation zu gelangen. Deren potente Technologie ist nach dem heutigen Stand der Wissenschaft nicht mehr zu erklären. Mit akribischer Genauigkeit zeichnet Minagawa authentische Waffen, Panzer und Flugzeuge, belässt es aber bei weitem nicht dabei: Fantasie-gestalten, wie Wolfsmenschen, Außerirdische und Naturgeister beteiligen sich mit Fantasiewaffen ebenfalls am Kampfgetümmel. Obwohl es sich hier um Fabelwesen handelt, sind diese ausge-sprochen realistisch gezeichnet: Bei ihren minuti-ös wiedergegebenen Kämpfen mit den Menschen vergisst man die Fiktion. Minagawas Sinn für Design und seine dynamischen Zeichnungen machen aus einer simplen Kampf-Action-Story einen Abenteuer- und Expeditions-Manga. Für „Arms", in dem die jugendlichen Protagonisten sich mit Hilfe einer unbekannten Kraft verwandeln können, erhielt Ryôji Minagawa den 44. Manga-Preis des Shôgakukan-Verlagshauses.

Ryôji Minagawa continue de produire des man-gas d'action. Il crée des images rapides à l'aide de lignes efficaces et il se spécialise dans les scènes de combat qui mettent en valeur les per-sonnages. Son manga le plus connu est « Sprig-gan », qui raconte l'histoire d'un combat contre un ancien et dangereux monstre appelé « O-Parts », une bizarrerie que la science moderne ne peut expliquer. De nombreux pays et de sinistres insti-tuts de recherche se battent pour sa possession. Des armes telles que les pistolets, les chars et les avions sont dessinés avec une grande précision. De plus, des loups-garous, des extra-terrestres et même des esprits combattent à l'aide d'un arse-nal étrange et peu courant. Même ses créatures extravagantes paraissent véritablement réa-listes, et avec ses scènes de combat et ses hu-mains hautement détaillés, il est facile d'oublier qu'il s'agit d'œuvres de science-fiction. Grâce aux images fortes de Minagawa et à son excellent sens du design, un simple combat devient un manga impliquant de l'aventure et de l'explora-tion. En 1999, il a publié « ARMS », une histoire sur un groupe de personnages qui obtiennent de mystérieux pouvoirs de transformation, ce qui lui a valu le 44e prix du manga Shôgakukan.

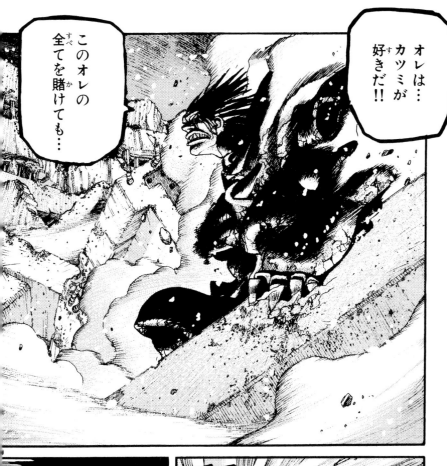

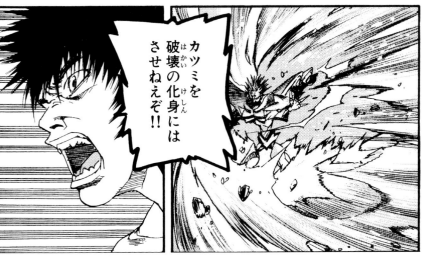

Nayuka Mine makes a great story from the beginning, not only with titles such as "Arasa-chan," the story of the sex lives of women in their 30s. The title that started on her website in 2011 was later on brought to print. Up to that point, for over five years, Mine was one of the most famous porn stars in Japan. However, the dream to be a mangaka had always been with her since childhood. After making her last film in 2011 entitled *Too Hot Lesbians: The Reason Vaginas Love Vaginas*, she decided to become a full time writer and manga artist. The artist is naturally constantly asked about sex, and the sex lives of ordinary people. Used to camera and public appearances, Nayuka Mine was once alleged to have claimed to "promise to coax even the shiest of social molluscs out of their shells." On another occasion, speaking to *The Japan Times*, she saw "their married friends sexless, bogged down caring for their husbands' infirm parents and so on, while they cavort worry-free with 20-something boyfriends." Once, she said, they were considered losers because they'd missed the marriage boat, but: "Who's having the last laugh now?"

NAYUKA MINE

Born

1984 in Gifu Prefecture, Japan

Debut

with "Arasa-chan" in 2011 published in *Weekly SPA!* magazine (first published on her online blog)

Best known works

"Arasa-Chan"
"Onna kudoki meshi"
"Sexy joyū-chan girigiri Mosaic"

TV adaption

"Arasa-chan"
"Onna kudoki meshi"

ゆるふわちゃんが結婚を焦る理由

普通の女子は何度かの進化を経て

30代 大人女子
20代 お姉さん
10代 女の子

ゆっくりとおばさんに向かっていきますが

40代 熟女

そしておばさんに…

童顔女子はほとんど変化のないまま

30代 ロリっこ
20代 ロリっこ
10代 ロリっこ

ある日突然かわいいおばさんになります

あめちゃん食べる?

5年後か!?明日か!?

私にはもう時間が残されていない!!

現在 34歳

肉便器ちゃんのフェチズム

童貞が好きすぎて童貞カミングアウトが自虐風自慢にしか聞こえない

ぼく童貞なんですよね…

なんだよオイオイ自慢かよ!!

そんなこと言ってもどうせ私にはヤラせてくれないんだろ!?

くそが!!

ああイラつく!!でも好き!!そういうところ大好きッ!!

わーん!!

とても複雑な気持ち

Die Biografie von Nayuka Mine ist von Anfang an interessant – und das nicht nur aufgrund von Titeln wie „Arasa-chan", einer Geschichte über das Sexualleben von Frauen in ihren Dreißigern, die sie 2011 zunächst auf ihrer Website veröffentlichte, bevor sie später auch gedruckt erschien. Bis zu diesem Zeitpunkt war Mine, die seit ihrer Kindheit davon geträumt hatte, Mangaka zu werden, mehr als fünf Jahre lang einer der berühmtesten Pornostars Japans gewesen. Nachdem sie 2011 ihren letzten Film mit dem Titel *Too Hot Lesbians: The Reason Vaginas Love Vaginas* abgedreht hatte, entschloss sie sich, fortan nur noch Mangas zu schreiben und zu zeichnen.Es überrascht nicht, dass die Künstlerin dennoch ständig zu Sex befragt wird. Mine, die Kameras und öffentliche Auftritte gewöhnt ist, soll einmal gesagt haben, sie könne „selbst die schüchternste Molluske aus ihre Schale locken". Bei einer anderen Gelegenheit, in einem Gespräch mit der *Japan Times*, verriet sie, dass ihre verheirateten Freundinnen keinen Geschlechtsverkehr mehr hätten und sich nur noch um die gebrechlichen Eltern ihrer Ehemänner kümmern würden, während sich die ledigen sorglos mit ihren 20-jährigen Liebhabern vergnügten. Einst hätten sie als Loser gegolten, weil sie den Zug der Ehe verpasst hätten, aber: „Wer lacht jetzt zuletzt?"

Dès le départ, l'histoire de Nayuka Mine est intéressante. Elle est l'auteure de titres comme « Arasa-chan », sur la vie sexuelle des femmes dans les années 30, une œuvre commencée sur son site Web en 2011 et publiée par la suite. En parallèle, pendant cinq années, Mine a été la plus grande star porno du Japon. Elle nourrissait cependant depuis son enfance le rêve d'être mangaka. Après la sortie en 2011 de son dernier film intitulé « Too Hot Lesbians: The Reason Vaginas Love Vaginas », elle a décidé de devenir une écrivain et artiste manga à part entière. L'artiste reçoit évidemment en permanence des questions sur le sexe et sur la vie sexuelle des gens ordinaires. Habituée des caméras et des apparitions en public, Mine aurait apparemment « promis de convaincre le plus timide des mollusques de sortir de sa coquille ». À une autre occasion, dans une interview au *The Japan Times*, elle a déclaré avoir vu « des amies en pleine abstinence avec leur mari, totalement dévouées à s'occuper des beaux-parents devenus dépendants, mais qui s'envoient tranquillement en l'air avec des amants d'une vingtaine d'années. D'abord considérées comme des ratées pour ne pas s'être épanouies dans leur mariage, elles peuvent bien rire maintenant ! »

#5

3点セット

グラビアポーズの極意は顔・乳・具を同時に見せることにある!!

Not very well known until quite recently, Natsujikei Miyazaki has been a revelation with two titles, "Henshin no News," and "Boku wa mondai arimasen," launched in 2011 and 2012 respectively. The first is a collection of short stories featuring the mystery of human behavior with a seemingly surreal and yet purist literature-like style. The second is an inquiry on how we judge people to be normal or strange, and who decides what the standards for those judgments are. It is a collection of eight short stories that lift the spirit of the reader. Tackling human sensitivity and exploring the wonders of the human mind though literature and poetry in comic form, Miyazaki courageously tries to develop a new type of narrative, a task seldom worth a try due to the complex structures of the manga market and its career pathways. The artist attracted attention at the Jury Selections of the 17th Japan Media Arts Festival in 2013, creating a wider awareness of his work for the first time.

NATSUJIKEI MIYAZAKI

Born

1987 in Miyagi Prefecture, Japan

Debut

with "Yūgata made ni kaeru yo" in 2010 published in *Morning Two*

Best known works

"Henshin no News"
"Boku wa mondai arimasen"

Prizes

- 56th Tetsuya Chiba Award: General Category Second Prize (2009)
- 17th Japan Media Arts Festival: Jury Selections in Manga Division (2013)

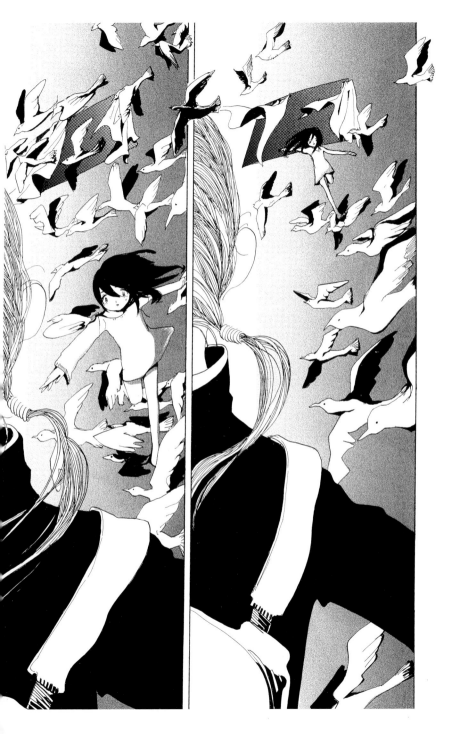

Der bis vor Kurzem noch weitgehend unbekannte Natsujikei Miyazaki sorgte 2011 bzw. 2012 mit den beiden Titeln „Henshin no News" und „Boku wa mondai arimasen" für Aufsehen. Ersterer ist eine Kurzgeschichtensammlung über die Rätselhaftigkeit menschlichen Verhaltens, die in einem scheinbar surrealen und doch puristischen literarischen Stil verfasst ist. Der zweite beschäftigt sich mit der Frage, wonach wir beurteilen, ob Menschen normal oder absonderlich sind und wer die Normen für solche Urteile festlegt. Es handelt sich auch hier um eine Sammlung von Kurzgeschichten – acht an der Zahl –, die erbaulich auf den Leser wirken sollen. Indem er durch Literatur und Poesie in Comicform menschliches Empfinden beleuchtet und die Wunder des menschlichen Geistes erforscht, versucht Miyazaki mutig, eine neue Art der Erzählform zu entwickeln, was sich aufgrund der komplexen Strukturen des Manga-Marktes und seiner typischen Karriereverläufe selten auszahlt. Durch die Auswahl des Preisgerichts für das 17. Japan Media Arts Festival 2013 rückte Miyazakis Werk erstmals in das Bewusstsein eines größeren Publikums.

D'une popularité assez récente, Natsujikei Miyazaki a créé l'événement avec les titres « Henshin no News » et « Boku wa mondai arimasen » [Je n'ai pas de problème], respectivement sortis en 2011 et 2012. Le premier est une série de nouvelles qui s'intéressent au mystère du comportement humain, dans un style apparemment surréaliste mais pour autant puriste sur le plan littéraire. Le second s'interroge sur la façon dont nous considérons autrui normal ou étrange, et qui dicte les normes de ces jugements. Cette série de huit nouvelles donne du baume au cœur au lecteur. En abordant la sensibilité humaine et en explorant les merveilles de l'esprit à travers la littérature et la poésie sous la forme de bande dessinées, Miyazaki tente courageusement d'élaborer un nouveau type de récit ; un effort rarement payant compte tenu de la complexité du marché du manga et des parcours professionnels habituels. L'artiste a été remarqué en 2013 par le jury du 17e Japan Media Arts Festival, ce qui a donné à son travail une grande visibilité.

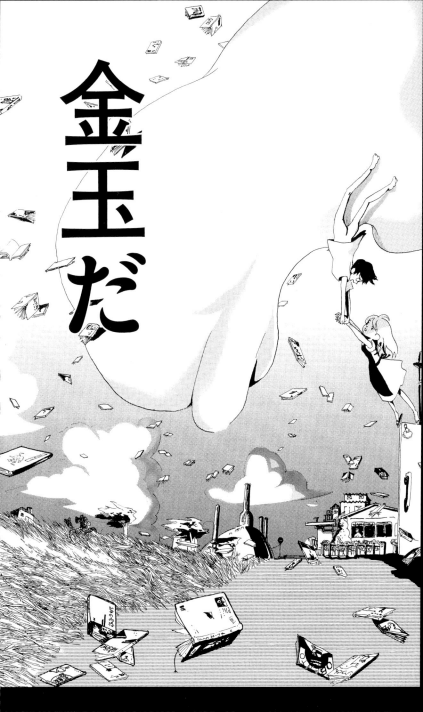

Shigeru Mizuki is a manga artist, as well as a *youkai* [spirits and demons] researcher. His popular series "GeGeGe no Kitarô" depicts the story of a *youkai* boy named Kitarô who punishes bad *youkai*. His unique hero story attracted considerable attention when first published. Mizuki has depicted the *youkai* from Japan's ancient myths and folklore, and introduces them in several of the *youkai* picture books he has written. Many Japanese kids have flipped through these books during their childhood. The character of Kitarô was first introduced during the days of rental bookshops, when Mizuki first started writing manga, but the character has continued to live on through the years. It has been published in new magazines, and it has been animated in a television series. It continues to remain a nationally loved character. Other works include "Akuma-kun" [Devil Boy] and "Kappa no Sanpei" [Sanpei the Kappa]. His stories, which combine children and strange creatures, continue to be popular. Also, after the tragic experience of losing his arm during World War II, he has worked as a peace-activist, writing manga about military history and the history of the Showa period. There is a "Shigeru Mizuki Memorial Museum" in his hometown in the Tottori Prefecture, and there is a street lined with *youkai* sculptures that has been christened "Mizuki Road."

S M
H I
I Z
G U
E K
R I
U

Dates

Born 1922 in Ôsaka Prefecture, Japan
Died 2015 in Tokyo Prefecture

Debut

with "Rocket Man" in 1957

Best known works

"GeGeGe no Kitarô" [Spooky Kitarô]
"Akuma-kun" [Devil Boy]
"Kappa no Sanpei" [Sanpei the Kappa]
"Komikku Shôwashi" [Comic History of the Showa Era]

TV adaption

"GeGeGe no Kitarô" [Spooky Kitarô]
"Akuma-kun" [Devil Boy]
"Kappa no Sanpei" [Sanpei the Kappa]
"Nonnonbaa to ore"

Prizes

• 6th Kôdansha Children's Manga Award (1966)
• 13th Kôdansha Manga Award (1989)
• Purple Ribbon Medal (1991)
• 25th Education Minister Award from the Japan Cartoonists Association (1996)
• 7th Tezuka Osamu Cultural Award Special Prize (2003)

柳条湖事件は
当時数百人の
中国兵の
しわざである
とされた……

しかし
後に明らかに
されたように
関東軍の
※板垣征四郎
※石原莞爾らが
中心となった
某略であった

Mizuki ist nicht nur als Mangaka, sondern auch als *yôkai*-Forscher bekannt [*yôkai* ist der japanische Ausdruck für Gespenster, Monster und Dämonen]. Mit „GeGeGe no Kitarô", einer Superhelden-Story der etwas anderen Art – ein kleiner Monsterjunge erteilt hier bösen Monstern eine Lektion – wurde er ungeheuer populär. Daneben widmete er sich Gespenstern aus alten japanischen Überlieferungen, um diese dann in „*yôkai*-Bilderlexika" einem breiten Publikum zugänglich zu machen. Es ist sicher nicht übertrieben zu behaupten, dass jedes japanische Kind schon einmal eine Monsterzeichnung von Shigeru Mizuki gesehen hat. Seine ersten Geschichten um Kitarô schrieb er in der Nachkriegszeit, als Mangas noch hauptsächlich über halblegale Leihbüchereien in Umlauf waren, später wurde die Serie für ein Manga-Magazin neu aufgelegt und schließlich sogar als Anime verfilmt: ein Manga von zeitloser, nationaler Popularität. Die Kombination Kinder und *yôkai* erwies sich auch in Serien wie „Akuma-kun" oder „Kappa no Sanpei" als Erfolgsgarant. Seine entsetzlichen Erfahrungen aus dem Zweiten Weltkrieg, in dem er einen Arm verlor, verarbeitete er in antimilitaristischen Kriegsaufzeichnungen und historischen Mangas über die Shôwa-Ära. In seiner Heimatpräfektur Tottori wurde vor Kurzem die Shigeru Mizuki Memorial Hall eröffnet und es gibt eine Mizuki-Road, die selbstverständlich von Monster-Statuen gesäumt ist.

Mizuki est un auteur de mangas ainsi qu'un chercheur de youkai (esprits et démons). Sa série populaire « GeGeGe no Kitarô » dépeint l'histoire d'un garçon youkai nommé Kitarô qui punit les mauvais youkai. Ce héros unique a attiré une attention considérable lorsque la série a été publiée pour la première fois. Mizuki dépeint les youkai des anciens mythes et du folklore japonais, et les utilise dans les différents livres d'images sur les youkai qu'il a réalisés. De nombreux enfants japonais ont feuilleté ses ouvrages Le personnage de Kitarô est apparu à l'époque où on pouvait louer des mangas dans des magasins spécialisés, lorsque Mizuki a débuté sa carrière, et le personnage a continué d'exister. La série a été publié dans de nouveaux magazines et a été animée pour la télévision. Kitarô reste un personnage adoré par le public. « Akuma-kun » [Un garçon diabolique] et « Kappa no Sanpei » [Sanpei le Kappa] font également partie de ses œuvres. Ses histoires combinent des enfants et des créatures étranges et sont très populaires. Depuis son expérience tragique de la Seconde Guerre mondiale, durant laquelle il a perdu un bras, il est devenu militant pour la paix et a écrit des mangas sur l'histoire militaire et la période Showa. Il existe un musée « Shigeru Mizuki Memorial Museum » dans sa ville natale située dans la préfecture de Tottori, et une des rues baptisée « Mizuki Road » est bordée de sculptures de youkai.

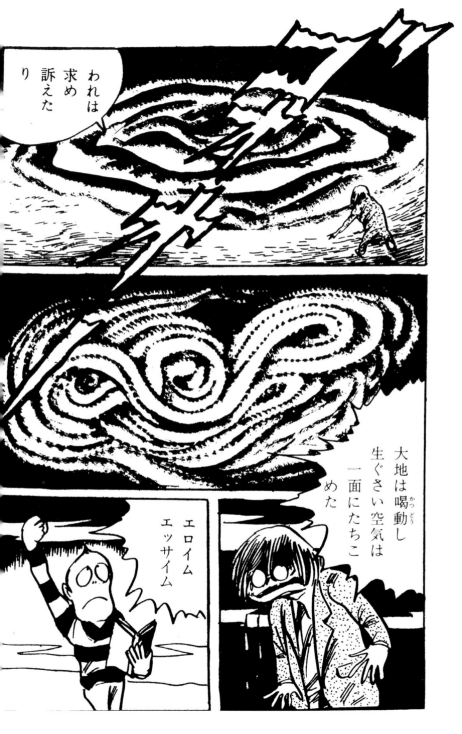

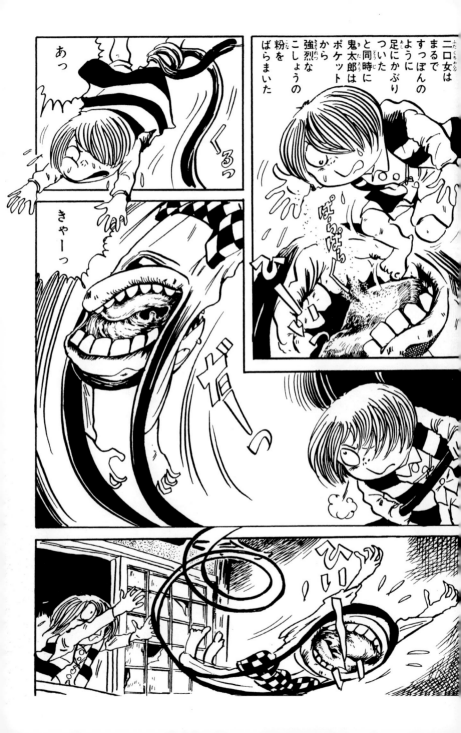

二口女は
まるで
すっぽんの
ように
足にかぶり
ついた
と同時に
鬼太郎は
ポケット
から
強烈な
こしょうの
粉を
ばらまいた

あっ

きゃーっ

ゲーの

ひい

鬼太郎は　全身の力を使って　術にはいろうとしたが急所を強くしめつけられているので術が使えないままに　二口女に引きよせられた。……

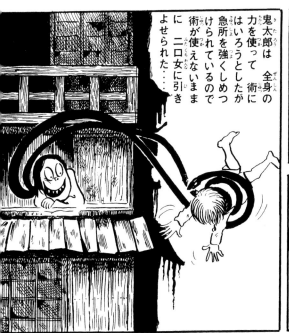

うわーっ

早くも　妖怪たちの異常な戦いの幕は

きっておとされたのだ

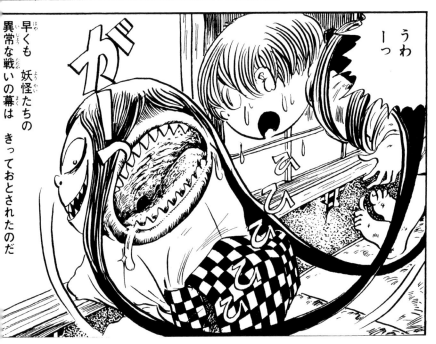

ガブ

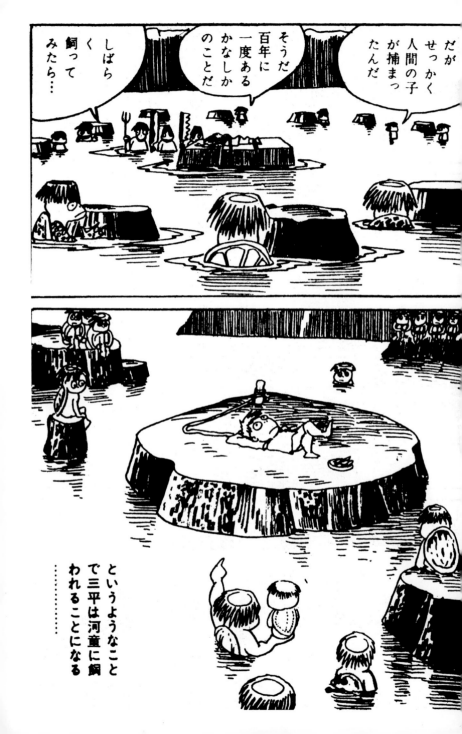

だがせっかく人間の子が捕まったんだ

そうだ百年に一度あるかなしかのことだ

しばらく飼ってみたら…

というようなことで三平は河童に飼われることになる
……

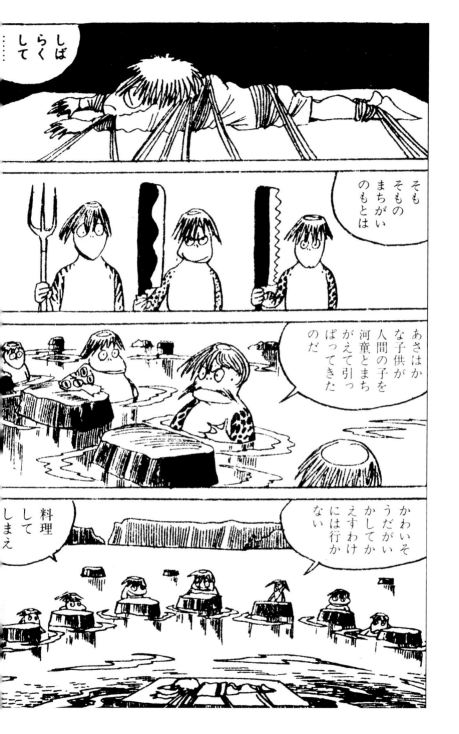

Minetaro Mochizuki's debut work, "Bataashi kingyo" is also one of his most famous. The story revolves around a high school student named Kaoru who is too full of self-confidence and is a nuisance to others. He loves one of his classmates, Sonoko, and he joins the swim team even though he cannot swim. Trouble of course ensues in this humorous story. With a drawing style that leaves a uniquely inexplicable impression on readers, his work brought considerable attention as a "new wave" manga that had not yet been seen before. In his most recent panic/disaster story, "Dragon Head," he depicts a high school student and the huge disaster that befalls his train while travelling through a tunnel. The confused youngster journeys through the devastated landscape of Japan without a clue as to what had happened. The author does not even divulge to the reader what happened, and this method of making the reader experience the same uncertainty as the main character was highly successful. His wavering lines cause a sense of uneasiness, and this style was very effective for works like "Dragon Head" and the horror story "Zashiki onna" [Phantom Stalker Woman]. He is also known for the live action movies made from some of his works, such as "Bataashi kingyo" [Swimming Upstream] "Samehada otoko to momojiri onna" [Shark Skin Man and Peach Hip Girl] and "Dragon Head."

M I N E T A R O M O C H I Z U K I

Born

1964 in Kanagawa Prefecture, Japan

Debut

with "Bataashi kingyo"
[Swimming Upstream], published
in *Young Magazine* in 1985

Best known works

"Bataashi kingyo"
[Swimming Upstream]
"Samehada otoko to momojiri onna"
[Shark Skin Man and Peach Hip Girl]
"Dragon Head"
"Maiwai"

Animation & Drama

"Bataashi kingyo"
[Swimming Upstream]
"Ochanoma"
"Samehada otoko to momojiri onna"
[Shark Skin Man and Peach Hip Girl]
"Dragon Head"

Prizes

• 21st Kôdansha Manga Award
(1997)
• 4th Tezuka Osamu Cultural Prize
Manga Award for Excellence (2000)

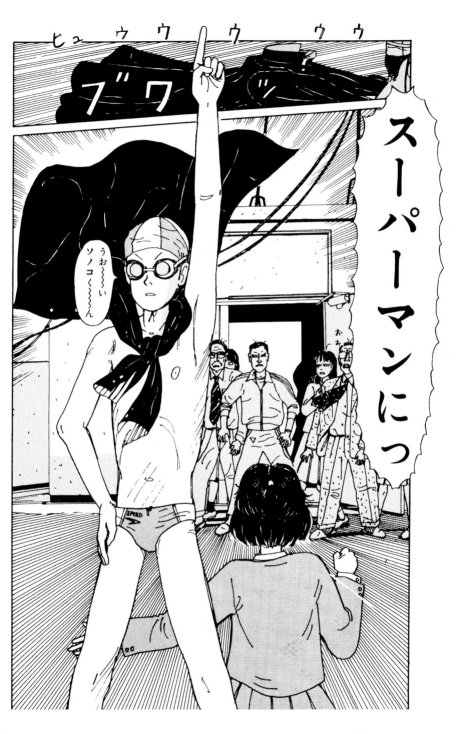

Sein erster großer Erfolg war die Serie „Bataashi kingyo" [der Spielfilm lief in Deutschland unter dem Titel *Gegen den Strom*] um den nervenden Oberschüler Kaoru, der ohne jeden Grund sehr von sich überzeugt ist. Nachdem er sich in seine Mitschülerin Sonoko verliebt, tritt er dem Schwimmclub bei, obwohl er nicht schwimmen kann, was natürlich zu vielen komödiantischen Verwicklungen führt. Die unverwechselbaren skizzenhaften Zeichnungen trugen dazu bei, dass der Manga als Vertreter eines ganz neuen Stils der New Wave gefeiert wurde. In einem seiner jüngeren Werke „Dragon Head" kommt es zur Feuerkatastrophe, während ein Zug durch einen Tunnel fährt. Zwei Oberschüler überleben, aber als sie endlich dem Tunnel entkommen, hat sich die Außenwelt in eine Ruinenlandschaft verwandelt. Ohne den Auslöser dieser Katastrophe zu erfahren, wandern sie durch eine apokalyptische Welt. Da auch der Leser über keinerlei Hintergrundinformation verfügt, wird er vom Autor äußerst geschickt in den gleichen Zustand zermürbender Ungewissheit versetzt. Mochizukis zittrige Linienführung beunruhigt den Betrachter noch zusätzlich, außer in „Dragon Head" kann man diesen Effekt beispielsweise auch in der Horrorgeschichte „Zashiki onna" erleben. Ungewöhnlich sind auch die vielen Realverfilmungen seiner Mangas, „Bataashi kingyo", „Samehada otoko to momojiri onna" [Shark Skin Man and Peach Hip Girl] und „Dragon Head" dienten alle als Vorlage für Spielfilme.

Sa première œuvre « Bataashi kingyo » est également sa plus fameuse. L'histoire décrit un lycéen nommé Kaoru qui est plein d'assurance et pénible. Il aime une de ses camarades de classe nommée Sonoko et rejoint l'équipe de natation bien qu'il ne sache pas nager. Bien sûr, des problèmes surviennent dans cette histoire humoristique. Avec un style de dessin qui laisse une impression inexplicable aux lecteurs, ses travaux lui ont valu une attention considérable en tant que manga d'une nouvelle génération encore jamais vu auparavant. Dans son histoire de panique et de désastre la plus récente, « Dragon Head », il dépeint un lycéen et l'énorme catastrophe qui survient pendant que son train passe dans un tunnel. Le jeune garçon confus erre au travers d'un Japon dévasté sans comprendre ce qui s'est passé, et la manière de l'auteur d'associer les lecteurs à ce que vit le personnage est très réussie. Ses lignes tremblantes provoquent une certaine appréhension et son style est très efficace dans des œuvres telles que « Dragon Head » ou l'histoire d'épouvante « Zashiki onna » [La dame de la chambre close]. Il est également réputé pour les films d'action inspirés de ses œuvres, tels que « Bataashi kingyo » [Swimming Upstream], « Samehada otoko to momojiri onna » [Shark Ski Man and Peach Hip Girl] et « Dragon Head ».

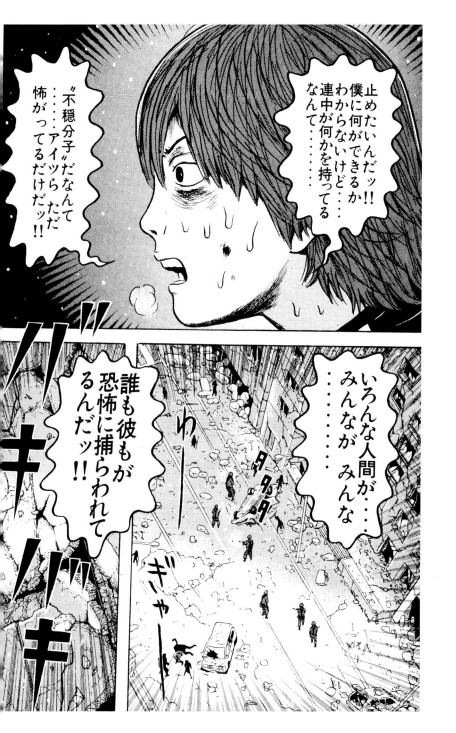

Ever since her debut in 1981, Milk Morizono published mostly in *shoujo* manga and *seinen* manga magazines, but from around 1987 she switched to the "Ladies Comics" genre. "Ladies Comics" are stories in tankoubon books or magazines that are geared toward adult women, and which deal with the theme of sex. Many of Morizono's best known works are in this genre. "Kiala," "Hong Kong Yûgi," and "Bondage Fantasy" all feature women's romantic or adulterous relationships with harlequin-like beautiful men. They show bold sex scenes and plenty of drama, but her drawing style is worthy of special mention. There is an aesthetic feel to her multi-layered lines, and she takes realism into consideration when designing her beautiful images. Her style is rare to this genre. In addition to her work in the manga industry, she also plays in a band, writes columns that deal with beauty, has published photographs, and has appeared on cable TV programs as a guest personality.

M I L K

M O R I Z O N O

Born

1957 in Yamaguchi Prefecture, Japan

Debut

with in "Crazy Love misshôhô" published in a special issue of *Shojo Comic* in 1981

Best known works

"Kiala"
"Hong Kong Yûgi"
"Bondage Fantasy"

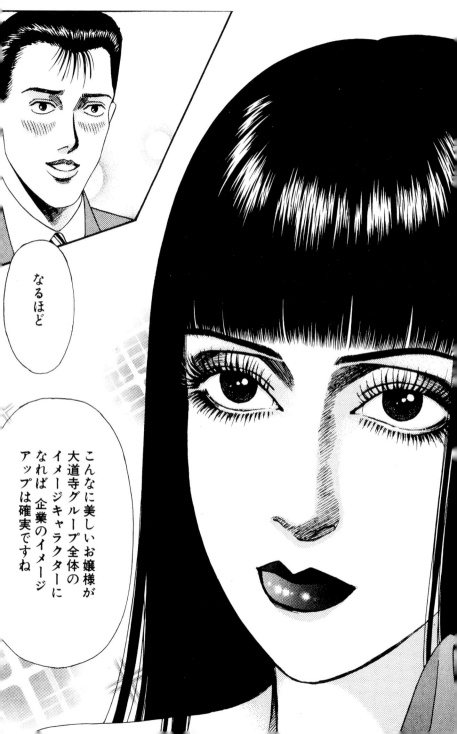

なるほど

こんなに美しいお嬢様が大道寺グループ全体のイメージキャラクターになれば企業のイメージアップは確実ですね

Nach ihrem Debüt 1981 zeichnete Milk Morizono zunächst *shôjo*- und *seinen*-Mangas, konzentriert sich seit 1987 jedoch hauptsächlich auf das Genre der *lady's comics*. Dieser Begriff bezieht sich auf Magazine beziehungsweise Mangas, die für die Zielgruppe der erwachsenen Frauen geschrieben werden und sich oft mit dem Thema Sex beschäftigen. Viele Arbeiten der Mangaka sind typisch für dieses Genre. In „Kiala", „Hong Kong Yûgi", „Bondage Fantasy" und anderen dreht sich die dramatische Handlung um Liebesgeschichten und Affären, inklusive freizügiger Sexszenen mit jungen Männern, deren Schönheit ein bisschen an Harlekins erinnern. Auffällig sind dabei ihre formvollendeten Linien und Schraffuren, mit denen sie wunderschöne, aber trotzdem realistische Bilder zeichnet, wie sie in *lady's comics* selten zu sehen sind. Auch außerhalb der Manga-Szene tritt Milk Morizono häufig in Erscheinung: Sie gründete eine Band, schreibt eine Kolumne über das Thema Schönheit, betätigt sich als Fotografin und tritt häufig im Fernsehen auf.

Depuis ses débuts en 1981, elle a principalement publié ses œuvres dans des magazines de mangas shoujo et seinen, mais à partir de 1987, elle est passée à un genre différent, celui des « Ladies Comics ». Il s'agit d'histoires dans des tankoubon ou des magazines qui sont destinés à des femmes adultes, sur le thème du sexe. La plupart des œuvres de Morizono sont dans ce style. « Kiala », « Hong Kong Yûgi » et « Bondage Fantasy » comportent des relations romantiques ou adultères avec de superbes hommes, ainsi que des scènes de sexes et des mélodrames. Son style de dessin mérite une attention particulière. Ses lignes sur plusieurs couches ont un effet esthétique et elle prend un certain réalisme en compte lorsqu'elle crée ses images. Son style est unique en son genre. En plus de ses œuvres pour le marché des mangas, elle fait partie d'un groupe musical, écrit des rubriques dans des journaux sur le thème de la beauté, a publié des photos et a été invitée à des émissions télévisées.

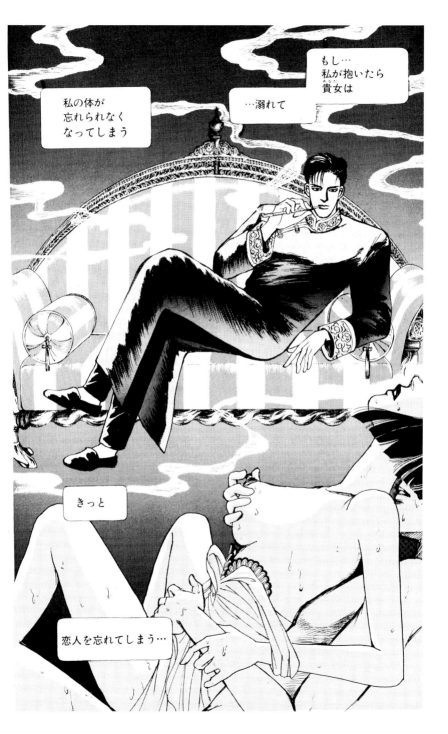

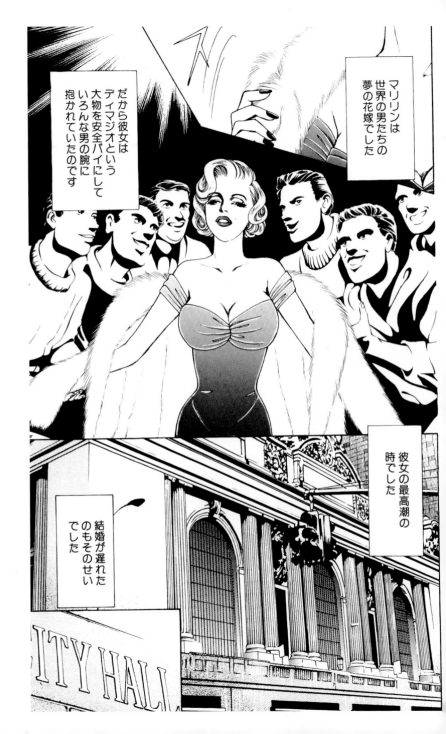

マリリンは
世界の男たちの
夢の花嫁でした

だから彼女は
ディマジオという
大物を安全パイにして
いろんな男の腕に
抱かれていたのです

彼女の最高潮の
時でした

結婚が遅れた
のもそのせい
でした

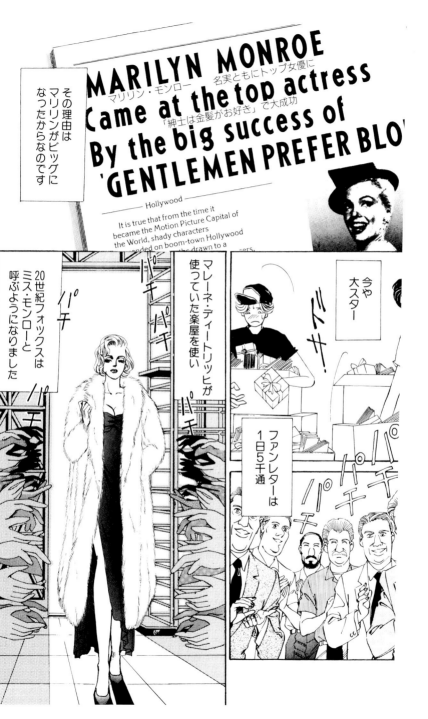

MARILYN MONROE
マリリン・モンロー　名実ともにトップ女優に

Came at the top actress
「紳士は金髪がお好き」で大成功

By the big success of
'GENTLEMEN PREFER BLO'

— Hollywood —

It is true that from the time it
became the Motion Picture Capital of
the World, shady characters

その理由は
マリリンがビッグに
なったからなのです

20世紀フォックスは
ミス・モンローと
呼ぶようになりました

マレーネ・ディートリッヒが
使っていた楽屋を使い

今や
大スター

ファンレターは
1日5千通

This manga artist has extensive knowledge of mythological legends, folklore, and cultural anthropology. Daijirô Morohoshi pairs this knowledge together with highly advanced story composition and a wonderful imagination. He portrays the existence of entities and events that exceed human understanding, and draws the reader into a strange world. In his sci-fi works, he often portrays incidences where the characters are drawn into bizarre situations. He doesn't simply describe the advanced technologies when dealing with stories about outer space, but depicts it as a place full of unknown mysteries. He has boldly adapted classics and history in "Saiyû yôen den" and "Kôshi ankoku den," which are both set in China. In "Mud Men" he combined mythology from both Japan and New Zealand. Ancient people used the power of their imaginations to create mythology based on the reality of their lives, and Morohoshi's manga exhibit the same kind of power. In addition, "Shiori to Shimiko" is a witty horror/comedy story about two high school student girls who become involved in a mysterious event. The story's silliness was a new kind of appeal. He has considerable respect from his peers. He is a leading artist in the fact that once you start reading his work, you are drawn deeper and deeper into a wonderful universe.

DAIJIRÔ MOROHOSHI

Born

 1949 in Tokyo, Japan

Debut

 with "Junko kyôkatsu"
 [Junko/ Blackmail] published
 in *COM* magazine in 1970

Best known works

 "Shiori to Shimiko" series
 "Saiyû yôen den"
 "Ankoku shinwa"
 "Yôkai Hunter"

Anime adaptation

 "Hiruko yôkai Hunter"
 "Ankoku shinwa"

Prizes

 • 21st Japan Cartoonists
 Association Excellence
 Award (1992)
 • 4th Tezuka Osamu
 Cultural Award Manga
 Grand Prix Award (2000)

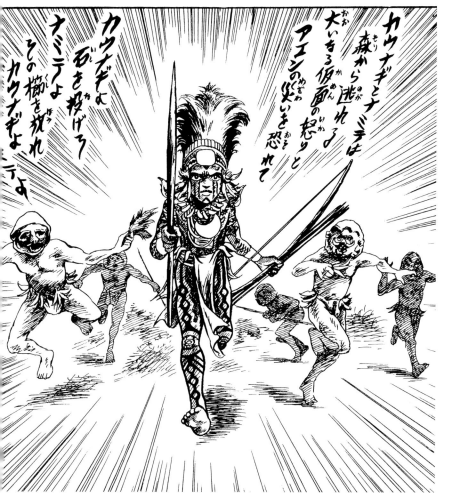

カウナギとナミテは
森から逃れる
大いちる仮面の
アユンの災いを恐れて

カウナギよ
石を投げろ
ナミテよ
その櫛を取れ
カウナギよ
…テよ

Morohoshi verbindet seine erstaunliche Vorstellungskraft mit profunden Kenntnissen der Mythologie, Volkskunde und Anthropologie sowie einem sicheren Gespür für Handlungsaufbau. Mit der Darstellung von Vorkommnissen und Lebewesen, die empirisch nicht zu erklären sind, versetzt er seine Leser in eine völlig fremdartige Welt. Auch in seinen Sciencefiction-Mangas werden die Protagonisten meist in mysteriöse Geschehnisse verwickelt – Morohoshi geht dieses Genre nicht vom Aspekt des naturwissenschaftlich-technischen Fortschritts an, sondern zeichnet das All als eine durch und durch unergründliche Welt. Bei seinen in China spielenden Serien „Saiyû yôen den" und „Kôshi ankoku den" handelt es sich um kühne Adaptionen klassischer Werke und historischer Begebenheiten, während er in „Mud Men" Göttersagen aus Neuguinea und Japan miteinander verwebt. Wenn man davon ausgeht, dass die Menschheit von alters her aufbauend auf ihrer Lebenswirklichkeit eine Welt der Mythen geschaffen hat, kann man sagen, dass auch Morohoshis Mangas Ähnliches bewirken. In „Shiori to Shimiko", eine geistreiche Horrorkomödie um zwei Oberschülerinnen, die in mysteriöse Vorfälle verwickelt werden, zeigt er sich wiederum von einer ganz neuen burlesken Seite. Auch unter Kollegen genießt Daijirô Morohoshi großen Respekt, als ein einzigartiger Künstler, dessen Werke umso vielschichtiger werden, je mehr man sich in sein wundersames Universum vertieft.

Cet auteur de mangas a une connaissance poussée des légendes mythologiques, du folklore et de l'anthropologie culturelle. Il combine cette connaissance avec des scénarii développés et une imagination débordante. Il dépeint l'existence d'entités et d'événements qui dépassent l'entendement humain, et attire les lecteurs dans un monde étrange. Dans ses œuvres de sciencefiction, ses personnages sont souvent mêlés à des situations bizarres. Il ne décrit pas simplement les avancées technologiques dans ses histoires qui se déroulent dans l'espace, mais plutôt des endroits remplis de mystères. Il a adapté des histoires classiques avec audace, dans « Saiyû yôen den » et « Kôshi ankoku den », qui se déroulent tous deux en Chine. Dans « Mud Men », il combine la mythologie du Japon et de la Nouvelle-Zélande. Des peuplades anciennes utilisaient la puissance de leur imagination pour créer de la mythologie basée sur la réalité de leur vie. Les mangas de Morohoshi manifestent la même puissance. « Shiori to Shimiko » est une histoire d'épouvante/comédie sur deux lycéennes qui sont mêlées à un événement mystérieux. L'humour de cette histoire est unique. Morohoshi est un auteur qui est considérablement respecté par ses pairs. Il est un des meilleurs auteurs et dès qu'on commence à lire une de ses histoires, on se sent attiré plus en avant dans un univers merveilleux.

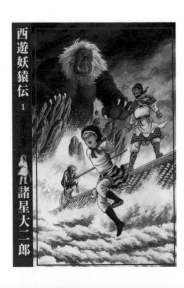

あのぼろ人形のこと…
話してみようか
変な子って…
道で会った
あの子？
そうよ
どうする？

よーぐー
どーこー

そうね…

よそうよ
どっか行っちゃった
ことだし…
この上 あんな子に
関わりたくないわ

よーぐー…
よぐそと
ほーとー…

なに
これ!?
誰が
やったの!?

きっとボリスが
どこかへ持ってっ
ちゃったんだわ
もういいから
お茶にしよう

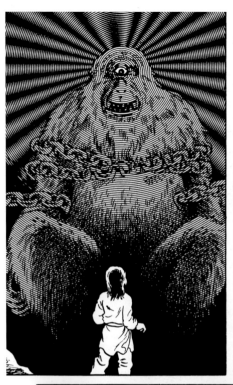

どうした
それをとれ
さあ早く…

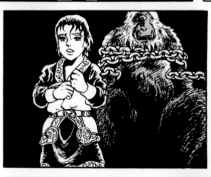

ニタ…

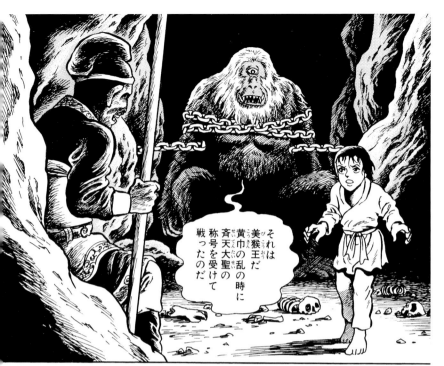

それは
美猴王だ
黄巾の乱の時に
斉天大聖の
称号を受けて
戦ったのだ

お前がわしの称号を
受けるなら
その服を着 その帽子を
かぶり その矛をとれ

バサッ

In 1967, a year after his debut, Gô Nagai hit it big with "Harenchi gakuen," a story set at an elementary school full of teachers with highly quirky personalities. The story is about a character named Yamagishi-kun, and the trouble he and his friends get into. The manga was filled with hilarious gags and plenty of sex appeal. Peeking under the skirts of the girls, which was something depicted in the manga, became something of a fad among school children at the time, and as a result the manga came under severe criticism from educational organizations and parents. This is one of the reasons why this title received so much publicity. In 1972, Nagai published an action piece called "Devilman," where after several tens of thousands of years, demons have awoken into our present day society. In order to battle with them, the main character, Akira Fudô, merges with a demon's body to become Devilman.

Although in the beginning, the series dealt with the subject of humans versus demons, the story progressed to depict a witch-hunt as frightened humans mistakenly prosecuted other humans. Paradoxically, this revealed the hidden evil in people, and finally developed into becoming a form of punishment for them. This sudden reversal of events was a shocking development, and the manga had an effect on many other creative artists, in addition to the readers. The same year Nagai published "Mazinger Z," a story of a young boy who climbs into a huge robot and controls it to battle against evil robotic monsters. Nagai helped to build this "robot" manga genre. He is a pioneer who greatly expanded the form of manga expression, with titles such as "Cutey Honey," which was of the "Henshin Bishôjo Action" format [Transforming Beautiful Girl Action].

G Ô
N A G A I

Born

1945 in Ishikawa Prefecture, Japan

Debut

with "Meakashi Porikichi" in *Bokura* in 1967

Best known works

"Harenchi gakuen" [Shameless School]
"Devilman"
"Mazinger Z"
"Susano Ô densetsu"

Anime adaption

"Harenchi gakuen"
[Shameless School]
"Devilman"
"Cutey Honey"

Prizes

• 4th Kôdansha Manga Award (1980)

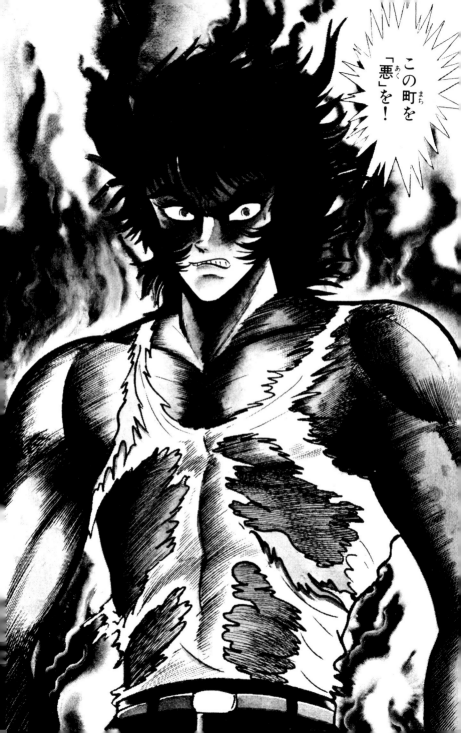

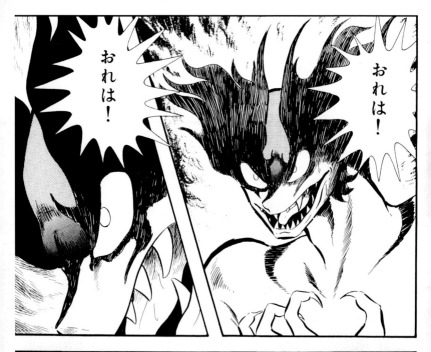
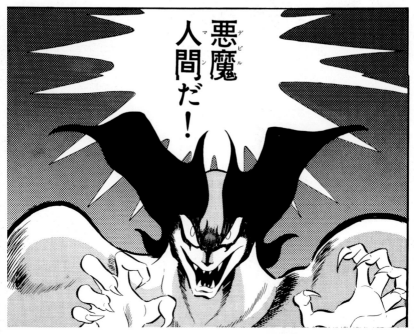

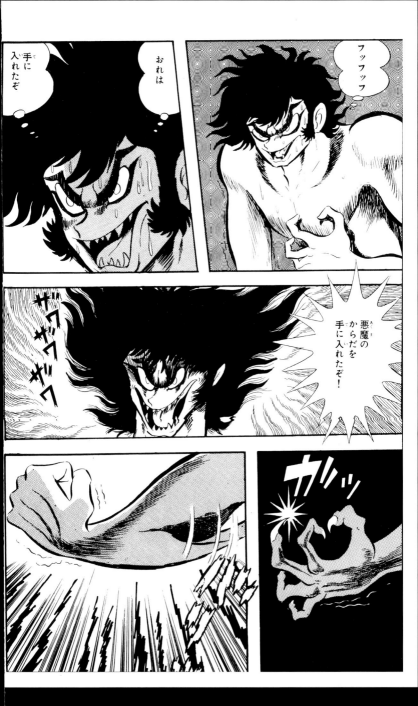

Ein Jahr nach seinem Debüt 1967 veröffentlichte Gô Nagai mit großem Erfolg den erotischen Gag-Manga „Harenchi gakuen" [Shameless School]. An einer von kauzigen Lehrern bevölkerten Grundschule bringen der Protagonist Yamagishi-kun und seine Freunde Leben in die Bude. Hochgezogene Röcke, wie Nagai sie in dem Manga gezeichnet hatte, wurden unter Schulmädchen bald große Mode, woraufhin Lehrer und Erziehungsberechtigte das Werk scharf kritisierten; kurzum der Manga wurde in jeder Hinsicht zum Tagesgespräch. Nagais Serie „Devilman" aus dem Jahr 1972 ist im Action-Genre anzusiedeln: Der Protagonist Akira Fudô soll Dämonen bekämpfen, die nach vielen zehntausend Jahren wieder zum Leben erwachen. Zunächst verschmilzt er aber selbst mit einem Dämon und kämpft von nun an als Devilman. Die anfängliche Rollenverteilung „gute Menschen gegen böse Dämonen" wich mit fortschreitender Handlung einem Hexenjagd-ähnlichen Schlagabtausch unter den in Furcht vor den Dämonen lebenden Menschen, so dass paradoxerweise nun das Dämonische im Menschen im Vordergrund stand. Schließlich wurde das Konzept, das darauf abzielte, das Böse am Ende zu bestrafen, gänzlich umgekehrt. Der Manga hinterließ nicht nur bei den Lesern, sondern auch bei vielen Künstlern einen nachhaltigen Eindruck. Im selben Jahr veröffentlichte Nagai „Mazinger Z", und mit dieser Serie, in der der jugendliche Held an Bord eines riesigen Roboters gegen böse Maschinen-Bestien kämpft, begründete er das *giant robot*-Genre. Auch das Format des *magical girl*-Action-Mangas kann auf seine Serie „Cutey Honey" zurückgeführt werden. Zu Recht gilt Gô Nagai als ein Pionier, der die Ausdrucksmöglichkeiten im Manga erheblich erweiterte.

En 1967, un an après ses débuts, Gô Nagai est devenu célèbre avec « Harenchi gakuen » [L'école impudique], une histoire se déroulant dans une école élémentaire, où tous les professeurs ont une personnalité excentrique. Il s'agit de l'histoire d'un personnage appelé Yamagishi-kun et des problèmes que ses amis et lui rencontrent. Le fait de regarder sous les jupes des filles, chose qui apparaissait souvent dans la série, est devenu une sorte de mode parmi les jeunes écoliers à cette époque, et a suscité une critique sévère de la part des organisations éducatrices et des associations de parents d'élèves. C'est une des raisons qui ont rendu cette série célèbre. En 1972, Nagai a publié un manga d'action intitulé « Devilman », dans lequel des démons se réveillent à notre époque, après des dizaines de milliers d'années de sommeil. Pour les combattre, le personnage principal, Akira Fudô, fusionne avec le corps d'un démon pour devenir Devilman. Bien que l'histoire ait commencé par une lutte des humains contre des démons, son sujet a évolué pour dépeindre une sorte de chasse aux sorcières, des humains effrayés poursuivant d'autres humains par erreur. Paradoxalement, elle a révélé le mal caché dans les gens devenant une forme de châtiment pour eux. Ce retournement soudain des événements était un développement choquant, et la série a eu un impact sur de nombreux créatifs, en plus de ses lecteurs. La même année, Nagai a publié « Mazinger Z », l'histoire d'un jeune garçon qui grimpe dans un grand robot et le contrôle pour combattre des monstres robotiques. Nagai a ainsi contribué à la création d'un nouveau genre de mangas. Il a également développé différentes formes d'expression, avec des séries telles que « Cutey Honey » qui ont contribué au genre « Henshin Bishoujo Action » (de jolies filles avec des pouvoirs de transformation).

パパ

ぜったい
ゆるさない！
パパを殺した
豹の爪を！

ひとり残らず
地獄へ
たたきこんで
やる！

The weird speech bubbles have become one trademark of Tsuchika Nishimura, an early alumnus of the Tokiwaso Project, in which amateur manga artists shared apartments and lived in a creative environment, allowing for great exchange of ideas, as well as a competitive flair that pushed the artists to produce their best. Other manga artists turned legends who took part in the project include Osamu Tezuka and Fujiko Fujio, who were actually flatmates. Nishimura strives to innovate, carving panels out of other panels, often giving it a very Western feel, and developed his own technique for producing shadows which he named "kana-ami," while never letting the reader down through his recognized drawing skills. Titles like "Kawaisô na Mayumi-san" and "Sayônara mina-san" have succeeded through a mixture of drama, supernatural themes, and psychological affairs. Other titles include "Nakayoshi dan no bôken," and "Comic hoshi Shin'ich." One of his career high points has been a tribute chapter he drew for the late Jun'ichirô Tanizaki's 50th anniversary.

TSUCHIKA NISHIMURA

Born
1984 in Hyôgo Prefecture, Japan

Debut
with "Kuroiwa-san" in 2000
published in *Comic Ryu*

Best known works
"Kawaisô na Mayumi-san"
"Sayônara mina-san"

Prizes
• 15th Japan Media Arts Festival:
New Face Award in Manga Division
(2011)

カッ

キッ

という
のは…
店長？

聞いてます？

わわ、
渡辺さん
ちょっと…

店長、

土曜日の
映画の件
ですけど、

やっぱり
おことわり
します。

Merkwürdige Sprechblasen wurden zum Markenzeichen von Tsuchika Nishimura, einem frühen Teilnehmer des Tokiwa-sô-Projekts, bei dem Amateur-Mangaka kreative Wohngemeinschaften bildeten, in denen sie Ideen austauschen konnten und durch den Wettbewerb untereinander zu Bestleistungen angespornt wurden. Zu den weiteren Mangaka, die an dem Projekt teilnahmen und inzwischen zu Legenden ihrer Branche wurden, gehören Osamu Tezuka und Fujiko Fujio, die sich sogar eine Wohnung teilten. Nishimura versucht stets innovativ zu sein, indem er etwa einzelne Bilder aus anderen Bildern herausschnitzt und ihnen häufig eine sehr westliche Anmutung verleiht. Er entwickelte zudem eine eigene Technik zur Darstellung von Schatten, die er als *kana-ami* bezeichnet. Seine Leser werden dabei dank seines anerkannten Zeichentalents nie enttäuscht. Titel wie „Kawaisô na Mayumi-san" und „Sayônara mina-san" wurden durch eine Mischung aus Drama, Übersinnlichem und Psychologie zu Erfolgen. Weitere Werke von Nishimura sind „Nakayoshi dan no bôken" und „Comic hoshi Shin'ich". Zu seinen besten Arbeiten zählt ein Kapitel, das er zum 50. Todestag des Schriftstellers Jun'ichirô Tanizaki zeichnete.

Les bulles de texte décalées sont devenues la marque de fabrique de Tsuchika Nishimura. L'artiste est un ancien élève du Tokiwasou Project qui regroupait dans une résidence des artistes manga amateurs : la vie dans cet environnement créatif favorisait les échanges d'idées et créait une dose de compétition pour pousser les artistes à se dépasser. Osamu Tezuka et Fujiko Fujio, deux anciens participants colocataires, sont devenus des légendes du monde manga. Nishimura est toujours en quête d'innovation en prenant des vignettes comme base pour d'autres ce qui donne souvent un style occidental, et en développant sa propre technique d'ombres qu'il a baptisée kana-ami. Il ne déçoit jamais le lecteur grâce à son remarquable talent de dessinateur. Les titres « Kawaisô na Mayumi-san » et « Sayônara mina-san » [Au revoir tout le monde] enchaînent drame, thèmes surnaturels et intrigues psychologiques. Il est aussi l'auteur de « Nakayoshi dan no bôken » et « Comic hoshi Shin'ich ». L'une des œuvres phares de sa carrière est l'hommage rendu au 50e anniversaire de Jun'ichirô Tanizaki.

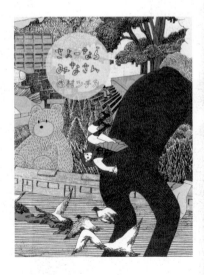

Miho Obana's work, "Kodomo no omocha" [Kodocha: Sana's Stage] was first serialized in the popular young girl's manga magazine *Ribbon*, before becoming a hit animated series. The series is full of humor, but her ambitious manga also incorporates such modern themes as inadequate parenting and the breakdown of the educational system. The energetic main character of the story, Sana Kurata, is an actress with a theatrical group. The diligently detailed lives and feelings of all of the characters that surround her are one reason for this manga's popularity. "Kodomo no omocha" managed to go beyond the magazine's target audience, to grab the attention of a far wider range of fans. The reason for its extensive popularity, despite dealing with some serious themes in a young girl's magazine, is Obana's gorgeous drawings. She applies effective tones not only to the cute and adorable characters that are drawn with her characteristically fine lines, but also to the nuances of the background visuals, and even to the shadows created by each strand of hair. This meticulous attention in her work has become her trademark. She draws the kind of sparkling scenes that are characteristic of *shoujo* manga, while creating something that can be read smoothly. She recently announced a new series in the women's magazine *Chorus*, and this story will likewise incorporate the themes of society and human relations.

M I H O
O B A N A

Born

1970 in Tokyo, Japan

Debut

with "Mado no mukô"
[The Other Side of the Window]
published in a special fall edition
of *Ribbon* in 1990

Best known works

"Kodomo no omocha"
[Kodocha: Sana's Stage]
"Andante"
"Partner"

Anime adaption

"Kodomo no omocha"
[Kodocha: Sana's Stage]

Prizes

• 22nd Kôdansha Manga Award
(1998)

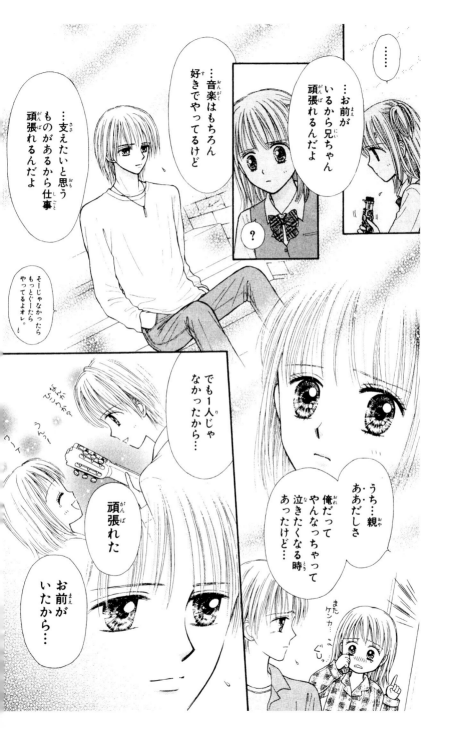

…お前が
いるから兄ちゃん
頑張れるんだよ

……

…音楽はもちろん
好きでやってるけど

…支えたいと思う
ものがあるから仕事
頑張れるんだよ

そーじゃなかったら
もっとぐーたら
やってるよオレ。

でも1人じゃ
なかったから…

頑張れた

お前が
いたから…

うち…親
ああだしさ

俺だって
やんなっちゃって
泣きたくなる時
あったけど…

うんっ…

またケンカ…
ぐしっ

Ihr Manga „Kodomo no omocha", der in *Ribbon*, einem Manga-Magazin für kleine Mädchen, veröffentlicht wurde, ist zwar sehr lustig geschrieben, greift aber bewusst Gegenwartsthemen auf, wie beispielsweise gefühlsarme Kinder oder mangelnde Disziplin im Klassenzimmer. Sana Kurata, ein unbeschwertes, fröhliches Mädchen und Star im Kinderfernsehen, steht im Mittelpunkt der Geschichte, in der auch ihr Umfeld sowie die Gefühle und Gedanken der anderen Protagonisten detailliert vorgestellt werden. Der Manga wurde zu einem großen Publikumserfolg und als Anime verfilmt. Dass „Kodomo no omocha" mit seinen nicht immer leicht verdaulichen Themen auch über die Zielgruppe des Magazins hinaus so populär ist, liegt zu einem großen Teil an Obanas prächtigen Zeichnungen. Typisch sind nicht nur die fein gezeichneten niedlichen Charaktere, sondern auch die Rasterfolien-Effekte, die sie für nuancenreiche Hintergründe und bei Bedarf sogar für den Schatten jedes einzelnen Härchens verwendet. Die funkelnden Bilder, wie sie typisch für Kleinmädchen-Mangas sind, hat sie bis an die Grenze des Möglichen perfektioniert und dazu eine sehr flüssig zu lesende Geschichte geschrieben. Mittlerweile veröffentlicht Miho Obana auch Arbeiten in der Frauen-Manga-Zeitschrift Chorus und geht darin ebenfalls gesellschaftlich relevanten Themen und zwischenmenschlichen Beziehungen auf den Grund.

L'œuvre « Komodo no omocha » de Miho Obana est apparue dans le magazine populaire pour jeunes filles *Ribbon*, avant de devenir une série animée. La série est remplie de gags, mais ce manga ambitieux intègre également des thèmes modernes tels que l'éducation insuffisante des enfants et la dégradation du système éducatif. Le personnage principal énergique, Sana Kurata, est une actrice dans une troupe de théâtre. La vie et les émotions de tous les personnages qui l'entourent sont détaillées avec zèle. C'est une des raisons de la popularité de ce manga. « Kodomo no omocha » va au-delà de l'audience ciblée par le magazine et attire l'attention d'un plus large public. Les raisons de son importante popularité, malgré l'utilisation de thèmes sérieux dans un magazine pour jeunes filles, résident dans les superbes dessins d'Obana. Elle utilise des tonalités efficaces non seulement sur les personnages adorables qui sont dessinés à l'aide de lignes fines caractéristiques, mais également de nuances pour les décors et même des ombres pour chaque mèche de cheveux. Cette attention méticuleuse est devenue sa griffe. Elle dessine des scènes pétillantes qui sont caractéristiques des mangas shoujo, mais qui peuvent être lues aisément. Elle a récemment annoncé une nouvelle série dans le magazine féminin *Chorus*, et cette histoire intègrera probablement des thèmes sur la société et les relations humaines.

While still a high school student, Takeshi Obata won an award sponsored by the popular manga magazine *Weekly Shônen Jump*. He then went on to create several manga series for the same magazine. His most recent work, "Hikaru no go," tells the story of a boy who takes up the challenge of the ancient Japanese game of "go." This popular manga started the "go mania" among elementary school students. Apart from winning manga awards for this series, Obata has also received a number of awards from the go world for his contributions. Besides his go series, he created other series with a distinctly Japanese flavor, such as a story based upon the Japanese national sport of sumo wrestling in "Rikijin densetsu," and a story set in the world of Japanese classical puppetry in "Karakurizôshi Ayatsuri Sakon." The latter not only depicts the world of ancient Japanese puppetry, it is also a unique mystery story in which the puppeteer must solve the numerous crimes and mysteries he encounters. In addition, Obata has a reputation for creating delicate, high quality images. As an artist, he frequently leaves the story up to a scriptwriter. Indeed, following his debut of "Cyborg Jiichan G," he has always worked together with a *gensaku-sha*, an author who doesn't draw. His color illustrations also have considerable appeal and his reputation as a painter is high.

T O
A B
K A
E T
S A
H
I

Born

1969 in Niigata Prefecture, Japan

Debut

with "Cyborg Jiichan G" [Cyborg Grandpa G], which was published in *Weekly Shônen Jump* in 1986

Best known works

"Arabian Lamp Lamp"
"Karakurizôshi Ayatsuri Sakon"
"Hikaru no go" [Hikaru's Go]

Anime adaption

"Karakurizôshi Ayatsuri Sakon"
"Hikaru no go" [Hikaru's Go]

Prizes

• 45th Shôgakukan Manga Award fc the Shônen Category (2000)
• 7th Tezuka Osamu Cultural Prize New Life Award (2003)

Schon während seiner Schulzeit gewann Takeshi Obata einen Preis beim *Weekly Shônen Jump* und veröffentlichte im gleichen Magazin bis heute zahlreiche weitere Serien. In „Hikaru no go" zeichnet er Kinder, die in Japans althergebrachtem Brettspiel Go gegeneinander antreten, und war damit so erfolgreich, dass unter Grundschülern ein richtiggehendes Go-Fieber zu grassieren begann. Nicht nur einen Manga-Preis gewann Obata mit diesem Werk, sondern er wurde mehrfach von Go-Vereinigungen für seine Verdienste um das Go-Spiel ausgezeichnet. Auch in seinen anderen Mangas behandelt er häufig typisch japanische Motive: in „Rikijin densetsu" beispielsweise den Nationalsport Sumô und in „Karakurizôshi Ayatsuri Sakon" das traditionelle japanische Puppentheater. In Letzterem wird nicht einfach nur die Welt des Puppentheaters geschildert, sondern es handelt sich um eine Krimigeschichte, in der den Puppenspielern Unheimliches widerfährt und bizarre Vorfälle gelöst werden müssen. Die Qualität seiner exakten, feinfühligen Zeichnungen ist allgemein anerkannt; Dialog und Story überlässt er bereits seit seinem Erstling „Cyborg Jiichan G" meist einem Partner. Auch seine Farbillustrationen sind hervorragend und er genießt einen ausgezeichneten Ruf als Maler.

Pendant ses études au lycée, Takeshi Obata a gagné un prix sponsorisé par le magazine *Weekly Shônen Jump*. Il a ensuite créé plusieurs mangas pour ce magazine. Son œuvre la plus récente, « Hikaru no go » [Le Go d'Hikaru], raconte l'histoire d'un jeune garçon qui relève le défi de l'ancien jeu de Go japonais. Ce manga populaire a déclenché la passion pour ce jeu auprès des écoliers. En plus des prix décernés par les associations de bandes dessinées pour cette série, Obata a également reçu un certain nombre de prix de la part des associations de jeu de Go pour sa contribution. En dehors de cette série, il en a créé d'autres à la saveur typiquement japonaise, telle que « Rikijin densetsu », une histoire basée sur le sumo, le sport national de lutte japonaise, et « Karakurizôshi Ayatsuri Sakon », une histoire se déroulant dans le monde des marionnettes classiques japonaises. Cette dernière ne dépeint pas seulement ce monde, mais elle est également une histoire policière dans laquelle un marionnettiste doit résoudre les nombreux crimes et affaires mystérieuses auxquels il est confronté. Obata à la réputation de créer des images délicates de grande qualité. En tant qu'artiste, il laisse souvent le soin à un scénariste d'écrire l'histoire. Depuis ses débuts avec « Cyborg Jiichan G », il a toujours procédé ainsi avec un gensakusha (auteur). Ses illustrations en couleur ont un attrait considérable et il a une grande réputation en tant que peintre.

With his popularity and great talent, Eiichiro Oda is a living symbol of the *shounen* manga world. His runaway hit, "One Piece," broke all previous publication records. 2,600,000 first edition copies of the 26th volume were printed (the highest number for a first edition comic). Even now in the 21st century, the series has held its place as the best selling manga ever. The secret of its popularity is the overwhelmingly high quality it maintains as a *shounen* manga. The story is about a young pirate who roams the open seas in search of adventure. It seems like a classic plot, but it is rich in detail and imagination. The manga has elements that cleverly step up the tension and thus the reader's excitement level, combining thrill, the unexpected, and emotional impact. Oda skillfully adds the elements of friendship, passion, and adventure. This is a treasured series for boys, and also a special treasure for adults, as it brings back nostalgic feelings. The series was recently turned into a hit animated series.

EIICHIRO ODA

Born

1975 in Kumamoto Prefecture, Japan

Debut

with "Wanted," which was published in *Weekly Shônen Jump* in 1992 and subsequently won the Tezuka Award. Began serialization of "One Piece," in *Weekly Shônen Jump* in 1997

Best known works

"Wanted"
"One Piece"

Anime adaption

"One Piece"

おれはさ

海賊王に
なるんだ!!!

にいっ

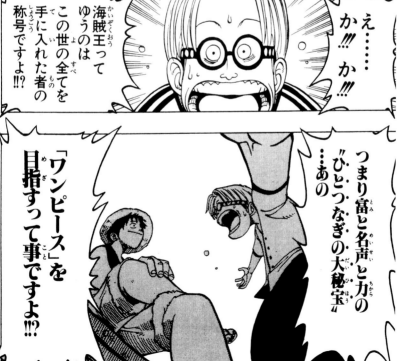

え……
か!!!
か!!!

海賊王って
ゆうのは
この世の全てを
手に入れた者の
称号ですよ!!?

つまり富と名声と力の
"ひとつなぎの大秘宝"
…あの

「ワンピース」を
目指すって事ですよ!!?

Oda ist der Vertreter der zeitgenössischen *shônen*-Manga-Welt schlechthin, sowohl was Popularität als auch was Können betrifft. Sein bekanntester Manga „One Piece" erreichte absolute Höchstauflagen: Der 26. Sammelband hatte eine nahezu unglaubliche Erstauflage von 2 600 000 Stück und hält somit alle Rekorde. Auch im 21. Jahrhundert ist es diesem Manga gelungen, seinen Platz als meistverkauftes Comicbuch zu behaupten. Das Erfolgsgeheimnis liegt wohl in der überragenden Qualität als *shônen*-Manga. Die Grundidee eines Piratenjungen, der auf den Weltmeeren Abenteuer erlebt, ist zwar eher konventionell, aber dahinter verbirgt sich eine Welt voller wunderbarer Details und die vielen verschiedenen Emotionen wie Spannung, Staunen, Rührung, Freundschaft, Leidenschaft und Abenteuerlust ziehen den Leser in ihren Bann. Für Jungs ist dieser Manga ein echter Piratenschatz und auch Erwachsene fühlen sich in längst vergessen geglaubte Zeiten zurückversetzt. Die Anime-Serie läuft derzeit mit ebenso großem Erfolg im Fernsehen.

Avec sa popularité et son talent, Eiichiro Oda est le symbole vivant du monde des mangas shounen. Son œuvre « ONE PIECE », a dépassé tous les précédents records de publication. En effet, 2 600 000 exemplaires de la première édition (le chiffre le plus important pour une première édition) du 26e tome ont été imprimés. Encore aujourd'hui au 21e siècle, sa série conserve sa place de best-seller de tous les temps. Le secret de sa popularité réside dans la qualité incroyable de ses mangas shounen. Il s'agit de l'histoire d'un jeune pirate qui parcourt les océans à la recherche d'aventures. Cela ressemble à un scénario classique, mais il est riche en détails et en imagination. Ce manga contient des éléments qui accentuent finement les tensions, influant ainsi sur le niveau d'excitation des lecteurs, et combine des sensations fortes, de l'imprévu et un impact émotionnel. Oda ajoute avec talent des éléments d'amitié, de passion et d'aventure. C'est une série adorée des enfants et également des adultes car elle leur apporte un peu de nostalgie. Elle a récemment donné lieu à une série animée.

私だ

数ある能力の中でも……

確かに……"無敵"と謳われる能力の一つ

悪魔の実か……

おそらく……"ゴロゴロの実"……!!

クルクル……

ド

サッ

そんなの

雷…!?

人間が敵うわけない……じゃない……!!

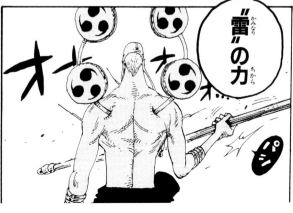

"雷"の力

オ

パシ

"Onmyôji" is a manga based on a novel about Sei-mei Abe, who was an *onmyôji* [diviner] during the Heian period. Even though there is an original story that accompanies this manga, it can be viewed as an independent work of extraordinary quality. Reiko Okano creates a realistic perspective of the Heian period's city atmosphere. Her drawings of scenes where demons and other evil entities wreak pandemonium, can almost be mistaken for Japanese paintings, and the author uses her own words to describe *onmyoudou* [the way of mystical Taoist sorcery, based on Yin and Yang]. These qualities give a freshness to her works. In particular, Okano showcases her incredible talent with her spectacularly expressive drawings and the abundant use of wit and humor. As can be seen in the examples, these incredibly detailed scenes are created by meticulously stacking up several layers of drawings. In addition, Okano combines philosophical thinking with comedy in "Fancy Dance," which is about the lives of fashionable youngsters living in a temple, and "Yômi henjô yawa," a Chinese comedy about the world of *sennin* [immortal sages living a hermit-like existence]. She is one of the best modern day mangaka to skillfully blend philosophy with comedy in her drawings.

REIKO OKANO

Born

1960 in Ibaraki Prefecture, Japan

Debut

with "Esther, Please," which appeared in *Petit Flower* in 1982

Best known works

"Fancy Dance"
"Onmyôji"
"Y Yômi henjô yawa"

TV adaption

"Fancy Dance"
"Onmyouji"

Prizes

• 34th Shôgakukan Manga Award (1989)
• 5th Tezuka Osamu Cultural Prize Manga Award (2001)

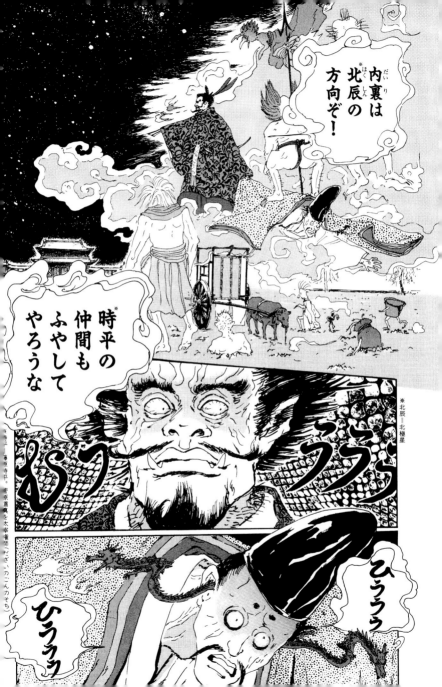

内裏は
北辰の
方向ぞ！

時平の
仲間も
ふやして
やろうな

※北辰=北極星

ひぅララ

ひぅララ

Bei „Onmyôji" handelt es sich um die Adaption eines Romans um den Yin-Yang-Meister Seimei Abe der Heian-Zeit. Obwohl dieser Manga auf einer Vorlage basiert, ist er durchaus ein eigenständiges Kunstwerk von hoher Perfektion. Perspektivisch realistische Stadtansichten der Heian-Zeit, Pandämoniumsszenen, deren Pinselstrich an japanische Malerei erinnert, und eigene Erklärungen der Autorin zum Weg von Yin und Yang ergeben einen ganz neuen Stil, der so sonst nirgends zu sehen ist. Vor allem auch Okanos geistreicher Humor und ihre filmische Ausdruckskraft sind bemerkenswert an diesem rundum großartigen Manga. Für ihre Manuskripte fertigt sie seitenweise Zeichnungen an, die übereinandergelegt dann das fertige Bild ergeben. Diese unglaublich sorgfältige Arbeitsweise möchte man am liebsten in einem Dokumentarfilm festgehalten sehen. „Fancy Dance" beschreibt einen modernen Jugendlichen in einem Zen-Tempel, und ebenso wie in „Yômi Henshô Yawa" – in dieser Komödie ist das chinesische taoistische Paradies Ort der Handlung – verbindet sie Komik mit philosophischem Nachsinnen. Sie ist derzeit wohl die einzige Mangaka, der das gelingt.

« Onmyôji » est un manga inspiré d'un roman sur Seimei Abe, qui était un onmyôji (devin) durant la période Heian. Bien qu'il existe une histoire originale accompagnant ce manga, il peut être considéré comme une œuvre indépendante d'une qualité extraordinaire. Okano a apporté une perspective réaliste à l'atmosphère des villes durant la période Heian. Ses dessins de scènes dans lesquelles des démons et autres entités diaboliques dévastent tout, ressemblent à s'y méprendre à des peintures japonaises, et l'auteure utilise ses propres mots pour décrire l'onmyoudou (la sorcellerie taoïste basée sur le Yin et le Yang). Ces qualités apportent une certaine fraîcheur à ses œuvres. En particulier, Okano démontre ses talents incroyables au travers de dessins très expressifs et l'utilisation abondante d'esprit et d'humour. Comme on peut le voir dans les exemples, ses scènes incroyablement détaillées sont créées par la superposition méticuleuse de plusieurs couches de dessins. De plus, Okano combine de la pensée philosophique avec de la comédie dans « Yômi henjô yawa », une comédie chinoise sur le monde des sennin (des sages immortels qui vivent des existences d'ermites). Elle est une des meilleurs mangakas modernes à mêler habilement philosophie et comédie dans ses mangas.

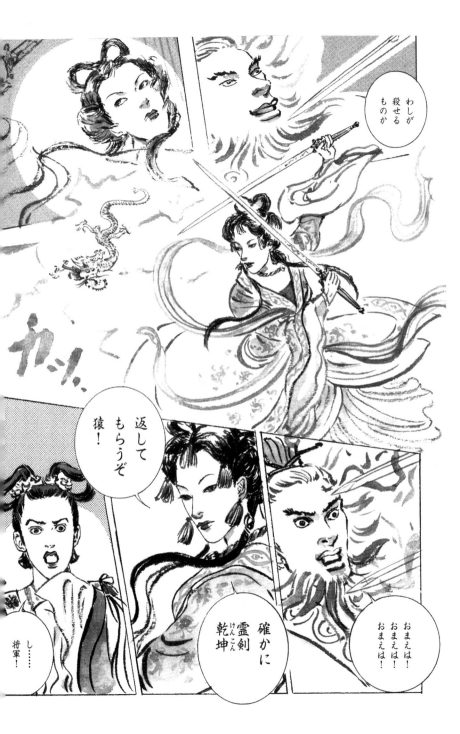

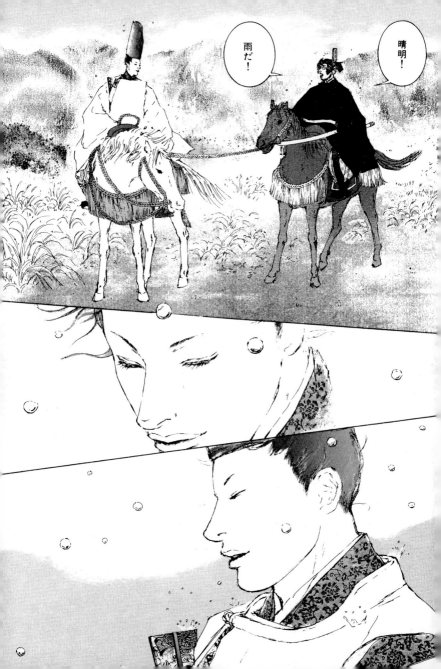

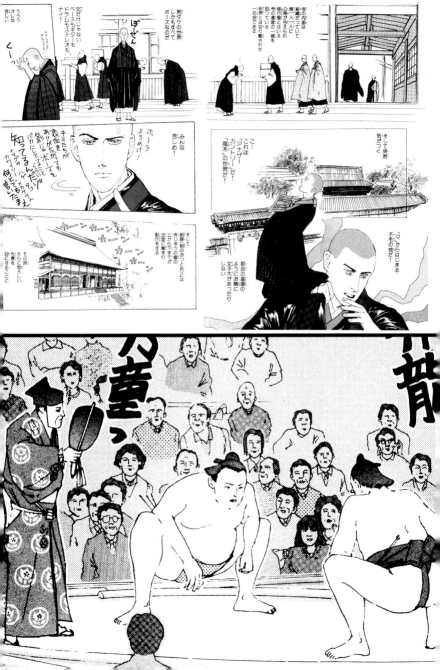

While covering the cutting edge fashions and customs of the 1980s and 1990s, Kyôko Okazaki also vividly describes the loneliness and emptiness that was characteristic of the period. The youth of this generation identified with Okazaki's works and gave her their strong support. After the 1980s, Japan and its foremost symbol, Tokyo, were overflowing with goods and information. Greed and desire colored the nation. Okazaki was one of the rare manga artists to successfully capture the mentality of the young people who lived during this period in a realistic manner. In addition, she was also able to portray the difficulties of living amidst this particular period. In 1996, the mangaka was hit by a drunk driver and sustained severe injuries. She has not announced any new manga works. However, her previous works continue to be published and even now in the 21st century, the themes of her stories remain as sharp as ever. Her best known work is "Helter Skelter." This popular manga series portrays the insanity and sensuality of a famous model who gained her dazzling beauty through head-to-toe plastic surgery. The series was published 21 years ago, but the story continues to make readers reflect on the world as it is today, while serving as a reminder of the author's talents.

KYÔKO OKAZAKI

Born

1963 in Tokyo, Japan

Debut

with several works in *Manga Burikko* around 1983

Best known works

"Pink"
"River's Edge"
"Helter Skelter"

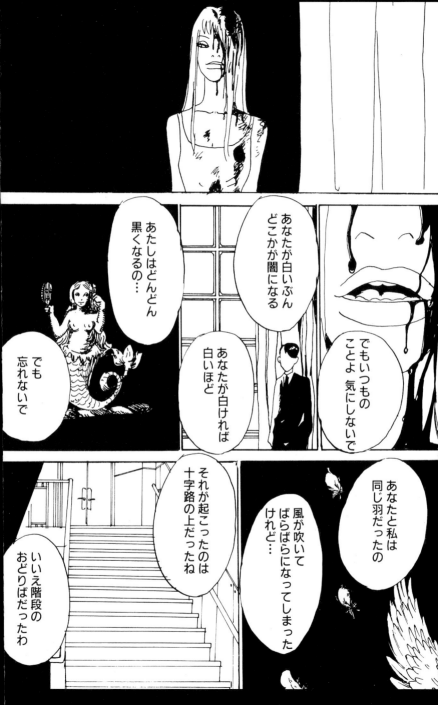

Okazaki integrierte die neuesten Moden und Verhaltensmuster der 1980er und 1990er Jahre mit leichtem Federstrich in ihre Mangas und zeigte deutlich die verborgene Einsamkeit und Leere der Epoche, wofür sie von jungen Leuten geliebt wurde. In den 1980er Jahren war Japan – beziehungsweise stellvertretend Tokio – plötzlich grell koloriert von einem Überfluss an Waren und Information, aber auch von der Gier danach. Wie sonst kaum jemandem gelang es der Autorin, die Gefühle dieser Generation wirklichkeitsnah festzuhalten und von der Schwierigkeit zu erzählen, in einer solchen Zeit zu leben. Kyôko Okazaki wurde 1996 von einem betrunkenen Autofahrer angefahren und von den schweren Verletzungen, die sie dabei davontrug, hat sie sich bis heute nicht vollständig erholt. Seitdem hat sie kein neues Werk veröffentlicht, ihre alten Arbeiten jedoch werden weiterhin verlegt und ihre Themen sind auch im 21. Jahrhundert aktuell. Bezeichnend ist „Helter Skelter" um Sinnlichkeit und Wahnsinn eines Supermodels, das sich am ganzen Körper Schönheitsoperationen unterzogen hat. Der inzwischen sieben Jahre alte Manga wirkt immer noch hochaktuell und vermittelt einen Eindruck vom Talent der Autorin.

Tout en montrant la mode et les coutumes des années 1980 et 1990, Kyôko Okazaki a décrit de manière vivide la solitude et le vide caractéristiques de cette période. Les jeunes de cette génération se sont identifiés aux œuvres d'Okazaki et lui ont apporté leur soutien. Après les années 1980, le Japon et son principal symbole, Tokyo, ont été submergés de biens et d'informations. L'avidité et l'envie ont déteint sur la nation. Okazaki était l'une des rares auteurs de mangas à capturer avec succès et de manière réaliste la mentalité des jeunes gens vivant durant cette période. En 1996, elle a été victime d'un accident causé par un conducteur ivre et a subi de nombreuses blessures. Elle est toujours en cours de réhabilitation. Depuis, elle n'a pas édité de nouveaux mangas. Toutefois, ses travaux précédents continuent d'être publiés, et les thèmes de ses histoires restent d'actualité. Son œuvre la plus connue est « Helter Skelter ». Cette série populaire dépeint la folie et la sensualité d'un modèle célèbre qui a obtenu sa beauté incroyable en recourant à la chirurgie esthétique. La série a été publiée au milieu des années 1990, mais l'histoire continue de faire réfléchir les lecteurs sur le monde tel qu'il est aujourd'hui. Elle rappelle également aux lecteurs le talent de l'auteure.

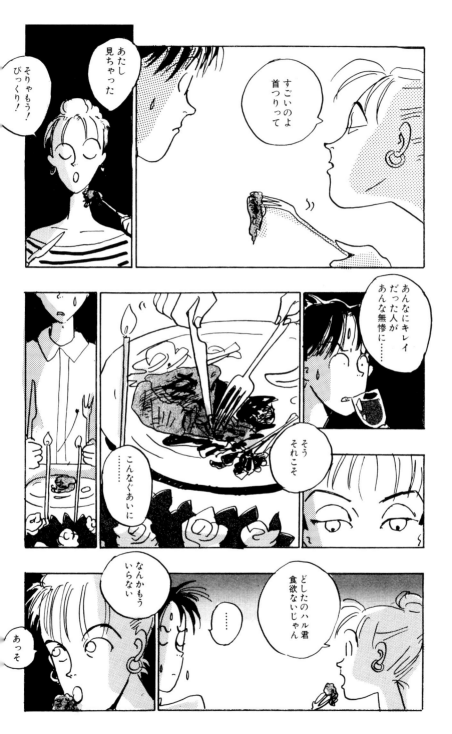

キャー!!

Hiroya Oku debuted with a manga portraying a young man who finds that his body is changing into a woman's body. He went on to create "Hen," which depicts a boy who falls in love with a young, feminine male classmate. Then came a story called "HEN" [Strange Love], a tale of a well-proportioned girl who falls in love with a less developed girl in her class. Oku has written many of these kinds of stories that revolve around the physical appearances of the sexes. In the beginning, his illustrations were detailed and realistic, but he later used different kinds of lines in a creative manner by mastering the more simplified and delicate lines. He further challenged himself with recent works by utilizing 3D models to create his character designs, and he even uses 3D designs for some of his background visuals. His drawings of the physical body are also a highlight in such creative stories as "01 Zero One," which features virtual reality game players and "Gantz," which features people who travel back and forth through different worlds as they battle aliens. From flying body parts to exotic shots of a woman's cleavage, Oku always manages to leave an indelible image on the reader's mind – haunting scenes that are sometimes sexy and sometimes shocking. Furthermore, the tension he creates in his illustrations is equally unforgettable. The fascination with manga comes from the portrayal of action and movement. But Oku relies on clever timing throughout each frame to beautifully show off the movement of his characters, and thus succeeds in creating tremendous impact to his story.

H O
I K
R U
O
Y
A

Born
1967 in Fukuoka Prefecture, Japan

Debut
with "Hen" published in *Young Jump* magazine in 1989

Best known works
"HEN" [Strange Love]
"01 Zero One"
"Gantz"

Anime adaption
"Hen"
"HEN" [Strange Love]

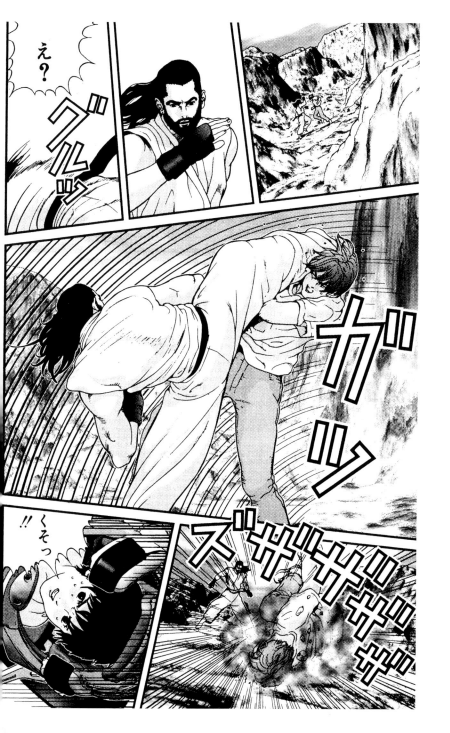

In seinem Erstlingswerk findet sich ein Junge in einem Mädchenkörper wieder, „Strange" ist die Geschichte eines Jungen, der sich in einen mädchenhaft niedlichen Mitschüler verliebt, und „Strange Love" beschreibt die aufkeimende Liebe einer toll aussehenden Schülerin für eine zierliche neue Mitschülerin – Hiroya Oku erzählt seine Geschichten oft über körperliche Beziehungen. Seine ersten Zeichnungen waren geprägt von genauem Realismus, den er jedoch bald zu äußerst einfachen Linien verdichtete und nach Bedarf mit zarter Strichelung ergänzte. Neuerdings fertigt Oku Zeichnungen nach am Computer erstellten 3-D-Figuren und komponiert die entsprechenden 3-D-Hindergründe, stellt sich also immer wieder neuen Herausforderungen. Seine Darstellung von Körperlichkeit zeigt sich am gelungensten etwa in „01 Zero One", wo sich Gamer im virtuellen Raum bekämpfen, oder in den Schießereien der Wanderer zwischen den Welten aus „Gantz". Ob niedergemetzelte Körper oder bebende Frauenbusen, Schockszenen ebenso wie Sexszenen wirken absolut unmittelbar, die gesamte Bildfläche ist von Spannung erfüllt. Die Faszination des Mediums Manga liegt in der Darstellung von Bewegung: Hiroya Oku ist Meister darin, in jedem einzelnen Bild bewegte Körper im spannendsten Moment einzufangen und zeichnerisch die Intensität der Story zu vermitteln.

Hiroya Oku a débuté avec un manga sur un jeune homme dont le corps se transforme graduellement en celui d'une femme. Il a ensuite créé « Hen » [Strange], une histoire à propos d'un garçon qui tombe amoureux d'un jeune camarade de classe efféminé. Le manga suivant, « Hen » [Strange Love], est l'histoire d'une jeune fille bien proportionnée qui tombe amoureuse d'une autre jeune fille moins bien développée de sa classe. Oku a écrit de nombreuses histoires de ce genre, qui traitent de l'apparence physique des hommes et des femmes. À ses débuts, ses illustrations étaient détaillées et réalistes, puis il s'est essayé à différents types de lignes de manière créative pour finir par utiliser des lignes simplifiées et plus délicates. Il s'est également surpassé récemment avec l'utilisation de modèles en 3D pour créer des personnages, et il utilise même la 3D pour certains de ses décors. Ses dessins de corps humains sont également l'attrait principal d'histoires novatrices telles que « 01 Zero One », qui met en scène des joueurs de jeux de réalité virtuelle, et « Gantz » qui montre des personnages combattant des extra-terrestres dans des mondes différents. Que ce soit des bras et des jambes qui volent dans tous les sens ou des vues plongeantes de la poitrine d'une femme, Oku réussit toujours à laisser une image indélébile dans l'esprit des lecteurs – des scènes obsédantes qui sont quelquefois sexy et quelquefois choquantes. Les tensions qu'il crée dans ses illustrations sont aussi inoubliables. La fascination envers les mangas vient de l'action et des mouvements. Oku utilise un timing précis dans ses vignettes pour montrer les mouvements de ses personnages, et il réussit ainsi à donner un impact énorme à ses histoires.

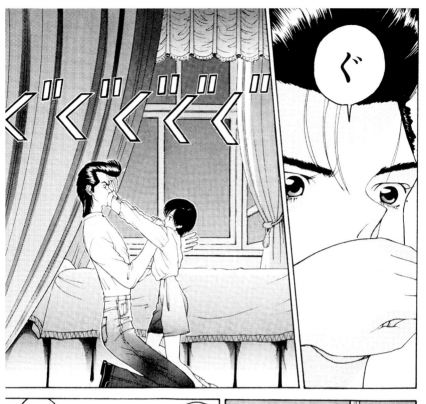

With her unique story structure, Yumiko Ōshima's works are often cited as examples whenever it is said that "in Japan, the manga has surpassed other works of literature." As a mangaka she has influenced many creative minds, from Japanese writers to film directors. Even when her story settings involve something novel and out of the ordinary, they are filled with the strong and earnest hopes and sentiments of all her characters. She does not strive to invent completely new imaginary worlds, but manages to create a fantasy world derived from the ordinary one. The characters' intense emotions are depicted in the action or explained in the monologue, utilizing the frame to the fullest. The written information is also detailed. Her manga are extremely condensed, and given that she has written mostly short stories,

she is best known by the series "Wata no kuni hoshi." The main character of the story is an anthropomorphized kitten named Chibineko, and we see the unfolding drama through her eyes. This story is not a simple animal manga story. Instead, it explores the psychology and the inner workings of the heart. Many people might assume that Ōshima's works have a soft and cuddly feel to them, but her characters are strong as well as naive, and their lives are gentle yet intense. With her characters' complex psychological depictions, she has managed to create some very well-known and popular characters. Recently she announced the publication of a picture book depicting Chibineko, and essay format manga that were inspired by the author's cats. Her fans eagerly await a new story-based manga.

YUMIKO
ŌSHIMA

Born

1947 in Tochigi Prefecture, Japan

Debut

with "Paula no namida" [Paula's Tears] published in *Weekly Margaret* in 1968

Best known works

"Wata no kuni hoshi"
"Lost House"
"Mainichi ga natsuyasumi" [Summer Holiday Everyday]
"Banana Bread no Pudding" [Banana Bread Pudding]
"Joka e"

Anime adaption

"Kuni hoshi"
"Shigatsu kaidan" [April Ghost Story]
"Mainichi ga natsuyasumi" [Summer Holiday Everyday]
"Kinpatsu no sōgen" [Across a Golden Prairie]

Prizes

• Japan Cartoonists Association Excellence Award (1973)
• 3rd Kōdansha Manga Award (1979)

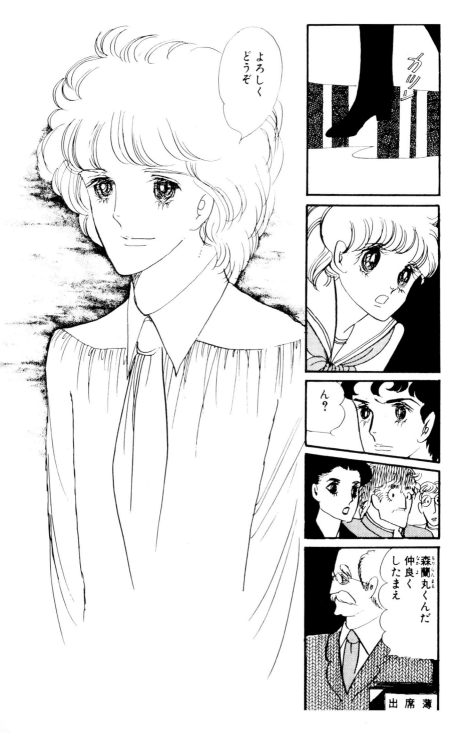

Wenn die Sprache darauf kommt, dass dank seiner einzigartigen Konstruktion der Manga in Japan die Literatur übertroffen habe, fällt stets der Name Yumiko Ôshima; und in der Tat hatte sie einen nachhaltigen Einfluss auf Schriftsteller, Filmregisseure und andere Kulturschaffende. Ihre Geschichten spielen an einem Ort, der der Realität immer ein wenig entrückt scheint, sind jedoch ganz von der Ernsthaftigkeit, den starken Gefühlen und Wünschen der dort lebenden Personen geprägt. Sie sucht das Besondere nicht in einer anderen, fantastischen Welt, sondern zeigt es im Alltäglichen. Die verdichtete Gedankenwelt ihrer Protagonisten beherrscht die Bildfläche, sei es durch Handlung oder durch inneren Monolog und die textliche Information ist dabei äußerst gehaltvoll. Da ihre Mangas sehr komprimiert sind und so hauptsächlich kurze Arbeiten entstanden, wurde Ôshima erst mit „Wata no kuni hoshi" [The Star of Cottonland] einem größerem Publikum bekannt. Die Protagonistin und Reflektorfigur ist ein personifiziertes Kätzchen namens Chibineko; es handelt sich aber keinesfalls nur um eine nette Tiergeschichte, vielmehr werden psychische und mentale Befindlichkeiten äußerst differenziert dargestellt. Alle ihre Werke wirken sehr soft und zart, jedoch ist die Reinheit und Sanftheit der Protagonisten immer gepaart mit Stärke und Strenge, und so wurden ihre Figuren alle durch ihre komplizierten Innenansichten berühmt. In den letzten Jahren veröffentlichte Ôshima Manga-Essays über ihre Katzen sowie ein Bilderbuch über Chibineko – jedoch schon seit geraumer Zeit keinen Manga mehr mit einer fiktionalen Geschichte.

Avec leur structure unique de scénario, les œuvres d'Yumiko Ôshima sont souvent citées en exemple lorsqu'on dit qu'« au Japon, les mangas ont surpassé les œuvres littéraires ». En tant que mangaka, elle a influencé de nombreux esprits créatifs, des auteurs ou des réalisateurs de films japonais. Même lorsque ses histoires impliquent quelque chose de nouveau ou peu ordinaire, elles sont remplies des peurs et des espérances sincères et profondes de ses personnages. Elle n'essaie pas d'inventer de nouveaux mondes imaginaires, mais tente plutôt de créer un monde fantastique dérivé du monde ordinaire. Les émotions intenses des personnages sont dépeintes dans les actions ou expliquées dans le monologue, utilisant la vignette en entier. L'information écrite est également très détaillée. Ses mangas sont extrêmement condensés et elle se contente habituellement d'écrire des histoires courtes. Elle est toutefois connue pour sa série « Wata no kuni hoshi ». Le personnage principal de l'histoire est un chaton anthropomorphé nommé Chibineko, et nous voyons l'action se dérouler au travers de ses yeux. Cette histoire n'est pas un simple manga sur le thème des animaux mais un récit qui dépeint la psychologie et le fonctionnement des sentiments. De nombreuses personnes pensent que les œuvres d'Ôshima ont une touche de douceur plus prononcée, mais ses personnages sont aussi forts que naïfs et leur vie est douce mais intense. À travers une psychologie complexe, elle a réussi à créer des personnages populaires et très connus. Elle a récemment annoncé la publication d'un livre d'images sur Chibineko et un manga sous forme d'essai littéraire inspiré par les chats de l'auteur. Ses fans attendent avec impatience un nouveau manga.

一九九五年十月初め
十三歳で死んだ猫サバのときは
激安の缶詰を与えていた

ねこ缶ラシ
4缶100円
本日かぎり!!

やっすーい
買いだめしとかなきゃ

激安缶詰は
なかには塩分過多のものが
あるし、なにより
栄養面でかたよってしまう

サバの体調はいつも
万全ではなかった

ゲキヤス缶が
おまけにすぎだった

それにあき缶を
洗うときよく
けがをしてた

いたっ

ここが
キケン
↑
catfood
まぐろ

ドライ
フードのお皿は
ただ洗って
ふくだけで
らくちーん

らくちんなのは
グーグーがドライフードを
たべてくれることだけではない

今の生活が
らくちんなのは
グーグーがドライフードを
たべてくれることだけではない

生活全般がスムーズに
進行しているのだ

たとえば昔
サバがあやまって
ものを落としたときは。

サバァ

と、
どなり

ど、どうすんの
こんなんなっちゃって
どうすんのよっ

と、
いつまでも
いつまでも
おこっていたが

"Flowers of Evil," a bizarre story of a high-school boy who accidentally steals a classmate's underwear causing a series of great events in the suburbs in Japan, was an immediate success after its release in 2009, with subsequent works "Shino Can't Say Her Own Name," "Inside Mari," and "Happiness" also drawing great attention to Shuzo Oshimi's work. With his debut at the age of 20 in 2001 with the independently published "Superfly," Oshimi had already shown his skills in expressing the subtleties of human nature and the works of the heart, attracting adolescent boys and girls especially. In his latest writings, Oshimi suggests that the fact that he stammers has led him to think deeply about a person's mind and thoughts through their expressions and movements. The artist has also been credited with work on several anime series, producing for instance background artwork for the popular manga series "Attack on Titan." The series "The Flowers of Evil," whose title was inspired by Charles Baudelaire's *Les Fleurs du Mal*, endured for five years, ending in 2014, and was made into an anime and aired in 2013.

SHUZO OSHIMI

Born
1981 in Gunma Prefecture, Japan

Debut
with "Superfly" in 2003 published in *Bessatsu Shōnen* magazine

Best known works
"Drifting Net Cafe"
"The Flowers of Evil"
"Boku wa Mari no naka" [Inside Mar▪

TV adaption
"Drifting Net Cafe"

Feature animation
"The Flowers of Evil"

Feature film
"Sweet Poolside"

Prizes
• 46th Tetsuya Chiba Award: Young Category Rookie Prize (2011)
• 17th Japan Media Arts Festival: Jury Selections in Manga Division (2013)

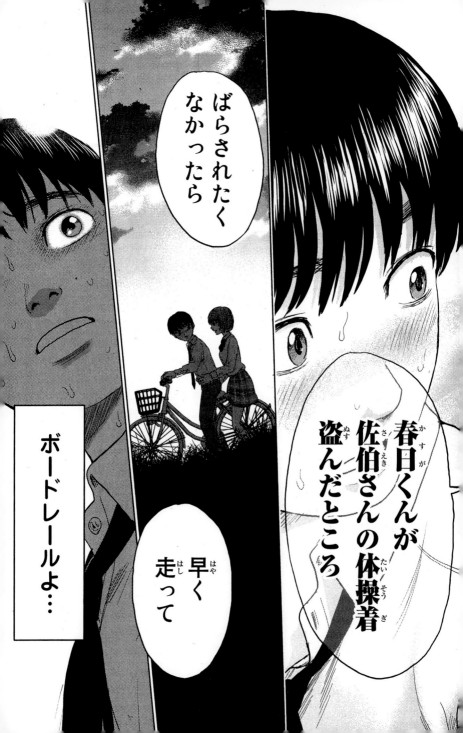

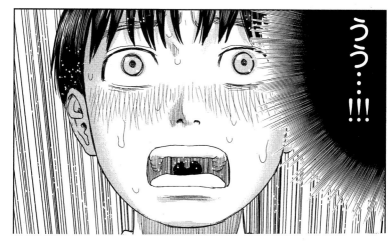

„Aku no Hana" [Die Blumen des Bösen] – die bizarre Geschichte eines Schülers, der die Unterwäsche einer Klassenkameradin stiehlt und damit eine Reihe von Ereignissen in einer japanischen Vorstadt auslöst – wurde nach ihrem Erscheinen 2009 sofort zu einem Erfolg. Diesen konnte Shuzo Oshimi mit den nachfolgenden Werken „Shino-chan wa jibun no namae ga ienai", „Boku wa Mari no naka" und „Happiness" weiter ausbauen. Seinen Einstand gab er 2001 im Alter von 20 Jahren mit dem unabhängig publizierten Titel „Superfly", bei dem Oshimi bereits bewies, dass er die Feinheiten der menschlichen Natur und Gefühlswelt kunstvoll darzustellen vermag, was ihm besonders bei Jugendlichen zu großer Popularität verhalf. In seinen jüngsten Werken deutet Oshimi an, dass sein Stottern ihn dazu veranlasste, sich anhand der Gestik und Mimik von Personen mit deren Gedankenwelt auseinanderzusetzen. Der Künstler arbeitete auch an verschiedenen Anime-Serien mit, so zeichnete er beispielsweise Hintergründe für die beliebte Manga-Serie „Shingeki no kyojin" [Attack on Titan]. Die Reihe „Aku no hana", deren Titel auf Charles Baudelaires *Les Fleurs du mal* zurückgeht, erschien fünf Jahre lang bis 2014 und wurde 2013 als Anime adaptiert und ausgestrahlt.

« Aku no Hana » [Les fleurs du mal] raconte l'étrange histoire d'un lycéen qui dérobe la tenue de sport d'une camarade de classe, ce qui entraîne toute une série d'événements dans les banlieues japonaises, Après cette consécration immédiate en 2009, Shuzou Oshimi s'est également distingué dans des collaborations comme « Shino Can't Say Her own Name», «Inside Mari » et « Happiness ». À ses débuts en 2001 à l'âge de 20 ans avec la publication indépendante *Superfly*, Oshimi montrait déjà son art d'exprimer les subtilités de la nature humaine et des états du cœur, séduisant notamment le public adolescent Dans ses derniers écrits, Oshimi explique que son bégaiement l'a poussé à analyser en détail l'esprit et les pensées des personnes à travers leurs expressions et leurs mouvements. L'artiste a aussi été acclamé pour son travail dans plusieurs séries animées : par exemple, pour les décors de la populaire série manga « Attack on Titan ». La série « Aku no hana », titre directement inspiré de l'ouvrage de Charles Baudelaire *Les Fleurs du Mal*, a duré cinq ans, jusqu'en 2014 ; elle a été adaptée en anime et diffusée en 2013.

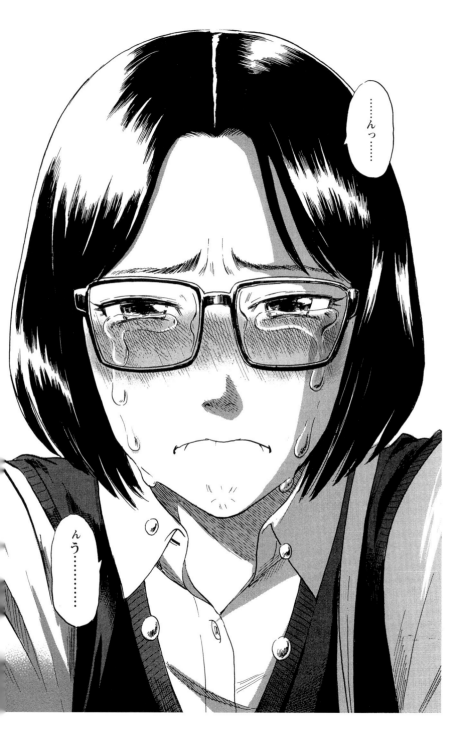

チュン
チュン
チュン

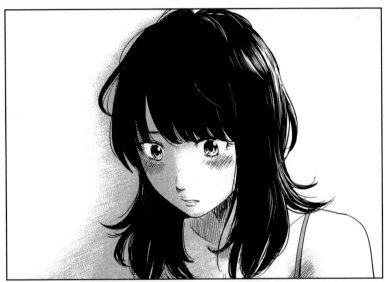

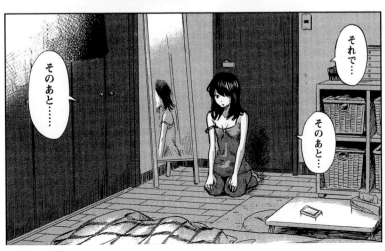

それで…

そのあと…

そのあと……

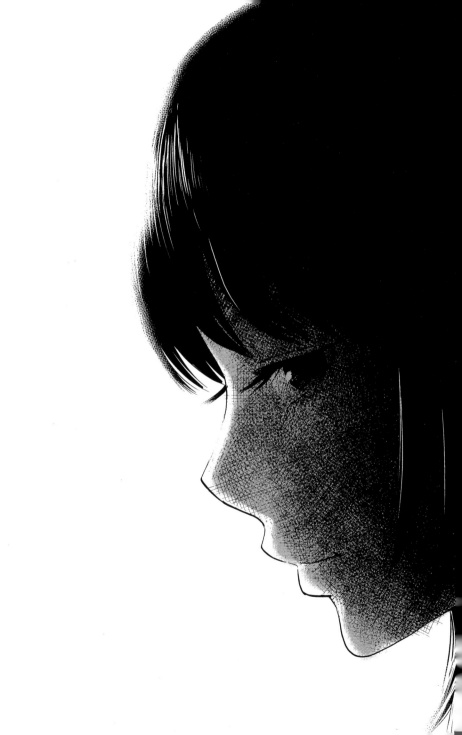

Katsuhiro Ôtomo's breakthrough hit "Akira" was the first Japanese manga to enjoy international popularity. His works are filled with a strong presence, and the deeply constructed plots draw the readers into another world. After writing eccentric short stories, his great talent was discovered and he added drawings and expressions to his stories. Very detailed in both imagery and story, the manga series "Dômu" [A Child's Dream] takes place in an apartment complex. Ôtomo uses strong visuals such as explosions and facial expressions to show human emotions and the building's ultimate destruction. The way he portrays the total destruction of Tokyo in "Akira" is simply breathtaking. He also has a great knack for capturing the people in these kinds of environments, so that they seem to almost leap off the pages. "Akira" is an honest manga with many superb scenes, where the readers can almost experience the changes that occur in familiar spots of post-apocalyptic Tokyo. Ôtomo has become famous as a leading representative of Japanese mangaka. He is currently engaged in film production.

KATSUHIRO ÔTOMO

Born

1954 in Miyagi Prefecture, Japan

Debut

with "Jûsei" [A Gun Report] (original story by Prosper Mérimée) which was published in *Manga Action* magazine in 1973

Best known works

"Short Peace"
"Kibun wa mô sensô" [Urge for War, Hard On]
(original story by Toshihiko Yahagi)
"Dômu" [A Child's Dream]
"Akira"
"Kanojo no omoide ..." [Memories]

Feature film

"Akira" (Director)
"Memories" (Director)

Prizes

• 4th Japan Science Fiction Grand Prix Award (1983)
• 15th Seiun Award in Comics Category (1984)
• 8th Kôdansha Manga Award (1984)

行こうぜ みんな！
高速26号をずっと行って
旧市街だ!!
ついて来られりゃだけどな

とっとと行けよ金田
ちゃんと後ろに
いるからさ

„Akira" war der erste japanische Manga, der weltweite Popularität erlangte. Beim Lesen taucht der Leser völlig ein in die vielschichtige Handlung und hat das Gefühl, unmittelbar dabei zu sein. Bereits mit seinen ersten Arbeiten – aus ungewöhnlichen Blickwinkeln verfasste Gesellschaftsbilder und Sciencefiction-Geschichten – wurde Ôtomo als Ausnahmetalent erkannt. Gleichzeitig experimentierte er mit Bildaufbau und Manga-spezifischen Techniken, schrieb Lautmalereien in die Sprechblasen, skizzierte Augen, Nase und Konturen auf eine für Mangas sehr wirklichkeitsgetreue Weise und zeichnete realistische Hintergründe, die an Gemälde erinnerten. Mit „Dômu" [A Child's Dream/ Das Selbstmordparadies] schuf er einen Manga, der in Bild und Story sorgfältigst durchkonstruiert war und in der Manga-Welt wie eine Bombe einschlug. In der Geschichte um unheimliche Vorfälle in einer Wohnsiedlung gelingt es Ôtomo, einstürzende Gebäude und menschliche Gefühle nur durch Bilder überzeugend darzustellen. Die Geschichte wird nicht durch Text erklärt, sondern der Leser erlebt sie gewissermaßen am eigenen Leib. In seinem Meisterstück „Akira" bewältigt er die schwierige, zeichnerische Darstellung eines apokalyptischen Tokio aufs Glanzvollste. Das Leben im Ausnahmezustand wird mit vielen Details geschildert und als Sciencefiction in Szene gesetzt. Als Quintessenz der Kunstform Manga und als Chronik einer atemberaubenden Metamorphose Tokios machte „Akira" den Autor im In- und Ausland zur Galionsfigur des japanischen Comics.

La série « AKIRA » d'Ôtomo a été le premier manga japonais à connaître un succès international. Ses œuvres sont remplies d'une forte présence et le scénario très structuré propulse les lecteurs dans un autre monde. Il a commencé par écrire de courtes histoires quelque peu excentriques sur le thème de la sciencefiction ou des gens d'aujourd'hui et des groupes avec lesquels ils vivent. Il a reçu une attention considérable pour son grand talent. Au même moment, il a introduit des idées novatrices avec ses dessins et ses expressions. Il a par exemple mis des effets sonores onomatopéiques dans ses bulles et a dessiné des décors composés de lignes et de contours réalistes. Dans « Dômu » [Rêve d'un enfant], il a créé une série qui a eu un impact substantiel dans le domaine des mangas, avec beaucoup de détails dans l'imagerie et le scénario. Il a un talent particulier pour véhiculer les émotions, pas simplement en écrivant des mots mais en permettant aux lecteurs de les vivre personnellement. La manière dont il décrit la destruction totale de Tokyo dans « AKIRA » est juste époustouflante. Il décrit avec détail les sagas de gens qui vivent dans le désarroi, et ajoute une touche de science-fiction à ses images. Ôtomo est très représentatif des mangakas japonais et a acquis une renommée nationale et internationale.

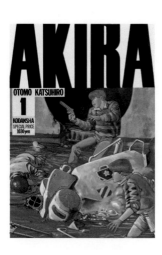

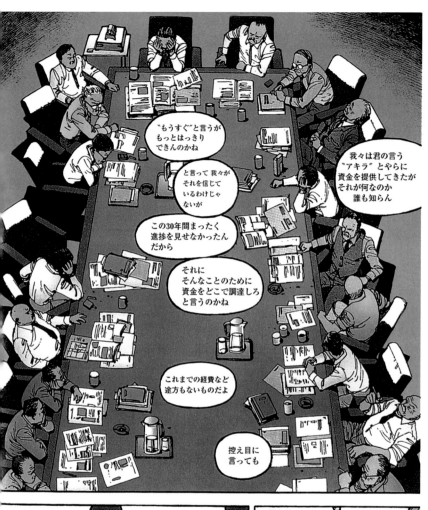

……

ヘリの音で
聞こえない
んですが…

はあ!?

照明だ
馬鹿者ッ
照明を
消せ
いっ

承知しました

数マイル四方の全員に
この秘密基地のことを
知らせたいのかあっ

A look at Yoshiyuki Sadamoto's career shows that he has constantly worked in both manga and animation. He debuted in the 1980s while still a university student, winning a new artist award sponsored by *Shônen Champion* magazine for his bike manga "Final Stretch." After that came "Lonely Lonesome Night" [Furimuita Natsu] and "18R (Hairpin) no taka," which were published in the same magazine. After graduation, he worked for an animation company called Telecom Animation Film before switching to the renowned Gainax company. He gained fame working as a director and character designer on such Japanese anime classics like "Ôritsu uchûsengun Oneamisu no tsubasa" [Wings of Honneamise], "Top wo Nerae!" [Gunbuster] and "Fushigi no umi no Nadia" [Nadia – The Secret of Blue Water]. In 1993, he published his first manga in a long while, "R20," in *Gekkan New Type* magazine, and in 1995 he worked on the character design for "Shinseiki Evangelion " [Neon Genesis Evangelion], published by *Shônen Ace Magazine*. Both his anime and manga versions of this title became enormous hits. Not only does Sadamoto draw catchy character designs, the high quality of his images have also attracted a strong following. In particular, his color illustrations are highly regarded in the manga and anime industries, and Sadamoto has become so popular that he has released art prints and published books containing collections of his manga art.

YOSHIYUKI SADAMOTO

Born

1962 in Yamaguchi Prefecture, Japan

Debut

with "18R (Hairpin) no taka" published in *Weekly Shonen Champion* in 1981

Best known works

"R20"
"Shinseiki Evangelion" [Neon Genesis Evangelion]

Anime adaption

"Ôritsu uchûsengun Oneamisu no tsubasa" [Wings of Honneamise– Character Design, Illustration Supervisor]
"Fushigi no umi no Nadia" [Nadia – The Secret of Blue Water – Character Design, Illustration Supervisor]
"Shinseki Evangelion" [Neon Genesis Evangelion – Character Design]
"Furi Kuri" (Character Design)

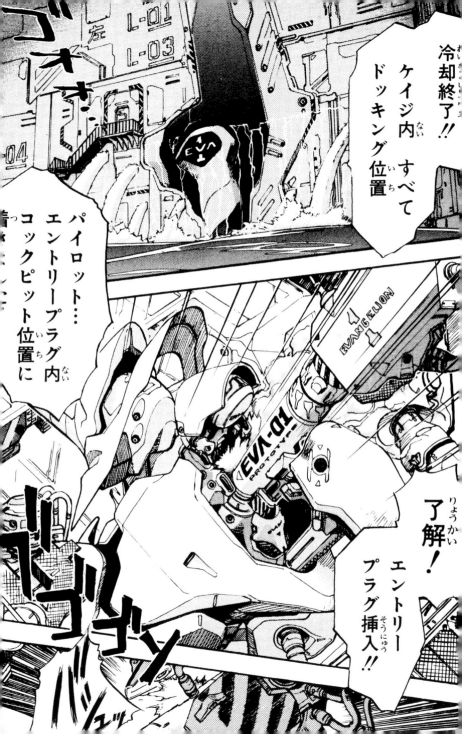

Sadamotos Karriere erstreckt sich über die beiden Genres Manga und Anime. In seiner Universitätszeit gewann er 1980 den Nachwuchspreis des Manga-Magazins *Shônen Champion* und gab sein professionelles Debüt mit dem Biker-Manga „Final Strech". Auch mit „Lonely Lonesome Night" [Furimuita Natsu] und „18R (Hairpin) no taka" blieb er dem *shônen*-Magazin treu. Nach seinem Universitätsabschluss arbeitete er aber zunächst für die Anime-Produktionsfirma Telecom Animation Film, um kurze Zeit später zu Gainax zu wechseln. Hier machte er sich mit Charakterdesign und Regiearbeiten zu Filmen wie „Royal Space Force: The Wings of Honneamise", „Top wo Nerae!" und „Nadia – The Secret of Blue Water" einen Namen in der japanischen Anime-Welt. 1993 veröffentlichte er mit „R20" seit langem wieder eine Manga-Serie, diesmal in *Gekkan New Type*. Ab 1995 widmete er sich dann dem Charakterdesign für den Anime „Neon Genesis Evangelion" sowie dem gleichnamigen Manga, die beide großen Erfolg hatten. Der Charme seiner Charaktere und die Ausdruckskraft seiner Bilder sind allgemein anerkannt; vor allem seine Farbillustrationen werden in der Anime- und Manga-Welt hoch geschätzt, weshalb es eine ganze Reihe prachtvoller Artbooks und Bildbände von ihm gibt.

La carrière de Yoshiyuki Sadamoto démontre qu'il a constamment travaillé sur des mangas et des animations. Il a fait ses débuts dans les années 1960 pendant qu'il était étudiant à l'université, et a remporté le Prix des nouveaux auteurs décerné par le magazine *Shonen Champion* pour son manga sur le cyclisme, « Final Stretch ». « Lonely Lonesome Night (Furimuita Natsu) » et « 18R (Hairpin) no Taka » ont suivi, et ont été publiés dans le même magazine. Après avoir obtenu son diplôme, il a travaillé pour une société d'animation appelée Telecom Animation Film avant de passer chez Gainax. Il est devenu célèbre en tant que réalisateur et concepteur de personnages, sur des classiques tels que « Ôritsu uchûsengun Oneamisu no tsubasa » [Les ailes d'Oneamisu], « Top wo Nerae! » [Gunbuster] et « Fushigi no umi no Nadia » [Nadia, le secret de l'eau bleue]. En 1993, il a publié « R20 », son premier manga depuis longtemps, dans le magazine *Gekkan New Type*, et il a travaillé sur la conception des personnages de « Shinseiki Evangelion » en 1995. Leurs versions manga et animation sont devenues très célèbres. Non seulement Sadamoto dessine des personnages accrocheurs, mais la grande qualité de ses images plaît à un large public. En particulier, ses illustrations en couleur sont très appréciées dans l'industrie du manga et de l'animation, et Sadamoto est devenu si populaire qu'il a publié des ouvrages contenant des collections d'images de ses mangas.

あなたの後ろに無限に広がる海の向こうなのかしら

あなたがどこに行こうと私はいつもあなたを見てるわ

自分の進む道は

あなたが自分で決めるのよ

Rieko Saibara is a tough manga artist who refuses to follow ordinary writing techniques. In her works, she combines aggressively strong writing with underdog characters that are given expressive facial expressions. "Uramishuran" was the title that catapulted her to fame. In this controversial work, Saibara teamed up with another writer to visit a number of well-known restaurants. They then unveiled harsh opinions as to the service and the quality of food. They were criticized for their strongly written opinions. Their suspicious views over these widely raved about restaurants are written in an extreme manner.

On the other hand, she has a kind way of showing the sad and humorous stupidity of both the foolish and the poor. Her best known work is "Bokunchi" [My House], a story that portrays the daily lives of an older sister and younger brother living in a small fishing village. She vividly describes the stark reality of characters who act on the whims of monetary greed, sex, and violence. Saibara persists in portraying all of this in a forgiving manner. She manages to explore the foolishness of people, and with real meaning, she positively affirms the existence of humanity.

R S
I A
E I
K B
O A
R
A

Born
 1964 in Kôchi Prefecture, Japan

Debut
 with "Chikuro yôchien," which
 appeared in *Young Sunday Magazine*
 in 1988

Best known works
 "Bokunchi" [My House]
 "Mahjong hôrôki"
 "Yunbo-kun"

Anime adaption
 "Bokunchi" [My House]

Prizes
 • 43rd Bungeishunjû Manga Award
 (1997)

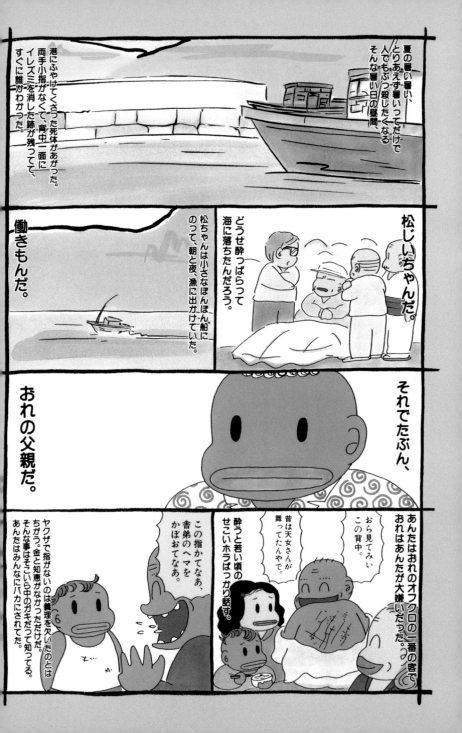

夏の暑い暑い、とりあえず暑いってだけで人でもぶっ殺したくなるそんな暑い日の昼間、

港にふやけてくさった死体があがった。両手小指がなくて、背中一面に、イレズミを消した跡が残ってて、すぐに誰かわかった。

松じいちゃんだ。

どうせ酔っぱらって海に落ちたんだろう。

松ちゃんは小さなぽんぽん船にのって、朝と夜、漁に出かけていた。

働きもんだ。

それでたぶん、

おれの父親だ。

あんたはおれのオフクロの一番の客で、おれはあんたが大嫌いだった。

おら見てみい、この背中。

昔は天女さんが舞ってたんやで。

酔うと若い頃のせこいホラばっかり話す。

この指かてなあ、舎弟のヘマをかぼおてなあ。

ヤクザで指がないのは義理を欠いたのとはちがう。金と知恵がなかっただけだ。そんな事はそこいら中のガキだって知ってる。あんたはみんなにバカにされてた。

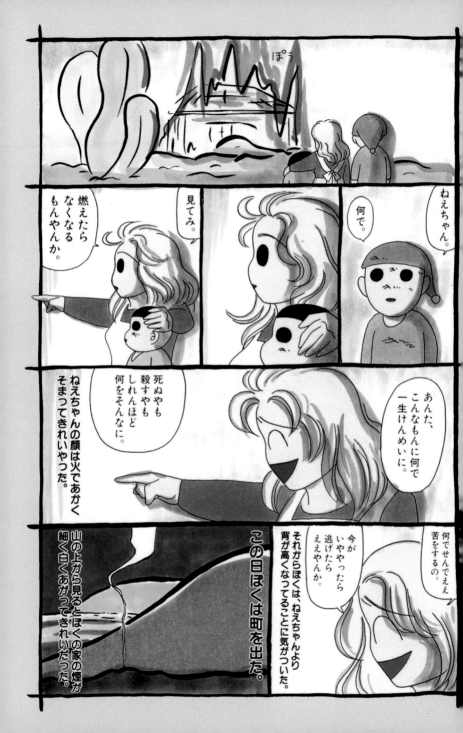

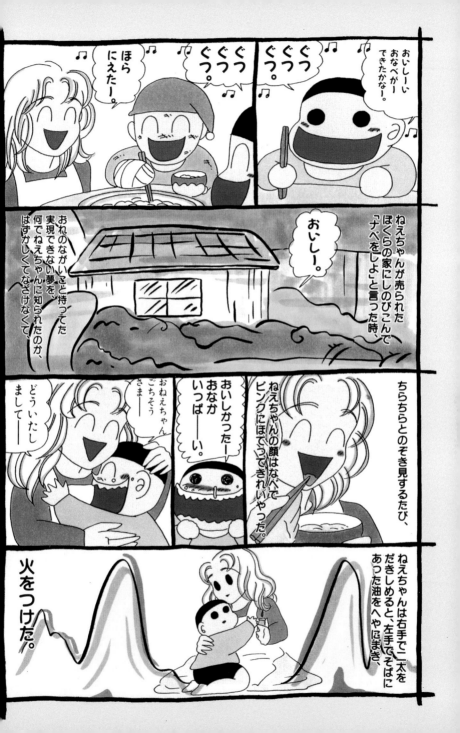

Rieko Saibara vereint scharfzüngige Angriffslust mit einem lyrischen Blick auf die Schwachen und gilt als starke Zeichnerin, die sich nicht auf ein Genre festnageln lässt. Allgemein bekannt wurde sie mit „Uramishuran", den sie in Zusammenarbeit mit einem Texter verfasste: Sie ging in die exklusivsten Restaurants und verlieh in der Serie völlig unbeeindruckt ihrer wahren Meinung über Essen und Service Ausdruck – die allzu spitze Feder erregte damals einige Gemüter. Ihr Argwohn richtet sich gegen Affektiertheit und Effekthascherei; den Armen und Schwachen aber gilt ein Blick voller Warmherzigkeit, obgleich sie sich über deren Dummheit ebenfalls mokiert. In ihrem bekanntesten Werk „Bokunchi" [Mein Haus] beschreibt Saibara das von Armut geprägte Leben dreier Geschwister in einem Fischerdorf. Geld, Sex und Gewalt bestimmen ihre Existenz, aber obwohl Saibara hier ein hoffnungsloses Porträt völlig entblößter Menschenleben zeichnet, vergibt ihr Blick letzten Endes doch alles. Die Torheit miteingeschlossen, bejaht sie die menschliche Existenz im eigentlichsten Sinne.

Rieko Saibara est un auteur de mangas endurci qui refuse de se conformer aux techniques d'écriture traditionnelles. Ses œuvres combinent des récits fortement agressifs avec des personnages faibles à qui elle donne des visages très expressifs. « Uramishuran » est l'œuvre qui l'a rendue célèbre. Dans cette œuvre controversée, Saibara s'est associée à un autre auteur pour se rendre dans un certain nombre de restaurants bien connus. Ils ont émis des opinions sévères sur le service et la qualité de la nourriture. Ils ont naturellement été critiqués pour leurs avis catégoriques. Leur attitude méfiante de ces restaurants très populaires est décrite de manière extrême. D'un autre côté, Saibara a une manière de montrer la stupidité triste et humoristique des idiots et des pauvres. Son œuvre la plus fameuse est « Bokunchi » [Ma maison], une histoire qui dépeint la vie courante d'une sœur et de son jeune frère dans un village de pêcheurs. Elle décrit de façon très nette la réalité saisissante des personnages qui agissent sur le coup de l'avidité, du sexe et de la violence. Saibara continue à montrer tout cela de manière indulgente. Elle a beau décrire la bêtise des gens sous une lumière crue, elle défend positivement l'existence de l'humanité.

このページを編集長にみせるのがとてもこわかった西原

まず とりのパイを かいてみる

いやー毎月 みてますよ ゴールド

どうも

しっぱい

麻雀マンガなのに 麻雀パイが全然 でてこない

というのが 実におも しろいですね

はあ

そっか！ナルシ

また 失敗

ってゆうにね

ほめられ たからね

この世界に 絵の下手な まんが家が いるんだ よう！

ちゃんと 麻雀パイ かいて！

はい

Following her debut, Fumi Saimon published mainly in *seinen* manga magazines, and she immediately attracted considerable attention for winning over fans with exciting story development and the realistic psychological portrayal of her characters. In particular, Saimon is skilled at describing the inner psychology of a woman's mind. Instead of just painting a pretty picture, she also includes the ugly truths of a woman's psychology, without any trace of maliciousness. Her tone work and the lines she uses to portray emotions and movement are not in the tradition of the *shoujo* manga. Instead, she succeeds at combining her simple and refreshing images with a direct portrayal of her character's relationships and mentality. In the 1980s and 1990s, her popular series "Dou-Kyû-Sei" [Classmate], "Tokyo Love Story," and "Asunaro Hakusho" [Asunaro White Paper] were all made into hit TV dramas. At the time, they were part of a boom of trendy dramas, and they enjoyed wide success. She obtained an enormous following, particularly from women. Because of her great skill at portraying romance, Saimon has also written many works on the subject of love as an essayist. Her latest manga, "Minna kimi ni koi shiteru" [Everybody Loves You], tells the story of two self-conscious girls and the men that enter their lives, set against the world of the mass-media.

F U M I

S A I M O N

Born

1957 in Tokushima
Prefecture, Japan

Debut

with "Kumo otoko funbaru!,"
which was published in
a special issue of *Shônen
Magazine* in 1979

Best known works

"Tokyo Love Story"
"Onna tomodachi" [Women Friends]
"P.S. Genki desu, Shunpei"
[P.S. I'm Fine, Shunpei]

TV dramas

"Tokyo Love Story"
"Asunaro hakusho"
[Asunaro White Paper]
"Dou-Kyû-Sei" [Classmate]

Prizes

• 7th Kôdansha Manga
Award (1983)
• 37th Shôgakukan
Manga Award (1992)

Seit ihrem Debüt zeichnet Fumi Saimon hauptsächlich für Magazine, die sich an junge Erwachsene richten. Realitätsnahe, psychologische Skizzen und atemberaubende Storyentwicklung fesselten ihr Lesepublikum und verschafften Saimon schon bald einen hohen Bekanntheitsgrad. Insbesondere versteht sie sich wie sonst kaum jemand darauf, das – nicht immer edle – Innenleben ihrer Frauenfiguren schonungslos darzustellen. Effektlinien und Rasterfolien, wie sie besonders für *shôjo*-Mangas typisch sind, kommen bei ihr eher selten zum Einsatz. Vielmehr gelingt es ihr gerade mit klaren Formen, zwischenmenschliche Beziehungen und die Gefühlswelt ihrer Protagonisten sehr direkt zu vermitteln. In den 1980er bis 1990er Jahren veröffentlichte sie „Dou-Kyû-Sei", „Tokyo Love Story" und „Asunaru Hakusho", streng genommen eine einzige zusammenhängende Serie, die mit Fernsehverfilmungen auf der trendy Drama-Welle um 1990 vor allem beim weiblichen Publikum erfolgreich war. Ihr sicheres Gespür für Herzensangelegenheiten stellt sie immer öfter auch als Essayistin unter Beweis. Derzeit zeichnet Fumi Saimon den in der Medienbranche spielenden Manga „Minna kimi ni koi shiteru" um zwei miteinander konkurrierende Frauen und die Männer in ihrem Umfeld.

Après ses débuts, Fumi Saimon a principalement publié ses mangas dans des magazines de mangas seinen et a immédiatement capté une attention considérable pour avoir conquis autant de fans avec ses développements excitants et la représentation psychologique réaliste de ses personnages. En particulier, Saimon est douée pour décrire la psychologie intérieure de l'esprit des femmes. Plutôt que d'en montrer une jolie image, elle montre également les vérités laides de la psychologie des femmes, sans aucune mauvaise intention. Les couleurs et les lignes qu'elle utilise pour dépeindre les émotions et les mouvements n'entrent pas dans la tradition des mangas shoujo. Elle réussit à combiner ses images simples et rafraîchissantes avec les relations et la mentalité de ses personnages. Dans les années 1980 et 1990, ses célèbres séries « Dou-Kyû-Sei » [Camarade de classe], « Tokyo Love Story » et « Asunaro Hakusho » [Livre blanc Asunaro] ont été adaptées pour la télévision. Elles faisaient partie d'un nouveau genre de fictions à la mode et ont connu un grand succès. Elle a conquis beaucoup de fans, principalement des femmes. Avec son incroyable talent pour décrire la romance, Saimon a également écrit de nombreuses œuvres sur le sujet de l'amour en tant qu'écrivain. Son dernier manga, « Minna kimi ni koi shiteru » [Tout le monde t'aime], raconte l'histoire de deux filles timides et des garçons qu'elles rencontrent, sur fond du monde des médias.

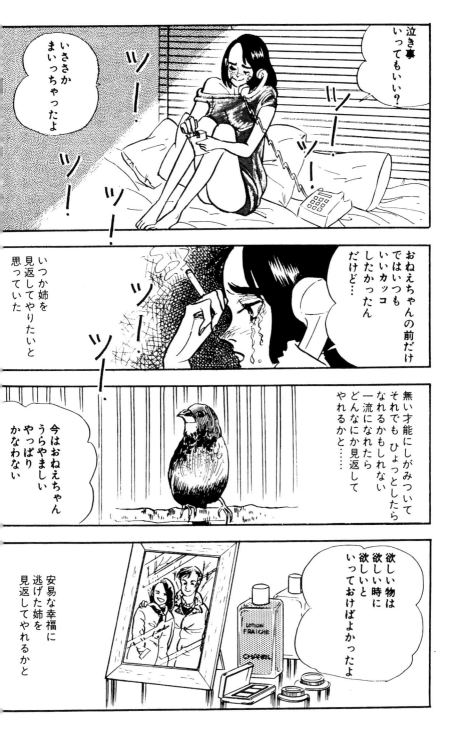

In the 1950's, during a generation where manga could be rented from rental shops, there was a movement to break away from the usual manga stories that always included amusing and funny elements, to create manga stories with a serious content geared toward adult audiences. Takao Saitô was one of these mangaka. He ambitiously produced many works, and his best known manga, "Golgo 13," resulted in the rapid spread of the popularity of the gekiga style. The series has continued without a break for over 30 years, resulting in some 130 comic volumes. There is no one in Japan who is not familiar with this famous gekiga. The story's hero is a skillful international sniper called Golgo 13. The hard-boiled character and the surprising methods and techniques he uses to kill his victims caught people's imaginations. He can attack people standing behind them, he always fulfills even the most impossible assignments, and he is ruthless, not letting any outside ideologies influence him. By portraying such an intense character, and then allowing him to step into incidents around the world that closely mirrored current affairs, readers can enjoy a robust international frisson. Saitô has also created period pieces based on historical novels. He consistently continues to create hard-boiled stories that show off cool adult characters

TAKAO SAITÔ

Born

1936 in Wakayama Prefecture, Japan

Debut

with "Kûki danshaku" published by Hinomaru Bunko in 1955

Best known works

"Golgo 13"

Anime adaption

"Onihei hankachô"
"Survival"
"Kagegari"
"Golgo 13" [The Professional: Golgo 13]
"Muyô no kai"
"Kagegari"

Prizes

• 21st Shôgakukan Manga Award (1976)

Wo die Schulmeinung Humor und Slapstick für unverzichtbare Elemente eines Manga hielt, kam in den 1950er Jahren, als Comicbücher noch hauptsächlich aus kommerziellen Büchereien entliehen und nicht gekauft wurden, der Gegenentwurf des *gekiga*. Einer der Initiatoren dieser Bewegung war Takao Saitô und mit „Golgo 13" sorgte er schließlich für den Durchbruch dieses Genres. Seit über 30 Jahren ununterbrochen in Serie und mit inzwischen über 130 Sammelbänden ist dieses *gekiga* jedem Japaner ein Begriff. Der Titelheld ist ein begnadeter international tätiger Auftragskiller und sein eiskaltes Gemüt sowie seine verblüffenden Mordtechniken machten ihn rasch zum Publikumsliebling. Golgo 13 erschießt Gegner, auch wenn sie hinter ihm stehen, löst unlösbare Aufgaben und kennt weder Gefühl noch Skrupel. Diese *hard-boiled*-Figur bleibt in allen Folgen gleich, seine Fälle auf internationalem Parkett jedoch werden dem Zeitgeschehen angepasst. So liegt der Reiz dieses *gekiga* auch in den vielschichtigen weltpolitischen Angelegenheiten im Hintergrund. Populäre Samurai-Romane lieferten die Vorlage für einige seiner anderen Mangas, immer aber zeichnet Takao Saitô eine harte Erwachsenenwelt voller Coolness.

Dans les années 1950, à l'époque d'une génération où les mangas pouvaient être loués dans des boutiques de location de bandes dessinées, un mouvement a tenté de se démarquer des mangas habituels, qui étaient toujours drôles et amusants, et créer des mangas sur des thèmes sérieux pour adultes. Takao Saitô était un de ces mangakas. Il a produit de nombreuses œuvres, la plus connue étant « Golgo 13 », qui a permis à ce style gekiga de devenir rapidement populaire. La série s'est poursuivie sans relâche pendant plus de 30 ans, pour constituer une collection de 130 albums. Il n'existe personne au Japon qui ne connaisse ce fameux gekiga. Le héros de cette histoire est un habile tueur international appelé Golgo 13. Le personnage, les méthodes et les techniques surprenantes qu'il utilise pour tuer ses victimes ont attiré l'imagination des lecteurs. Il peut tirer sur des personnes se tenant derrière lui, remplir n'importe quelle mission, même la plus difficile, et il est impitoyable. Il ne laisse aucune idéologie l'influencer. En donnant une image si intense à son personnage et en le laissant participer à des incidents qui rappellent les affaires internationales du moment, les lecteurs peuvent ressentir le frisson de l'actualité internationale. Saitô a également créé des mangas basés sur des romans historiques. Il continue de créer des histoires dures qui montrent des personnages adultes intéressants.

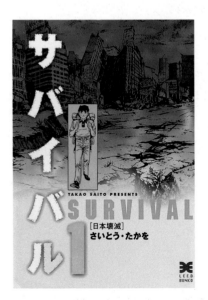

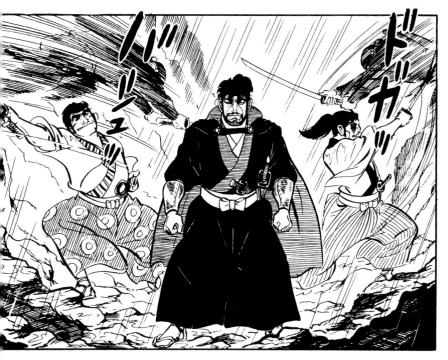

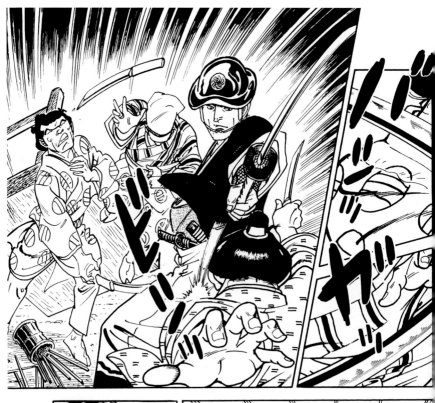

チン…

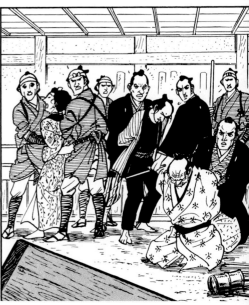

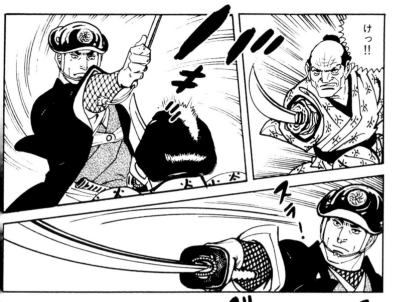

けっ!!

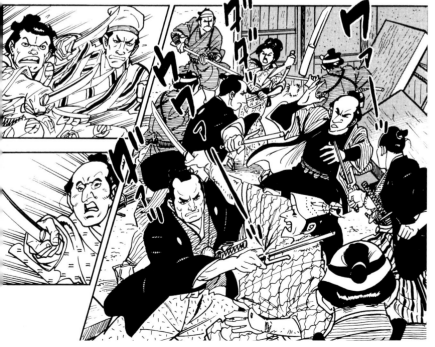

Momoko Sakura is best known for her famous manga "Chibi Maruko-chan," in which the author reflects back upon her own childhood as a third grader, growing up in an average family during the 1970s. The main character, Maruko, is a precocious little eight- year-old who is at that age when children start yearning to be grown up. Through her frank and simple drawings, Sakura is a genius at finding extraordinary humor in Maruko's slightly unusual and off-kilter interactions with classmates and family members. Readers are drawn to the stories, which feature situations that everyone remembers encountering in their own pasts. With warm drawings that can be enjoyed in living rooms across Japan, she brings out the humor and deep emotions found in such ordinary occasions as Mother's Day, a school field day, or the usual family quarrel. That is probably why fans of every age and gender are so taken by her work. Some even call the series "Heisei no Sazae-san" [Heisei Period's "Sazae-san"] after the nationally loved manga series that has been running for over 50 years. After "Chibi Maruko-chan" was made into a hit TV animated series, Sakura has also written several magazine columns, which focus on the humor that is tucked away in our everyday lives. The topics range from a case of athlete's foot the writer caught, to her opinions and ideas after seeing an antlion (doodlebug). The difficulties in conjuring up laughter using only the written word can often prove frustrating, but Sakura easily has the power to induce belly aching laughter with her humorous descriptions of ordinary situations.

MOMOKO SAKURA

Born
1965 in Shizuoka Prefecture, Japan

Debut
with "Oshiete yarunda arigataku omoe!" which was published in *Ribbon Original* 1984 autumn edition

Best known works
"Chibi Maruko-chan"
"Coji-coji"
"Nagasawa-kun"

Anime adaption
"Chibi Maruko-chan"
"Cojicoji"

Prizes
• 13th Kôdansha Manga Award (1989)

Ihr berühmter Manga „Chibi Maruko-chan" spielt in den frühen 1970er Jahren und zeigt Momoko Sakura selbst als Drittklässlerin inmitten einer Durchschnittsfamilie. Mit ihren neun Jahren ist die altkluge Protagonistin Maruko in einem Alter, in dem man sich gerne erwachsen gibt. Das Genie der Autorin besteht darin, durch die frechen Wortwechsel der Göre mit ihrer Familie und ihren Klassenkameraden sowie einen sehr direkten, einfachen Zeichenstil ihr Lesepublikum mit Alltagssituationen zum Lachen zu bringen. In ihren Geschichten kann sich jeder wiederfinden, weshalb „Chibi Maruko-chan" vielen Japanern besonders ans Herz gewachsen ist. Die heiteren, familiengerechten Bilder, Gelächter und Tränen in einfachen Erzählungen über Muttertag, Schulsportfest oder Geschwisterstreit sorgten für generationsübergreifende Popularität und den Beinamen „*Sazae-san* der 1990er Jahre". Nach dem Riesenerfolg der Anime-Adaption wurde Momoko Sakura zu einer gefragten Kolumnistin und natürlich gewinnt sie auch hier den banalsten Alltagssituationen Komik ab. So schreibt sie etwa über ihre Erfahrungen mit Fußpilz oder ihre Gedanken beim Anblick eines Ameisenlöwen und überwindet dabei mühelos die Schwierigkeit mittels gedruckter Buchstaben witzig zu sein: Die „alltäglichen Lachgeschichten" erreichen garantiert ihr Ziel.

Momoko Sakura est connue pour son manga « Chibi Maruko-chan » dans lequel elle fait un retour sur sa propre enfance à l'âge de l'école élémentaire et sur sa famille durant les années 1970. Le personnage principal, Maruko, est une petite fille précoce de 8 ans qui est à un âge où les enfants aspirent déjà à devenir adultes. Au travers de ses dessins simples et francs, Sakura réussit à montrer un humour extraordinaire dans les interactions quelque peu inhabituelles de Maruko avec ses camarades de classe et sa famille. Les lecteurs sont attirés par l'histoire, qui montre des situations que tout le monde a déjà vécues dans son passé. Ses dessins chaleureux sont appréciés dans les salons des familles japonaises, et elle fait ressortir de l'humour et de profondes émotions que l'on trouve dans des occasions ordinaires telles que la fête des mères, une sortie de classe, ou des disputes familiales courantes. C'est probablement pourquoi les fans de tous âges et des deux sexes sont si attirés par ses œuvres. Certains appellent même la série « Heisei no Sazae-san » [La période Sazae-san de Heisei], d'après ce manga très populaire dont la série dure depuis déjà plus de 50 ans. Après que « Chibi Maruko-chan » a été adapté pour la télévision, Sakura a également écrit des articles pour des magazines, sur le thème de l'humour qui se cache dans nos vies quotidiennes. Les thèmes variés vont d'une mycose que l'auteure a attrapée, à ses opinions et ses idées après avoir vu une larve d'insecte. La difficulté de provoquer le rire avec des mots peut souvent être frustrante, mais Sakura parvient aisément à provoquer des fous rires avec ses descriptions humoristiques de situations ordinaires.

えっ

私の右上に
霊の顔が
写ってるの!?
心霊写真
てこと!?

…はっきり
わかんない
けど…
この写真
なんだ

…どれ
見せて…

ドキ
ドキ…

げっ

ホントだ!!
コレ人の顔だ!!

やだ
まるちゃん
おちついてっ
しっかりして!!

ガク
ガク
ガク

…昨日
テレビで
見たんだ…

霊の顔が
写っていた写真と
一緒に写っていた
人達が次々と
ひどい目に
あったって…

ガク
ガク

ガリ

ええっ…!!
それじゃあ
私達も!?

うん…

もしかしたら
私達も次々と
ひどい目に
あうかもね…

ガク
ガク

Noriko Sasaki's "Dôbutsu no o-isha-san", which became a huge nationwide hit, depicts the everyday lives of veterinary school students. In this manga, the main character Masaki, his friend Nikaidô, and Masaki's dog Chobi find themselves drawn into various curious happenings that center around the eccentric characters at their veterinary school. Beginning with the quiet and calm-headed main character, the author reveals the humorous and endearing qualities in everyday human behavior. The way in which the amusing stories cause involuntary laughter and leave the readers wanting more is excellent. In addition,

Chobi's scary and grim exterior appearance is totally opposite of her lovable personality, and this character ended up giving rise to a Siberian Husky boom in Japan. This is an unusual manga that also had the social impact of causing a large increase in the number of veterinary school applicants. In addition, "Otanko Nurse" is about the life of a scatterbrained nurse, and "Heaven?" is about the troubled owner of a restaurant and his employees. Each of Sasaki's works features quirky and amusing characters, and her manga are always top quality.

N O R I K O S A S A K I

Born

1961 in Asahikawa, Hokkaidô, Japan

Debut

with "Apron Complex," which appeared in the summer special issue of *Hana to Yume* in 1980

Best known works

"Dôbutsu no o-isha-san" [Animal Doctor]
"Otanko Nurse" [Ditzy Nurse]
"Heaven?"

Drama

"Dôbutsu no o-isha-san" [Animal Doctor]

Der Manga „Dôbutsu no o-isha-san" [Mr. Veterinarian aka Animal Doctor] über den Alltag von Studierenden an der Fakultät für Veterinärmedizin verhalf Noriko Sasaki zum Durchbruch. Die Hauptfigur Masaki, sein Freund Nikaidô und der Hund Chobi werden in jeder Folge des Mangas von den schrulligen Individuen, die den Campus bevölkern, in allerlei Aufregungen verwickelt. Mit dem bedächtigen Masaki im Mittelpunkt schildert Sasaki die Komik und den Charme alltäglicher menschlicher Handlungen mit unbewegter Miene. Wie es ihr dabei gelingt, ihre Leser zuerst laut auflachen und nach dem Lesen noch einmal nachdenklich werden zu lassen, ist wohl einmalig. Ganz nebenbei löste die Autorin mit dem äußerst würdevoll wirkenden Chobi, der in Wahrheit ein verschmustes Schoßhündchen ist, eine ungeheure Nachfrage nach Sibirischen Huskys aus, und auch die Veterinärmedizin konnte stark angestiegene Immatrikulationsraten verzeichnen. Ein Werk mit derartigen sozioökonomischen Auswirkungen dürfte Seltenheitswert besitzen. Auch nach „Mr. Veterinarian" zeichnete Noriko Sasaki Mangas mit kauzigen Protagonisten und hohem Qualitätsanspruch, wie zum Beispiel „Otanko Nurse" über eine schusselige Krankenschwester oder „Heaven?" über einen Restaurantbesitzer in Nöten und seine Angestellten.

« Dôbutsu no o-isha-san » [Vétérinaire], qui est devenu célèbre au Japon, dépeint la vie quotidienne d'étudiants à l'école vétérinaire. Dans ce manga, le personnage principal Masaki, son ami Nikaidô et Chobi, le chien de Masaki, se trouvent mêlés à des événements curieux qui touchent les personnages excentriques de leur école vétérinaire. Avec son protagoniste discret et calme, l'auteur révèle les qualités humoristiques et attachantes des comportements humains de tous les jours. Ses histoires amusantes provoquent des rires involontaires et font que les lecteurs en demande plus. De plus, l'apparence extérieure effrayante et sinistre de Chobi est totalement à l'opposé de son caractère sympathique, et il a provoqué un engouement pour les chiens husky au Japon. C'est un manga peu commun qui a eu un impact sur la société en provoquant une augmentation du nombre d'inscriptions dans les écoles vétérinaires. Le manga « Otanko Nurse » [L'infirmière écervelée] raconte la vie d'une infirmière véritablement écervelée, et « Heaven? » dépeint un restauranteur préoccupé et ses employés. Chacune des œuvres de Sasaki montre des personnages amusants et excentriques, et ses mangas sont toujours d'excellente qualité.

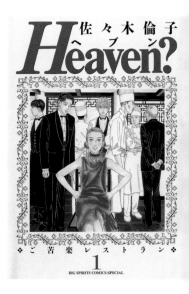

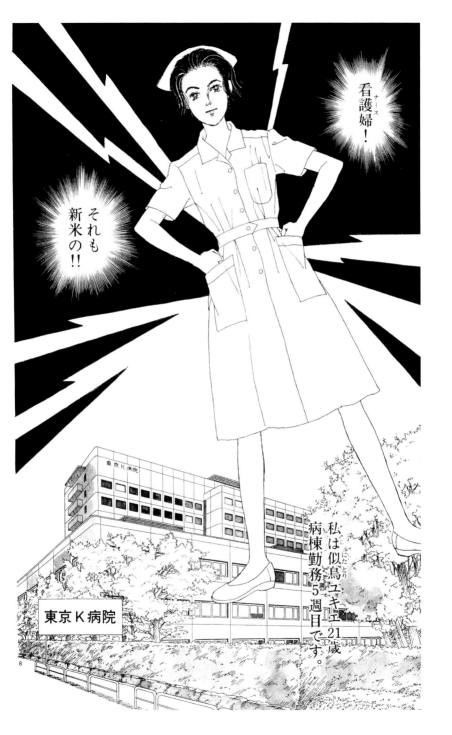

オープンして一か月。
「この世の果て」を訪れる客は、
ほとんどなかった――

でも
お客が
ゼロって
わけでも
ないもんね
伊賀くん。

そうですね。

シェフの料理のファンが
毎日ひとりふたり…

↑
コアなファン

小澤シェフ
塩が効いてないよ。

そうですか
すみません。

ハッ

シェフは弱気になると
味が薄くなるのよねぇ。

小澤シェフ
自信を
持ってよ。

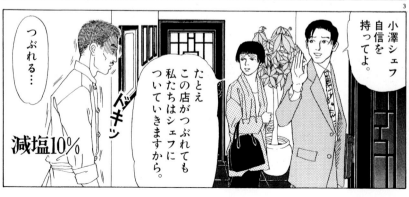

たとえ
この店がつぶれても
私たちはシェフに
ついていきますから。

つぶれる…

バキッ

減塩10％

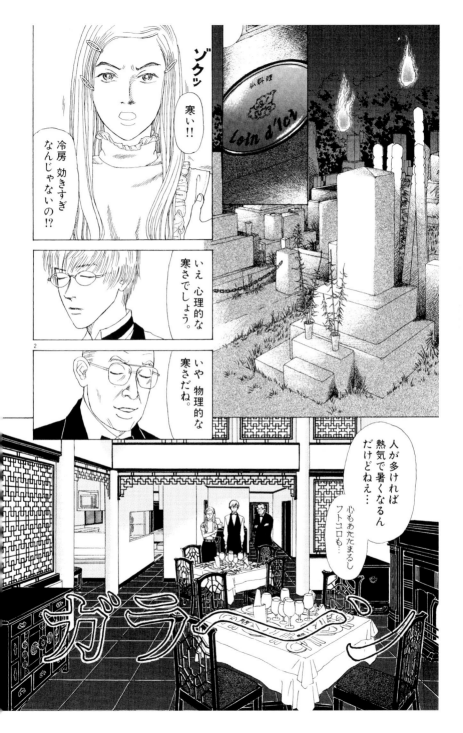

ゾクッ

寒い!!

冷房 効きすぎなんじゃないの!?

いえ 心理的な寒さでしょう。

いや 物理的な寒さだね。

2

人が多ければ熱気で暑くなるんだけどねぇ…

心もあたたまるし フトコロも…

仏料理

Loin d'or

Having had careers as both a manga artist and a typical Japanese white collar worker, it is logical that many of Kotobuki Shiriagari's manga are set in an office environment. "Hige no OL Yabuuchi Sasako" [Yabuuchi Sasako, the Mustached Office Lady] is the crazy tale of a female office clerk who vows never to get rid of her noticeable facial hair until she finds true love. The manga has the power to induce fits of laughter, as there is not a serious scene in the entire plot. On the artistic side, Shiriagari's drawings seem at first glance like mere scribbles, but, as a corporate worker, he had previously designed packaging for beer products and therefore has considerable artistic skills at his command. Recently he has branched out into other genres, receiving the Tezuka Osamu Cultural Prize Manga Award for Excellence for his work on "Yajikita in Deep." For this he took Jippensha Ikku's picaresque tale "Tōkaidōchū hizakurige" [Shank's Mare] and developed it into the story of a homosexual junkie couple who embark on an immoral Ise Pilgrimage. Shiriagari weaves into the journey ancient mythology, folklore, religious stories, and fairy tales – the rich tapestry of humankind's infinite imagination and delves deep into his characters' psyches.

K S
O H
T I
O R
B I
U A
K G
I A
R
I

Born

1958 in Shizuoka Prefecture, Japan

Debut

in 1981, while a full time office worker, he published manga in his free time. In 1985 he published his first tankōbon, "Ereki na haru"

Best known works

"Yajikita in Deep"
"Hige no OL Yabuuchi Sasako"
[Sasako Yabuuchi, the Mustached Office Lady]
"Ryūsei kachō"

Prizes

- 46th Bungeishunjū Manga Award (2000)
- 5th Tezuka Osamu Cultural Prize (2001)

Seine Karriere als Mangaka verband er mit einem Berufsleben als Angestellter und so spielen sich auch zahlreiche seiner Geschichten im Büro ab. Shiriagari veröffentlicht bei vielen Verlagen und sein „Hige no OL Yabuuchi Sasako" erscheint noch immer mit neuen Folgen. Hauptfigur ist eine Büroangestellte, die schwört, erst dann wieder ihre Barthaare zu rasieren, wenn sie die wahre Liebe gefunden hat. Keine einzige ernsthafte Szene gibt es in diesem Manga, und beim Lesen muss man einfach lachen. Shiriagaris Zeichnungen wirken auf den ersten Blick zwar wie Kritzeleien, zeugen aber doch von Talent, denn nicht umsonst wurde ihm in seiner Firma schon mal das Design einer Bierverpackung anvertraut. Shiriagari wurde mit Gag-Mangas berühmt, erweiterte aber in den letzten Jahren sein Spektrum und gewann mit „Yajikita in Deep" den Osamu-Tezuka-Kulturpreis. Als Vorlage benutzte er Jippensha Ikku's „Tôkaidôchû hizakurige" [Shank's Mare]. Die degenerierte Pilgerreise eines homosexuellen drogenabhängigen Paares nach Ise dient ihm als Hintergrund für Anspielungen auf die Sagen des klassischen Altertums sowie auf Fabeln, Heiligenlegenden, Kindermärchen, den heiligen Gral und das Rittertum. Die verschlungene Geschichte, in welcher der Autor ein Licht auf verborgene Bewusstseinsschichten wirft, wurde vom Publikum enthusiastisch aufgenommen.

Avec une carrière en tant qu'auteur de mangas et une carrière d'employé de bureau typique, il est logique que la plupart des mangas de Kotobuki Shiriagari se déroulent dans un environnement professionnel. « Hige no OL Yabuuchi Sasako » [Yabuuchi Sasako, la secrétaire à moustache] est l'histoire incroyable d'une secrétaire qui a juré de ne pas se débarrasser des poils sur son visage tant qu'elle n'aura pas trouver le véritable amour. Ce manga ne contient aucune scène sérieuse et provoque le fou rire. Les dessins de Shiriagari ressemblent au premier abord à des gribouillages. Lorsqu'il travaillait en entreprise, il concevait des emballages de bières et a donc des talents artistiques considérables. Il est même de notoriété publique que de son vivant, Osamu Tezuka a fait l'éloge des dessins de Shiriagari. Bien qu'il ait continué de se faire un nom avec ses mangas comiques, il s'est récemment tourné vers d'autres genres, et a reçu un prix pour son œuvre « Yajikita in Deep ». Il s'est inspiré de l'histoire picaresque « Tôkaidôchû hizakurige » [À pied] de Jippensha Ikku et l'a développée pour dépeindre l'histoire d'un couple de drogués homosexuels qui s'embarquent dans un pèlerinage immoral. Shiriagari y mêle de la mythologie, du folklore, des histoires religieuses et des contes de fées. Le couple se retrouve à cheval entre la signification et la non-signification, la réalité et le rêve, la vie et la mort, et lorsque l'existence même de tout ce qui les entoure devient totalement ambiguë, ils passent dans un monde irrationnel. Alors que l'histoire s'engage dans la confusion et le chaos, Shiriagari creuse profondément dans le psychisme des personnages, ce qui lui a valu de nombreux éloges pour cette œuvre.

そのOLは…
かのように
そらない
ヒゲを
優勝するまで
球児が
甲子園

真実の
愛がみつかるまで

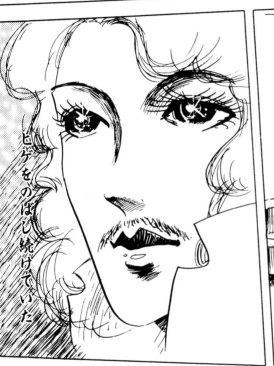

ヒゲをのばし続けていた

ふさ

ふさ

ふさ
ふさ

The fruitful collaboration between writer Yû Sasuga and manga artist Ken'ichi Tachibana in their first work "Terra Formars" has excited a large audience in this sci-fi title. With a plot set on Mars in the year 2577, the story starts with the first arrival of a manned ship from earth with six crewmembers. What the crew surprisingly finds are giant mutated humanoid cockroaches with incredible physical strength. The acclaimed series became a weekly publication in 2012 due to its popularity. "Terra Formars" has now been scheduled to become a feature film directed by Takashi Miike with a release scheduled for 2016. Born in 1988 and part of a new generation of writers, Sasuga wrote "Terra Formars" while still in college, making his debut in 2011. Artist Tachibana received the 6th Manga Grand Prix Award with "Potchari Maniacs" from *Young Jump* in 2003, at the age of 25. This wiz kid from Saitama went on to win many other prizes in the following years. He has also authored "Ore no Tomodachi wa Akai Yatsu," "Three Seven Honey," "Hana no Bakuchi-gumi!!," "Lucky Seven Star," and "Shower Curtain."

KEN'ICHI

TACHIBANA

DESIGN

YÛ

SASUGA

STORY

Born

Ken'ichi Tachibana: 1977 in Saitama Prefecture, Japan
Yû Sasuga: 1988 in Kanagawa Prefecture, Japan

Debut

Ken'ichi Tachibana: with "Ore no tomodachi wa akai yatsu" in 2004 published in *Young Jump Zôkan Mankaku*

Best known works

"Terra Formars"

Anime adaption

"Terra Formars"

Prizes

• Ranked 1st in "This Is the Amazing Manga! Boy's Section 2013 (Kono manga ga sugoi! Otoko hen 2013)"

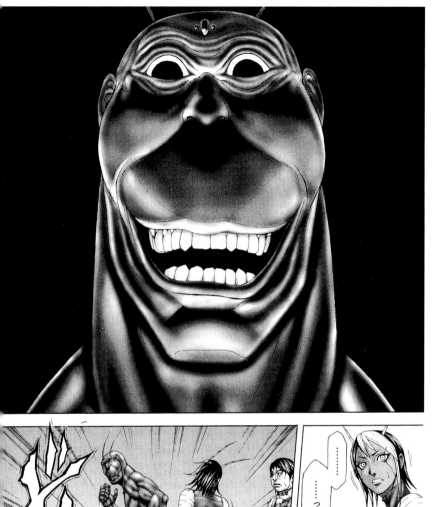

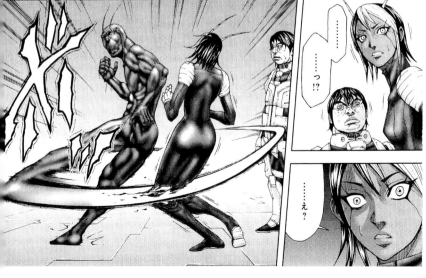

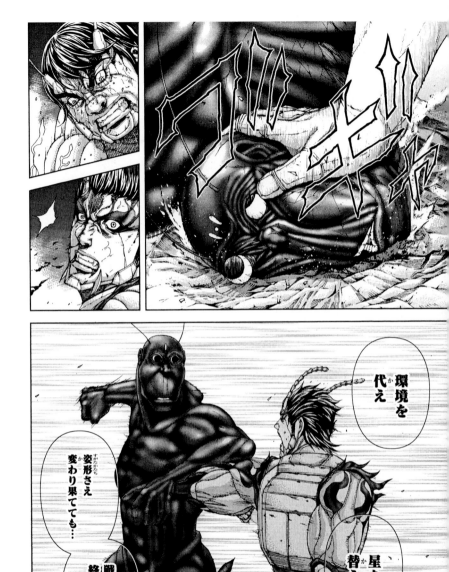

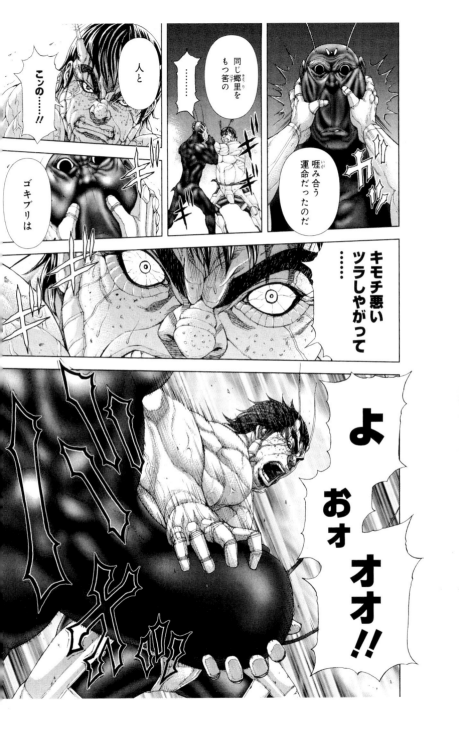

Das erste gemeinsame Werk von Texter Yû Sasuga und Manga-Zeichner Ken'ichi Tachibana, der gelungene Sciencefiction-Titel „Terra Formars", stieß bereits auf großes Interesse beim Publikum. Die Geschichte spielt im Jahr 2577 und beginnt damit, dass ein Raumschiff von der Erde mit sechs Besatzungsmitgliedern auf dem Mars landet. Dort treffen sie überraschenderweise auf riesige mutierte humanoide Kakerlaken, die über eine unglaubliche Körperkraft verfügen. Die vielgepriesene Serie erschien aufgrund ihrer Popularität ab 2012 wöchentlich. Eine Verfilmung von „Terra Formars" unter der Regie von Takashi Miike soll 2016 in die Kinos kommen. Yû Sasuga, der 1988 geboren wurde und einer neuen Generation von Textern angehört, schrieb „Terra Formars" noch während seines Studiums, erstmals veröffentlicht wurde er 2011. Zeichner Ken'ichi Tachibana bekam 2003 im Alter von nur 25 Jahren von *Young Jump* für „Potchari Maniacs" den 6. Manga Grand Prix verliehen. In den folgenden Jahren erhielt das Wunderkind aus Saitama noch zahlreiche weitere Preise. Zu seinen Werken gehören außerdem „Ore no Tomodachi wa Akai Yatsu", „Three Seven Honey", „Hana no Bakuchi-gumi!!", „Lucky Seven Star" und „Shower Curtain".

La collaboration entre l'écrivain Yû Sasuga et l'artiste manga Ken'ichi Tachibana a donné naissance à l'ouvrage de science-fiction « Terra Formars », largement acclamé. L'intrigue se déroule sur Mars en l'an 2577, et l'histoire commence avec la première arrivée d'un vaisseau habité venu de la Terre avec 6 personnes à bord. L'équipage découvre avec stupeur des blattes humanoïdes géantes d'une force physique incroyable. Cette série d'une grande popularité a fait l'objet en 2012 d'une publication hebdomadaire. Il est prévu que « Terra Formars » soit adapté en long métrage par Takashi Miike, avec une sortie en salles prévue en 2016. Né en 1988, Yû Sasuga a écrit « Terra Formars » pendant ses années universitaires. Il a fait ses débuts en 2011 et appartient à une nouvelle génération d'écrivains. L'artiste Ken'ichi Tachibana a remporté en 2003, à l'âge de 25 ans, le 6e grand prix du manga de *Young Jump* avec « Potchari Maniacs ». Ce jeune prodige originaire de Saitama a remporté de nombreux autres prix depuis lors. Il est également l'auteur de « Ore no Tomodachi wa Akai Yatsu », « Three Seven Honey », « Hana no Bakuchi gumi!! », « Lucky Seven Star » et « Shower Curtain ».

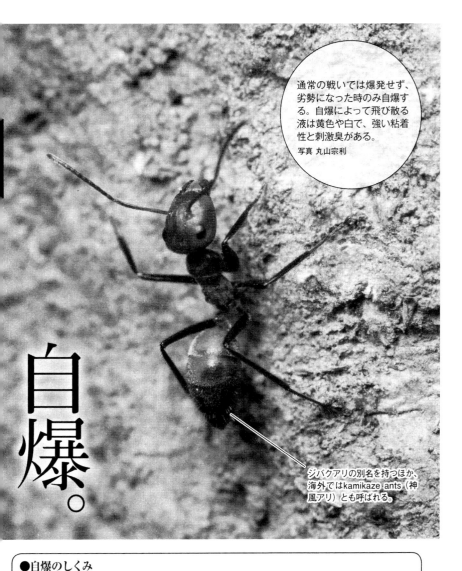

通常の戦いでは爆発せず、劣勢になった時のみ自爆する。自爆によって飛び散る液は黄色や白で、強い粘着性と刺激臭がある。
写真 丸山宗利

自爆。

ジバクアリの別名を持つほか、海外ではkamikaze ants（神風アリ）とも呼ばれる。

●自爆のしくみ

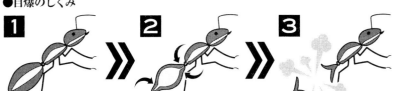

1 発達した大あご腺が頭部から腹部まで広がっている。

2 腹部の筋肉を収縮させ、大あご腺の中の液体を一カ所に集める。

3 空気を詰めすぎると風船が破裂するように、腺の一部が破れて液が飛び散る。

For an artist whose family descends from Samurais, Gengoroh Tagame has had no problem pursuing a very unexpected lifestyle. After making his name as a gay manga artist, touching on a variety of hard-core subjects such as bondage, domination, erotic roleplaying, submission, and sadomasochism, Tagame recently launched a lighter phase with "Otôto no otto," the story of Yaichi and his daughter Kana who are visited by Mike, the Canadian husband of Yaichi's twin brother. This time, even though he incorporated the gay subject in the story, the artist has made his storytelling more affordable, inviting new reads to appreciate not only his drawing style, but also his narrative. Tagame started working professionally in 1982, while still studying Graphic Design at Tama Art University. Initially published by known gay publications such as *Sabu*, *G-men*, and *SM-Z*, he has been able to live off his art since 1986. He launched his international career in France in 2005, with the translation of the title *Gunji*, which was followed by the publication of a book about his work and an exhibition in 2009.

GENGOROH TAGAME

Born

1964 in Japan

Best known works

"Otôto no otto"
[My Brother's Husband]

Prizes

• 19th Japan Media Arts Festival:
 Excellence Award in Manga
 Division (2015)

ただいまー

夏菜帰ってるかー?

あパパ帰ってきた!

あ…‥‥!

パパおかえ…

176

カナもマイク好きだからハグー！

ハイ　カナチャンのこと大好き

わーすごーい！

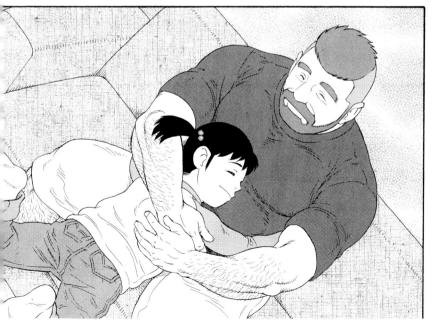

Für einen Künstler, dessen Familie von einem Samurai abstammt, führt Gengoroh Tagame ein recht unkonventionelles Leben. Nachdem er sich als Zeichner von Schwulen-Mangas mit diversen Hardcore-Elementen wie Bondage, Dominanz, Unterwerfung, Sadomasochismus und erotischem Rollenspiel einen Namen erworben hatte, trat Tagame mit „Otôto no otto" [Der Ehemann meines Bruders] kürzlich in eine weniger extreme Schaffensperiode ein. Der Manga handelt von Yaichi und seiner Tochter Kana, die Besuch von Mike erhalten, dem kanadischen Ehemann von Yaichis verstorbenem Zwillingsbruder. Wenngleich auch hier eine gleichgeschlechtliche Beziehung thematisiert wird, ist diese Geschichte leichter zugänglich und lädt neue Leser ein, nicht nur den Zeichenstil des Künstlers, sondern auch seine Erzählweise schätzen zu lernen. Tagame begann bereits 1982, professionell zu zeichnen, als er noch Grafikdesign an der Tama Art University studierte. Seit 1986 kann er von seinen Werken, die ursprünglich ausschließlich in reinen Schwulenzeitschriften wie *Sabu, G men* und *SM-Z* erschienen, leben. Seine internationale Karriere startete Tagame 2005 in Frankreich mit der Übersetzung von „Gunji", der ein Buch über sein Werk und 2009 eine Ausstellung folgten.

Artiste dont la famille descend des samouraïs, Gengoroh Tagame a mené une vie des plus surprenantes. Il s'est fait un nom en tant que mangaka gay, abordant une foule de sujets hard core comme le bondage, la domination, les jeux de rôles érotiques, la soumission et le sadomasochisme. Dernièrement, Tagame est dans une phase moins extrême : « Otôto no otto » [Le mari de mon frère] raconte l'histoire de Yaichi et de sa fille Kana qui reçoivent la visite de Mike, le mari canadien du frère jumeau de Yaichi. Cette fois, bien que la thématique gay soit présente, l'artiste offre un récit plus abordable et plus à même de plaire à de nouveaux lecteurs pour ses dessins et son intrigue. Tagame a débuté sa carrière professionnelle en 1982, alors qu'il était encore étudiant en design graphique à la Tama Art University. Avec des parutions dans de célèbres publications gay comme *Sabu, G-men* et *SM-Z*, il a pu vivre de son art dès 1986. Il a lancé sa carrière internationale en France en 2005, avec la traduction du titre « Gunji », suivi de la publication d'un ouvrage sur son travail et d'une exposition en 2009.

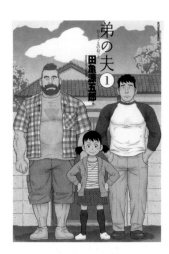

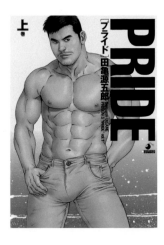

実験の結果はどんな具合かね？

ヤシッ

ニヤリ

すごいいきり勃ちようじゃ

見たまえ

ねとっ

先走りが床まで

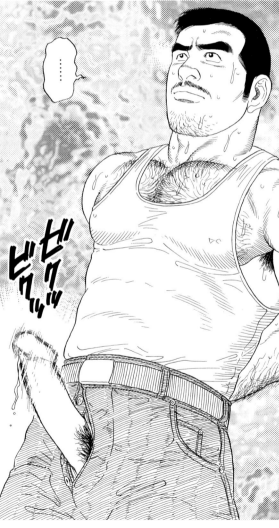

‥‥‥

ビクッ
ビクッ

Yuzo Takada's best known work is "Sazan Eyes" [3x3 Eyes], a romantic fantasy adventure with a plot that involves an ancient legend. The story involves a girl named Pai who not only has three eyes, but also the power to bestow eternal youth and immorality. She is the last one of her kind, and is searching for a way to become human. During the course of the story, she saves the life of a high school student named Yakumo Fujii and confers immortality on him, but at the price of taking his soul. The two encounter a destructive god named Kaiyan-Wang who is intent on destroying the earth. This story is set on an epic scale, as a great battle unfolds against Kaiyanwan and his minions. The series first went into publication in 1987, and it has built up a strong fan base over the course of 15 years. Some 40 volumes of comic books have been published in the series, and they have sold over 30 million copies. Takada also has a considerable fan base in other countries, and his work has been translated in 17 languages in Asia, Europe, and the United States. The major factor of his appeal is the attractiveness of his character designs. In particular, the adorable Pai has captured the hearts of fans worldwide. This bestseller is a pioneering manga that gained the wide support of the anime and otaku generations.

YUZO TAKADA

Born

1963 in Tokyo, Japan

Debut

with "Shûshoku Beginner" published in *Young Magazine* in 1983

Best known works

"Sazan Eyes" [3x3 Eyes]
"Bannô bunka nekomusume" [All-Purpose Cultural Cat Girl Nuku Nuku]
"Genzô hitogata kiwa" [Genzo's Puppet Tales]

Anime adaption

"Sazan Eyes" [3x3 Eyes]
"Bannô bunka nekomusume" [All-Purpose Cultural Cat Girl Nuku Nuku]
"Aokushimitama Blue Seed" [Blue Seed]

Prizes

• 17th Kôdansha Manga Award (1993)

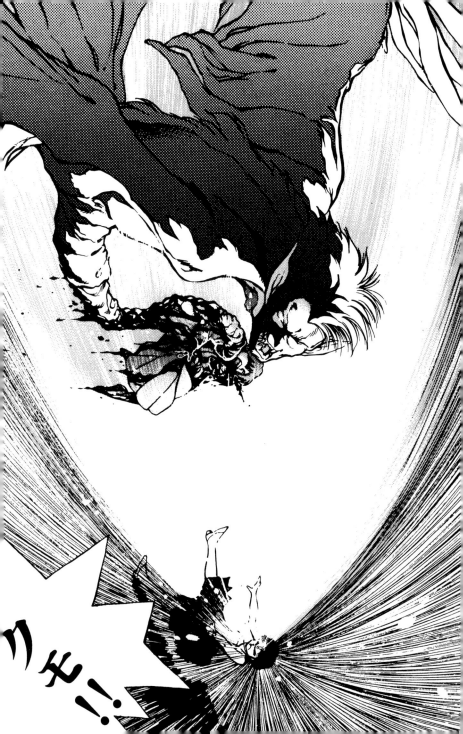

Bei seinem wohl bekanntesten Werk „3x3 Augen" handelt es sich um eine abenteuerliche Fantasy-Saga vor dem Hintergrund uralter Legenden. Hauptfiguren in der groß angelegten Geschichte sind das Mädchen Pai, das als letzte Überlebende einer Stadt unsterblicher Monster ein Mittel sucht, zum Menschen zu werden, und der Junge Yakumo Fujii, der durch Pai vor dem Tod gerettet und so ebenfalls unsterblich wurde. Die beiden kämpfen heroisch gegen den Vernichtungsgott Kaiyan-Wang und sein Gefolge, die die Welt zu vernichten drohen. Die Serie begann 1987 und wird seit 15 Jahren von treuen Fans verfolgt. Von den insgesamt 40 Sammelbänden der Serie wurden bisher über 30 000 000 Stück verkauft. Auch im Ausland war dieser Manga außerordentlich erfolgreich und wurde in 17 Ländern in Asien, Amerika und Europa übersetzt. Der Hauptauslöser für diese Popularität ist wohl im Charakterdesign zu suchen, mit dem Takada genau den Geschmack der Anime-Generation traf. Vor allem die niedliche Pai hatte es Otakus über alle Landesgrenzen hinweg angetan. „3x3 Augen" darf als einer der ersten Mangas gelten, die durch Fans aus der Anime- und *Otaku*-Szene zum Bestseller wurden.

L'œuvre la plus connue de Yuzo Takada est « Sazan Eyes » [3X3 Eyes], une aventure romantique qui intègre des anciennes légendes. L'histoire implique une jeune fille nommée Pai qui a non seulement trois yeux, mais qui a également le pouvoir d'accorder la jeunesse éternelle et l'immortalité. Elle est la dernière de sa race et tente de devenir humaine. Durant le cours de l'histoire, elle sauve la vie d'un lycéen nommé Yakumo Fujii et lui accorde l'immortalité, mais au prix de son âme. Ils rencontrent un dieu destructeur nommé Kaiyan-Wang qui a l'intention de détruire la Terre. L'histoire se déroule à une échelle épique, avec une grande bataille contre Kaiyanwan et ses armées. La série a été publiée en 1987, et a obtenu un grand nombre de fans depuis 15 ans. Quelque 40 volumes de bandes dessinées ont été publiés sur cette série, et plus de 30 millions d'exemplaires ont été vendus. Takada a également de nombreux fans dans d'autres pays et ses œuvres sont traduites en 17 langues, en Asie, en Europe et aux États-Unis. Le design de ses personnages est l'attrait majeur de Takada. En particulier, l'adorable Pai a conquis le cœur des fans dans le monde entier. Ce best-seller est un manga novateur qui a rencontré un fort succès parmi les fans d'animations et les otaku.

一身上の都合により
この花見
しきらせて
いただきます♡

婦警の制服で
来られたら
みんな酒飲む気
のーなってまう
からなあ

ふく
ふく

やったね
夕美ちゃん
かしこい!!

カゼをひいーたら
聖子さ…

一番
高田裕三
踊ります

ホラホラ
芸ナシは
おどきなさいね
君!!

あ

あの…

あの?

あの?

えっ?

死ぬわっ

アミ募集!!

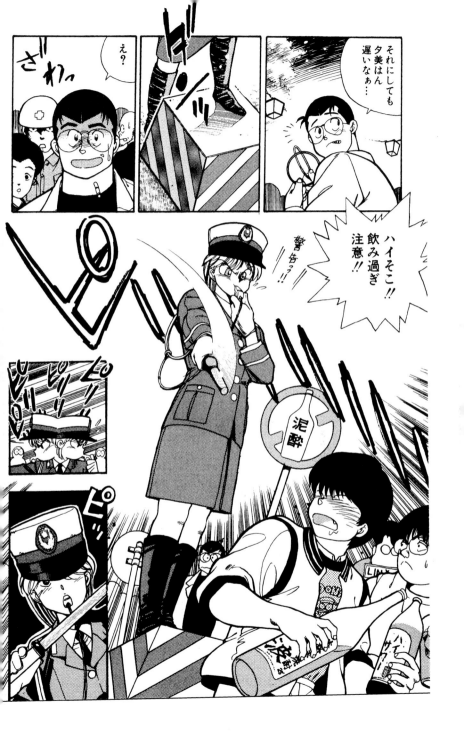

Rumiko Takahashi has continued to publish popular titles, all of which have become very long-running series. Her stories are very appealing to children, and expand their dreams. Her first big hit "Urusei yatsura" is the tale of an unfortunate boy who tends to attract a world of misfortune. He finds himself relentlessly pursued by a beautiful alien girl who has invaded Earth. It's an out-of this world story that blends reality and the unreal. As the story progressed, it began to feature more and more strange characters. Along with crisp dialogue, it featured strong willed girls who are strong fighters, vampires, kappa [a mythical Japanese water creature], unicorns, and yuki onna [a Japanese female demon that appears with the snow]. The story kept a continuous high level of tension, and the momentum never abated throughout the series. Her fight story "Ranma 1/2" is about a main character who, due to a fall into a cursed spring called jusenkyou, he now turns into a woman with cold water and turns into a man with hot water. "Inu Yasha" depicts the story of a boy who is half human and half demon, and a normal girl who grew up at a shrine. Their adventures center around the pursuit of the scattered fragments of a mysterious ball called shikon no tama [Jewel of Four Souls]. The story is set in a feudal world full of turmoil, but still manages to retain a fairy-tale atmosphere. Takahashi's story settings are always novel, and she is able to express such a lively action, that readers are continually surprised by her creations.

R U M I K O

T A K A H A S H I

Born
1957 in Niigata Prefecture, Japan

Debut
with "Katte na yatsura" [Overbearing People] published in *Weekly Shônen Sunday*

Best known works
"Ranma 1/2"
"Inu Yasha"
"Maison Ikkoku"
"Urusei yatsura"

Anime adaption
"Ranma 1/2"
"Inu Yasha"
"Urusei Yatsura"
"Maison Ikkoku"

Prizes
• 27th and 47th Shôgakukan Manga Award (1980 and 2002)

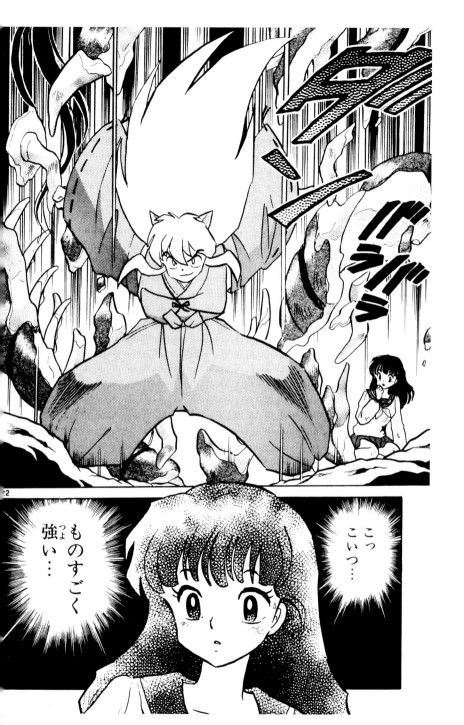

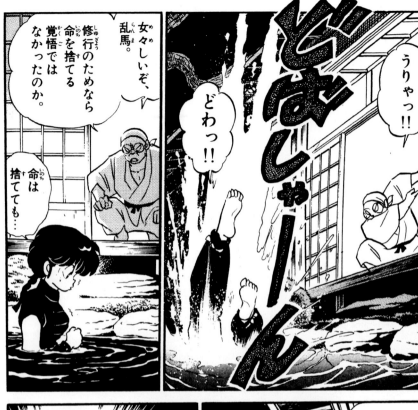

女々しいぞ、乱馬。

修行のためなら命を捨てる覚悟ではなかったのか。

命は捨てても…

どわっ!!

うりゃっ!!

男を捨てる気はなかったわい、ぼけーっ!!

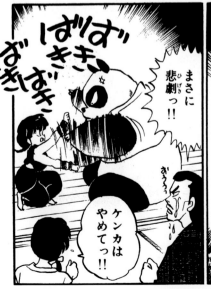

まさに悲劇っ!!

ケンカはやめてっ!!

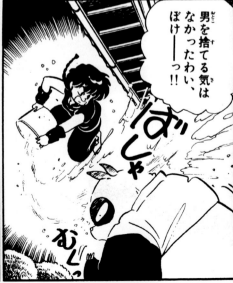

ちりりーーん

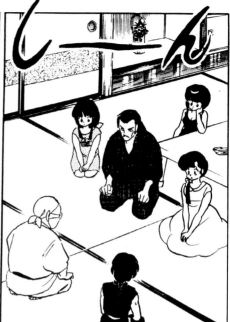

しーーん

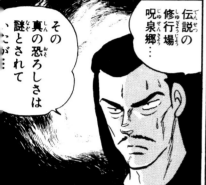

伝説の
修行場
呪泉郷…

その
真の恐ろしさは
謎とされて
いたが…

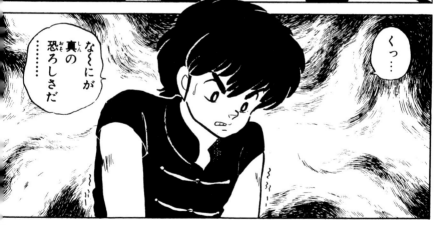

なくにが
真の
恐ろしさだ
………

くっ……

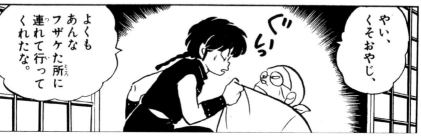

よくも
あんな
フザケた所に
連れて行って
くれたな。

やい、
くそおやじ、

ぐらっ

Takahashi zeichnet endlose, höchst erfolgreiche Serien, mit denen sie ihr junges Publikum in Atem hält. Ihr erster großer Erfolg war „Urusei yatsura", in dem der jugendliche Held, ein legendärer Unglücksrabe, zuerst vom Pech und dann auch noch von einer Außerirdischen auf Schritt und Tritt verfolgt wird. Fantastische und realistische Elemente wechseln sich ab in diesem Manga voller origineller Einfälle, witziger Dialoge und eigensinniger hübscher Mädchen. Vampire, Flusskobolde, Einhörner, böse Schneefeen – im Laufe der temporeichen Geschichte tauchen immer mehr rätselhafte Gestalten auf und sorgen dafür, dass der Leser bis zum Schluss nicht zum Atemholen kommt. Der Titelheld des Kampfkunst-Mangas „Ranma 1/2" wird, seit er in eine verwunschene Quelle gefallen ist, jedesmal zum Mädchen, wenn er mit kaltem Wasser in Berührung kommt, und erst durch warmes Wasser wieder zum Jungen. In „Inu Yasha" machen sich ein Halbdämon mit einem menschlichen und einem dämonischen Elternteil und eine ganz normale Schülerin, deren Vater Shintô-Schreinpriester ist, gemeinsam auf die abenteuerreiche Suche nach den Einzelteilen des „Juwels der vier Seelen". Dessen Splitter wurden bei seiner Zerstörung in alle Himmelsrichtungen verstreut. Rumiko Takahashi überrascht ihr Publikum mit immer neuen Ideen, die sie in Zeichnungen voller Dynamik verpackt.

Takahashi continue de publier des séries populaires qui sont toutes très longues. Ses histoires sont très attrayantes pour les enfants et les font rêver. Son premier succès, « Urusei yatsura » est l'histoire d'un garçon malchanceux qui semble attirer toutes sortes de malheurs. Il est constamment poursuivi par une jolie extra-terrestre qui est arrivée sur Terre. Il s'agit d'une histoire incroyable qui mêle le réel et l'irréel. À mesure que l'histoire évolue, des personnages étranges font leur apparition. En plus des dialogues croustillants, les histoires mettent en scène des filles qui ont une forte volonté et qui sont de puissantes combattantes, des vampires, des kappas (des créatures marines japonaise mythique), des licornes et des yuki onna (des démons femmes qui apparaissent avec les premières neiges). L'histoire a conservé un haut niveau de tension et n'a jamais perdu son élan dans toute la série. Son histoire de combat « Ranma 1/2 » implique un personnage principal qui, à la suite d'une chute dans une source maudite appelée « jusenkyou », se transforme en femme avec de l'eau froide et en homme avec de l'eau chaude. « Inu Yasha » dépeint la vie d'un garçon qui est moitié humain moitié démon, et d'une fille normale qui a été élevée dans un temple. Leur aventure se concentre sur la poursuite des fragments éparpillés d'un mystérieuse boule appelée « shikon no tama » (le bijou des quatre âmes). L'histoire se déroule dans un monde féodal en plein désarroi qui pourtant conserve une certaine atmosphère de conte de fées. Les histoires de Takahashi sont toujours un modèle et elle sait si bien exprimer de l'action percutante que ses lecteurs sont toujours surpris par ses créations.

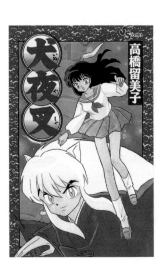

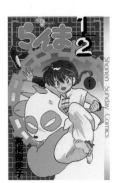

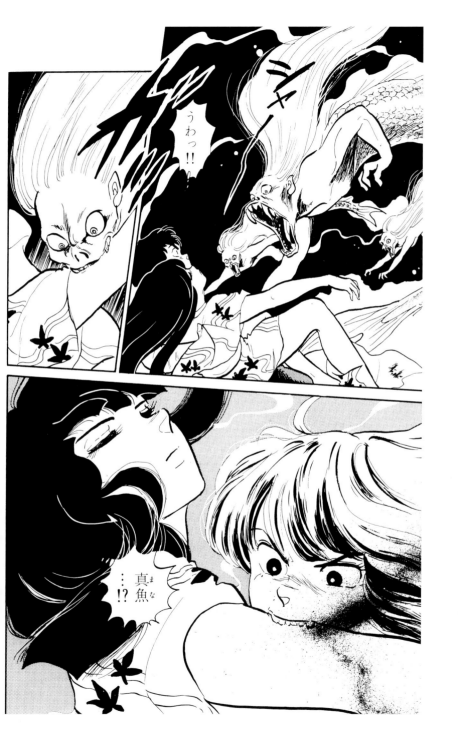

Fumiko Takano's work mostly consists of short stories, but her composition and expressiveness shine with excellence and originality. Since her debut she has only published six volumes of manga, but she still manages to retain a strong following. "Zettai anzen kamisori" is a collection that includes some of her best known pieces, love stories, historic tales, and social satires. "Bô ga ippon" is another collection of short stories where she depicts the emotions of ordinary people. Then there is "Ruki-san" in which she portrays the story of a woman named Ruki-san who enjoys going through life at her own pace. In particular, with "Bô ga ippon," she showed remarkable conceptu-alization and a high freedom of expression. Here, readers can see the enormous possibilities of a manga completely unlike those with incredulous story lines. In 2002 she published a first book in a long while with "Kiiroi hon," in which she exhibits originality in the stories and scene composition. There's a certain nostalgic and experimental style to her stories, and her work is filled with an inter-esting quality all her own, something that cannot be seen elsewhere. That's probably the reason for her long-lived and immense popularity.

FUMIKO TAKANO

Born

1957 in Niigata Prefecture, Japan

Debut

with "Hana" [Flower] published
in *Rakugakikan* in 1977

Best known works

"Kiiroi hon" [Yellow Book]
"Ruki-san"
"Zettai anzen kamisori"
[Totally Safe Razor]

Prizes

• Japan Cartoonists Association
 Excellence Award (1982)
• Tezuka Osamu Culture Prize (2003)

Fumiko Takano konzentriert sich hauptsächlich auf Kurzgeschichten, die allerdings sind sowohl im Konzept als auch in der Ausführung außerordentlich originell. Mit bisher nur sechs veröffentlichten *tankôbon* ist sie eine wenig produktive Schriftstellerin, besitzt jedoch eine enthusiastische Fangemeinde. Typisch für Takanos Stil sind der Band „Zettai anzen kamisori", in dem mit Liebesgeschichten, von Samurai-Dramen inspirierten Erzählungen sowie Gesellschaftssatiren sehr unterschiedliche Werke vereint sind. „Bô ga ippon", eine Sammlung von Kurzgeschichten über Menschen und ihre Gefühle angesichts völlig alltäglicher Begebenheiten, oder „Ruki-san", in dem die Titelheldin unbeirrt ihren Weg geht und sich ihr Leben nach ihrem Geschmack einrichtet. Vor allem in „Bô ga ippon" zeigt Takano mit wunderbaren Einfällen und einer souveränen Ausdrucksweise der Kunstform Manga abseits alberner Fantasiegeschichten völlig neue Wege auf. Unverbrauchte Storys und Bildkompositionen finden sich auch in ihrem 2002 nach langer Pause veröffentlichten Band „Kiiroi hon". Fumiko Takano bietet in ihren manchmal nostalgisch, manchmal experimentell gezeichneten Mangas unvergleichliche Leseerlebnisse und dafür lieben sie ihre Fans.

Takano réalise principalement des histoires courtes, mais ses compositions et son expressivité brillent par son excellence et son originalité. Depuis ses débuts, elle n'a publié que 6 volumes de mangas, mais elle conserve toutefois de nombreux fans. « Zettai anzen kamisori » est une collection qui comprend certaines de ses œuvres les plus fameuses, des histoires d'amour, des contes historiques et des satires de la société, dans lesquelles les lecteurs peuvent percevoir des impressions différentes. « Bô ga ippon » est une autre collection d'histoires courtes qui dépeignent les émotions de gens ordinaires dans leurs vies ordinaires. « Ruki-san » dépeint la vie d'une femme nommée Ruki-san qui aime vivre à son propre rythme, sans être influencée par ce que pense le reste du monde. En particulier avec « Bô ga ippon », l'auteure fait preuve d'une conceptualisation remarquable et d'une grande liberté d'expression. Les lecteurs peuvent voir les possibilités énormes d'un manga totalement différent des mangas aux scénarios peu réalistes. En 2002, elle a publié son premier ouvrage depuis longtemps, « Kiiroi hon », où elle fait preuve d'originalité dans l'histoire et la composition des scènes. Ses histoires ont une certaine nostalgie et un style expérimental, et ses œuvres sont remplies de qualités intéressantes qu'on ne retrouve pas ailleurs. C'est probablement la raison de sa longue et immense popularité.

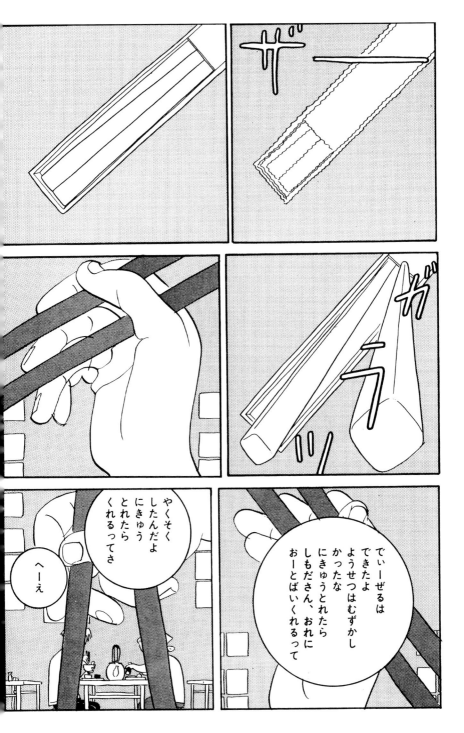

そうだよ
だれだってちっとばかし
傷ついてるふうに見える
やつのほうがかっこいい

斗め！

きっ！

うーん
もしかして
そうかな？
なんとなく
そんな気に
なってきたな

ふーん
そーお？

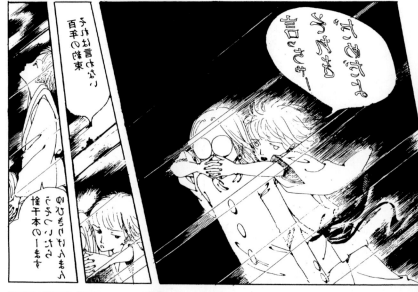

どうかするとあざあ言うわよー

子供時代の言い合い
百年の約束

怪千本のーます

のひらひらへもへこここしはへ

動かなく
なっちゃった

あれれ

あれ？

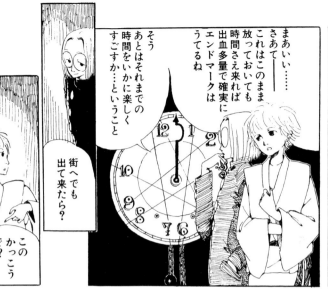

まったく、うちの母親の打算的なことと言ったら……死んでもなおかんないだろうな、あれ

まあいい……

さあて——

これはこのまま放っておいても時間さえ来れば出血多量で確実にエンドマークはうってるね

そうあとはそれまでの時間をいかに楽しくすごすか…ということ

街へでも出て来たら?

このかっこうで!?

そりゃそうさラストショーなんだろ見せないってではないよ

観覧料とってもいいくらいだ

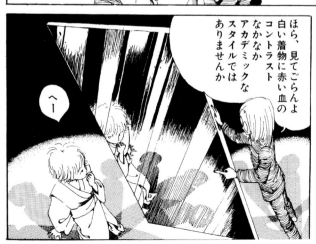

女の子がキャーッてふりむくぜ

ほら、見てごらんよ白い着物に赤い血のコントラストなかなかアカデミックなスタイルではありませんか

へー

Jirô Taniguchi is a talented artist who is always breaking new ground with different kinds of images for every new story or theme he pursues. He thoroughly researches each of his stories. When he was first starting out, he created interesting hard-boiled action pieces. He then experimented with a variety of themes. He collaborated with Natsuo Sekikawa to create "Botchan no jidai," which depicted a group of Japanese literary giants, and he portrayed an elderly couple taking care of their dying dog in "Inu o kau" [Owning a Dog]. He wrote the science fiction piece "Icaro," which is an adaptation of a story by the great French artist Moebius. He also created "Aruku Hito" [Walking Man] about the subtle and deep observations during an everyday stroll, and an adaptation of the original mountain climbing story by Baku Yumemakura in "Kamigami no itadaki." He shows a curiosity for a variety of subjects, and his faithful portrayals are impressive. He seems to be telling us that you can be moved by the simplest of things in this vast world we live in. From the familiar drama that goes on around us, to unfamiliar situations set in the North Pole or imaginary worlds, he manages to create a world that we can easily set foot in, a fascinating world for us to get to know. He has received many manga awards for his achievements, and his work has recently become highly regarded in France. He won an award for best story at the prestigious Angouleme Festival, and became well-known in France as a Japanese artist.

JIRÔ TANIGUCHI

Dates

Born 1947 in Tottori Prefecture, Japan
Died 2017 in Tokyo Prefecture

Debut

with "Kareta heya" [Husky Room] published in *Young Comic* in 1972

Best known works

"Inu o kau" [Owning a Dog]
"Kamigami no itadaki"
"Botchan no jidai"

Prizes

- Shôgakukan Manga Award (1992)
- Japan Cartoonists Association Award (1993)
- Tezuka Osamu Cultural Prize Manga Grand Prix Award (1998)
- Media Arts Festival Excellence Award for Manga (2000)

この時からその後の羽生の伝説が始まったといってもいい

日本の岩場に残されたビッグネームの最後の難所を羽生がクリアした 冬期の岩攀りに対する概念を羽生が変えたのである

この後 羽生は次々に日本の困難な岩場のみを誰よりも短い時間で征服してゆくことになる

Jirô Taniguchi ist ein Künstler, der für jedes Werk ausführliche Recherchen anstellt, Story und Zeichnungen entsprechend gestaltet und dem Manga immer wieder Neuland erschließt. Seine ersten Arbeiten waren vom *hard-boiled*-Stil geprägt, aber bald widmete er sich mit großer Neugier einer Vielzahl von Themen, die er alle gewissenhaft ausarbeitete: Zusammen mit Natsuo Sekikawa zeichnete er in „Botchan no jidai" ein Gruppenporträt japanischer Literaten der Meiji-Zeit; in „Inu o kau" geht es um ein Ehepaar, das zusieht, wie ihr alt gewordener Hund dem Sterben entgegengeht; für den Sciencefiction „Icaro" schrieb Comicgigant Moebius das Szenario; in „Aruku Hito" sieht ein Spaziergänger die tieferen Geheimnisse in alltäglichen Begebenheiten; und für den Bergsteiger-Roman „Kamigami no itadaki" lieferte Baku Yumemakura die Story. Taniguchi zeigt, dass jeder Gegenstand Emotionen auslösen kann und sich hinter allen Dingen eine weite Welt verbirgt. Von den Dramen in unserer unmittelbaren Umgebung über reale Landstriche, die wir nie kennenlernen werden, wie den Nordpol bis hin zu Fantasiewelten – Taniguchi gelingt es wie sonst kaum jemandem, glaubwürdige Mikrokosmen zu erschaffen und dem Leser deren Reiz zu vermitteln. Mit zahlreichen Manga-Preisen ausgezeichnet, wird Jirô Taniguchi auch in Frankreich immer beliebter. Auf dem renommierten Festival von Angoulême erhielt er den Preis für das beste Szenario und ist so als japanischer Autor weltweit bekannt geworden.

Jirô Taniguchi est un dessinateur talentueux qui innove en permanence avec différents types d'image pour chaque nouvelle histoire ou sujet qu'il dépeint. Il fait des recherches minutieuses pour ses histoires. Lors de ses débuts, il a créé des mangas d'action intéressants. Il s'est ensuite essayé à différents thèmes, et a collaboré avec Natsuo Sekikawa pour la création de « Botchan no jidai », qui dépeint un groupe de géants de la littérature japonaise. Il décrit un vieux couple prenant soin de leur chien mourant dans « Inu o kau » [Posséder un chien]. Il a produit le manga de science-fiction « Icaro », inspiré d'une histoire du célèbre dessinateur français Moebius. Il a également créé « Aruku Hito » [L'homme marchant], sur les observations subtiles et profondes d'une promenade de tous les jours, et une adaptation de « Kamigami no itadaki », une histoire d'escalade écrite par Baku Yumemakura. Il fait preuve d'une grande curiosité pour divers thèmes, et ses descriptions fidèles sont impressionnantes. Il semble nous dire que nous pouvons être touchés par les choses les plus simples dans ce vaste monde où nous vivons. Des mélodrames familiers qui nous entourent à des situations inhabituelles qui se déroulent au pôle Nord ou dans des mondes imaginaires, Taniguchi parvient à créer des mondes dans lesquels nous pouvons facilement entrer et que nous pouvons mieux connaître. Il a reçu de nombreux prix pour ses œuvres, qui ont d'ailleurs rencontré un grand succès en France. Il a reçu le prix de la meilleure histoire lors du prestigieux Festival d'Angoulême.

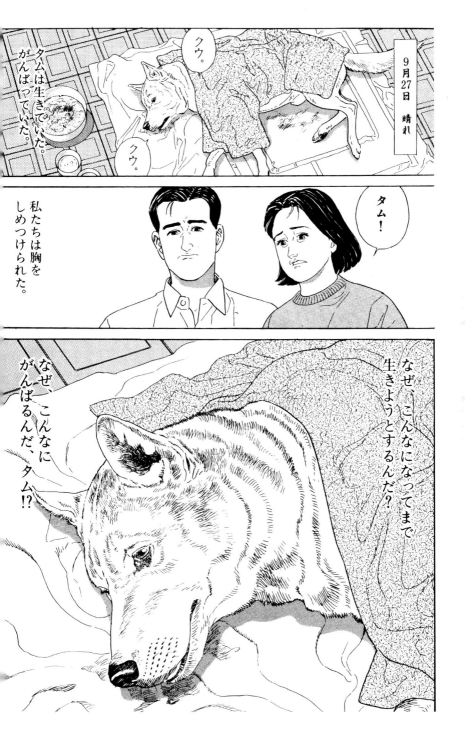

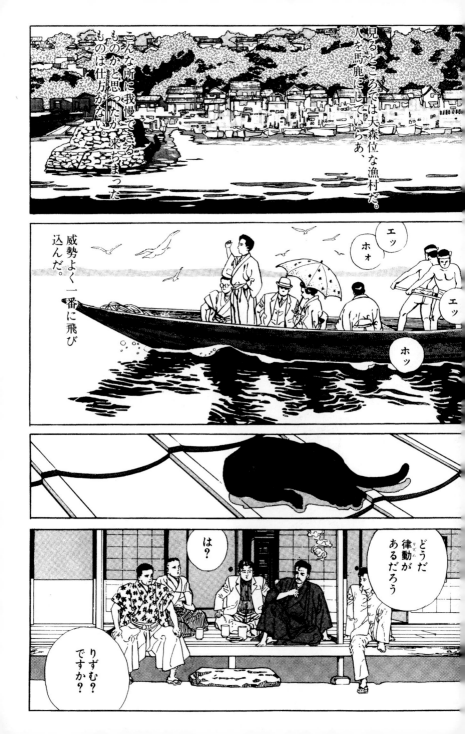

見るところでは大森位な漁村だ。人を馬鹿にしていらあ、
こんな所に我慢できるものかと思ってたが来ちまったものは仕方がない

威勢よく込んだ。一番に飛び

エッ
ホォ
エッ
ホッ
ホッ

どうだ律動(リズム)があるだろう

は？

りずむ？ですか？

書き出しの腹案はこんなふうだ

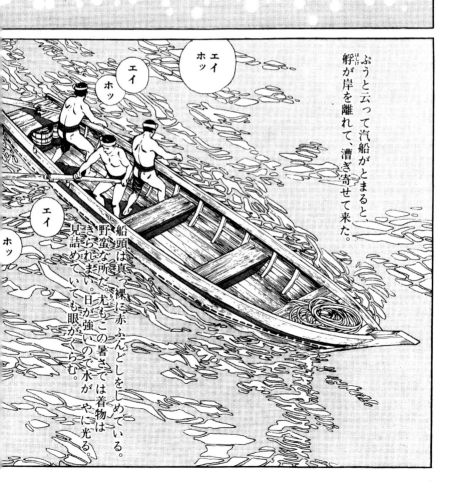

ぷうと云って汽船がとまると、艀が岸を離れて、漕ぎ寄せて来た。

エイ
ホッ

エイ
ホッ

エイ
ホッ

船頭は真っ裸に赤ふんどしをしめている。野蛮な所だ。尤もこの暑さでは着物はきられまい。日が強いので水がやに光る。見詰めていても眼がくらむ。

The use of strong colors has helped Natsuko Taniguchi to become a manga star in Japan, especially after the release of Sayonara, Reba Sashi—Kinshi Made no 438 Nichikan, a story about love for liver sashimi. Bizarre as it seems, the title caused great interest, first in her personal online blog, then as a publication. Born in Japan, in 1988, Taniguchi enrolled at the Tama Art University in Tokyo and studied information design. Apart from her enduring work with other manga titles such as Jinseiyama Ari Taniguchi and Watashi wa Zenzen Fukuo ja Arimasen kare ne!, the artist dedicates a good part of her time writing about food—which is another big passion of hers—and producing commercial illustrations. The latter ones are also well known since here she collaborates with the Japanese female idol group Dempagumi.inc.

NATSUKO TANIGUCHI

Born
1988 in Japan

Debut
with "Lever Michelin" published in
Hontô ni atta onna no harabanjô jinsei in 2011

Best known works
"Sayônara, Reba Sashi"
"Mutant Setsuko"
"Jinsei yama ari Taniguchi"

19皿目 「くさい」は「うまい」!?（後編）

前回のあらすじ

ドリアン 腐乳 バロット

Kさんから送られてきたくさい食べ物を色々食べたが、中でも特にくさいというくさやと臭豆腐を家で食べることを躊躇していた私…

谷口さん吉報です!!くさやと臭豆腐を食べれるイベントがあります

え…

その名も

世界の
ぐ ウ マ
実食会

出演食材
シュールストレミング
etc...

"出演食材"ってこいつらが出てなんか演技するのかよ…

てかシュールストレミングって世界一くさい食材じゃ…

色々不満はこみあげてきますが仕事と思ってがんばります

今回ももちろんKさんは来ないので

くさいはムリ…

ピンチヒッターとして友人のノンちゃんに来てもらいました

どうも〜

飲んで働く
デザイナー
ノンちゃん

Durch den Gebrauch kräftiger Farben wurde die 1988 in Japan geborene Natsuko Taniguchi in ihrer Heimat zum Manga-Star, vor allem nach der Veröffentlichung von „Sayonara, Reba Sashi – Kinshi Made no 438 Nichikan", einer Erzählung über die Liebe zu Leber-Sashimi. Taniguchi studierte an der Tama-Kunsthochschule in Tokio Informationsdesign. Neben ihrer erfolgreichen Arbeit an anderen Manga-Titeln wie Jinseiyama Ari Taniguchi und Watashi wa Zenzen Fukuo ja Arimasen kare ne! widmet die Künstlerin einen Großteil ihrer Zeit dem Zeichnen gewerblicher Grafiken und dem Verfassen von Texten über das Essen, eine ihre anderen großen Leidenschaften. Ihre Illustrationen wurden auch durch ihre Zusammenarbeit mit der japanischen Mädchen-Idol-Gruppe Dempagumi.inc sehr bekannt.

L'emploi de couleurs vives a fait de Natsuko Taniguchi une star du manga au Japon, notamment après la sortie de « Sayonara, Reba Sashi—Kinshi Made no 438 Nichikan », l'histoire d'un amour pour le foie cru en tranches. À la surprise générale, ce titre a suscité un grand intérêt, d'abord dans son blog personnel, puis comme publication. Née en 1988 à Kanagawa, au Japon, Taniguchi s'est inscrite à la Tama Art University de Tokyo, avant d'étudier le design d'information. Outre son travail constant avec d'autres titres manga comme Jinseiyama Ari Taniguchi et Watashi wa Zenzen Fukuo ja Arimasen kare ne!, l'artiste consacre une bonne partie de son temps à rédiger des articles culinaires, son autre grande passion, et à produire des illustrations commerciales. Ces dernières sont également connues grâce à sa collaboration avec le groupe de musique féminin Dempagumi.inc.

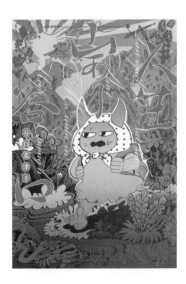

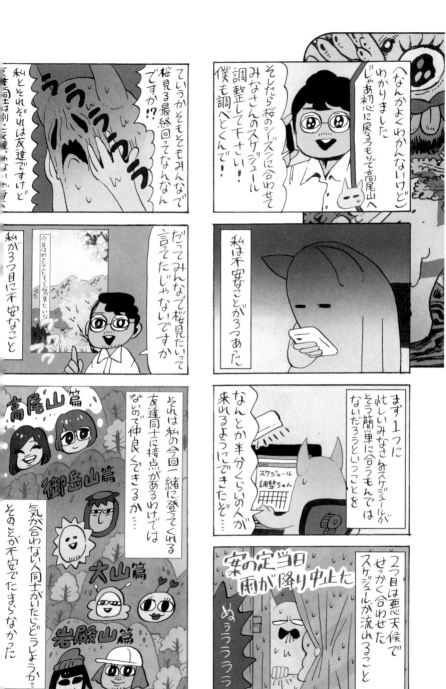

As a former nuclear plant worker, Kazuto Tatsuta knew very well what he was writing after the tsunami in Japan that caused the nuclear incident in Fukushima. After half a year into the job and exposed to the limit of acceptable radiation levels, he resigned, and went on to tell his story in manga form. In his book, Kodansha is the main character in Kazuto Tatsuta's "Ichi-Efu [1F]: The Labour Diary of Fukushima Dai-ichi Nuclear Power Plant." Speaking to the newspaper *The Guardian* in 2014, he said, "I had been looking for work around the time of the disaster and wondered if there was anything I could do to help the region." Even with all the criticism about the title, ranging from accusations of propaganda to a romanticized way to describe the disaster and its recovery, the title has attracted great attention from a younger generation. Shortly before the incident, Tatsuta was about to quit his former job, and needed another one for the income. Attracted by the experience of direct contact and also the higher salaries at the Fukushima plant, the artist applied for the job there. After being in the news around the world, the upcoming artist is yet to release other bestselling titles.

K A Z U T O
T A T S U T A

Born
1965 in Japan

Best known works
"Ichi-Efu [1F]: The Life of Fukushima Nuke Worker Recorded as Manga"

Prizes
• 34th Manga Open Award of *Morning* magazine (2013)

《第二話》
鼻が痒い

あぁ……

鼻が痒い……

これ被るとどっかしら痒くなるんだよなぁ

マスクの周囲をテープで目張りしてあるし

そうじゃなくてもマスクを外して掻くなどもってのほかだ

Kazuto Tatsuta – unter diesem Pseudonym arbeitet der Mangaka – wusste nach dem Tsunami vom 11. März 2011, der den Zwischenfall im Kernkraftwerk Fukushima auslöste, sehr genau, worüber er schreiben wollte. Kurz vor dem Reaktorunfall spielte er mit dem Gedanken, seine damalige Beschäftigung aufzugeben und brauchte daher unbedingt eine neue Einkommensquelle. In einem Gespräch mit der britischen Zeitung *The Guardian* erklärte Tatsuta 2014: „Ich war um die Zeit der Katastrophe auf Arbeitssuche und fragte mich, ob ich etwas tun könnte, um der Region zu helfen." Weil ihn der unmittelbare Kontakt zum Ort des Geschehens reizte und auch weil die Arbeit im Kraftwerk Fukushima gut bezahlt wurde, bewarb er sich dort. Er arbeitete 2012 ein halbes Jahr in dem beschädigten Kraftwerk, bis er die Grenze der verträglichen Strahlendosis erreicht hatte. Anschließend schrieb er seine Geschichte in dem Manga „1F: The Labour Diary of Fukushima Dai-ichi Nuclear Power Plant", dessen Hauptfigur Kodansha heißt, auf. Trotz aller Kritik an dem Buch – die von Propagandaanschuldigungen bis zum Vorwurf der Verklärung der Katastrophe und des anschließenden Wiederaufbaus reichen – erfuhr der Titel gerade von jüngeren Lesern großen Zuspruch. Nachdem er weltweit in die Schlagzeilen geraten war, hofft der Künstler, bald einen neuen Bestseller veröffentlichen zu können.

En tant qu'ancien employé d'une centrale nucléaire, Kazuto Tatsuta savait parfaitement ce qu'il écrivait quand un tsunami a frappé le Japon à la suite de l'incident nucléaire à Fukushima. Après six mois de travail, exposé aux niveaux acceptables maximum de radiation, il a démissionné et a décidé de raconter son histoire sous forme de manga. Dans cet ouvrage, Kodansha est le protagoniste de « 1F: The Labour Diary Of Fukushima Dai-ichi Nuclear Power Plant ». Dans une interview en 2014 pour *The Guardian*, il déclarait : « Je cherchais du travail au moment de la catastrophe et je me suis demandé si je pouvais faire quelque chose pour aider la région ». En dépit des critiques reçues, des accusations de propagande et de description romancée du désastre et des efforts de reconstruction, le titre a remporté un grand succès auprès des jeunes. Peu de temps avant l'incident, Tatsuta voulait laisser son ancien travail mais ne pouvait pas rester sans revenus. Attiré par l'expérience et par les salaires élevés offerts à la centrale de Fukushima, l'artiste a postulé pour le poste. Après sa projection médiatique dans le monde, il a d'autres ouvrages en préparation.

同じく2巻収録第八話参照

廃車置き場も

こっちの規模はまた…

今や草叢（くさむら）の中に数台残すのみ

作業が進んだ所
進まない所
変わった所
変わらない所

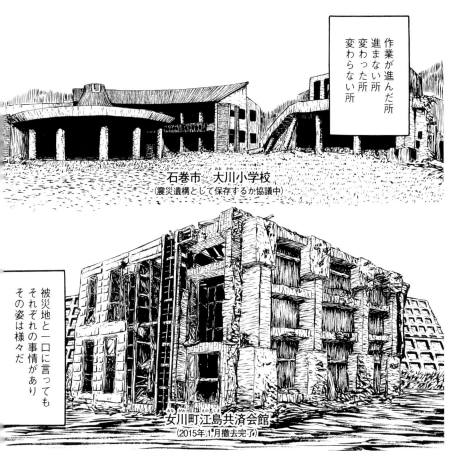

石巻市　大川小学校
（震災遺構として保存するか協議中）

被災地と一口に言っても
それぞれの事情があり
その姿は様々だ

女川町江島共済会館
（2015年1月撤去完了）

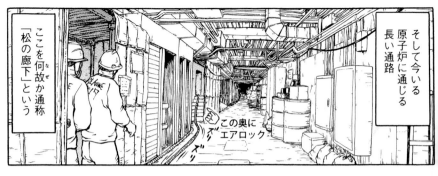

そして今いる原子炉に通じる長い通路

ここを何故か通称「松の廊下」という

この奥にエアロック

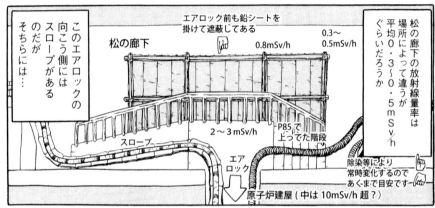

松の廊下の放射線量率は場所によって違うが平均0・3〜0・5mSv/h ぐらいだろうか

除染等により常時変化するのであくまで目安です

このエアロックの向こう側にはスロープがあるのだがそちらには…

エアロック前も鉛シートを掛けて遮蔽してある

松の廊下

0.3〜 0.5mSv/h

0.8mSv/h

2〜3mSv/h

P85で上ってた階段

スロープ

エアロック

原子炉建屋（中は10mSv/h超？）

このもう一台というのが除染ロボットラクーン

中継ユニット コンプレッサー搭載で除染水の吹き付け吸引回収を行う

中にブラシの入った除染用ヘッド

走行ユニット

高圧洗浄ヘッドにも換装可能

俺たちの後に作業する除染班が担当

ここから出入りするもう一台のロボットのホースが置かれている

「スケボー」と呼ばれるキャスター付き台車除染用の水がホースを通る

線量低減に貢献してくれる
ありがたい奴なのだが

このスケボーがスロープを
占拠しているのでパックボットは階段を使うのだ

スケボー

うわ
来たか

はい

引っ掛かりましたか

了解

曲がり角等でホースが
引っ掛かりパックボットが
止まると免震棟操作室の
オペレーターから電話がくる

俺行きます

いいよ
今度は
俺の番だ

不思議なもので被曝を
避けたいのは皆同じ
筈なのに
誰もが他人より先に
行きたがる

なんだろうね
この感情は？

勿論仲間を思いやる
人情から来る行動
なのだろうが

男の見栄
みたいなのも
あるのかもね…

Osamu Tezuka was the first Japanese manga artist to create a true story-based manga. He has been called *Manga no Kamisama* [the God of manga] and continues to be respected by artists everywhere. Tezuka grew up in the midst of war during which he lived side by side with death. In all his works we see a theme of "the preciousness of life." Even while he presents themes such as the destruction of humanity or the foolishness of mankind, at the same time he portrays the beautiful love of humans and all living creatures. We can see this in his most famous work, "Tetsuwan Atom" [Astro Boy], where the main character of Atom is portrayed as even more human-like than any other human. Tezuka was even revered during the period when manga was looked down upon as harmful reading, and his works went on to finally become a cultural phenomenon. He has a doctorate's degree in medicine and later cre-

ated the now-classic story "Black Jack," which involves the theme of medicine. He wrote stories in the 1960s that were way before his time, stories of organ transplants of the cornea and hands/feet, as well as cloning technology. He dealt with these topics from various points of view. In terms of manga technique, he utilized many ideas from the movie industry, including the close-up, changing point of view, and changing frame. He was able to demonstrate his ability to tell a heated and dramatic story through his manga. Even in his later years, he challenged new areas such as children's manga and *shoujo* manga, as well as manga dealing with society and sex. He has made many wide-ranging contributions to the industry, such as his creation of the manga magazine *Com*, which supported experimental manga.

O S A M U T E Z U K A

Dates

Born 1928 in Ôsaka Prefecture, Japan
Died 1989 in Tokyo Prefecture

Debut

with "Ma-chan no nikkichô" [Diary of Ma-chan] published in *Shokokumin Shinbun* in 1946

Best known works

"Tetsuwan Atom" [Astro Boy]
"Black Jack"
"Hi no tori" [The Phoenix]

Anime adaption

"Tetsuwan Atom" [Astro Boy]
"Black Jack"
"Hi no tori" [The Phoenix]
"Ribbon no kishi" [Princess Knight]
"Umi no Triton" [Triton of the Sea]

Prizes

- 1st Kôdansha Culture Award – Children's Manga Category (1970)
- 4th Japan Cartoonists Association Special Award (1975)
- 1st, 9th, and 10th Kôdansha Manga Award (1977, 1985, 1986)
- 10th Japan Science Fiction Grand Prix Special Prize (1989)

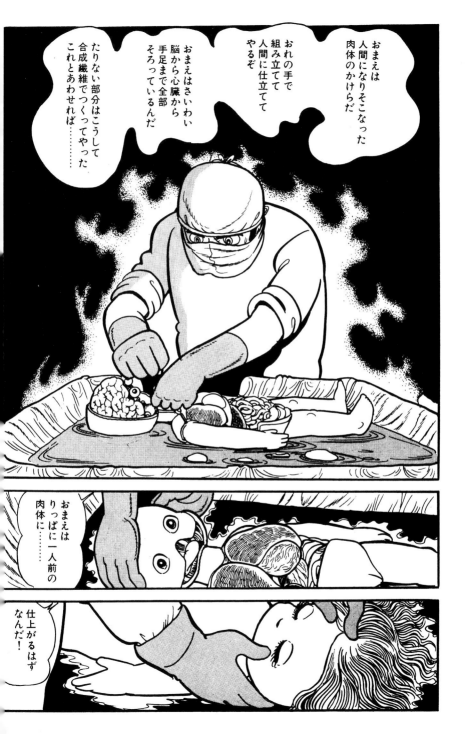

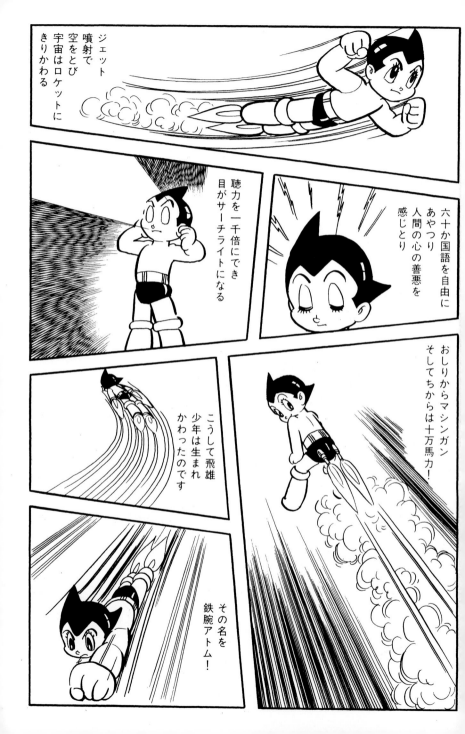

飛雄がロボット商人の
手で　どこへ売られた
かはしりません

それからかなりたって
アトムというロボット
少年を売りものにした
サーカスがやってきました

その
ロボット
少年が
ただ
もので
ない
ことを
みぬきました

ちょうど見にきていた
お茶の水研究所長の
お茶の水博士は

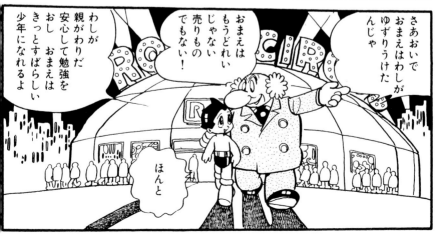

さあおいで
おまえはわしが
ゆずりうけた
んじゃ

おまえは
もうどれい
じゃない
売りもの
でもない！

わしが
親がわりだ
安心して勉強を
おし　おまえは
きっとすばらしい
少年になれるよ

ほんと

Osama Tezuka zeichnete in Japan als Erster echte Story-Mangas und wird als „Gott des Manga" von vielen Künstlern verehrt. Tezuka, der in seinen Jugendjahren während des Krieges häufig mit dem Tod konfrontiert war, betont in allen Werken die Kostbarkeit des Lebens. Auch wenn er von Vernichtung und menschlicher Dummheit schreibt, seine Liebe zu Menschen und allen Lebewesen scheint immer wieder durch. So gestaltete er etwa den Roboterjungen seiner berühmtesten Serie „Astro Boy" menschlicher als die meisten Menschen. Als promovierter Mediziner zeichnete er mit „Black Jack" auch meisterhafte Arbeiten aus der Welt der Medizin und bewies dabei visionären Weitblick. In den 1960er Jahren beschrieb er beispielsweise Transplantationen von Hornhaut und Gliedmaßen und schon früh widmete er der Klon-Wissenschaft große Aufmerksamkeit. Im technischen Bereich brachte Tezuka mit Nahaufnahmen, Perspektiven- und Einstellungswechsel zahlreiche, dem Film entliehene Ausdrucksmöglichkeiten zum Einsatz und erzielte ein hohes Maß an Dramatik und Spannung. Auch in seinem Spätwerk versuchte er sich an immer neuem Material und erweiterte seine Bandbreite von Mangas für Kinder über Mangas für junge Mädchen bis zu Themen wie Gesellschaft und Sexualität. Auch in anderer Weise machte er sich verdient um den Manga – er rief das Manga-Magazin *COM* ins Leben und unterstützte experimentelle Arbeiten.

Il a été le premier auteur de mangas japonais basés sur de véritables histoires. On le surnomme « Manga no Kamisama » [Le Dieu des mangas] et il est toujours aussi respecté. Tezuka a grandi pendant la guerre et il a souvent côtoyé la mort. Dans toutes ses œuvres, nous pouvons voir le thème de la vie et sa valeur. Il dépeint souvent un certain amour pour les humains et toutes les créatures vivantes. Dans son œuvre la plus fameuse, « Tetsuwan Atom » [Astro Boy] le personnage principal nommé Atom ressemble plus à un humain que n'importe quel autre humain. L'artiste possède un doctorat en médecine et a créé l'histoire « Black Jack », qui est devenue un classique, sur le thème de la médecine. Dans les années 1960, il a écrit des histoires bien en avance sur son temps, de transplantations d'organes de la cornée, des pieds et des mains, ainsi que sur les technologies de clonage. En termes de techniques de mangas, il a utilisé de nombreuses idées empruntées au cinéma, dont les plans rapprochés et les changements de points de vue. Il a réussi à raconter des histoires véhémentes et spectaculaires dans ses mangas. Plus récemment, il s'est lancé dans les mangas shoujo et les mangas pour enfants, ainsi que dans les mangas sur les thèmes de la société et du sexe. Il a lancé le magazine *COM*, spécialisé dans les mangas expérimentaux.

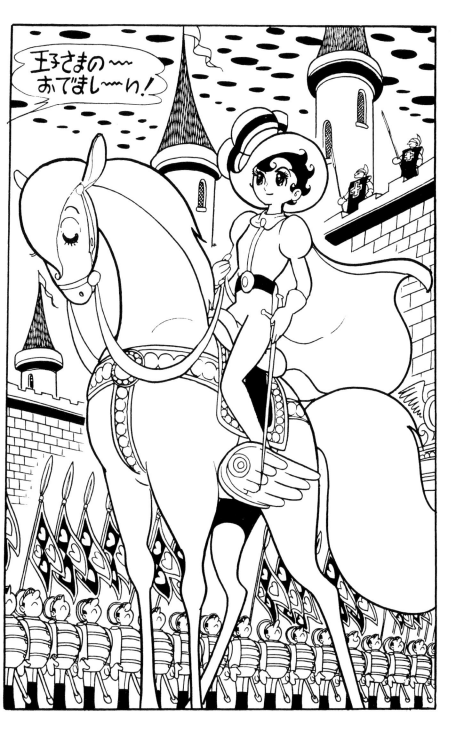

Yoshihiro Togashi's best known work, "Yû yû hakusho" was first serialized in the 1990s. It is the story of a boy named Yûsuke Urameshi who fights the forces of a demon world to save humankind from destruction. It portrays the friendships between Yûsuke and his friends, and their battles. This series was published along with "Dragon Ball" and "Slam Dunk" in *Weekly Shônen Jump* during the 1990s, during the heyday of this manga magazine. The series attracted not only children and pre-teens, but also men and women of all ages, with its exciting battle scenes and the individuality and charming personality of Yûsuke and the other characters. During the final stages of the series, the occasional episode failed to appear, or the drawings started to look shaky due to pressures the author was under, which subsequently earned Togashi some public criticism. After completing the series, he took a long-needed rest before commencing a series called "Level E" at a more leisurely pace of one issue per month. This series portrayed an alien prince who had crash-landed on earth. The unique storyboard and the wild twists and turns of the plot even managed to captivate sceptical manga fans. The series showed a new side of Yoshihiro Togashi. Currently he is working on the series "Hunter x Hunter," the story of a boy named Gon who aspires to become a "Hunter" that seeks the unknown. Togashi is married to the noted manga artist Naoko Takeuchi.

YOSHIHIRO TOGASHI

Born

1966 in Yamagata Prefecture, Japan

Debut

with "Tonda Birthday Present" published in *Weekly Shônen Jump* in 1986

Best known works

"Yû yû hakusho"
"Hunter x Hunter"
"Tende shôwaru kyûpiddo" [Wicked Cupid]
"Level E"

Anime adaption

"Yû yû hakusho"
"Hunter x Hunter"

Prizes

• 39th Shôgakukan Manga Award (1994)

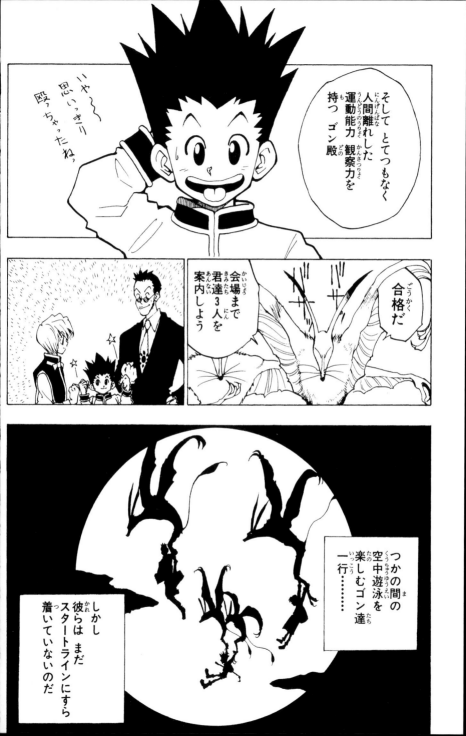

そしてとてつもなく
人間離れした
運動能力
観察力を
持つゴン殿

いや〜〜
思いっきり
殴っちゃったね。

会場まで
君達3人を
案内しよう

合格だ

つかの間の
空中遊泳を
楽しむゴン達
一行……

しかし
彼らはまだ
スタートラインにすら
着いていないのだ

1990 begann Togashi seine bekannteste Serie „Yû yû hakusho" um Yûsuke Urameshi's Kämpfe gegen die Dämonenwelt, vor der er die Menschheit retten muss. Auch Yûsukes Freundeskreis spielt eine wichtige Rolle. Zusammen mit „Dragon Ball" und „Slam Dunk" prägte dieser Manga das goldene Zeitalter des *Weekly Shônen Jump*-Magazins in den 1990er Jahren. Kampfszenen, bei denen der Leser unwillkürlich die schweißnassen Hände zusammenballt, sowie unverwechselbare, Charaktere wie Yûsuke fanden nicht nur unter Kindern, sondern auch unter Frauen und Männern aller Altersstufen viele begeisterte Anhänger. Im kontroversen Endstadium der Geschichte wurde die Serie immer öfter unterbrochen und man konnte die Schreibblockade des Autors förmlich in den immer hastigeren Bildern spüren. Nach einer Ruhepause begann er, sein nächstes Werk „Level E" nicht im üblichen Wochenrhythmus, sondern in monatlichen Abständen zu veröffentlichen. In der Geschichte um einen raumschiffbrüchigen außerirdischen Prinzen zeigte sich Togashi von einer ganz neuen Seite. Mit unvorhersehbaren Wendungen und leicht geändertem Konzept in jeder Folge fesselte er auch die heikelsten Manga-Liebhaber. Sein aktueller Manga „Hunter x Hunter" handelt vom Jungen Gon und seinem Ziel, ein „Hunter" zu werden, einer, der sich auf die Suche nach Unbekanntem begibt. Yoshihiro Togashi ist mit der Mangaka Naoko Takeuchi verheiratet.

L'œuvre la plus connue d'Yoshihiro Togashi, « Yû yû hakusho » a été publiée dans les années 1990. Il s'agit de l'histoire d'un jeune garçon nommé Yûsuke Urameshi qui combat les forces d'un monde démoniaque pour sauver l'humanité de la destruction. Elle dépeint l'amitié entre Yûsuke et ses amis, ainsi que leurs combats. La série a été publiée en même temps que « Dragon Ball » et « Slam Dunk » dans le magazine *Weekly Shônen Jump*, durant l'âge d'or de ce magazine. Elle a attiré non seulement des enfants mais également des hommes et des femmes de tous âges, grâce aux scènes de combats et à la personnalité charmante et l'individualité de Yûsuke et des autres personnages. À la fin de la série, quelques épisodes n'étaient pas publiés, ou leurs dessins devenaient tremblants, ce qui a valu à Togashi quelques critiques publiques. Après avoir terminé la série, il s'est arrêté quelque temps avant de débuter une série intitulée « Level E », publiée au rythme d'un épisode par mois. La série dépeint un prince extra-terrestre qui s'est écrasé sur Terre. Le scénario unique et ses rebondissements ont réussi à captiver les fans de mangas sceptiques. La série a montré une nouvelle facette de Yoshihiro Togashi. Il travaille actuellement sur la série « Hunter x Hunter », qui raconte l'histoire d'un garçon nommé Gon aspirant à devenir un chasseur à la recherche de l'inconnu. Togashi est marié à la célèbre dessinatrice Naoko Takeuchi.

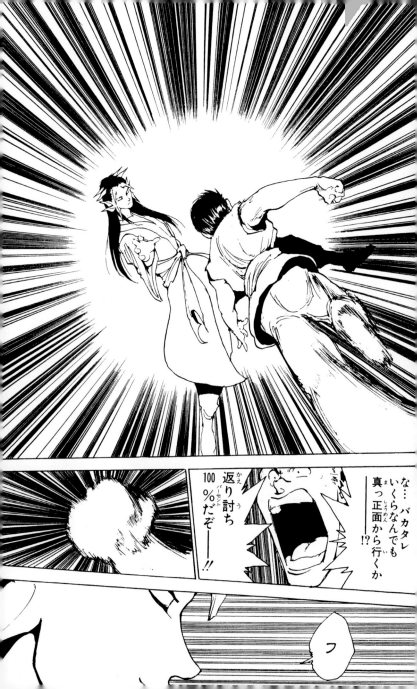

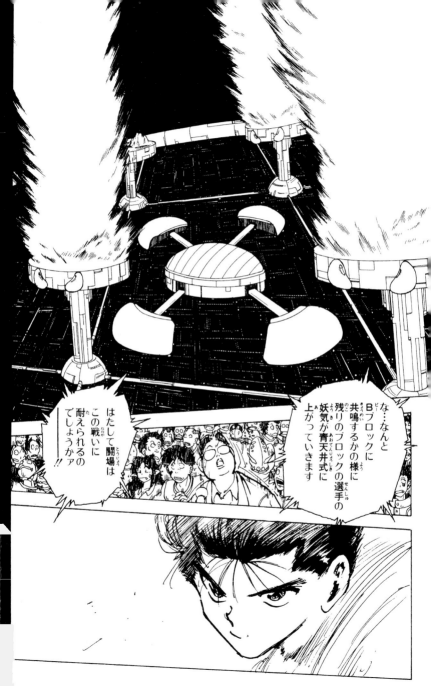

Akira Toriyama is well known for creating worlds of fantasy with highly imaginative characters, animals, and monsters. His characters have a personality and charm all of their own, indeed, his creations never fail to fascinate his readers. The fascination radiated by his work has led to animations and games based on his manga. His phenomenal worldwide success, "Dragon Ball," is modelled after "Seiyuuki" (Journey to the West) and features the adventures of a mysterious character named Son-Gokū, a young boy with a monkey's tail. There is a legend that if someone collects seven dragonballs, a real dragon will appear to fulfil any wish they name. Son-Gokū goes on a quest to find these dragonballs in order to bring back the dead grandfather who raised

him, after Son-Gokū accidentally killed him when he transformed into a big ape during a full moon. During his long quest, he participates in a contest called Tenka-ichi Budoukai to determine who is the strongest martial arts fighter in the land. He also encounters various other fighters during his journey, and becomes increasingly strong. And with that, this main character won the admiration of young boys everywhere. Given his reputation for interesting characters and his high artistic ability, Toriyama also worked on the character design for a popular game in the 1980s called "Dragon Quest." The muscular and brave men, cute girls, the realistic skin texture on the imaginary dragons, and the merging of pop fashion with realism all contribute to its irresistible appeal.

AKIRA TORIYAMA

Born

 1955 in Aichi Prefecture, Japan

Debut

 with "Wonder Island" published
 in *Weekly Shōnen Jump* in 1978

Best known works

 "Dragon Ball"
 "Dr. Slump"
 "Sand Land"
 "Cowa!"

Anime adaption

 "Dr. Slump/Arale-Chan"
 "Dragonball"

Prizes

 • 27th Shōgakukan Manga Award
 (1982)

Akira Toriyamas fantastische Welt ist bevölkert von zahlreichen imaginären Tieren, Menschen und Geistern. Mit seinen originellen, ansprechenden Charakteren begeisterte er sein Lesepublikum immer wieder, sein Hauptwerk „Dragon Ball" eroberte auch als Anime und Videospiel die Welt im Sturm. Für die Abenteuergeschichte um den rätselhaften Jungen mit Affenschwanz, Son-Gokû, diente der klassische chinesische Roman „Die Pilgerfahrt nach dem Westen" als Inspiration. Bei Toriyama durchstreift Son-Gokû die Welt auf der Suche nach den Dragon Balls, um seinen Großvater, der ihn aufzog, wieder zum Leben zu erwecken. Er selbst hatte ihn zuvor getötet, als er sich während einer Vollmondnacht in einen riesigen Affen verwandelt hatte. Im Laufe seiner Suche trifft Son-Gokû auf viele Feinde, die er im Kampf besiegen muss, kämpft bei einem Turnier, das den Stärksten aller Kampfkünstler ermittelt und wird mit jedem bezwungenen Gegner immer stärker. Dieses Szenario machte Son-Gokû zum Idol aller kleinen Jungen. Berühmt ist Toriyama auch für das interessant ausgestaltete und versiert gezeichnete Charakterdesign zu „Dragon Quest", einem der beliebtesten Videospiele der 1980er Jahre. Akira Toriyamas tapfere Helden, niedliche Mädchen und fantastische Drachen wirken zum Anfassen echt. Seine poppig-gestylten, aber gleichzeitig realistischen Bilder begeistern jeden, der sie sieht.

Toriyama est célèbre pour avoir créé des mondes fantastiques remplis de personnages, d'animaux et de monstres ingénieux. Ses personnages ont une personnalité et un charme propres qui ne cesse de fasciner ses lecteurs. Cette fascination pour ses travaux a conduit à leur adaptation en animations et en jeux vidéo. Son succès phénoménal mondial, « Dragon Ball » est inspiré de « Seiyuuki » [Voyage vers l'ouest], qui décrit les aventures d'un mystérieux personnage appelé Son-Gokû, un jeune garçon avec une queue de singe. Une légende raconte que si quelqu'un réunit 7 boules du dragon, un véritable dragon apparaît et exauce tous ses vœux. Son-Gokû se lance dans cette quête pour ressusciter son grand-père qui l'a élevé, accidentellement tué par Son-Gokû après qu'il se soit métamorphosé en singe monstrueux durant la pleine lune. Pendant sa longue quête, il participe à un concours appelé « Tenka-ichi Budoukai » pour déterminer qui est le meilleur combattant en arts martiaux de la région. Il rencontre différents combattants durant ses aventures et devient incroyablement fort. Grâce à cela, le personnage principal a gagné l'admiration des jeunes garçons. Avec sa réputation de créer des personnages intéressants et ses talents artistiques, Toriyama a également travaillé sur la conception des personnages d'un jeu populaire durant les années 1980, appelé « Dragon Quest ». Les combattants braves et musclés, les jolies filles, la texture réaliste des dragons imaginaires et la fusion de la mode pop avec un certain réalisme ont contribué à l'attrait irrésistible de cette série.

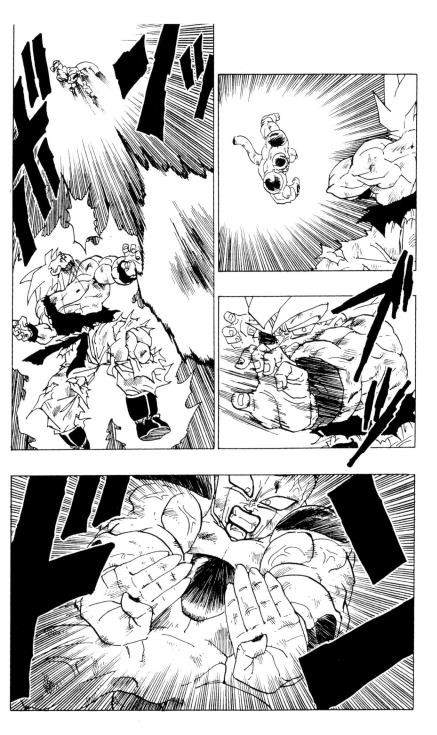

Yoshiharu Tsuge is often cited as an example whenever the topic of manga expression as an art form comes up. He also paved the way for a more serious literature style in the manga industry, and he is an artist who succeeds in expressing himself through his manga works. In a manga industry that stresses entertainment, his work was considered a bit peculiar, and at first it was not readily understood. In addition, instead of changing his manga style, he instead chose to keep quiet, and as a result he has been far from prolific. However, he has managed to secure substantial support with his ability to create distinctive worlds, ranging from the surreal, to stories involving realistically portrayed lives. Other artists from different fields have continued adapting his work into movies and film. Tsuge has been active since the 1950s, but works he published in the famed *Garo* magazine in the 1960s created a cult-like following. One example of this is "Neji-shiki" [Screw-Style], which features surrealistic images. Series such as "Munô no hito" [Nowhere Man], in which he realistically depicts a desperately poor but lazy character, have also long struck a big response in readers.

Y T
O S
S U
H G
I E
H
A
R
U

Born

1937 in Tokyo, Japan

Debut

with "Hakumen yasha" published through Wakagi bookshop in 1955

Best known works

"Neji-shiki" [Screw-Style]
"Akai hana" [Red Flowers]
"Munô no hito" [Nowhere Man]
"Realism no yado" [Hotel Realism]

Anime adaption

"Neji-shiki" [Screw-Style]
"Realism no yado" [Hotel Realism]
"Gensen-kan shujin"
[Gensen-kan Inn]
"Munô no hito" [Nowhere Man]

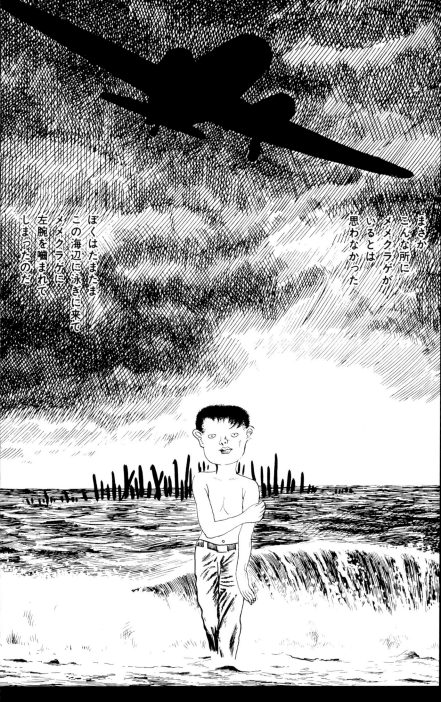

まさか
こんな所に
メメクラゲが
いるとは
思わなかった

ぼくはたまたま
この海辺に泳ぎに来て
メメクラゲに
左腕を噛まれて
しまったのだ

Wenn Mangas als Kunstform diskutiert werden, fällt stets der Name Yoshiharu Tsuge. Tsuge beschäftigte sich intensiv mit schöner Literatur und fand seine ureigene künstlerische Ausdrucksform schließlich im Manga. In der Welt der Comicbücher, wo es vor allem um Unterhaltung geht, nimmt er in mancher Beziehung eine Sonderstellung ein und es gab auch Zeiten des Unverständnisses. Hinzu kommt, dass er lieber schweigt, als seine künstlerische Integrität zu verbiegen, und so bisher nur wenige Werke veröffentlichte. Trotzdem fand er eine treue Fangemeinde mit seinen abgründigen, singulären Bilderwelten, deren Bandbreite von surrealistisch bis hyperrealistisch reicht. Kunstschaffende aus allen Bereichen verehren Yoshiharu Tsuge und seine Werke wurden immer wieder verfilmt. Seit den 1950er Jahren zeichnet er Mangas, seine legendären Arbeiten aus den 1960er Jahren für die Zeitschrift *Garo* erlangten Kultstatus. Stellvertretend für diese Epoche gilt das in surrealistischen Bildern erzählte „Neji-shiki". Serien wie „Munô no hito" [Nowhere Man; in Deutschland wurde die Verfilmung unter dem Titel *Herr Taugenichts* bekannt], eine realistische Darstellung des Lebens am Rand der Gesellschaft ohne Geld und Energie, inspirieren Künstler seit Jahrzehnten.

Tsuge est souvent cité en exemple dès qu'on parle des mangas comme forme d'art. Il a également ouvert la voie à un style littéraire plus sérieux, et il est un auteur qui réussit à s'exprimer au travers de ses mangas. Dans un marché qui privilégie le divertissement, ses œuvres étaient considérées au début comme étant un peu étranges ou incomprises. Plutôt que de changer de style, il a choisi de rester discret et n'a donc pas produit beaucoup de mangas. Toutefois, il a réussi à gagner une audience fidèle grâce à sa capacité à créer des mondes distincts, allant du surréaliste à des histoires réalistes. D'autres auteurs venant de domaines différents ont continué d'adapter ses œuvres au cinéma. Tsuge est actif depuis les années 1950, et les œuvres qu'il a publiées dans le fameux magazine *GARO* dans les années 1960 sont devenues des classiques. Un bon exemple est « Neji-shiki » [Système vissé], qui présente des images surréalistes. Des séries telles que « Munô no hito » [L'homme inutile], dans lesquelles il dépeint de manière réaliste un personnage désespérément pauvre mais fainéant, lui ont valu un fort succès auprès des lecteurs.

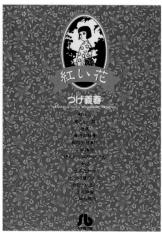

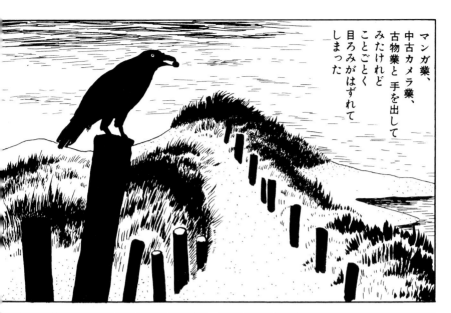

マンガ業、
中古カメラ業、
古物業と手を出して
みたけれど
ことごとく
目ろみがはずれて
しまった

この石屋だって
まるで素人だ

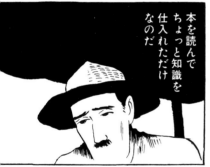

本を読んで
ちょっと知識を
仕入れただけ
なのだ

ただ
元手がかから
ないということが
おれに向いて
いたのかも
しれない

Kazuo Umezu is a leading horror manga artist. "Hyôryû kyôshitsu" is the story of a group of elementary school students, and their struggle to survive after they are mysteriously transported through time to an unknown world due to an earthquake. "Watashi wa Shingo" is the story of a computer that becomes conscious through the efforts of a young boy named Satoru and a young girl named Marin. "14 Sai" describes a near future when civilization lies in ruins, and humans are faced with the impending danger of extinction. Umezu produces highly original stories with his particular point of views and unique story development. These are qualities that cannot be copied. In addition to the stories, his drawings also show extraordinary talent. His crosshatched characters, highly detailed background drawings, and use of dark scenes all add persuasiveness to his creations. The expressions of his characters are also highly realistic, and many of his scenes are so shockingly frightening that it becomes borderline-traumatic for the reader. In addition, his best known gag comic, "Makoto-chan" is also very famous. This manga even led to a popular fad where the word "Gwashi!" is shouted, along with the accompaniment of a unique hand gesture. The character of Umezu himself also stands out, and when he appears on television, he always sports a striped shirt and is seen as a highly unique individual.

K U
A M
Z E
U Z
O U

Born

1936 in Wakayama Prefecture, Japan.

Debut

with "Betsusekai" and "Mori no kyôdai," published through Tomo Books Publications in 1955

Best known works

"Hyôryû kyôshitsu" [Drifting Classroom]
"Makoto-chan"
"Watashi wa Shingo" [My Name Is Shingo]
"14 Sai" [Fourteen]

TV/Anime adaptation

"Makoto-chan"
"Hyôryû kyôshitsu" [Drifting Classroom]

Prizes

• 20th Shôgakukan Manga Award (1975)

わたしは、動物を代表してやってきました！

助けてーっ!!

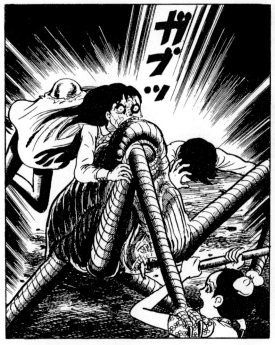

ガブッ

ワーッ!!

バーン

キャーッ!!

大月さんっ!!

美川さんっ、助けてっ!!

助けてーっ!!

Kazuo Umezu ist der Meister aller Horror-Mangaka. Seine Werke sind „The Drifting Classroom", in dem eine Gruppe Grundschüler nach einem Erdbeben durch einen Zeitsprung auf unbekanntes Land gerät und dort ums Überleben kämpft, „My Name Is Shingo", die Geschichte eines Computers, der durch den Jungen Satoru und das Mädchen Marin Bewusstsein erlangt, oder „Fourteen", wo es um Menschen am Rande des Untergangs in einer verwüsteten Zivilisation der nahen Zukunft geht. Alle beziehen ihren Reiz aus Umezus unnachahmlicher Sichtweise und Story-Entwicklung. Seine Genialität zeigt sich aber nicht nur in der Plot-Konstruktion, sondern auch in den hervorragenden Artworks. Seine dichten, suggestiven Bilder leben von den mit Schraffuren umschatteten Charakteren, den detailreichen Hintergründen und geschickt eingesetzten, schwarzen Flächen. Die Mimik seiner Figuren ist meisterhaft und viele der schauerlich-schockierenden Szenen hinterlassen beim Betrachter einen traumatischen Eindruck. Daneben ist Umezu auch der Schöpfer des berühmten Gag-Mangas „Makoto-chan". Der Schrei „Gwashi!" mit dazugehöriger Handbewegung der Titelfigur wurde in ganz Japan nachgeahmt. Umezu selbst ist übrigens auch ziemlich eigenwillig und tritt öfter als Kauz in grenzwertigen Hemden im Fernsehen auf.

Kazuo Umezu est un des principaux auteurs de mangas d'épouvante. « Hyôryû Kyôshitsu » [La classe en dérive] est l'histoire d'un groupe d'écoliers et de leur lutte pour survivre après avoir mystérieusement voyagé dans le temps vers un monde inconnu, suite à un tremblement de terre. « Watashi wa Shingo » [Mon nom est Shingo] est l'histoire d'un ordinateur qui développe une conscience au travers des efforts d'un jeune garçon nommé Satoru et d'une jeune fille nommée Marin. « 14 Sai » [Quatorze] décrit un futur proche dans lequel la civilisation est en ruine et la race humaine risque l'extinction. Umezu produit des histoires hautement originales dotées d'un point de vue particulier et d'un développement unique. Ce sont des qualités qui ne peuvent être copiées. En plus de ses histoires, ses dessins font également preuve d'un talent extraordinaire. Ses personnages hachurés, les décors très détaillés et l'utilisation de scènes sombres ajoutent à l'effet de persuasion de ses créations. Les expressions de ses personnages sont également très réalistes, et la plupart de ses scènes sont si effrayantes qu'elles deviennent presque traumatisantes pour les lecteurs. Son manga comique « Makoto-chan » est également très fameux. Il a même entraîné une mode dans laquelle on crie le mot « Gwashi ! » en l'accompagnant d'un certain geste de la main. La personnalité même d'Umezu est forte, et lorsqu'il apparaît à la télévision, il est toujours vêtu d'une chemise rayée et est considéré comme un individu assez unique.

Chika Umino debuted with "Hachimitsu to Clover," which won her a Kôdansha Manga Award. The story revolves around five students attending an art college, and their youthful lives and romantic relationships are described with a soft touch. The characters all have distinct personalities and histories, and their portrayal is both vivid and deep. The main character out of the group of five can even brighten up the faces of the surliest teachers or dogs. The conflicts and insecurities that are associated with the process of going from student to working member of society to adult... Sounding like a complete idiot in the presence of that special someone, and agonizing as the one-sided crush continues on and on... Umino describes these feelings in a detailed and poetic manner, while at the same time injecting some warm humor into the story. This is one of the reasons why she was able to capture the hearts of such a wide-ranged age of fans with her debut manga. The delivery of the characters' lines and the lovable expressions on their faces prompt the readers to laugh and cry along with their joys and sorrows. With this title, Chika Umino has accomplished drawing a manga that is gentle, fun, and beautiful, and she has one of the most highly anticipated futures ahead of her.

CHIKA UMINO

Born

in Tokyo, Japan

Debut

with "Hachimitsu to Clover" in the monthly *Comic Cutie* in 2000

Best known works

"Hachimitsu to Clover"

Prizes

• 27th Kôdansha Manga Award (2003)

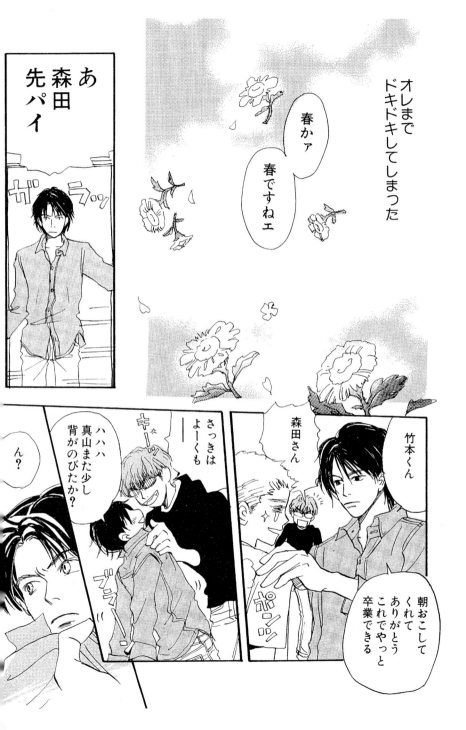

In ihrem Erstlingswerk „Honey and Clover", das mit dem Kôdansha-Manga-Preis ausgezeichnet wurde, schildert Chika Umino behutsam die jugendlichen Liebesverwicklungen von fünf Studenten und Studentinnen einer Kunsthochschule. Die Protagonisten werden durchweg ausführlich vorgestellt, als lebendige, vielschichtige Charaktere etabliert und nicht nur die fünf Hauptfiguren, auch die Dozenten und sogar der Hund wirken so lebensecht, als wären sie aus Fleisch und Blut. Umino zeichnet die Unsicherheiten, die wohl jeder beim Erwachsenwerden zwischen Studium und Beruf erlebt hat. Wie man, ohne die richtigen Worte zu finden, an einer unerwiderten Liebe leidet, die man aber doch nicht aufgeben will. Solche Emotionen werden sehr feinfühlig und lyrisch geschildert, aber zugleich ist überall in dem Manga ein warmherziger Humor zu spüren. Darin liegt wohl der besondere Reiz dieses Debüts, mit dem Umino sich die Sympathie einer breiten Leserschaft in allen Altersklassen eroberte. Die Dialoge der Protagonisten und ihre niedlichen Mienen bringen die Leser zum Lächeln und rühren sie manchmal auch zu Tränen – Lachen und Weinen gehören hier zusammen. Diese Arbeit, die Einfühlungsvermögen, Witz und Ästhetik miteinander verbindet, lässt von Chica Umino noch einiges erwarten.

Chika Umino a débuté avec « Hachimitsu to Clover » [Miel et trèfle], qui lui a valu le prix du manga Kôdansha. Il s'agit de l'histoire de 5 étudiants d'une université d'art, et de leurs relations amoureuses décrites avec une certaine douceur. Les personnages ont tous des personnalités et des histoires distinctes, et leur description est autant vive que profonde. Le protagoniste de ce groupe peut éclairer les visages des professeurs les plus revêches. Les conflits et les insécurités associés avec le passage à l'âge adulte, se sentir idiot en présence de quelqu'un de très cher, ou agoniser quand l'amour n'est pas réciproque, etc. Umino décrit ces sentiments de manière poétique et détaillée, tout en injectant un peu de chaleur et d'humour à l'histoire. C'est une des raisons pour lesquelles elle a réussi à captiver des lecteurs de tous âges avec son premier manga. Les répliques des personnages et les expressions adorables de leurs visages font rire ou pleurer les lecteurs avec leurs joies et leurs peines. Avec cette série, Chika Umino a réussi à créer un manga doux, drôle et superbe, et sa carrière en tant qu'auteure de mangas semble être toute tracée.

Naoki Urasawa belongs to a rare breed of comic artists who have the talents of both an entertainer and of a skilled artist. "Yawara" is the manga that first brought him fame, and it represents the artist's best work as an entertainer. This sports manga depicts the trials and tribulations of a talented and skilled women's judo wrestler, Yawara Inokuma. This story became so popular in Japan, the real-life Olympic gold medallist in women's judo, Ryōko Tamura, was given the nickname of "Yawara-chan." On the other hand, his work as an artist is best represented by the suspense/mystery "Monster," which is about a Japanese doctor living in Germany, who becomes increasingly entangled in a huge, diabolical plot. This manga is reminiscent of the excellent mystery novels and suspense movies of America and Europe, and the composition and finishing touches on the final product are very impressive. His current series, called "20 seiki shōnen" (20th Century Boys), is a story that is intricately woven around the past and the future, and depicts a frightening world where society is strictly controlled. His work can be enjoyed by a broad readership, yet at the same time he has completely mastered the professional aspects of technique and skill. He is a major author in the present day world of manga.

NAOKI URASAWA

Born

1960 in Tokyo, Japan

Debut

with "Beta!!," which appeared in an extra issue of the *Big Comic* Magazine 13 in 1983

Best known works

"Yawara!"
"Master Keaton"
"Monster"
"20 seiki shōnen"
[20th Century Boys]

Anime adaption

"Yawara!"
"Master Keaton"

Prizes

- 35th, 46th Shōgakukan Manga Award (1990, 2001)
- 3rd Osamu Tezuka Cultural Prize Manga Grand Prix Award (1999)
- 25th Kōdansha Manga Award (2001)
- 6th Agency for Cultural Affairs Media Arts Festival Excellence Award in the Manga Division (2002)

Ein Naturtalent, das neben gelungener Unterhaltung auch künstlerischen Anspruch bietet – Urasawa nimmt unter Japans Mangaka eine Ausnahmestellung ein. Den hohen Unterhaltungswert kann man in seinem Bestseller „Yawara!" in Reinform erleben. Die Handlung des unkomplizierten Sport-Mangas dreht sich um die geniale Judôka Yawara Inokuma und das ganze Ausmaß der Popularität dieses Mangas in Japan ist daran zu ermessen, dass der Goldmedaillistin im Frauen-Judo Ryôko Tamura der Spitzname Yawara-chan verliehen wurde. Urasawas künstlerisches Potential kommt in „Monster" am deutlichsten zur Geltung. In diesem Thriller wird ein in Deutschland praktizierender japanischer Arzt in eine weitreichende Verschwörung verwickelt. Der hohe Grad an Perfektion und die fehlerlose Konstruktion erinnern an qualitativ hochwertige Kriminalromane und Filmthriller aus Europa und Amerika. Mit seinem derzeit in Serie veröffentlichten „20th Century Boys" schlägt er neue Wege ein und zeigt in einer komplizierten Konstruktion mit vielen Zeitsprüngen die Schrecken unserer verwalteten Gesellschaft. Auch hier gelingt es ihm, einerseits mit der Geschichte ein breites Publikum anzusprechen und andererseits mit seiner Kunstfertigkeit die Anerkennung der Fachleute zu gewinnen. Im zeitgenössischen Manga ist er einer der ganz Großen.

Naoki Urasawa appartient à une rare catégorie d'auteurs de mangas qui ont les talents d'un comique et d'un dessinateur. « Yawara »est le manga qui lui a apporté son premier succès et il représente la meilleure œuvre de l'artiste en tant que comique. Ce manga sur le thème du sport dépeint les épreuves et les tribulations de Yawara Inokuma, une talentueuse lutteuse de judo. L'histoire est devenue si populaire au Japon que la véritable médaillée d'or olympique en judo féminin, Ryôko Tamura, a hérité du surnom « Yawara-chan ». D'un autre côté, ses meilleures œuvres en tant que dessinateur sont représentées par la série à suspense « Monster ». Il s'agit de l'histoire d'un docteur japonais qui vit en Allemagne et qui devient étroitement mêlé à un important complot diabolique. Ce manga est non sans rappeler les excellents romans policiers et les films à suspens d'Amérique et d'Europe, et la composition et les dernières touches apportées au produit final sont très impressionnantes. Sa série actuelle, intitulée « 20 seiki shônen » [Les garçons du 20e siècle], est une histoire qui mêle de façon complexe le passé avec le futur, et qui dépeint un monde effrayant où la société est strictement contrôlée. Ses œuvres sont appréciées d'un vaste public et il maîtrise totalement les aspects professionnels de la technique et du talent. Il est un auteur majeur de mangas contemporains.

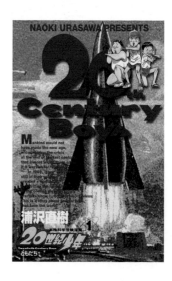

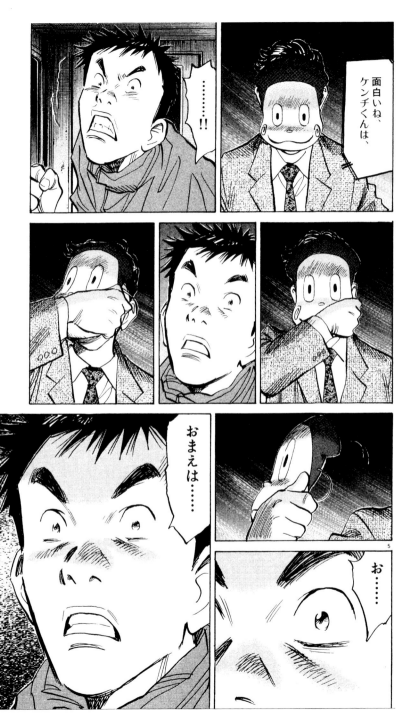

Hideo Yamamoto is best known for "Ichi the Killer," the manga series that displayed so much violence that when the inspired film version directed by Takashi Miike toured international film festivals, vomit bags were handed out to the audience. Since then, dramatic and realistic violent scenes have been a trademark of Yamamoto, who while rejected by many readers, accumulated an impressive number of fans, making his stories into successful series. After working as an assistant to Kenshi Hirokane, best known for the "Kachô Shima Kôsaku" series, he debuted with "Sheep" in 1989 at *Weekly Young Sunday*. "Homunculus," another hit from Yamamoto, shares some of the constant topics of violence, sexual deviations, and the quirkiness of the human mind. The story is about a former businessman, turned homeless, Susumu Nakoshi, who in an act of hopelessness, decides to take part in an experiment of trepanning, which consists of drilling a hole in the skull for medical or mystical reasons. Hideo Yamamoto was the recipient of the 1988 Tetsuya Chiba Award, given to promising young artists and "Ichi the Killer" was adapted to film in 2001.

H I D E O Y A M A M O T O

Born
1968 in Saitama Prefecture, Japan

Debut
in 1989 with "Sheep" in *Weekly Young Sunday*

Best known works
"Nozokiya"
"Ichi the Killer"
"Homunculus"

TV adaption
"Nozokiya"

Feature film
"Nozokiya"
"Ichi the Killer"

Prizes
• Tetsuya Chiba Award: Young Category Encouragement Prize (1988)

垣原〜〜〜

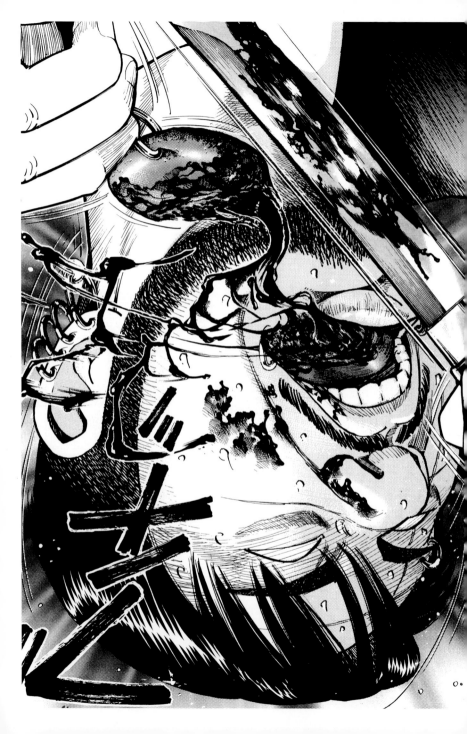

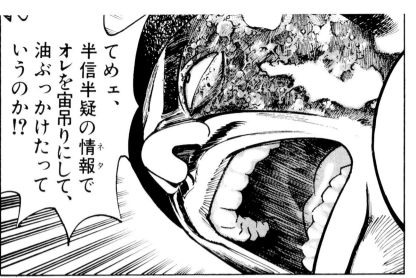

てめェ、半信半疑の情報（ネタ）でオレを宙吊りにして、油ぶっかけたっていうのか！？

キサマ～～

そういうことになるな。

ポリ ポリ

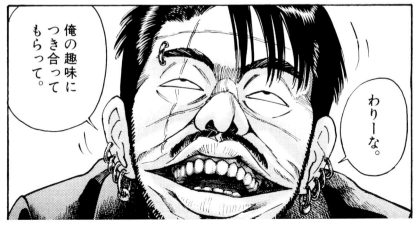

俺の趣味につき合ってもらって。

わりーな。

Hideo Yamamoto wurde vor allem durch „Ichi the Killer" bekannt, eine Manga-Serie, die so viel Gewalt zeigt, dass bei der Vorführung der Verfilmung von 2001 unter der Regie von Takashi Miike auf internationalen Filmfestivals Kotztüten ans Publikum verteilt wurden. Seither sind dramatische und realistische Gewaltszenen zu Yamamotos Markenzeichen geworden, das viele Leser zwar ablehnen, das ihm aber auch eine eindrucksvolle Fangemeinde beschert hat, die zum Erfolg seiner Werke beiträgt. Nachdem er als Assistent für Kenshi Hirokane tätig war, der durch die Serie „Kachô Shima Kôsaku" Berühmtheit erlangte, gab er seinen Einstand 1989 mit „Sheep" in der Zeitschrift *Weekly Young Sunday*. Auch in seinem erfolgreichen Manga „Homunculus" spielen Gewalt, Perversion und die Schrulligkeit des Menschen eine Rolle. Die Geschichte handelt von dem obdachlos gewordenen Geschäftsmann Susumu Nakoshi, der sich in einem Anfall von Verzweiflung und Hoffnungslosigkeit für ein Experiment trepanieren – also den Schädel aufbohren – lässt. 1988 erhielt Yamamoto den Tetsuya-Chiba-Preis für junge Nachwuchskünstler. „Ichi the Killer" wurde 2001 als Film adaptiert.

Hideo Yamamoto s'est fait un nom avec « Ichi the Killer », la série manga aux scènes si violentes que, lors des projections à des festivals internationaux du film de Takashi Miike qu'elle a inspiré, des sacs ont été fournis au public en cas de vomissements. Depuis lors, les scènes réalistes d'une violence extrême sont la marque de Yamamoto : bien que rejeté par de nombreux lecteurs, il a conquis une foule de fans qui ont fait de ses histoires de grands succès. Après avoir été l'assistant de Kenshi Hirokane, célèbre pour la série « Kachô Shima Kôsaku », son premier titre « Sheep » est paru dans *Weekly Young Sunday* en 1989. « Homunculus », autre succès de Yamamoto, combine violence, déviations sexuelles et fantaisies de l'esprit. L'histoire porte sur Susumu Nakoshi, un ancien homme d'affaires devenu sans-abri. Dans un accès de désespoir, il décide un jour de se livrer à une expérience de trépanation, à savoir la perforation du crâne à des fins médicales ou mystiques. En 1988, Hideo Yamamoto a reçu le prix Tetsuya Chiba décerné aux jeunes artistes prometteurs ; « Ichi the Killer » a été adapté en film en 2001.

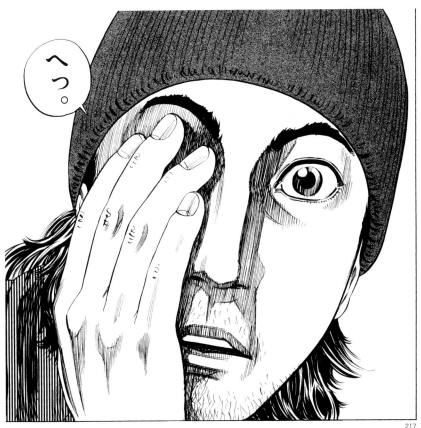

217

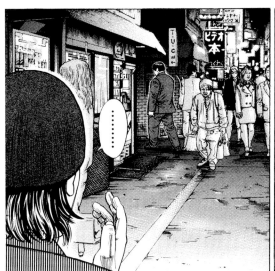

Naoki Yamamoto includes rich sexual drawings in his depictions of monotonous daily living. He uses a delicate touch to draw a world that exists somewhere between dreams and reality, or between this world and the next. They are dream-like worlds with a unique floating sensation quality. Although it may seem like they are silly, delusional worlds, all of his works feature main characters who have resigned to themselves that they will never experience such a dream-like world. This sense of balance is what draws the reader in. Ever since his debut in 1984, Yamamoto has used the aliases of Tô Moriyama and Mori Tôyama to create adult-oriented sex manga. But in the early 1990s, he began a series depicting the everyday lives of young students entitled "Blue" as Naoki Yamamoto. Because of sex scenes that depicted drug use, it was labeled as a harmful book. He consistently strives to have freedom of expression, and has pursued activities other than writing to do so. He continues to designate the use of his pen names to write short and medium length stories. His best known work "Arigatô" portrays a father who tries to fix his family's problems, after trouble erupts when he is sent away to work on a solo assignment. The father tries his best as his wife and daughters coldly look on. Another interesting tale is "Believers," a tale of three cult members who live on an uninhabited island as they continue to wait for the cult's founder.

NAOKI YAMAMOTO

Born

1960 in Hokkaidô, Japan

Debut

with "Hora konnani akaku natteru" as Tô Moriyama, published in *Pink House* magazine in 1984

Best known works

"Kiwamete Kamoshida"
"Asatte Dance" [Dance Till Tomorrow]
"Blue"

Anime adaption

"Kiwamete Kamoshida"
"Kimi to Itsumademo"
"Arigato"
"Mamotte agetai"

いつもこんなに積もるの？

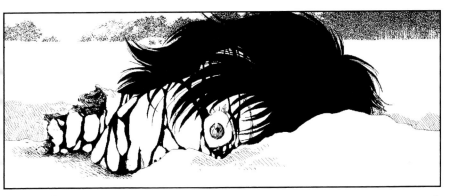

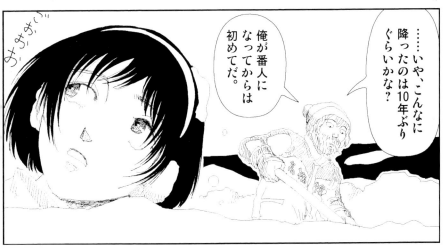

……いや、こんなに降ったのは10年ぶりぐらいかな？

俺が番人になってからは初めてだ。

Naoki Yamamoto zeichnet mit zartem Strich den Grenzbereich zwischen Traum und Realität, zwischen Diesseits und Jenseits. Deutliche Sex-szenen stechen dabei von seinen Darstellungen des grauen Alltags ab. Dieses besondere, an einen Tagtraum erinnernde schwebende Gefühl lässt auf den ersten Blick vermuten, Yamamoto zeichne lediglich alberne Fantasievorstellungen. In allen seinen Arbeiten sind sich die Protagonisten jedoch bewusst, dass ihre Traumwelt immer unerreichbar bleiben wird und es ist gerade dieser Balanceakt, der die Leser fasziniert. Der Autor zeichnete nach seinem Debüt 1984 zunächst unter den Pseudonymen Tô Moriyama beziehungsweise Mori Tôyama Sex-Mangas für den Erwachsenenmarkt. Anfang der 1990er Jahre veröffentlichte er schließlich unter dem Namen Naoki Yamamoto den Manga „Blue" über den Alltag einer Studentengruppe, der prompt wegen Sex- und Drogenszenen auf den Index gesetzt wurde. Daraufhin begann der Künstler sich in seinen Werken und andernorts für die Ausdrucks-freiheit im Manga zu engagieren. Er veröffent-lichte auch danach unter seinen verschiedenen Pseudonymen kürzere und mittellange Arbeiten. Wichtige Serien sind „Believers" über drei Sekten-angehörige, die auf einer unbewohnten Insel auf ihren Religionsstifter warten, sowie „Arigatô", die Geschichte einer Familie, die zerbrach, während der Vater aus geschäftlichen Gründen in einer anderen Stadt lebte. Er unternimmt alle Anstren-gungen, um die Schäden zu beheben, wobei ihm seine Frau und seine Töchter distanziert zusehen.

Naoki Yamamoto enrichit ses représentations d'une vie quotidienne monotone par de fortes images sexuelles. Il utilise un toucher délicat pour dessiner un monde qui existe quelque part entre rêve et réalité ou entre le monde présent et le suivant. Il dépeint des univers tels que ceux des rêves, avec une sensation unique de flottement. Alors que les principaux personnages de ses ouvrages semblent s'être résignés à ne jamais pouvoir profiter d'un tel univers, c'est l'impression d'équilibre qui attire le lecteur. Yamamoto utilise les pseudonymes Tô Moriyama et Mori Tôyama depuis ses premiers mangas pour adultes en 1984. Il a cependant démarré « Blue » au début des années 1990 sous son vrai nom, une série dans laquelle il raconte la vie de tous les jours de jeunes étudiants. Certaines scènes de nature sexuelle et usage de drogues ont donné à cette série un « label d'ouvrage dangereux ». Yamamoto recherche constamment la liberté d'expression, qu'il trouve également dans d'autres activités et continue à utiliser ces pseudonymes pour des nouvelles. Son ouvrage le plus connu, « Arigatô », présente un père qui essaie de régler ses problèmes familiaux à la suite d'une absence. Ce père fait de son mieux, sous le regard froid de sa femme et de ses filles. « Believers » est un autre manga intéressant dans lequel trois membres d'une secte attendent la venue du père fondateur sur une île déserte.

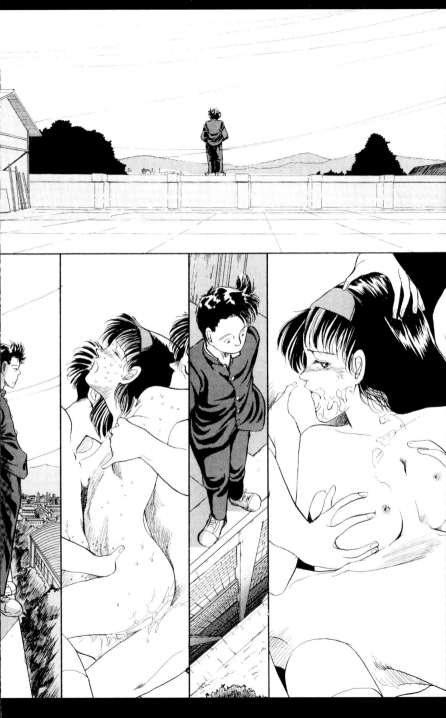

俺のいる空間は何処なんだ……?

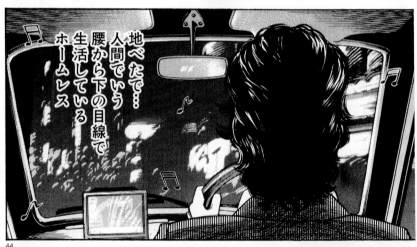

地べたで…人間でいう腰から下の目線で生活しているホームレス

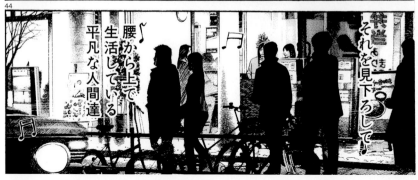

腰から上で生活している平凡な人間達

それを見下ろして

ブォ

オレは一体何者なんだ…?

The 28-volume series "The Life of the Genius Professor Yanagizawa" won the Kôdansha Manga Award in 2003. The story is a tale of a senior citizen teaching free-market economics, would make a hard sell to any publisher, specially a manga one. Despite the odds, the title has been released with great success by Kôdansha's *Weekly Morning*. The author, one of the few to have the courage to have an elderly person as the main character and hero, is Kazumi Yamashita, known for her observational abilities, attention to detail, and deep skills bringing hard characters to life. For this title, she was inspired by her dad, and despite her roots in manga for girls, with sweeter and softer lines, the artist has managed to avoid the melodramatic stories she herself was used to. With over 30 titles to her name by now, Yamashita debuted in 1984 with two titles, "Boy" and "Carnival." Her latest work, "Land," published in 2014, takes the reader to a world completely different to her first bestseller. Her relentless work to find new narratives has been one of her greatest strengths.

KAZUMI YAMASHITA

Born

1959 in Hokkaidô, Japan

Debut

with "Oshiire monogatari" in 1980 published in *Weekly Margaret*

Best known works

"The Life of Genius Professor Yanagizawa"
"Wonder Boy"
"Land"

Anime adaption

"The Life of Genius Professor Yanagizawa"

Prizes

• 27th Kôdansha Manga Award: General Division (2003)

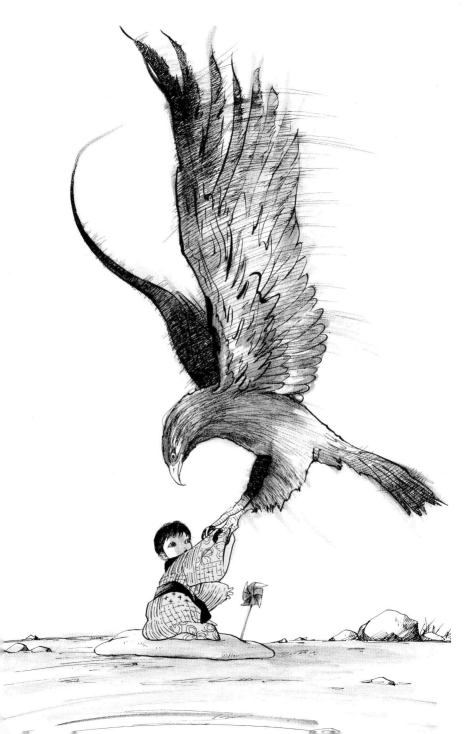

Kazumi Yamashitas 28-bändige Reihe „Tensai Yanagisawa Kyoju no Seikatsu" über einen älteren Professor, der freie Marktwirtschaft lehrt, wurde 2003 mit dem Kôdansha-Manga-Preis ausgezeichnet. Obwohl sich diese Geschichte nicht für eine lukrative Vermarktung zu eignen schien, vor allem für einen Manga-Verlag, erschien der Titel mit großem Erfolg in der Wochenzeitschrift *Weekly Morning* des Verlagshauses Kôdansha. Yamashita gehört damit zu den wenigen Künstlern, die den Mut haben, ältere Menschen in den Mittelpunkt einer Erzählung zu stellen. Sie ist bekannt für ihre Beobachtungsgabe, ihre Liebe zum Detail und ihre Fähigkeit, schwierige Charaktere mit Leben zu erfüllen. Die Anregung für diesen Titel lieferte ihr Vater, und obgleich ihre Kindheitslektüre Mangas für Mädchen waren, die mit feineren und sanfteren Strichen gezeichnet sind, mied die Künstlerin jene melodramatischen Geschichten, an die sie selbst gewöhnt war. Ihren Einstand gab Yamashita, von der inzwischen über 30 Titel erschienen sind, 1984 mit den beiden Mangas „Boy" und „Carnival". Ihr jüngstes Werk „Land", das 2014 veröffentlicht wurde, entführt den Leser in eine völlig andere Welt als ihr erster Bestseller. Ihr unermüdliches Bemühen, immer wieder neue Geschichten zu finden, ist eine ihrer größten Stärken.

La série « Tensai Yanagisawa Kyoju no Seikatsu » [La vie du grand professeur Yanagisawa] en 28 volumes a remporté en 2003 le prix du manga Kôdansha. Racontant l'histoire d'une personne âgée qui enseigne l'économie de marché libre, ce titre risquait d'être difficile à vendre, notamment pour une édition manga. Il a néanmoins connu un grand succès à sa parution dans le magazine *Weekly Morning* de Kôdansha. Kazumi Yamashita, l'une des rares auteurs à oser choisir une personne âgée comme protagoniste et héros, est réputée pour ses dons d'observation, son souci du détail et son talent pour donner vie à des personnages difficiles. Pour cette œuvre, elle s'est inspirée de son père et a réussi à éviter, en dépit de son expérience en mangas pour filles aux lignes plus douces, les mélodrames auxquels elle était habituée. Tamashita a maintenant plus de 30 ouvrages à son actif ; ses deux premiers titres, « Boy » et « Carnival », remontent à 1984. Son dernier travail, intitulé « Land » et publié en 2014, transporte le lecteur dans un monde totalement différent de son premier best-seller. L'un des points forts de cette artiste est de toujours rechercher des histoires inédites.

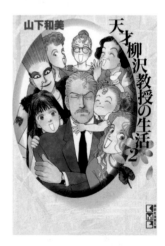

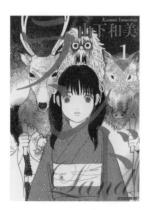

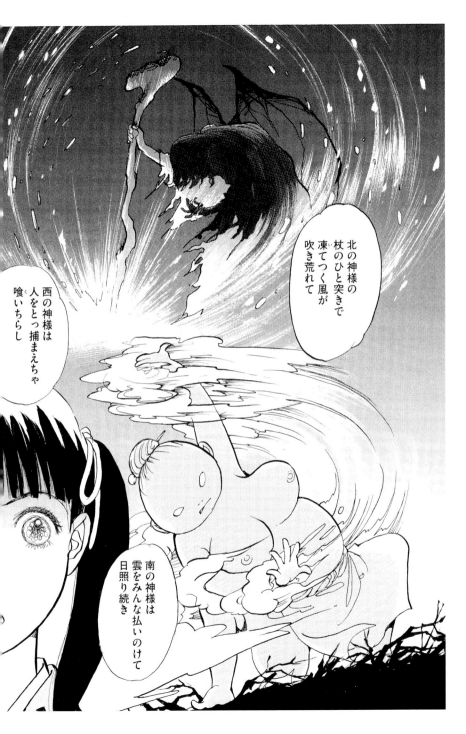

Currently a resident of Chicago, Mari Yamazaki was born and raised in Japan, and is the recipient of the Manga Taishō and the Osamu Tezuka Cultural Prize for short stories. "Thermae Romae," her bestselling title, has been adapted into a two-film sequence with the second film released in 2014. The manga depicts the story of Roman architect Lucius Modestus, who while in a bathhouse contemplating his difficulties in finding creative solutions for his projects, discovers a drain that sends him to a bathhouse in Modern Japan. The surreal time-machine story evolves as Lucius becomes famous and is commissioned to create new projects in ancient Rome. Specializing in subjects such as comedy, history, drama, romance, and supernatural, Yamazaki studied art history at the National Academy of Fine Arts in Florence, Italy, having lived also in Syria and Portugal. Since 2014 Yamazaki has also released two volumes of Walter Isaacson's biography of Steve Jobs in manga form. Often incorporating her international experience, other titles include "Sweet Home Chicago," "Tibet Guide," "Hanasaki in Asia," and "Pliny." One of her latest titles is an excursion into the Renaissance period in Italy, where she returns to her time as a student, trying to understand the painters of that age.

MARI YAMAZAKI

Born
1967 in Tokyo, Japan

Debut
with an essay style manga in 1996

Best known works
"Thermae Romae"
"Steve Jobs"

Feature film
"Thermae Romae"

Prizes
- 14th Tezuka Osamu Cultural Prize Short Story Award (2010)
- 3rd Cartoon Grand Prize (2010)
- Vogue Japan "Women of the Year 2012"

スティーブの個性と情熱
そして製品は
全体がひとつの
システムであるかのように
絡み合っているのだ……

Think different.

……誰にでもある
記憶違いの類も
あったが……

自分にとっての現実を
彼は私と
私に自分自身に
語り続けた……

そんな彼から聞いた話の
裏取りや肉づけを行うために
会った人々は

友人 親戚 競争相手
敵 仲間など合わせて
100人以上……

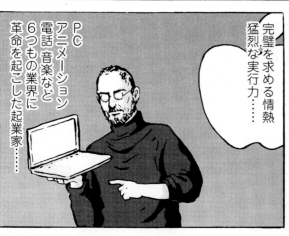

完璧を求める情熱
猛烈な実行力……

PC
アニメーション
電話 音楽など
6つの業界に
革命を起こした起業家……

ジョブズは正直
上司としても人間としても
模範になるような
人物ではない……

まるで
悪魔にとりつかれて
いるかのように
周囲の人々を怒らせ
絶望させる……だが……

そして求人広告で見つけたその日のうちにジョブズはゲーム会社「アタリ」を訪れていた

ここが楽しく金儲けさせてくれる会社か

Mari Yamazaki, die derzeit in Chicago lebt, ist in Japan geboren und aufgewachsen. Für ihre Kurzgeschichten erhielt sie den Manga Taishô und den Osamu-Tezuka-Kulturpreis. Ihr Bestseller „Thermae Romae" wurde 2012 und 2014 in Form zweier Realfilme vom japanischen Fernsehen adaptiert. Der Manga erzählt die Geschichte des römischen Baumeisters Lucius Modestus, der, während er in einer Therme sitzt und über die Schwierigkeit sinniert, kreative Lösungen für seine Projekte zu finden, einen Abfluss entdeckt, der ihn in ein Badehaus im heutigen Japan führt. Im weiteren Verlauf dieser surrealen Zeitreisegeschichte wird Lucius berühmt und erhält neue Aufträge im antiken Rom. Yamazaki, die auf die Bereiche Komödie, Geschichte, Drama, Romantik und Übernatürliches spezialisiert ist, studierte Kunstgeschichte an der Accademia di Belle Arti in Florenz und lebte zudem einige Zeit in Syrien sowie Portugal. Seit 2014 hat Yamazaki Walter Isaacsons Steve-Jobs-Biografie als zweibändigen Manga veröffentlicht und, inspiriert durch ihre Auslandserfahrung, die Titel „Sweet Home Chicago", „Tibet Guide", „Hanasaki in Asia" und „Pliny". Einer ihrer jüngsten Werke ist ein Ausflug ins Rinascimento, bei dem sie in ihre Studienzeit in Italien zurückkehrt und versucht, die Maler jenes Zeitalters zu verstehen.

Aujourd'hui installée à Chicago, Mari Yamazaki est née et a passé son enfance au Japon. Elle a reçu le prix du manga Taishô et le prix culturel Osamu Tezuka pour ses histoires courtes. Son best-seller « Thermae Romae » a été adapté en deux films, le second étant sorti en 2014. Ce manga raconte l'histoire de l'architecte romain Lucius Modestus qui, alors qu'il médite dans des thermes sur la difficulté de trouver de l'inspiration pour ses projets, est aspiré sous l'eau et projeté dans un sauna dans le Japon moderne. Avec ce voyage dans le temps surréaliste, Lucius devient célèbre et est sollicité pour des projets dans la Rome antique. Spécialisée dans les domaines de la comédie, de l'histoire, du drame, de la romance et du surnaturel, Yamazaki a étudié l'histoire de l'art à l'Académie des beaux-arts de Florence. Elle a aussi vécu en Syrie et au Portugal. Depuis 2014, Yamazaki a également sorti deux volumes de mangas sur la biographie de Steve Jobs par Walter Isaacson. S'inspirant souvent de son expérience internationale, elle est aussi l'auteure de « Sweet Home Chicago », « Tibet Guide », « Hanasaki in Asia » et « Pliny ». L'un de ses derniers ouvrages offre un voyage dans la Renaissance italienne, où elle revient à ses années d'étudiante pour comprendre les peintre de cette époque.

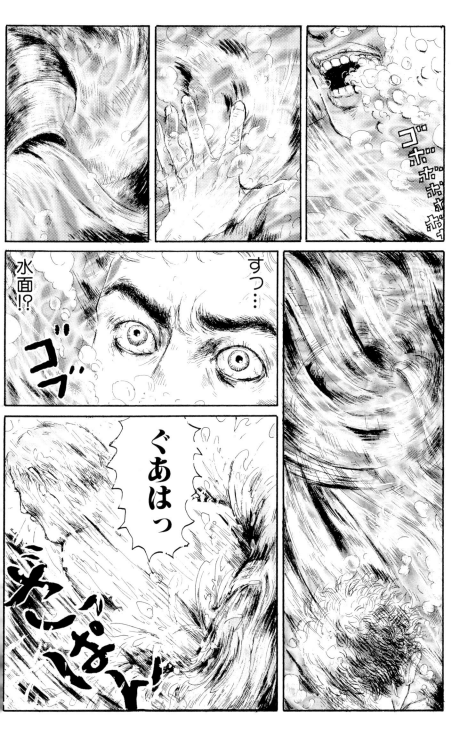

Ai Yazawa is one of most widely read *shōjo* manga artists working in Japan today. With her excellent ability at story telling, many readers have deeply sympathized with her characters and have been moved to tears. In her hit manga series, "Tenshi nanka ja nai" [I'm not an Angel] she uses the soft drawing style that is often seen in *shōjo* manga, creating an imaginary world that captivates us and draw us in. In the still-continuing series "Gokinjo monogatari" [Neighborhood Stories], she peppered the story with portrayals of the character's clothing designs and lifestyles, and by thus changing her manga style, she increased her fan base. She became popular with fans who were visually interested in the character's fashion styles. Following this, she published in fashion magazines, in addition to her work in manga magazines. However, what is important is that she is not just concerned with the illustration and the design aspect of her manga. Her descriptions of how people live, individual character's emotions, and their relationships with one another are always at the heart of her works. She creates the kind of background situations that are appealing to teenagers, such as youngsters who design clothes, or youths playing in a band. She then adds in emotion and drama, to deeply move readers. She has gained a strong support for her work.

A I
Y A Z A W A

Born

1967 in Hyōgo Prefecture, Japan

Debut

with "Ano natsu" [That Summer] published in *Ribbon Original* magazine in 1985

Best known works

"Tenshi nanka ja nai" [I'm not an Angel]
"Paradise Kiss"
"Nana"
"Gokinjo monogatari" [Neighborhood Stories]

Anime adaption

"Gokinjo monogatari" [Neighborhood Stories]

Prizes

- 48th Shōgakukan Manga Award (2003)

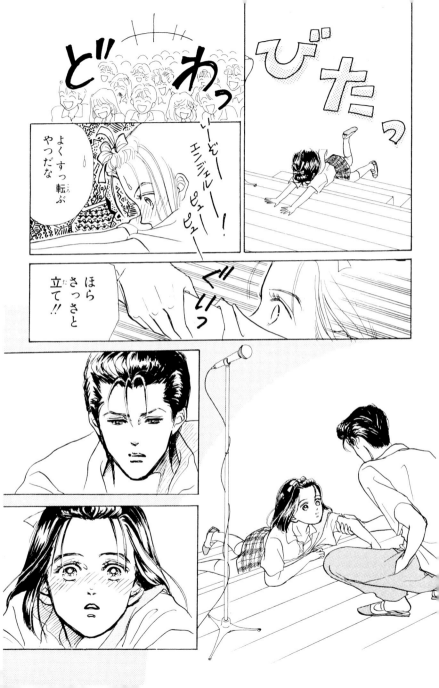

Ai Yazawa ist eine der derzeit meistgelesenen *shôjo*-Mangaka in Japan. Ihr Publikum fühlt so sehr mit den Protagonisten der meisterhaften Geschichtenerzählerin, dass es oft zu echten Tränen kommt . Bis zu ihrem Bestseller „Tenshi nanka ja nai" war ihr Stil von *shôjo*-typischen pastellfarbenen Zeichnungen geprägt, in denen die Gedankenwelt der Charaktere ausgebreitet wird und die Leserin so in die Geschichte zieht. In „Gokinjo monogatari" begann Yazawa, ihren Zeichenstil zu verändern. Mit vielen Designelementen betonte sie Kleidung und Lifestyle der Charaktere. Dadurch gewann sie zahlreiche neue Leserinnen, die besonders vom visuellen Aspekt ihrer Mangas beeindruckt waren und sich stark für die Kleidung der Protagonisten interessierten. Dieses Phänomen ebnete den Weg für die spätere Entwicklung, *shôjo*-Serien nicht nur in den einschlägigen Manga-Magazinen, sondern auch in Modezeitschriften zu veröffentlichen. Das Wesentliche an Yazawas Arbeiten ist jedoch nicht der dekorative Zeichenstil mit Betonung auf Design, sondern das Lebensgefühl individueller Persönlichkeiten mit ihren zwischenmenschlichen Beziehungen. Zeitgemäße Teenager-Träume, wie die Gründung einer Band oder das Modegeschäft, bilden zwar den Hintergrund für ihre Geschichten. Aber Yazawa haucht ihnen mit viel Dramatik und Gefühl das Leben ein, das ihr Publikum so fasziniert und der Autorin eine begeisterte Fangemeinde bescherte.

Yazawa est une des auteurs de manga *shôjo* les plus lus au Japon. Excellente conteuse, elle a réussi à créer une relation de sympathie entre ses personnages et les lecteurs, souvent très émus par les événements présentés. Dans « Tenshi nanka ja nai » [Je ne suis pas un ange], sa série la plus connue, elle utilise le style de dessin caractéristique des mangas *shôjo*, créant un monde imaginaire attirant et captivant. Dans « Gokinjo monogatari » [Histoires de voisinage], une série en cours, elle a parsemé le scénario de représentations des styles de vie et des intérêts vestimentaires de ses personnages, ce qui a non seulement changé le style de son manga mais a aussi augmenté le nombre de fans. Elle est tout particulièrement devenue populaire auprès de ceux intéressés par l'aspect visuel des articles de mode de ses personnages. Ses créations, d'abord apparues dans les magazines consacrés aux mangas, ont également été publiées dans des magazines de mode. Cependant, elle ne s'intéresse pas qu'à l'illustration et au design de ses mangas : ses descriptions de la vie, des émotions et des relations entre les différents personnages restent au cœur de ses travaux. Yazawa crée le type de situations dont les adolescents raffolent : jeunes en quête de nouvelles modes vestimentaires ou musiciens. Elle ajoute ensuite les aspects émotionnels et dramatiques.

．．．．．．

うざっ

Bonjour
ボンジュール
mademoiselle
マドモアゼル

キャロライン！
サ・ヴァ？

Comment allez-vous ？
コマン・タレ・ヴ

そっか そっちも今日
卒業式だったんだっけ

あれ？
制服？

すっかり
感化され
てるし…

今日のジョージの
歓送会はみんなの
卒業祝いも
兼ねてるのよ

ごちそういっぱい
作るから楽しみに
しててね♡

Oui
ウイ

一時は大きく
道を踏み外し
かけましたが
無事卒業
出来ました

キュゥゥゥ
キュゥゥ

あたしも手伝うよ
イザベラ

エプロン
持って
来た♪

あたしも♡

実和子

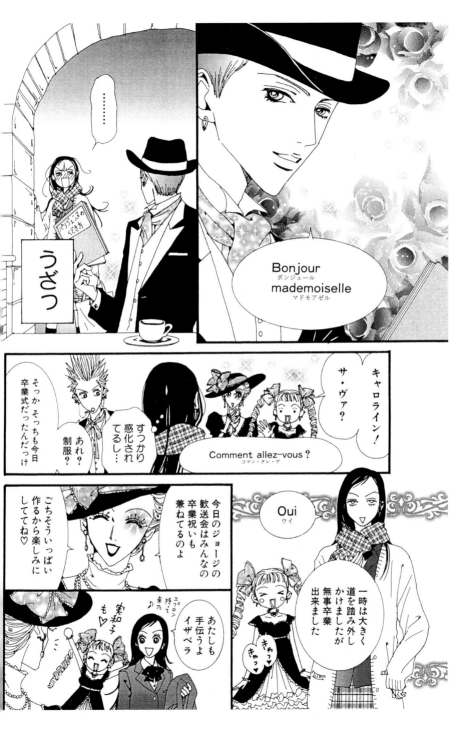

Sensha Yoshida's yon-koma manga "Utsurun desu." contains a series of irrational and surrealistic gags. It was a tremendous hit that even led to the creation of the term, "Fujouri Gag" [Absurd Gag]. The design of the tankôbon books also received much attention, in that he used various tricks throughout the books, such as rearranging the pages in a seemingly haphazard style. The main character is "Kawauso-kun." It is difficult to determine whether this being is a person, animal, or monster. The story unfolds using peculiar characters that encounter various bizarre situations. Although some of the stories are predictable, it nonetheless deviates from the traditional gag comic and manages to bring a smile to your face. It brought about a new era in gag comics with this strange style. His other manga also include frequent use of cryptic customs, words, and characters. Many of the eccentric side characters eventually spawned spin-off series of their own, such as "Ijimete-kun" and "Kaseida Machiko." Basically, his manga are geared toward adult audiences, but he also became popular among children with "Chikuchiku uniuni!," which depicts a school of sea urchins living in the ocean. It was published in a *shônen* manga magazine. He still continues to publish absurd characters and gag comics, and amazingly, he never seems to run out of material.

S E N S H A Y O S H I D A

Born

1963 in Iwate Prefecture, Japan

Debut

with "Pop-up" in 1983

Best known works

"Utsurun desu"
"Gakkatsu!! Tsuyatsuya tannin"
"Naguruzo"
"Chikuchiku uniuni!

Prizes

• 37th Bungeishunjū Manga Award (1991)

……ガム、

かんでる
ふり……

……本当に
かんでると
思った？……

ひ―…

Sein Vier-Bilder-Manga „Utsurun desu." [You'll get infected] sorgt mit widersinnigem, surrealem Humor für wahre Lachsalven und war Anlass für die Begriffsneuschöpfung „absurder Gag". Sensha [Panzer] Yoshida ließ dabei keinen Jux aus, so sorgten beispielsweise die absichtlich falsch gebundenen Seiten der *tankôbon*-Veröffentlichung für Aufsehen. Im Mittelpunkt steht meist Kawauso-kun, ein Wesen, von dem man nicht genau weiß, ob es sich um einen Menschen, ein Tier oder ein Monster handelt. Die übrigen Protagonisten sind auch reichlich bizarr und seine verrückten Geschichten kommen bisweilen auch ohne Pointe aus: Der Autor fühlt sich der Gag-Manga-Tradition keineswegs verpflichtet – lachen muss man trotzdem. So gilt Yoshida vielmehr als Erneuerer des Gag-Mangas. Auch in seinen anderen Werken gibt es zahlreiche rätselhafte Bräuche, Wörter und Charaktere, und frühere Nebenfiguren wie Ijimete-kun und Kaseida Machiko bekommen manchmal ihre eigene Serie. Eigentlich zeichnet er Mangas, über die sich Erwachsene amüsieren können. Er eroberte sich in einem *shônen*-Magazin mit „Chikuchiku uniuni", um eine Seeigelschule im Meer auch eine große Fangemeinde unter Kindern. Sensha Yoshida widmet sich auch weiterhin absurden Charakteren und widersinnigen Handlungsbögen – es ist erstaunlich, dass ihm die Gags nicht ausgehen.

Le manga yonkoma « Utsurun desu. » de Yoshida contient une série de gags irrationnels et surréalistes. C'est un manga extrêmement populaire qui a mené à la création du terme « Fujouri Gag » [Gag absurde]. Ses tankôbon ont également rencontré un grand succès et il a utilisé différentes astuces au travers de ses ouvrages, tels que la redisposition des pages apparemment au hasard. Le personnage principal est Kawauso-kun. Il est difficile de déterminer s'il s'agit d'une personne, d'un animal ou d'un monstre. L'histoire comprend des personnages étranges qui font face à des situations bizarres. Bien que certaines histoires soient prévisibles, elles dévient des bandes dessinées comiques traditionnelles et réussissent à faire sourire. Une nouvelle ère comique est née grâce à ce style étrange. Ses autres mangas utilisent fréquemment des mots, des caractères ou des coutumes énigmatiques. La plupart de ses personnages excentriques ont vu apparaître leurs propres séries, tels que « Ijimete-kun » et « Kaseida Machiko ». Ses mangas sont généralement destinés à des adultes mais il est devenu populaire auprès des enfants avec « Chikuchiku uniuni! », qui dépeint un banc d'oursins vivant dans les océans. Ce manga a été publié dans un magazine de mangas *shônen*. Il continue de publier des mangas comiques contenant des personnages absurdes, et semble ne jamais manquer d'inspiration.

ＡＢＣ英会話教習所です、パンフレットどおぞー！

久しぶりに人間国宝の様子でも見るかな。

Ah——, No！

学生さんですか？ふだん英語しゃべれたらなーとか、思ったりしたことありませんか？

No, thank you！

こちらまったく新しい英会話カリキュラムを組んでおりまして……

No thank youううう!!

英語話せるといろいろ楽しいですよ！人間関係も広がりますし！

つらいか？

ふる ふる ふる

……この穴が、玄関なのだろうか……

ドキドキドキ

ハッ！

ぴょーる

わぁぁぁあああ

ハワイに行ったことはいい……

わー、すごい人出だね、ミッチー！

本当！

おさいせん張り込んじゃおう！

わあ、なにをおがむんだい？

……かわうそ君？

な、なに？……

すべての人類が私の足元に跪（ひざま）きますように。すべての人類が私の足元に跪（ひざま）きますように。

問題は、なぜそのことを、かわうそであるこのぼくに話さなかったかだ！！

ねえ、なにをおがんだのさ、ミッチー？

ないしょ

Starting her career as a boys-love manga artist, Fumi Yoshinaga is a talented storyteller capable of constructing human dramas in various subjects. Her most popular work, "Ōoku: The Inner Chambers" has its story set in the Edo period in Japan (between 1603 and 1868), and depicts the love-hate drama of a matriarchal Japanese society in which the "Ōoku" has become a harem of men serving a female Shōgun. After its immense success, the story was made into a TV drama hit and movie series from 2010. The story won a special prize at The Japanese Association of Feminist Science Fiction and Fantasy's fifth annual Sense of Gender Awards in 2005, as well as the Excellence Prize at the 2006 Japan Media Arts Festival. It was also awarded the 2009 Grand Prix at the Osamu Tezuka Cultural Prize. A graduate of Keio University in Tokyo, Yoshinaga has had her titles widely published around the world, with her oeuvre selected by Masami Toku and exhibited as one of the twenty major manga artists to contribute to the world of *shōjo* manga [publications from the World War II to present].

FUMI YOSHINAGA

Born

1971 in Tokyo, Japan

Debut

with "Tsuki tō Sandal" [The Moon and the Sandals] published in *Hanaoto* magazine in 1994

Best known works

"What Did You Eat Yesterday?"
"Ōoku: The Inner Chambers"
"Antique Bakery"

TV adaption

"Ōoku: The Inner Chambers"
"Antique Bakery"

Feature animation

"Antique Bakery"

Feature film

"Ōoku: The Inner Chambers"

Prizes

- 26th Kōdansha Manga Award in the *shōjo* manga category (2002)
- 10th Japan Media Arts Festival: Excellence Award in Manga Division (2006)
- Grand Prize in the 13th Tezuka Osamu Cultural Prize (2009)
- James Tiptree, Jr. Award (2009)
- 56th Shōgakukan Manga Award in Girls' Category (2010)

春日局様は
女性にございます

三代家光公も
元は男子で
あられたので
ございます
よ…

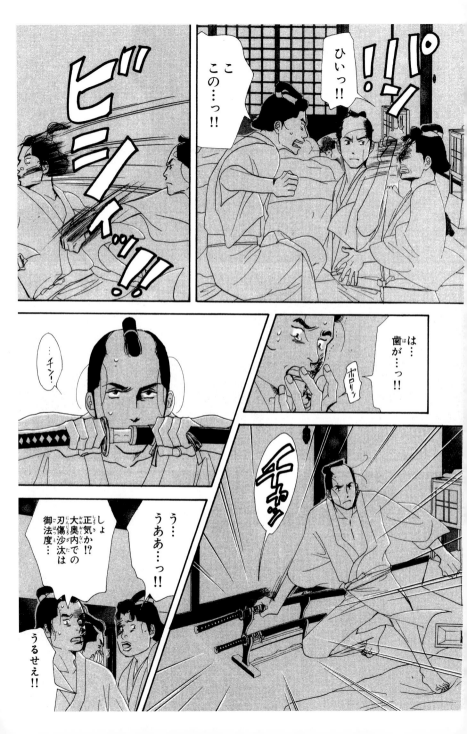

Fumi Yoshinaga, die ihren Abschluss an der Keio-Universität in Tokio erwarb und ihre Karriere mit *boys love*-Mangas begann, ist eine begabte Erzählerin, die anhand diverser Themengebiete menschliche Dramen darzustellen vermag. Ihr bekanntestes Werk „Ôoku" ist im Japan der Edo-Zeit (1603–1868) angesiedelt und beschreibt Dramen von Liebe und Hass in einer matriarchalischen Gesellschaft, in der der *Ôoku* [großer Innenraum] ein Harem mit Männern ist, die einem weiblichen Shôgun zu Diensten sind. Nach dem enormen Erfolg als Buch wurde der Manga 2010 verfilmt und 2012 als zehnteilige Fernsehserie adaptiert. Die Geschichte erhielt 2005 den Spezialpreis bei den fünften jährlichen Sense of Gender Awards der Japanese Association for Gender, Science Fiction and Fantasy sowie 2006 den Excellence Prize beim Japan Media Arts Festival. 2009 bekam die Künstlerin zudem den Osamu-Tezuka-Kulturpreis verliehen. Yoshinaga, deren Titel weltweit veröffentlicht werden, wurde von Masami Toku als einer von 20 großen Manga-Künstlern ausgewählt und ausgestellt, die einen Beitrag zur Welt der *shôjo*-Mangas vom Zweiten Weltkrieg bis zur Gegenwart geleistet haben.

Après des débuts comme artiste de mangas Boy's Love, Fumi Yoshinaga a affirmé ses talents de narratrice capable d'élaborer des drames humains dans divers sujets. Son titre le plus célèbre est « Ôoku » [Le pavillon des hommes] : l'histoire se déroule au Japon à l'époque d'Edo (entre 1603 et 1868) et raconte l'amour-haine d'une société japonaise matriarcale dans laquelle le « Ôoku » est devenu un harem d'hommes au service d'une femme Shôgun. Après son immense succès, l'histoire a été adaptée en série télévisée et de longs métrages à partir de 2010. Elle a remporté en 2005 un prix spécial Sense of Gender Awards décerné par The Japanese Association of Feminist Science Fiction and Fantasy, ainsi que le prix Excellence en 2006 lors du Japan Media Arts Festival. En 2009, elle a obtenu le grand prix culturel Osamu Tezuka. Diplômée de l'université Keio de Tokyo, Yoshinaga a vu ses titres publiés dans le monde entier ; son œuvre a été retenue par Masami Toku et exposée comme l'une des vingt plus grandes artistes de mangas *shôjo* (publications de la Seconde Guerre mondiale à nos jours).

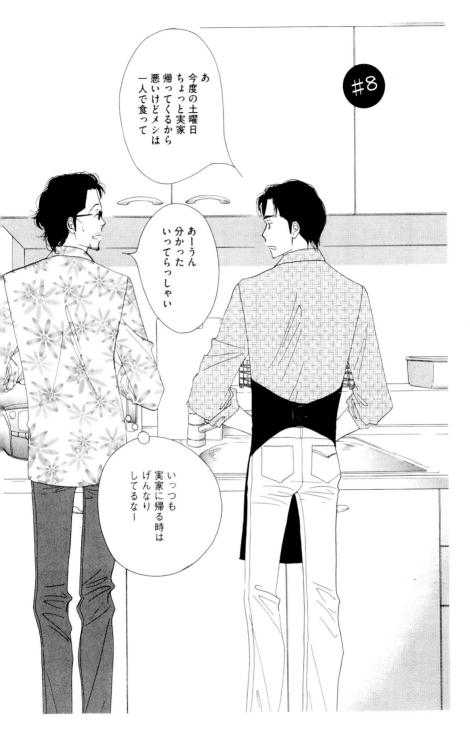

＃8

あ
今度の土曜日
ちょっと実家
帰ってくるから
悪いけどメシは
一人で食って

あーうん
分かった
いってらっしゃい

いっつも
実家に帰る時は
げんなり
してるなー

GLOSSARY

Manga – A manga is a story that is conveyed through a series of frames with drawings and accompanying dialog text. It is similar to the comic book in Western countries. In Japan, manga is not only for children to read, but there are unlimited types of Manga for every type of reading audience. Many of them have sophisticated stories, adult themes, and character development that is similar to that of regular literature. Osamu Tezuka is considered to be one of the pioneers of Japanese manga. Manga is usually read in manga magazines or tankoubon.

Anime – Shortened form of the word animation. Many popular manga stories are eventually made into animated television programs. Anime can also be seen in video tapes and movies. As with manga, anime is not only for children to watch, but many are sophisticated enough to be enjoyed by audiences of all ages. Hayao Miyazaki creates feature length animes such as "Spirited Away," that are popular around the world.

Yon Koma Manga – This is a four-frame gag manga that is similar to a gag strip. The four frames correspond to four course of events, called *ki-shou-ten-ketsu*. These roughly translate as: introduction, development, turn of events, and conclusion. The gag plays out within the course of these four frames.

Shoujo Manga (Girls Comic) – A manga that is geared towards school-aged girls, approximately below the age of 18, falls into this category. There are many manga magazines that are of the *shoujo* manga type. Some popular ones include *Nakayoshi, Margaret, Ribbon*.

Shounen Manga (Boys Comic) – A manga that is geared towards school-aged boys, approximately below the age of 18, falls into this category. There are many manga magazines that are of the *shounen* manga type. Some popular ones include *Shônen Jump, Ultra Jump, Shônen Magazine*.

Seinen Manga (Young Mens Comic) – A manga that is geared towards young men that are approximately over the age of 18 falls into this category. There are many manga magazines that are of the *seinen* manga type. Some popular ones include *Big Comic Spirits, Young Jump*.

Tanbi-kei (Shounen-Ai, Boys Love) – This is a manga genre that depicts male homosexual romance stories. The drawings of beautiful men are very popular among women. Many doujinshi are of this genre.

Gekiga – This is a graphic type of manga that stresses importance on the plot and drawing style. It is drawn in a highly realistic style and is usually read by men. A gekiga-ka is someone who writes gekiga.

Doujinshi – Similar to fan fiction, this is a fan manga that is written by the fans. The authors can either be amateur artists or professional mangaka. Doujinshi can be bought at bookstores, just like regular manga.

Tanpen – Manga magazines publish a variety of stories in each issue. These stories are either stand-alone short stories [tanpen] or serial stories [rensai] where the plot develops with each new issue of the magazine. Tanpen stories are usually published in special edition issues.

Rensai – Manga magazines publish a variety of stories in each issue. These stories are either stand-alone short stories [tanpen] or serial stories [rensai] where the plot develops with each new issue of the magazine. Rensai stories can be published weekly, bi-weekly, or monthly. The longest rensai story is currently Osamu Akimoto's "Kochira Katsushika-ku Kameari Kouen-mae Hashutsujo" which has been going on for 28 years.

Tankoubon – When a popular rensai is published in a magazine, it is usually later compiled into a comic book. This book is called a tankoubon. Each tankoubon can contain roughly ten installments of the serial story.

Mangaka – This is someone who writes manga; a manga artist.

Gensaku-sha – The gensaku-sha is the person who writes the manga's original story. They will develop the plot of the manga, and then the mangaka or their assistants will do the accompanying drawings to support the story.

Otaku – This term is used to describe an avid manga fan. It is similar to the English word, "fanatic," but it has underlying connotations of being a "geek" or "nerd" as well.

Onomatopoeic – These are special Japanese words written in the katakana alphabet, that describe sounds and adjectives. The Japanese language includes many onomatopoeic words. Some examples of sounds include "ban" (bang), "nyan" (meow), and "pi" (high pitched whistle or alarm sound). Some examples of adjectives include "gara gara" (empty), "kira kira" (sparkling), and "pika pika" (shiny).

Tone (screentone) – These are transparent layers that are applied on top of a manga image. They are imprinted with some kind of a pattern, and they are used in the shading and detailing of the final manga image. Tones are available commercially, but many manga artists create their own one of a kind tones.

GLOSSAR

Anime – Abkürzung des englischen *animation*, bezeichnet in Japan alle Zeichentrickfilme, im westlichen Ausland meist nur japanische Zeichentrickfilme. Populäre Manga-Serien werden oft als Anime-Fernsehserien, als OVA („original video animation") bzw. OAV („original animated video") direkt auf Video, oder (bei sehr beliebten Serien) als Kino-Anime verfilmt. Wie bei Mangas sind Animes nicht bloß Kinderunterhaltung, sondern viele richten sich mit anspruchsvollen Inhalten an alle Altersgruppen. Hayao Miyazaki ist weltweit berühmt als Regisseur von Kino-Animes in Spielfilmlänge, wie „Spirited Away" – Chihiros Reise ins Zauberland".

Boys love (shônen-ai, Tanbi-kei) – Ein Manga-Genre mit der Zielgruppe Frauen und Mädchen, das romantische Liebesgeschichten zwischen ausschließlich männlichen Protagonisten darstellt. Die Zeichnungen wunderschöner Männer erfreuen sich bei Frauen großer Beliebtheit. Viele *dôjinshi* haben *boys love*-Thematik.

Dôjinshi – Ähnlich wie *fan fiction* entstanden *dôjinshi* mit Amateurzeichnern, die ihre Lieblingsserien weiterzeichneten oder ihre Lieblingscharaktere beispielsweise in *boys love*-Szenarien darstellten. Auch professionelle Mangaka zeichnen zuweilen *dôjinshi*, die meist im Eigenverlag veröffentlicht werden und in Buchläden oder auf Conventions, wie der berühmten Comic Market, die zweimal jährlich in Tôkyô abgehalten wird, käuflich erwerblich sind.

Gekiga – Wörtlich „Bilderdrama". Bei diesen meist von erwachsenen Männern gelesenen Mangas liegt die Betonung auf ernsteren Themen und einem sehr realistischen Zeichenstil. Ein *gekiga-ka* ist jemand der *gekiga* verfasst.

Gensaku-sha – Der *gensaku-sha* schreibt die Originalstory für den Manga und entwickelt die Handlung. Die Mangaka beziehungsweise

ihre Assistenten fertigen dann die entsprechenden Zeichnungen an.

Lautmalerei/Onomatopöie – Im Japanischen sehr häufige Wörter, die Laute oder einen Zustand beschreiben und meist im *katakana*-Silbenalphabet geschrieben werden. Beispiele für Laute sind *ban* (Knall), *nyan* (Miau) und *pi* (hoher Pfeif- oder Alarmton). Zustandsbeschreibende Worte sind *gara gara* (leer), *kira kira* (glitzernd) und *pika pika* (glänzend sauber).

Manga – Comics aus Japan, die sich nicht nur an Kinder richten, sondern an zahlreiche Zielgruppen aller Altersstufen, mit Inhalten, die sogenannter ernster Literatur bisweilen in nichts nachstehen. Meist schwarz-weiß mit nur wenigen Farbseiten, wird eine Manga-Serie normalerweise zunächst in einem der unzähligen Telefonbuch-dicken Manga-Magazine veröffentlicht. Häufig liegt diesen eine Leserumfragekarte bei und Serien, die auf der Beliebtheitsskala nicht punkten können, wandern langsam nach hinten im Magazin (bzw. nach vorne – japanische Mangas werden von rechts nach links gelesen) bevor sie verschwinden. Ist die Serie dagegen erfolgreich, folgen *tankôbon*, TV-Anime und Kino-Anime. Osamu Tezuka gilt als einer der Pioniere im japanischen Manga.

Mangaka – Der Manga-Autor.

Otaku – Ein auf sein Hobby (vor allem bezogen auf Mangas, Animes oder Videospiele) fixierter Kauz. In westlichen Ländern oft einfach für begeisterte Manga- und/oder Anime-Fans verwendet.

Rensai – Manga-Magazine veröffentlichen in jeder Ausgabe zahlreiche Geschichten, die entweder in sich abgeschlossen sind (*tanpen* bzw. Kurzgeschichten) oder in Folgen (*rensai*) veröffentlicht werden, in letzterem Fall entwickelt sich die Handlung in jeder Ausgabe weiter. Die Veröffentlichung findet im monatlichen, zweiwöchentlichen oder Wochenrhythmus statt. Die längste *rensai*-Veröffentlichung ist derzeit Osamu Akimotos „Kochira

Katsushika-ku Kameari Kouen-mae Hashutsujo", die seit 28 Jahren erscheint.

Shôjo-Manga – Mangas mit der Zielgruppe Mädchen zwischen circa sechs und achtzehn Jahren. Es gibt zahlreiche *shôjo*-Magazine für verschiedene Altersgruppen, wie beispielsweise *Nakayoshi* und *Ribbon* für Mädchen im Grundschulalter (in Japan bis zur sechsten Klasse) und *Margaret* für die etwas ältere Zielgruppe.

Shônen-Manga – Mangas mit der Zielgruppe Jungen zwischen circa sechs und achtzehn Jahren. Die tatsächliche Leserschaft geht weit darüber hinaus und zahlreiche Manga-Magazine haben sich dem *shônen*-Manga verschrieben, wie zum Beispiel *Shônen Jump*, *Ultra Jump* und *Shônen Magazine*.

Seinen-Manga – Mangas mit der Zielgruppe junge Männer ab circa achtzehn Jahren. Viele Manga-Magazine richten sich an die *seinen* (ausgesprochen wie „sehnen") -Zielgruppe, wie zum Beispiel *Big Comic Spirits* und *Young Jump*.

Tankôbon – Wenn eine Magazin-Serie beliebt genug ist, wird sie später üblicherweise als *tankôbon*, also als Comicbuch veröffentlicht. Ein *tankôbon* enthält durchschnittlich ungefähr 10 Folgen einer Serie.

Tanpen – Manga-Magazine veröffentlichen in jeder Ausgabe zahlreiche Geschichten, die entweder in sich abgeschlossen sind (*tanpen* bzw. Kurzgeschichten) oder in Folgen (*rensai*) veröffentlicht werden, in letzterem Fall entwickelt sich die Handlung in jeder Ausgabe weiter. Kurzgeschichten erscheinen meist in Sonderausgaben.

Yon Koma Manga – Ein Gag-Manga in vier Bildern. Die vier Bilder entsprechen einem Spannungsbogen mit der Reihenfolge *ki-shô-ten-ketsu*, also etwa „Einleitung – Entwicklung – überraschende Wendung – Schluss".

GLOSSAIRE

Anime – Forme écourtée du mot animation. De nombreux mangas populaires donnent lieu à des séries animées pour la télévision. On trouve également des anime sur cassette vidéo ou sous forme de film. Comme pour les mangas, les anime ne sont pas exclusivement réservés aux enfants, mais sont pour nombre d'entre eux suffisamment sophistiqués pour être appréciés par des audiences de tous âges. Hayao Miyazaki a créé des long métrages d'anime, tels que « Spirited Away », qui sont populaires dans le monde entier.

Doujinshi – Similaires aux fictions écrites par des fans, il s'agit de mangas écrits par des fans. Leurs auteurs peuvent être des dessinateurs amateurs ou des auteurs professionnel (mangaka). On trouve les doujinshi dans des librairies, comme pour les mangas traditionnels.

Gekiga – Il s'agit d'un type de manga graphique qui met l'accent sur l'intrigue et le style des dessins. Les images sont dessinées de manière très réaliste et les histoires sont généralement lues par des hommes. Un gekiga-ka est un auteur de gekiga.

Gensaku-sha – Il s'agit de l'auteur du scénario original d'une bande dessinée. Il développe l'intrigue d'un manga, puis le mangaka ou ses assistants effectuent les dessins pour soutenir l'histoire.

Manga – Un manga est une histoire racontée au travers d'une série de vignettes, accompagnées de dessins et de dialogues, et est identique aux bandes dessinées des pays occidentaux. Au Japon, les mangas ne sont pas seulement destinés aux enfants, il en existe un nombre illimité différents pour chaque type d'audience. Beaucoup d'entre eux contiennent des histoires sophistiquées, des thèmes pour adultes, et un développement des personnages identique à celui de la littérature traditionnelle. Osamu Tezuka est considéré comme étant l'un des pionniers des mangas japonais. Les mangas sont généralement publiés dans des magazines de bandes dessinées ou des tankoubon.

Manga seinen (bande dessinée pour jeunes hommes) – Il s'agit d'un manga qui est destiné aux jeunes hommes, généralement de plus de 18 ans. De nombreux magazines de bandes dessinées sont dédiés aux mangas seinen. *Big Comic Spirits* et *Young Jump* font partie des magazines populaires de cette catégorie.

Manga shoujo (bande dessinée pour jeunes filles) – Il s'agit d'un manga qui est destiné aux jeunes écolières, généralement à l'âge de l'adolescence. De nombreux magazines de bandes dessinées sont dédiés aux mangas shoujo. *Nakayoshi*, *Margaret* et *Ribbon* font partie des magazines populaires de cette catégorie.

Manga shounen (bande dessinée pour jeunes garçons) – Il s'agit d'un manga qui est destiné aux écoliers, généralement à l'âge de l'adolescence. De nombreux magazines de bandes dessinées sont dédiés aux mangas shounen. *Shônen Jump*, *Ultra Jump* et *Shônen Magazine* font partie des magazines populaires de cette catégorie.

Manga yonkoma – Il s'agit d'un manga humoristique sur quatre vignettes similaire aux bandes dessinées qui paraissent dans les journaux. Les quatre vignettes correspondent à quatre type d'événements appelés « ki-shou-ten-ketsu », ce qui correspond grosso modo à l'introduction, le développement, un retournement de la situation et la conclusion. Le gag se déroule sur ces quatre vignettes.

Mangaka – Il s'agit d'un auteur ou d'un dessinateur de mangas.

Onomatopéique – Il s'agit de mots japonais spéciaux écrits avec l'alphabet katakana qui décrivent des sons et des adjectifs. La langue japonaise contient de nombreux mots onomatopéiques, par exemple « ban » (pan), « nyan » (miaou) et « pi- » (sifflement strident, alarme), ou des adjectifs tels que « gara gara » (vide), « kira kira » (scintillant, pétillant) et « pika pika » (brillant).

Otaku – Ce terme est utilisé pour décrire un fan avide de mangas. Il est identique au terme « fanatique », mais a également la connotation de « geek » ou « nerd » (termes anglais qui caractérisent souvent des individus mordus de technologie ou d'informatique).

Rensai – Les magazines de bandes dessinées publient différentes histoires à chaque parution. Ce sont soit des histoires indépendantes courtes (tanpen) soit des séries (rensai) dans lesquelles l'intrigue évolue lors des nouvelles parutions du magazine. Les histoires rensai sont publiées chaque semaine, toutes les deux semaines ou chaque mois. L'histoire rensai la plus longue est « Kochira Katsushika-ku Kameari Kouen-mae Hashutsujo » d'Osamu Akimoto, qui est publiée depuis déjà 28 ans.

Tanbi-kei (Amours de garçons) – Il s'agit d'un genre de manga qui dépeint des histoires de romance homosexuelle. Les dessins d'hommes très beaux sont très populaires parmi les femmes. De nombreux doujinshi font partie de cette catégorie.

Tankoubon – Lorsqu'une histoire rensai populaire est publiée dans un magazine, elle est généralement compilée plus tard dans un livre. Cet ouvrage est appelé un tankoubon. Chaque tankoubon, ou tome, contient en moyenne dix épisodes de la série.

Tanpen – Les magazines de bandes dessinées publient différentes histoires à chaque parution. Ce sont soit des histoires indépendantes courtes (tanpen) soit des séries (rensai) dans lesquelles l'intrigue évolue lors des nouvelles parutions du magazine. Les histoires tanpen sont généralement publiées dans des numéros hors série.

CREDITS / CRÉDITS

Abe, Tomomi
"Chii-chan wa chotto tarinai" – Akita Shoten
"Sora ga haiiro dakara" – Akita Shoten

Adachi, Mitsuru
"Touch" – Shôgakukan/*Shônen Sunday*
"KATSU!" – Shôgakukan/*Shônen Sunday*
"Miyuki" – Shôgakukan/*Shônen Sunday*
"Nijiiro tôgarashi" – Shôgakukan/*Shônen Sunday*

Aihara, Koji
"Manka" – Futabasha
"Mujina" – Shôgakukan/Young Sunday
"Sarudemo Kakeru Manga Kyoushitsu" – Shôgakukan/*Big Comic Spirits*

Akamatsu, Ken
"Mahou Sensei Negima!" – Kôdansha
"Love Hina" – Kôdansha
Art: RAN "Rikujô bôeitai Mao-chan" – Kôdansha
"Ai ga tomaranai!" – Kôdansha

Akatsuka, Fujio
"Osomatsu-kun" – Fujio Production/Takeshobô
"Tensai Bakabon" – Fujio Production/Takeshobô
"Môretsu Atarô" – Fujio Production/Takeshobô
"Kore de ii no da" www.koredeiinoda.net

Akimoto, Osamu
"Kochira Katsushika-ku Kameari Kôen-mae hashutsujo"- Atelier Bidama/Shûeisha
"Mr. Clice" – Atelier Bidama/Shûeisha

Anno, Moyoko
"Hana to Mitsubachi" – Kôdansha
"Sakuran" – Kôdansha
"Tundra Blue Ice" – Shûeisha
"Happy Mania" – Shôdensha

Aoki, Yûji
"Naniwa kin'yûdô" – Kôdansha
"Sasurai" – Magazine House
"Yodagawa kasenshiki" – Kôdansha

Aoyama, Gosho
"Meitantei Conan" – Shôgakukan/*Shônen Sunday*
"Magic Kaito" – Shôgakukan/*Shônen Sunday*
"YAIBA" – Shôgakukan/*Shônen Sunday*

Araki, Hirohiko
"Jojo no kimyô na bôken Stone Ocean" – Araki Hirohiko & Lucky Land Communications/Shûeisha
"Mashônen BT" – Araki Hirohiko & Lucky Land Communications/Shûeisha
"Baô raihôsha" Araki Hirohiko & Lucky Land Communications/Shûeisha

Asano, Inio
"Soranin" – Shôgakukan
"Dead Dead Demon's De De De De Destruction" – Shôgakukan

Azuma, Kiyohiko
"Azumanga daiô" – Media Works
"Yotsubato!" – Media Works

Chiba, Tetsuya
Manga: Chiba, Tetsuya/Gensaku: Takamori, Asao "Ashita no Joe" – Kôdansha
"Ore wa Teppei" – Kôdansha

"Ashita tenki ni naare" – Kôdansha
"Notari Matsutarô" – Shôgakukan
www.aruke.com/tetsuya/ Chiba Tetsuya Production
TEL + 81 (3) 3999-4292

Egawa, Tatsuya
"Tokyo Daigaku Monogatari" – Shôgakukan/*Big Comic Spirits*
"Magical Tarurûto-kun" – Shûeisha
"Be Free!" – Kôdansha
"Nichiro sensô monogatari" – Shôgakukan/*Big Comic Spirits*

Eguchi, Hisashi
"Seishônen no tame no Eguchi Hisashi nyûmon" – Eguchi Hisashi
"Stop!! Hibari-kun!" – Eguchi Hisashi
"Ken to Erika" – Eguchi Hisashi
www.kotobuki-studio.com

Fujio A., Fujiko
"Ninja Hattori-kun" – Chûôkôronsha
"Pro Golfer Saru" – Chûôkôron Comic-ban
"Warau Salesman" – Chûôkôron Comic-ban
"Manga michi" – Chûôkôron Comic-ban

Fujio, Fujiko F.
"Doraemon" – Shôgakukan/*CoroCoro Comic*
"Perman" – Shôgakukan/*CoroCoro Comic*
"Esper Mami" – Shôgakukan/CoroCoro Comic
"Kiteretsu daihyakka" – Shôgakukan/*CoroCoro Comic*

Furuya, Minoru
"Ike! Ina-chû takkyû-bu" – Kôdansha
"Boku to issho" – Kôdansha
"Himizu" – Kôdansha
"Green Hill" – Kôdansha

Furuya, Usamaru
"Palepoli" – Ôta Shuppan
"Shortcuts" – Shôgakukan/*Young Sunday*
"π" – Shôgakukan/*Big Comic Spirits*
"Garden" – East Press
"Plastic Girl" – Kawade Shobô Shinsha

Hagio, Moto
"Barubara ikai" – Shôgakukan/Flowers
"Zankoku na Kami ga Shihai suru" – Shôgakukan/*Petit Flower*
"Kono musume urimasu!" – Shôgakukan/*Shôjo Comic*
"11 nin iru!" – Shôgakukan/Bessatsu *Shôjo Comic*
"Toma no Shinzou" – Shôgakukan Bunko/*Shôjo Comic*
"Poe no ichizoku" – Shôgakukan Bunko/*Bessatsu Shôjo Comic*
"Star Red" – Shôgakukan/*Shôjo Comic*
"Hanshin" – Shôgakukan/*Petit Flower*

Hanazawa, Kengo
"Ressentiment" – Shôgakukan
"I Am a Hero" – Shôgakukan

Hara, Tetsuo
Hara, Tetsuo/Supervisor: Buronson "Sôten no ken" – Shinchôsha
Manga: Hara, Tetsuo/Gensaku: Buronson
"Hokuto no ken" – Shûeisha
Manga: Hara, Tetsuo/Gensaku: Ryu, Keiichiro/Scenario: Aso, Mio "Hana no Keiji" – Shûeisha
"Kôkenryoku Ôryô Sôsakan Nakabô Nintarô" – Shinchôsha

Hara, Yasuhisa
"Kingdom" – Shûeisha

Higashimura, Akiko
"Omo ni naitemasu" –
Kôdansha
"Kakukaku shikajika –
Shûeisha

Hirokane, Kenshi
"Kachô Shima Kôsaku" –
Kôdansha
"Kaji Ryûsuke no gi" –
Kôdansha
"Tasigare ryûseigun" –
Shôgakukan/
Big Comic Original
Manga: Hirokane, Kenshi/
Gensaku: Yajima, Masao
"Ningen Kôsaten" –
Shôgakukan/
Big Comic Original

Hôjô, Tsukasa
"Angel Heart" –
Shinchôsha
"Family Compo" –
Shûeisha
"City Hunter" – Shûeisha
"Cat's Eye" – Shûeisha
www.hojo-tsukasa.com

Hoshi, Yoriko
"Kyô no Nekomura-san" –
Magazine House
"Aizawa Riku" –
Bungeishunjû

Ichijô, Yukari
"Pride" – Shûeisha
"Yûkan kurabu" –
Shûeisha
"Suna no shiro" –
Shûeisha
"Designer" – Shûeisha

Ichikawa, Haruko
"Mushi to uta" – Kôdansha
"Hôseki no kuni" –
Kôdansha

Ikeda, Riyoko
"Berusaiyu no bara" –
Ikeda Riyoko Production
"Oniisama e..." –
Chûôkôron Shinsha
"Orefuesu no mado" –
Shûeisha
Yûgengaisha Ikeda Riyoko
Production
www.ikeda-riyoko-pro.com/
FAX 04-7191-0459

Inoue, Santa
"Tokyo Tribe 2" –
Santastic! Entertainment
"Tokyo Graffiti" –
Santastic! Entertainment
"Bunpuku Chagama
daimaô" – Santastic!
Entertainment
"Rinjin 13-gô" –
Santastic! Entertainment
"Santastic! Land"
www.santa.co.jp

Inoue, Takehiko
"Slam Dunk" –
I.T.Planning Inc.
"Vagabond" –
I.T.Planning Inc.
"Real" – I.T.Planning Inc.
www.itplanning.co.jp/

Isayama, Hajime
"Attack on Titan Outside" –
Kôdansha
"Attack on Titan" –
Kôdansha

Ishinomori, Shotaro
"Cyborg 009" –
Ishimoripro
"Kamen Rider" –
Ishimoripro
"Hotel" – Ishimoripro
"Manga Nihon no rekishi"
– Ishimoripro
"ishimori@style":
www.ishimoripro.com

Ishizuka, Shinichi
"Peak: Everyone's
Mountain" [Gaku, minna
no yama] – Shôgakukan
"Blue Giant" –
Shôgakukan

Itagaki, Keisuke
"Baki" – Akita Shoten
"Baki the Grappler" –
Akita Shoten
Manga: Itagaki, Keisuke/
Gensaku: Yumemakura,
Baku "Garôden" –
Kôdansha

Itô, Junji
"Uzumaki" – Shôgakukan/
Big Comic Spirits
"Gyo" – Shôgakukan/
Big Comic Spirits
"Tomie" – Asahi Sonorama

Iwaaki, Hitoshi
"Kiseijû" – Kôdansha
"Tanabata no kuni"–
Shôgakukan/
Big Comic Spirits
"Heureka" – Hakusensha/
Young Animal

Iwadate, Mariko
"Amaryllis" – Shûeisha
"Kodomo wa nandemo
shitteiru" – Shûeisha
"Uchi no Mama ga iu koto
ni wa" – Shûeisha
"Alice ni onegai" –
Shûeisha

Kago, Shintarô
"Sora kakeru junjô"
[Amatoria] – Kubo Shoten
"Koi no chôji kûhô" –
Kubo Shoten

Kaneko, Atsushi
"Bambi" – Enterbrain
"B.Q. The Fly Book" –
Aspect
"R" – Shôdensha

Kishimoto, Masashi
"Naruto" – Shûeisha
"Naruto gaiden" –
Shûeisha

Kon, Satoshi
"Opus" – Tokuma Shoten
"Kaikisen" – Bijutsu
Shuppansha
"Waira" – Kôdansha

Koyama, Yûjirô/Iipyao
"Tonkatsu DJ Agetarô" –
Shûeisha
"Tonkatsu DJ Agetarô" –
Shûeisha

Kubo, Mitsurô
"Moteki" – Kôdansha
"Again!!" – Kôdansha

Kuroda, Iou
"Sexy Voice and Robo" –
Shôgakukan
"Nasu" – Kôdansha
"Daiô" – East Press

Kusumi, Masayuki
"Kodoku no gurume" –
Fusôsha
"Hana no zuborameshi" –
Akita Shoten

Kyô, Machiko
"Cocoon" – Akita Shoten
"Strawberry War"
[Ichigo Senso) – Kawade
Shobô Shinsha

Man, Gatarô
"Chin'yûki" – Shûeisha
"Man'yûki" – Shûeisha
"Jigoku Koushien" –
Shûeisha
"Hade Hendrix
Monogatari" – Shûeisha

Manabe, Shôhei
"Yamikin Ushijima-kun" –
Shôgakukan
"Smuggler" - Kôdansha

Maruo, Suehiro
"Barairo no kaibutsu" –
Seirindô
"National kid" – Seirindô
"Shôjo tsubaki" –
Seirinkôgeisha
"Maruo jigoku" – Seirindô
„Inugami-hakase" –
Akita Shoten

Matsumoto, Leiji
"Uchûsenkan Yamato" –
Akita Shoten
"Ginga Tetsudou 999" –
Shônengahôsha
"Uchû kaizoku Captain
Herlock" – Akita Shoten
"Ganso dai yojouhan dai
monogatari" –
Asahi Sonorama
www.leiji-matsumoto.ne.jp

Matsumoto, Taiyô
"No. 5" – Shôgakukan
"Ping-Pong" –
Shôgakukan/
Big Comic Spirits
"Gogo Monster" –Shôgakukan

Minagawa, Ryôji
"D-Live!!" – Shôgakukan/
Shônen Sunday
Art: Minagawa, Ryoji/
Co-creator: Nanatsuki,
Kyoichi "Arms" –
Shôgakukan/
Shônen Sunday
Art: Minagawa, Ryoji/
Gensaku: Takeshige,
Hiroshi "Spriggan" –
Shôgakukan/
Shônen Sunday

Mine, Nayuka
"Arasa-chan" – Fusôsha
"Sexy joyû-chan girigiri
Mosaic" Futabasha

Miyazaki, Natsujikei
"Henshin no News" –
Kôdansha
"Boku wa mondai ari-
masen" – Kôdansha

Mizuki, Shigeru
"Yôkai daisaiban GeGeGe
no Kitarô" – Chikuma
Shobô
"Komikku Shôwashi" –
Kôdansha
"Akuma-kun" – Asahi
Sonorama
"Kappa no Sanpei" –
Asahi Sonorama

Mochizuki, Minetaro
"Dragon Head" –
Kôdansha
"Samehada otoko
to momojiri onna" –
Kôdansha
"Bataashi kingyo" –
Kôdansha
"Maiwai" – Kôdansha

Morizono, Milk
"Hong Kong Yûgi" –
Shôdensha
"Kiala" – Shôdensha
Manga: Morizono, Milk/
Gensaku: Murasaki,
Hyakuro "Cleopatra kôri
no kishô" – Bunkasha
Manga: Morizono, Milk/
Gensaku: Kirino, Natsuo
"Monroe densetsu" –
Shôdensha

Morohoshi, Daijirô
"Saiyû yôen den" –
Ushio Shuppansha
"Mud Men" –
Chikuma Shobô
"Shiori to Shimiko no
namakubi jiken" –
Asahi Sonorama
"Shitsurakuen" –
Shûeisha

Nagai, Gô
"Devilman" – Kôdansha
"Mazinger Z" –
Chûôkôron Shinsha
"Cutey Honey" –

Chûôkôron Shinsha
"Susano Ô" – Kôdansha

Nishimura, Tsuchika
"Sayônara mina-san" –
Shôgakukan

Obana, Miho
"Kodomo no omocha" –
Shûeisha
"Partner" – Shûeisha
"Andante" – Shûeisha

Obata, Takeshi
Manga: Obata, Takeshi/
Gensaku: Hotta
Yumi "Hikaru no go" –
Shûeisha
"Cyborg Jiichan G" –
Shûeisha
Manga: Obata, Takeshi/
Gensaku: Sharaku, Maro
"Karakurizôshi Ayatsuri
Sakon" – Shûeisha

Oda, Eiichiro
"One Piece" – Shûeisha
"Romance Dawn" –
Shûeisha

Ôshima, Yumiko
"F-shiki Ranmaru" –
Oshima Yumiko/
Asahi Sonorama
"Wata no kuni hoshi"
– Oshima Yumiko/
Hakusensha
"Lost House" –
Oshima Yumiko/
Hakusensha
"Gûgû datte neko de
aru" – Oshima Yumiko/
Kadokawa Shoten

Okano, Reiko
Manga: Okano, Reiko/
Gensaku: Yumemakura,
Baku "Onmyôji" –
Hakusensha/Melody
"Calling" – Magazine
House
"Yômi henjô yawa" –
Heibonsha
"Fancy Dance" –
Shôgakukan/*Petit Flower*
"Ryôgoku oshare rikishi" –
Shôgakukan/
Big Comic Spirits

Okazaki, Kyôko
"River's Edge" –
Takarajimasha
"Helter Skelter" –
Shôdensha
"Tokyo Girls Bravo" –
Takarajimasha
"Pink" – Magazine House

Oku, Hiroya
"Gantz" – Shûeisha
"01 Zero One" – Shûeisha
"Hen" – Shûeisha

Oshimi, Shuzo
"The Flowers of Evil" –
Kôdansha
"Boku wa Mari no naka"
[Inside Mari] – Futabasha

Ôtomo, Katsuhiro
"Short Peace" –
Futabasha
Manga: Otomo, Katsuhiro/
Gensaku: Yahagi,
Toshihiko "Kibun wa mô
sensô" – Futabasha
"Dômu" – Futabasha
"Akira" – Kôdansha
"Kanojo no omoide ..." –
Kôdansha

Sadamoto, Yoshiyuki
"Shinseiki Evangelion" –
Kadokawa Shoten

Saibara, Rieko
"Bokunchi" –
Shôgakukan/
Big Comic Spirits
"Chikuro yôchien" –
Shôgakukan/
Young Sunday
"Mahjong hôrôki" –
Takeshobô

Saimon, Fumi
"Tokyo Love Story" –
Shôgakukan/
Big Comic Spirits
"P.S. Genki desu, Shunpei"
– Kôdansha
"Asunaro hakusho" –
Shôgakukan/*Big Comic
Spirits*
"Onna tomodachi" –
Futabasha

Saitô, Takao
"Golgo 13" – Saito
Production/Leed-sha

"Survival" – Saito
Production/Leed-sha
"Onihei hankachô" – Saito
Production/Bungeishunjû
"Kagegari" – Saito
Production/Leed-sha
www.saito-pro.co.jp/
info@saito-pro.co.jp

Sakura, Momoko
"Chibi Maruko-chan" –
Shûeisha
"Coji-Coji" – *Gentôsha
Comics*
"Nagasawa-kun" – Sakura
Production, Ltd./
Shôgakukan

Sasaki, Noriko
"Dôbutsu no o-isha-san" –
Hakusensha/*Hana to
yume*
"Otanko Nurse" –
Shôgakukan/*Big Comic
Spirits*
"Heaven?" – Shôgakukan/
Big Comic Spirits

Shiriagari, Kotobuki
"Yajikita in Deep" –
Aspect Comics
"Ryûsei kachô" –
Takeshobô
"Hige no OL Yabuuchi
Sasako" – Takeshobô

**Tachibana, Ken'ichi/
Sasuga, Yû**
"Terra Formars" –
Shûeisha
"Terra Formars Official
Character Picture Book" –
Shûeisha

Tagame, Gengoroh
"Otôto no otto" [My
Brother's Husband] –
Futabasha
"Pride" – Furukawashobo

Takada, Yuzo
"3x3 Eyes" – Kôdansha
"Genzô hitogata kiwa" –
Kôdansha
"Aokushimitama Blue
Seed" – Takeshobô
"Mainichi ga nichiyôbi" –
Futabasha

Takahashi, Rumiko
"Inu Yasha" –
Shôgakukan/
Shônen Sunday
"Ranma 1/2" –
Shôgakukan/
Shônen Sunday
"Urusei Yatsura" –
Shôgakukan Bunko/
Shônen Sunday
"Ningyo wa warawanai"–
Shôgakukan/
Shônen Sunday

Takano, Fumiko
"Kiiroi hon" – Kôdansha
"Ruki-san" – Chikuma
Shobô
"Bô ga ippon" –
Magazine House
"Zettai anzen kamisori" –
Hakusensha

Taniguchi, Jirô
"Botchan no jidai" –
Futabasha
Taniguchi, Jiro: "Inu o
kau" – Shôgakukan/
Big Comic Spirits
Manga: Taniguchi, Jiro/
Gensaku: Yumemakura,
Baku "Kamigami no ita-
daki" – Shûeisha
"Tôkyô-shiki satsujin" –
Futabasha

Taniguchi, Natsuko
"Jinsei yama ari Taniguchi"
– Leed-sha
"Sayônara, Reba Sashi" –
Takeshobô

Tatsuta, Kazuto
"Ichi-Efu [1F]: The Life of
Fukushima Nuke Worker
Recorded as Manga" –
Kôdansha

**Tezuka, Osamu
(Tezuka Productions)**
"Tetsuwan Atom" –
Kôdansha
"Black Jack" –
Akita Shoten
"Hi no tori – Reimeihen" –
Kadokawa Shoten
"Ribbon no kishi" –
Kôdansha
"Buddha" – Ushio
Shuppansha
"Adolf ni tsugu" –

Bungeishunjû
Tezuka Osamu
Productions
www.tezuka.co.jp

Togashi, Yoshihiro
"Yû yû hakusho" –
Shûeisha
"Hunter x Hunter" –
Shûeisha
"Level E" – Shûeisha

Toriyama, Akira
"Dragon Ball" – Shûeisha
"Dr. Slump" – Shûeisha
"Sand Land" – Shûeisha

Tsuge, Yoshiharu
"Neji-shiki" – Chikuma
Shobô
"Akai hana" – Shôgakukan
"Munô no hito" –
Shinchôsha
www.mugendo-web.com/
y_tsuge/

Umezu, Kazuo
"Hôryû kyôshitsu" –
Shôgakukan
"Watashi wa Shingo" –
Shôgakukan
"Makoto-chan" –
Shôgakukan
"14 sai" – Shôgakukan

Umino, Chika
"Hachimitsu to Clover" –
Shûeisha

Urasawa, Naoki
"20 seiki shônen" –
Shôgakukan/
Big Comic Spirits
"Monster" – Shôgakukan/
Big Comic Original
"Yawara!" – Shôgakukan/
Big Comic Original
"Pineapple Army" –
Shôgakukan/
Big Comic Original

Yamamoto, Hideo
"Ichi the Killer" –
Shôgakukan
"Homunculus" –
Shôgakukan

Yamamoto, Naoki
"Anjû no chi" –
Shôgakukan
"Blue" – Futabasha

"Asatte Dance" –
Ôta Shuppan

Yamashita, Kazumi
"The Life of Genius
Professor Yanagizawa" –
Kôdansha
"Land" - Kôdansha

Yamazaki, Mari
"Thermae Romae" –
Enterbrain
"Steve Jobs"– Kôdansha

Yazawa, Ai
"Paradise Kiss" –
Shôdensha
"Nana" – Shûeisha
"Tenshi Nanka Janai" –
Shûeisha

Yoshida, Sensha
"Utsurun desu" –
Shôgakukan/
Big Comic Original
"Chikuchiku uniuni" –
Shôgakukan/*Shônen
Sunday*
"Puripuri-ken" –
Shôgakukan/
Big Comic Original

Yoshinaga, Fumi
"Ôoku: The Inner
Chambers" – Hakusensha
"What Did You Eat
Yesterday?" – Kôdansha

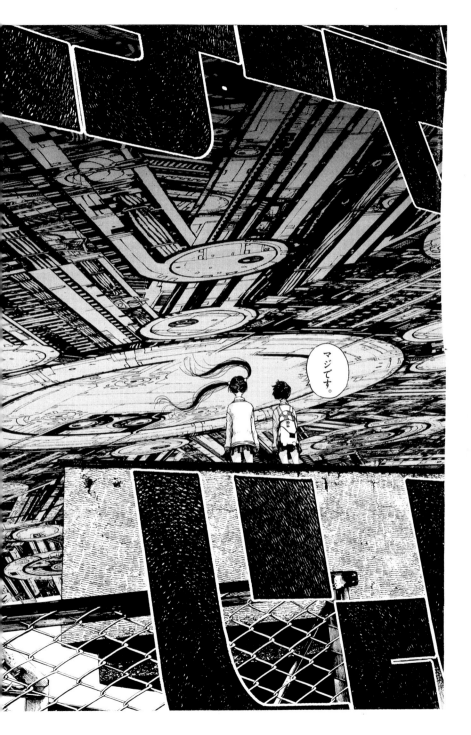

100 Illustrators

The Package Design
Book

Logo Design.
Global Brands

D&AD.
The Copy Book

Modern Art

Bookworm's delight:
never bore, always excite!

TASCHEN
Bibliotheca Universalis

Design of the 20th Century

1000 Chairs

1000 Lights

Industrial Design A–Z

Bauhaus

1000 Record Covers

20th Century Photography

A History of Photography

Photographers A–Z

Eugène Atget. Paris

Photo Icons

New Deal Photography

The Dog in Photography

Curtis. The North
American Indian

Stieglitz.
Camera Work

Burton Holmes.
Travelogues

Lewis W. Hine

Film Noir

Horror Cinema

100 All-Time
Favorite Movies

The Stanley Kubrick
Archives

20th Century Fashion

Fashion History

1000 Tattoos

Tiki Pop

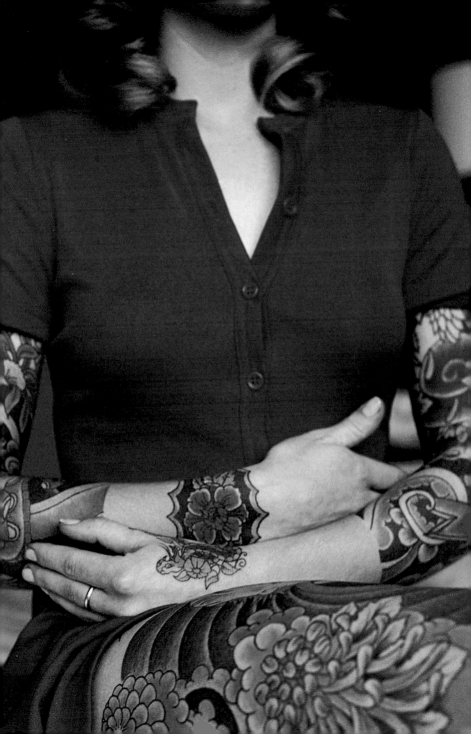

Wearable art

An exploration of tattoos' past and present

Whether you're thinking of getting a tattoo or just want to see to what lengths others have gone in decorating their bodies, this is the book to check out. *1000 Tattoos* explores the history of the art worldwide via designs and photos—from 19th-century engravings to tribal body art, from circus ladies of the 1920s to classic biker designs—giving a fascinating insight into the art of tattooing.

"A fascinating and discon-
certing book in which,
on every page, the human
body is displayed to fire
the imagination of each
of us..."

—*Connexion*, Monaco

1000 Tattoos
Henk Schiffmacher,
Burkhard Riemschneider
544 pages
TRILINGUAL EDITION IN:
ENGLISH / DEUTSCH / FRANÇAIS

2194

2195

2196

StickerNation.Net

2198

Swallow

2199

ZWERFVUIL
BLIKSEMSNEL IN DE BAK!

2200

2202

2203

2204

2206

2207

2208

Sure signs

Diverse logos from around the world

A good logo can glamorize just about anything. Now available in our popular *Bibliotheca Universalis* series, this sweeping compendium gathers diverse brand markers from around the world to explore the irrepressible power of graphic representation. Organized into chapters by theme, the catalog explores how text, image, and ideas distil into a logo across events, fashion, media, music, and retailers. Featuring work from both star names and lesser-known mavericks, this is an excellent reference for students and professionals in design and marketing, as well as for anyone interested in the visuals and philosophy behind brand identity.

"An excellent visual reference..."

— *Curve Magazine*, Sydney

Logo Design
Julius Wiedemann
664 pages
TRILINGUAL EDITION IN:
ENGLISH / DEUTSCH / FRANÇAIS

Imprint

**EACH AND EVERY TASCHEN BOOK
PLANTS A SEED!**
TASCHEN is a carbon neutral publisher. Each year, we offset our annual carbon emissions with carbon credits at the Instituto Terra, a reforestation program in Minas Gerais, Brazil, founded by Lélia and Sebastião Salgado. To find out more about this ecological partnership, please check: www.taschen.com/zerocarbon
Inspiration: unlimited. Carbon footprint: zero.

To stay informed about TASCHEN and our upcoming titles, please subscribe to our free magazine at www.taschen.com/magazine, follow us on Instagram and Facebook, or e-mail your questions to contact@taschen.com.

© 2023 TASCHEN GmbH
Hohenzollernring 53
D–50672 Köln
www.taschen.com

Original edition: © 2004 TASCHEN GmbH

English translation:
John McDonald & Tamami Sanbommatsu
German translation (from Japanese original):
Ulrike Roeckelein
German translation new entries:
Thomas J. Kinne
French translation:
Marc Combes and Delivering iBooks & Design
Research and editorial assistance:
Goki Miyakita

Page 1: Yoriko Hiroshi, "Kyou no Nekomure-san" – Magazine House
Pages 2, 4: Natsuko Taniguchi, "Jinsei Yama Ari Taniguchi" – Leed-sha
Page 6: "KATSU!" – Shôgakukan/*Shônen Sunday*
Page 569: Inio Asano, "Dead Dead Demon's De De De Deconstruction" – Shôgakukan

Printed in Bosnia-Herzegovina
ISBN 978-3-8365-2647-0

わるいけど あまり かつやく できそうも ないよ。

やっか いだな これを やろう。

コピーロボッ トだ。鼻の ボタンを おすと おした人と そっくりになる。 顔かたちだけ じゃなく、性質や 能力までも。

へえ〜 ほんと?

ブ〜ン

ブ・ブ…

カチッ ☆

それを おいとけば きみの いない あいだ 身がわりとして 行動して くれる。

帰ってから おでこを くっつけると、 るすちゅうの できごとが ちょくせつ きみの脳に つたわる。

フーン

きもち わるい。

ひとつ わすれて ならない ことが ある。

パーマンのひみつ は家族に もらしては ならぬ。もし 他人にひみつを しられたときは かわいそうだが…。

細胞 変換銃で 動物に変身 させてやる。

おどかさ ないでよ。